COAST
OUR ISLAND STORY

To Imogen, Kit and Connie

By Nicholas Crane

Mercator: The Man Who Mapped the Planet
Clear Waters Rising: A Mountain Walk Across Europe
Two Degrees West: An English Journey
Great British Journeys

NICK CRANE

COAST

OUR ISLAND STORY

A JOURNEY OF DISCOVERY
AROUND BRITAIN AND IRELAND

BOOKS

This book is published to accompany the television series entitled *Coast*.
Executive Producer: William Lyons
Series Producer: Steve Evanson

1 3 5 7 9 10 8 6 4 2

First published in hardback in 2010 by BBC Books, an imprint of Ebury Publishing.
A Random House Group Company.

This paperback edition published 2012

The Random House Group Limited Reg. No. 954009

Addresses for companies within the Random House Group can be found at
www.randomhouse.co.uk

A CIP catalogue record for this book is available from the British Library.

ISBN 978 1 849 90434 6

The Random House Group Limited supports The Forest Stewardship Council® (FSC®),
the leading international forest certification organisation. Our books carrying the FSC label
are printed on FSC® certified paper. FSC is the only forest certification scheme endorsed by
the leading environmental organisations, including Greenpeace. Our paper procurement
policy can be found at www.randomhouse.co.uk/environment

Commissioning editor: Muna Reyal
Project editor: Caroline McArthur
Copy-editor: Stephanie Evans

Back cover photos:
Isle of Skye © David Croy
Lindisfarne & beach huts – Shutterstock

Designed and set by seagulls.net
Printed and bound by CPI Group (UK) Ltd, Croydon, CR0 4YY

To buy books by your favourite authors and register for offers, visit www.randomhouse.co.uk

Contents

Best known for his work as a presenter on *Coast* and for his BBC series' *Map Man*, *Great British Journeys*, *Britannia* and *Town*, Nicholas Crane is a writer and geographer with a passion for maps and exploration. In 1992–3 he walked alone for eighteen months along the 10,000-kilometre mountain watershed of Europe, describing this epic adventure in his award-winning book *Clear Waters Rising*. Then came *Mercator*, a biography of the Renaissance mapmaker, published in 2002 and described by *The Sunday Times* as standing 'at the peak of Crane's achievement'. Nicholas' most recent books are *Great British Journeys* (2007), which follows the exploratory footsteps of eight intrepid writers, and *Coast: Our Island Story*.

Preface

Dear Reader,

Thank you for opening this book. I find myself writing these introductory words last. The manuscript is complete, and I'm on the coast. Before me is a scene of beauty. It's an estuary in Wales at dusk. The tide is flooding and all the boats have turned to face the sea, as if they are soon to slip their moorings and sail away on a voyage of discovery. Only a few hours ago, the same estuary was a sandy plain, parted by a meandering blue thread. Off the beach at the estuary mouth, a kite surfer was twisting balletically from breaking crests, and mountains floated on the salt haze. Beside the lifeboat station, families were playing football and Frisbee and two boys had built a turreted castle that rose like Harlech from the smoothed foreshore. A steam train passed, and a Hercules transport plane, and a timber sailing boat, rigged medieval-style with a dipping lugsail. A pair of gulls opened mussels by dropping them from 30 feet onto a tabletop of small, flat stones. Now the sea is pouring in and the estuary is restless. The tide slaps and gurgles against the old stone bulwarks of cottages whose attentive windows have seen square-riggers and tramp steamers, barques loaded with slate, and herring boats in from gales.

Our coast has more stories than can ever be written. These enviable islands have an ideal climate for life to flourish, and they're located in one of the busiest parts of the globe. They also have a very long history: the rocks that form our oldest shores date back three billion years, more than half the age of the planet. Visually, it's a diverse spectacle. There are cliffs in the north of blackest basalt, and cliffs in the south of purest white; cliffs in the west as red as blood and sands in the east the colour of honey. There are sea stacks taller than Nelson's

Column, and sea arches you can thread by boat. There are beaches framed by turquoise shallows and bays where dolphins play. Way back when the ice sheets melted, these seas were full of fish and you could feed a family from the foreshore. Is it any wonder that humans flocked to these coasts? The stories they brought lie layer upon layer around the edge of the islands. In this book, I've chosen to tell just eight of those stories.

The stories are thematic, so the places I've chosen to include are those that best illustrate the narratives; this isn't a gazetteer, and many coastal celebrities make no appearance at all, while plenty of lesser-known players are promoted to centre stage. The journey I take is not literal, but an odyssey through time and space. Having said that, most of the first-hand material I relate was accumulated on journeys of some sort. Each of the themed stories is chronological, so you can follow, say, fishermen from the early days of hunting with barbed harpoons through to beam-trawling, or the evolution of seaside resorts from the dipping of toes by wary Hanoverians to roller coasters and kayaking. I agonized and experimented before settling on the themed approach. My purpose was to explore the sources of our coast's extraordinary diversity, and by doing so, to gather insights into its value to us now, and in the future. I hope you find the eight journeys as fascinating as I did.

In the first story, I travel into the deep past to see how rocks and drifting continents and climate have created such a wonderful pattern of islands. The second story follows the fishers and foragers who discovered the natural bounty of these temperate, productive coasts. The third and fourth stories track the evolution of trading ports and the various means we've devised to defend our shores against our enemies. The fifth and sixth stories are tales of opportunism and selflessness (or sin and redemption) as we move from wrecking and smuggling to the heroes and heroines who made these shores safe by building lighthouses and manning lifeboats and coastguard stations. The seventh story looks at our recognition of the coast as a source of good health and at the ways in which we converted it into the biggest, most popular playground in the archipelago. In the final story, I follow the enduring role of the coast as a 'sacred place'.

This book sprang from the success of the BBC series *Coast*. All who worked on its first series were startled (in the best possible way) by its unexpected

popularity. Millions switched on, and have stayed loyal as BBC Birmingham produced series after series. There's a sense that Britons are discovering how much fun the coast can be, and what a huge role it has played in forging our identity. This has less to do with nationality than with being islanders. Everybody who grew up on these islands has a relationship with the sea, imaginary or actual. None of us live more than a couple of hours from the high-tide line. The history of these islands was built upon an understanding of the sea, and as we look for more enlightened ways to amuse ourselves, the coast is being revalued.

It's the right moment for a rethink. Our coast describes the body of our land, and yet it faces a spectrum of intense human demands. We need it to feed ourselves, and we need it to provide the havens for the ships that fill our shops and fuel tanks. We need it for the power generators that send electricity to our fridges, factories and vehicles. We need the coast for our holidays, and for living beside, and we need it because it is a sanctuary, both for wildlife and for the human spirit. In these eight stories, I hope I've shown why the coast is an unparalleled natural wonder, why it's our defining resource, and why we should take every care to preserve it for future generations.

Nick Crane
August, 2010

Particular Thanks

We did a photo-shoot once, on a beach in Wales, and we were all there: historian Mark Horton, zoologist Miranda Krestovnikoff, archaeologist Neil Oliver and biologist Dr Alice Roberts. And Alice's lime-green micro-bus. Other presenters have subsequently joined the team: Hermione Cockburn, Renee Godfrey, Kate Rew, Dick Strawbridge and, most recently, Tessa Dunlop and Adam Henson. I feel very fortunate to have shared the boat with you all.

Steve Evanson and Gill Tierney at BBC Birmingham not only built the boat, but managed to launch it on the epic circumnavigation that became the first series of *Coast*. Roly Keating, then the Controller of BBC2, gave *Coast* an enviable slot on the best TV channel in the world, and Janice Hadlow has kept it there. As BBC 'execs', Gary Hunter and now Bill Lyons have been invaluable champions of *Coast*, and so has the BBC's Emma De'ath, who was instrumental in forging such a successful partnership with the programme's coproducer, the Open University. Composer Alan Parker – guitarist to the greats – wrote the music that carries each film onto the next headland and Mike Bloore created *Coast*'s unique editorial style. Every director, cameraman, sound recordist, assistant producer, researcher, production manager, editor, sound engineer and production coordinator who worked on *Coast* was part of its success; part of the reason it picked up a BAFTA and various other awards, and became in its first year the highest-rating factual programme on BBC2. Among those who played a pioneering role on the first series, were director Oliver Clarke, cameraman Julian Clinkard and production manager Alison Jenkin. By the time this book is published, BBC Birmingham will have made eight series of *Coast* and several 'specials'; a total of over 60 films. Books too

can become epic endeavours, and this one is no exception. I wanted to go beyond the TV films, and for those of you who have followed the screen version of *Coast*, there will be much here that is new.

At BBC Books, I'd like to thank Caroline McArthur for finding such a splendid set of illustrations, Stephanie Evans for her copy-editing skills and my editor Muna Reyal, for the patience, encouragement and expertise she directed to the pages which follow. The updating and editing of this paperback edition has been masterminded at BBC Books by Nicholas Payne.

Once again, my pilots on the high seas have been Derek Johns, my literary agent, and Rob Kraitt, my TV agent, both at AP Watt, while Yasmin McDonald, Juliet Pickering and Bea Corlett at the same, august agency, have handled countless issues on my behalf while I've been *Coast*ing.

For keeping the harbour lights glowing during long nights at sea, there is one above all to whom I am grateful beyond measure: Annabel.

1.
Precious Stones, Set in the Silver Sea: The Creation of Our Coast

It's midsummer and silvery squalls are ghosting across the Irish Sea. Twenty-four hours of gale-force winds have massaged the waves into slow-moving ranges that collide with deep shudders against Anglesey's western bastion. South Stack is in formidable form. I'm on the edge of the cliff with Libby Peter and Graham Desroy. Bandoliers of clinking metal swing from their hips as they step over snakes of rope, tightening helmets, adjusting straps and buckles. They move with the slinky grace of stalking cats, smiles in their eyes. The brink of an abyss is their natural habitat: it's where they excel. They are rock climbers.

Libby goes first, stepping backwards into the void. Peering over the edge, I can see clouds of spray erupting against black rock. The yellow dot of Libby's helmet disappears beneath an overhang. The sea is a couple of hundred feet down.

'How will we know,' I ask Graham, 'when Libby's at the bottom?'

'The rope will go slack.'

I run my hands over my harness for the tenth time. We're going to abseil down the cliff to a ledge just above the waves, then traverse around the headland to the foot of a climb called *Illya Kuryakin*. It's my first cliff climb, graded VS, Very Severe; just a light scramble for the likes of Libby and Graham.

'You ready?' asks Graham.

I thread the abseil device, clip onto the rope and lean backwards (always a tricky moment, that initial, gravitational tilt).

'Just be careful on the first bit,' calls Graham from above my head. 'It's loose, and we don't want to drop rocks on Libby's head.'

I let the rope slide through my hand. I'm tip-toeing backwards. The feeling of 'time standing still' is more than a cliché. It really happens. The brain's response to mortality is to shut down every thought circuit except the one required to overcome immediate danger. The tick-tock of everyday concerns is replaced by a silent, temporal vacuum; an infinite cerebral space bisected by a single, narrative thread to the future. It's a pure space, reserved for survival and pleasure.

I watch my rock shoes touch the fissured rock. A piece of quartz the size of a dice trembles in its socket. I've forgotten how to abseil an overhang, and for a moment I'm dangling, with my helmet scraping the rock and feet cycling for contact. The sea, blue and hard, is heaving like the flank of an enormous beast. I ease the abseil device, and feel my toes touch the cliff.

Leaning back, I've got a clear view across Gogarth Bay to North Stack, one mile away. And there, oblique from this angle, is one of the greatest climbs in Britain, *Dream of White Horses*, 430 feet of airy, arching HVS [Hard Very Severe]; first ascended in 1968 by the poet–climber Ed Drummond. He once referred to rock as 'petrified patience'.

At the foot of the abseil, Libby organizes ropes while Graham slides down to join us. We traverse around the headland. Waves explode at our feet. I can taste the salt on my lips. 'That's it!' shouts Libby. 'Over there. The crack, then the arête.' I can't see what she is pointing at. The cliff doesn't appear to possess any features large enough to catch the eye. We traverse a bit further, then Libby turns again: 'We start from here. You step across this gap, then go up.'

Most of the rock climbs I've done (and it's not many) have started on serene lawns of rough grass, or banks of scree. The start of *Illya Kuryakin* is precarious, and tempestuous. The ocean booms and smokes, and I'm teetering on a chipped blade of rock, anchored to the cliff by my left hand. And yet this is one of the easiest climbs on these cliffs: just two pitches to the top.

Libby goes first, effortlessly crossing the chasm at the foot of the cliff, then pausing for a moment, looking upward. She floats up the first pitch as if gravity has been reversed. She arranges a belay. Then it's my turn.

The chasm is an immediate problem. I can't see how to reach the foot of the climb without falling into the sea. Graham advises a bridging movement. The

fact that I'm not swimming is a preliminary triumph. But I'm committed now. I've crossed the chasm, and the only way out, is up. And *Illya Kuryakin* is ridiculously vertical.

Belayed from above, I cannot fall, but that is not the point. Rock climbing is an exercise in grace. Ascent is measured by the manner of the moves. I'm poking and scrabbling, clinging to the cliff. There is a kind of fissure, sparkling with quartz, and I'm trying to wedge sufficient bits of my extremities into this crack to prevent a fall. I'm about 20 feet above the waves when I hear Graham calling:

'Nick … try spreading your legs, like a starfish. Use more of the cliff. You're trying to pedal up a line!'

I withdraw my left foot from the sanctuary of the crack, and explore the face of the cliff. A sharp nodule catches the edge of my climbing shoe. (He could be right.) I do the same with my right foot, then reach sideways for a handhold. Spreadeagled, I realize that I've doubled, trebled, the number of available holds. To move upward, I have to reach for the cliff, not hide from it.

I'm moving upward. The cliff feels warm. This is complex rock, quite unlike the uniform cliffs of Dover or Orkney, where uninterrupted walls of chalk or sandstone rise for hundreds of feet. Here at South Stack, I'm looking at a dog's breakfast of geology: rock of many textures and hues with no obvious arrangement. Geologists are still trying to understand what happened on Anglesey. It was, unquestionably, violent. This was once the collision zone between two of the earth's plates and the rock here has been baked by pressure and heat; folded, twisted and sheared.

I'm back on quartz again; a white, glassy vein in the cliff. The view is wonderful. The coast is an edge, and here, where Anglesey's ancient rocks meet the sea, the edge is emphatic. There are no sandbars or lagoons, or gentle peterings of land and sea. The land is cleaved as if by an axe. In the horizontal plane, there is an immediate transition from green to blue; I am suspended on that edge, in the other plane.

The crux comes too soon. It's an awkward move; a test of faith. The arête is like the corner of a shattered building. At the top, there is a huge, protruding block. There are no holds for my feet, and I cannot reach the top of the block.

The only means I have of pushing upward is to smear my right shoe against the smooth, tilted side of the block. It is nearly vertical, and I look down at my foot, wondering whether the friction between rubber and rock will be sufficient. If the shoe skates off, I'll fall. Well, not exactly fall, because I'm roped from above, so there will just be a sharp jolt. But humans are wired to fear falling, and besides, dropping off a rock climb breaks the spell. Climbing is feat of imagination, rather than a test of braided polyamide.

The sea is so far down that it is silent now. The fingers of my left hand are wedged in a crack. I've forgotten to remove my wedding ring, and realize that if I slip and the ring jams in the crack, my finger will be torn off. I rearrange the hand, so that the finger-at-risk is outside the crack, then push, tentatively, with my right foot, transferring my weight onto the face of the slab. I return my weight to the lower, left foot, take a breath, look upward, and move.

The rest is easy. I climb, absorbed in the pleasure of balancing each move. Then there is an abrupt change of plane, from vertical to horizontal, and I can walk. It's over, and I'm throwing my arms around Libby. Graham climbs up to join us and there is chatter and footling with coils of rope and racks of gear while the sun slips towards the sea. Off South Stack, the sea is boiling; the tide has turned.

In the big, spherical picture, the coasts of these islands are young; a tick of the clock in the planet's six-billion-year chronology. A mere 20,000 years ago, Scotland was covered with a mile-thick ice sheet that reached as far south as the Humber and the Severn. The North Sea and English Channel were arid, frozen wastes of wind-blown glacial dust. But the planet's climate is capricious, and when temperatures suddenly rose around 16,000 years ago summers became as warm as those of today. Sea levels rose, filling shallow basins. Thawing sands and gravels grew green with juniper and birch, and herds of wild horses grazed across herb-rich grasslands. Bears prowled the banks of wide, braided rivers and humans reappeared for a while. But around 12,700 years ago, the climate flipped again. Mean annual temperatures in Britain appear to have plummeted by about 15 degrees Celsius in ten years. For the best part of a thousand years,

the northern reaches of the continent reverted to a cold, dry tundra. Snow lay on the hills all the year round, and in the north, glaciers cascaded from the high corries. On the coast, average temperatures dipped to minus 20 degrees in winter, and struggled to reach 10 degrees in summer. Reindeer replaced the horse and deer, and the humans trekked for weeks at a time following the herds, as Lapps do today.

The Big Freeze was followed about 11,500 years ago by a virtually instantaneous Big Heat: extreme global warming that saw mean annual temperatures jump by 20 degrees. The greater part of this thermal aberration may have occurred in as little as 50 years. For around 4,000 years (from 9,000 to 5,000 years ago), the earth's climate was warmer and moister than it is today. Habitats went through a step change. Dense forests spread over much of western Europe. On better-drained vales and slopes, stands of oak, elder and elm took root, spreading into patchy forest which became the home of red and roe deer, wild boar, hares, and predators like brown bears, wolves and foxes. Among the wild foods were hazelnuts, which became a staple of the early human colonists.

At this kind of temporal range, it all looks like the Garden of Eden, but the warming climate had triggered a tipping point. Sea levels started to rise rapidly. The effect on our coast was transformative. In the far north, estuarine lands flooded to form a wide, salt-water gulf between the iced peaks of Scotland and those of Norway. To the west, seawater flooded river valleys and glacial trenches, detaching the Orkneys, Hebrides and Ireland from the northern European landmass. Change was most marked in the south. With the northern mountains relieved of their enormous burden of ice, the earth's crust sprung upward, but a 'see-saw' effect caused the land surface in the south of Britain to sink. Coupled with rising sea levels caused by melting ice, southern coasts were remodelled. Sea gradually flooded in from the west, turning green downland into white cliffs.

Human settlements were drowned as low-lying coasts were submerged, but the greatest loss was in the east, where a wide land bridge still linked eastern Britain to the continent. Archaeologists have dubbed the land bridge 'Doggerland', after the largest sandbank in the North Sea: the Dogger Bank. Doggerland was one of the richest territories in post-glacial Europe, a vast, rolling plain threaded with rivers, marshes and lakes. Seabed surveys have

revealed one thousand miles of river channels and 24 lakes or marshes, one of which covered nearly 200 square miles – an area twice the size of the Broads National Park. Ranges of low hills provided drained footings for woodland and dry passage for inland travel. Doggerland was also very 'coastal'. As the only land bridge to the continent, it was rimmed to north and south by salt water, while its central geographical feature was a huge estuary 60 miles long and 20 miles wide. The sea was always going to be Doggerland's destiny.

By northern European standards, Doggerland's climate was kind. The westerly weather systems beating in from the Atlantic had dropped most of their rain and velocity by the time they reached Doggerland, while its low altitude reduced the pinch of winter frosts. To this day, the plains of East Anglia are among the driest and sunniest parts of Britain. For its inhabitants, Doggerland was the dream landscape, for it offered four adjacent habitats: coast, freshwater wetland, forest and grassy plain. All human needs were covered. It seems probable that Doggerland's dwellers were fairly mobile, and that their seasonal migrations were anchored to their long coastline. From autumn through to spring they would have based themselves near the sea, or on the shores of their great estuary. Here they could fish and collect shellfish, and pick off migratory birds. On nearby systems of rivers and lakes, there were plenty of cormorant, grebe, crane and duck, and the wetland was rich in reeds which could be used for basketry and roofing material. In calm meres, they would have found edible plants like the water lily. In scrubland and woods they could forage for hazelnuts, raspberries, blackberries and fungi. Herbs like sorrel and meadowsweet were there for the picking, and there were any number of tubers, seeds and leaves that we've forgotten how to use. In the woods were deer and wild pig. Nodules of flint for tools and weapons could be collected on many of the beaches, and the woods provided timber for shelters, firewood and boat-building. Early in the summer, these early settlers probably left the coasts and headed inland to hunt for game.

As Doggerland was nibbled by the sea, the land bridge narrowed, and its use as a thoroughfare – a through route between the continent and the huge, bulbous promontory that would become Britain – must have intensified. From a land, it became a highway, and a cultural conduit. The folk living on the Doggerland bottleneck must have been party to information; to knowledge.

Doggerland was probably lost in a series of inundations, swamped by storms and surges; abandoned mile by mile. At around this time, there was also a freak tsunami. One autumn about 8,000 years ago, a slab of seafloor the size of Scotland slid into a trench off Norway and pushed up a surging wall of water. It was rather as if the Ice Age was sending a reminder that it wasn't yet done, for the cause of the tsunami was 3,000 cubic kilometres of glacial sediment and debris which had been destabilized by the shifting ocean. When the tsunami hit the Shetland Islands, the waves were over 20 metres high. As far south as the Firth of Forth, they were between 3 and 6 metres high. Anybody standing on the shoreline of eastern Scotland would have been bowled over and drowned. To this day, buried beneath a top cover of peat, you can see the thick layer of stones and gravel that were swept across Shetland. Looking at it, you wonder what effect the tsunami had on the remaining vestiges of Doggerland, or its coastal families.

The connecting thread that was Doggerland finally went under about 7,500 years ago, and the severed promontory became Europe's largest island. The water kept rising, chewing at the softer edges of the new archipelago. A new sea expanded in the east and on the southern shores of Britain and Ireland river valleys filled with seawater, creating sinuous inlets. Where a promontory was cut off, or an isthmus flooded, islands formed. The shores of southern Britain are dotted with relics from these lost lands. St Michael's Mount in Cornwall used to be a sharp hill surrounded by forest which now lies beneath the waters of the bay. Fragments of that forest still appear when gales strip away the sands. At low tide on the beach at Borth in North Wales, you can find the root systems of a forest that once occupied the shallow basin now filled with Cardigan Bay. And at Amroth in South Wales, another forest emerges from the sand below the Pembrokeshire coast path. Gerald of Wales, writing in 1188, described how the beach at Newgale had been scoured clean of sand by a great storm, which revealed tree trunks 'standing in the sea, with their tops lopped off … as if they had been felled only yesterday'. The ancient Welsh legend of a sunken land called Cantre'r Gwaelod beneath Cardigan Bay appears to be rooted in fact. On the other side of Britain, Doggerland's forests are still out there, too. If you take a low-tide walk along the beach at Titchwell Marsh RSPB reserve, you may

come across banks of peat poking from the wet sand. Last time I was there, the foreshore was strewn with branches, roots and the stubs of trunks, black and salt-saturated. Those trees used to reach the Netherlands. On a fishing boat out of Yarmouth, Simon Fitch, a landscape archaeologist and one of the authors of the definitive book on Doggerland, showed me core samples extracted from the seabed. We looked at the cores on the deck of the boat while the turbines of Scroby Sands wind farm revolved in the background. Each core contained a thick horizon of black peat; all that remained of the trees and shrubs that sustained the island's post-glacial explorers.

More poignant still was an afternoon spent on the tidal mud of the Severn Estuary. This time our filming guide was an archaeologist called Dr Martin Bell, who led us through canyons of slime to a tilted bank just above the water. As the mud was being eroded by the waters of the Severn, it was breaking into layers, each layer representing a deposit of silt laid down by a particular tide, more than 8,000 years ago. One of the layers was covered with footprints; tiny, human footprints. They were so clear that they might have been made ten minutes earlier. In the perfect, sculpted impressions of toes and heels, it was possible to see how the children had been jumping, turning; leaping perhaps. What were they doing? Hunting? Playing? Fighting? Their prints have now been washed away. These tree roots and footprints read like cryptic texts from our ancestors.

Around 6,000 years ago, the rate of sea-level rise slowed. In a geological blink of just 12,000 years, a frigid, icy desert had been transformed into a temperate archipelago. Sea levels had risen by 120 metres, slightly more than the height of St Paul's Cathedral. The shore of mainland Europe had shifted southward by 800 miles, from somewhere north of the Shetlands, to the cliffs of Calais. An area of land greater than the size of the United Kingdom had disappeared beneath the sea. What remained was the higher ground, the mountains, the plateaux and 6,000 islands. Shakespeare referred to one of those islands as a 'precious stone set in the silver sea', but he might have been writing for all of them.

It is an extraordinary archipelago. Eight hundred miles from north to south, and 500 miles wide, it rises from the sea midway between the Arctic Circle and

Africa. Its western shores are washed by the deep Atlantic Ocean; its eastern shores by the shallow North Sea. We are warmed by an ocean current that has come all the way from the Gulf of Mexico, and our weather – borne on winds that can blow from the Arctic, Africa or Atlantic – is, well, variable. We are also a geological freak.

The rocks that give our coast its character are unusually old and varied. They span around three billion years of the earth's history and have survived an incredible journey; a slo-mo marathon measured in thousands of miles and hundreds of millions of years. The oldest bits of Britain and Ireland are the travel-mangled remains of crustal plates that have slithered, collided and parted across the surface of the globe. Six hundred million years ago, the parts of the Earth's crust that were to form Scotland and northwest Ireland were somewhere in the region of today's Antarctic coast. At the time, England, Wales and southeast Ireland were a geographically separate part of the Earth's crust, located in warmer latitudes roughly level with present-day South Africa. Drifting north, these two main crustal parts of Britain and Ireland merged, crossed the equator and were subject to every force in the geological toolkit. Layers of silt washed from mountain and plain emerged on our shores millions of years later as rock that looks like folded sandwiches. We have cliffs of cooled volcanic lava, and others that were metamorphosed deep underground by extremes of heat and pressure. Some of our shorelines were formed from desert sands; others were created on seabeds from the shells of dead creatures. This is the ancient land that found itself poking from the Atlantic rim 6,000 years ago when the seas became more settled.

For the first time since the ice had melted, sea and land had found some kind of equilibrium, and the forces of the ocean became focused on a relatively stable shoreline. This was the moment that the sea really went to work as a sculptor; the moment when the form of our modern coast became defined. Water is an immensely powerful tool, and the sea is famously restless. Cliffs were undercut and rinsed by storms to form caves and crevices. Great arches and towers were hewn from headlands. Waves, tides and currents worked around the clock, shifting millions of tons of rock, sand and earth from one part of the coast to another to form beaches and spits. Coastal winds built

ranges of dunes. Search the planet, and it's hard to find a coastline of equivalent length with such an incredible variety of coastal landforms.

Our wildest coast is also our oldest. A few summers ago, I climbed a hill called Heaval on the Hebridean island of Barra. It's only just over a thousand feet, but it's the highest point on the island. The air was blue with sky and sea, and so clear that the southern Hebrides were as sharp as a map: Vatersay and Sandray, Lingeigh, Pabbay and Mingulay tapering into the immense Atlantic. Across the summit of this ancient hill, lichen-speckled rock protruded from the wiry grass like the greyed remains of a gigantic fossil. Over the next three weeks, as we made our way north along the Hebridean chain to the Isle of Lewis, we'd see a lot more of this rock. We found it as the encircling arms of blue lagoons, as flotillas of islets, and as defiant cliffs being battered by a westerly gale. It's called Lewisian gneiss, and it's the oldest rock in Britain, formed at a time when simple, bacterial organisms were striving to evolve on earth. Baked, frozen, rent, folded and scoured on its three billion-year-journey, Lewisian gneiss is a relic, and it gives the Hebridean shores their ancient countenance. You can find it on the mainland, too, where it defines sections of shoreline between Cape Wrath and Skye – including the wild fringe of Assynt. This is one of my favourite coasts in Britain; a ragged edge of rock and beach fronted by islands and backed by isolated, monumental mountains. At places like Clachtoll and Achmelvich, the space between sea and peak is filled with low, hummocky hills dotted with old grey rock which has been around for more than half the age of the planet. There are few places in the world where you can stand on a piece of stone and feel such a passing of time through the soles of your feet.

It's up here, in northern Scotland, that we find some of our most astonishing natural architecture. The fjord-like scenery that clogs the memory card on your camera as you take the long and winding roads north from Skye has been given its beauty by billion-year-old sandstone that has been eroded into 3,000-foot mountains and deep sea-inlets. Geologists call the sandstone 'Torridonian', after the sea loch which squirms for 12 miles into the depths of this primeval stonework. I first climbed these mountains as a teenager, and have been coming back ever since – a couple of times by bicycle. Inner Loch

Torridon can be tempestuous or moody, or bewitch you with sunlight. The peaks tilt to 3,500 feet from the water's edge. One January night when the sky was stuffed with stars, I stood on a rock above the loch watching the Northern Lights play in luminescent curtains beyond the horns of Beinn Alligin – the Jewelled Mountain – the only time I've seen the Aurora Borealis from Britain.

It's in this remote precinct of Scotland, too, that you find one of the largest and most dramatic coastline caves in Britain. It's also one of the oldest. Smoo's limestone was laid down 500 million years ago on the bed of a tropical sea when Scotland lay south of the equator. More recently, as sea levels stabilized, freshwater and seawater made a two-pronged attack on a geological fault in the limestone, widening it into three caverns, the largest of which is 60 metres long and 40 metres wide. The second chamber contains a 25-metre waterfall, and the third can only be reached by small boat. Smoo is described at the end of the 16th century by the great mapmaker Timothy Pont, who wrote of 'a great hollow cave' containing 'a freshe pond of great deep' and a spring tumbling through a hole in the roof. When the Scottish novelist, Walter Scott, came visiting in August 1814, he found himself lost for words: 'Impossible,' he noted in his diary, 'for description to explain the impression made by so strange a place.'

The most spectacular coasts of Wales are built on old rock, too. The jagged cliffs and reefs that form Anglesey's north-western defences against the precocious Irish Sea began to be formed shortly after Smoo's sediments fell to the floor of a shallow sea. Wales has several very old islands. Islands, like caves, have tended to be favoured through the ages as 'sacred places', and it's often been the case that the older islands are the most sacred. Off the coast of North Wales, Holy Island and Bardsey Island (which would become one of the holiest places in Wales) are nearly 500 million years old. Further south, off Pembrokeshire, Skomer and Skokholm sound too Scandinavian to be found off the tip of Pembrokeshire, but that's because 'Cloven island' and 'Island in a channel' were named by seafaring folk from the far side of the North Sea. Separated from the mainland by tide races, they have become sanctuaries for wildlife. The last time I visited Skomer, I was guided by Anna Sutcliffe, a marine biologist who had lived on the two-mile long island for seven years. On cliff paths, puffins pottered about our ankles building nests and looking unamused by the tearing

wind and rain. 'In good weather,' explained Anna, 'you won't see them. They'll all be off having a good time fishing.' At the Wick, a sea-sluiced chasm on the island's west coast, we watched thousands of seabirds adhering to the cliff, guillemots on a long, luxury ledge at the bottom, black-booted kittiwakes further up, then razor bills in cushioned nooks where the cliff relented, and at the top, fulmars gazing down imperiously from sheltered grassy belvederes. Skokholm is even smaller than Skomer, but has the world's third-largest population of Manx shearwaters and perhaps one-fifth of Europe's storm petrels. Harbour porpoise play in the currents, and sometimes dolphins, too.

Skokholm's jagged reefs and red cliffs have much in common with the Orkneys, where a rock called Old Red Sandstone has been eroded into some of our most iconic coastal architecture. Old Red Sandstone is younger than the gneiss of Lewis, the limestone of Durness and the Torridonian sandstones, but it's still old enough to have been formed before the constituent parts of Britain and Ireland crossed the equator. Massive ranges of mountains were ruckled up by a collision between two of the earth's plates, and then worn down and dumped as sediment in basins. Fossils in Old Red Sandstone suggest that, around 350 million years ago, life on Britain's crustal plates was taking a turn for the better: fish had developed jaws and lungs, and were on the threshold of becoming amphibian; plants had evolved from 2-foot swamp ferns to large tree ferns. One of those basins became the Orkney Islands: the sea-stack capital of Britain.

The king of Stacks is the Old Man of Hoy, whose 450 feet of improbable sandstone makes it the tallest in the UK. Described as a 'crumbling colossus' by Tom 'Doctor Stack' Patey – one of the three climbers who made the first ascent in 1966 – the Old Man became the subject of the BBC's first, genuine reality TV show the following year, when 15 million viewers watched a live transmission of the stack being reascended by six climbers. On the rare occasions when I volunteer to carry a camera tripod (a hideous contraption designed to impress troughs into your shoulder), I remind myself that in 1967, when the BBC chartered an army landing craft to reach Hoy, they had to hump 16 tons of TV equipment to the cliff edge. In 2008, three climbers parachuted from the top of the Old Man.

The height of a stack is related to the height of its adjacent cliffs, so Hoy also has the second-highest stack in the Orkneys – a remote column called the Needle, which was first climbed in 1990 by the legendary Revenue and Customs officer, Mick Fowler. On the west coast of the island known as Mainland are three more stacks: two-legged Yesnaby Castle is a tiddler at 115 feet, but looks ready to topple at any minute, and a couple of miles to the south, on a very lonely section of Orcadian coast, towers North Gaulton Castle, which is almost twice as high as Yesnaby. Quite unlike the other stacks because it is short and so undercut by waves that it appears to overhang on all sides, is Stack o' Roo. At the northern tip of Mainland, is a chunky, twin-peaked stack called Standard. The island of South Ronaldsay has stacks called the Kist, the Clett of Crura and Stackabank, which looks like a pile of gigantic nibbled biscuits. Stronsay has a huge flat-topped stack called the Brough, and Westray has its Castle of Burrian, a broken pencil of stone which was far taller until it was lopped by storms.

The wonders worked by the sea on Orkney's old sandstone go way beyond sea stacks. Most sea stacks are the surviving pillar of a collapsed natural arch which has been cut from the face of the cliff by waves as they exploit vertical cracks in the rock. Arches are rarer than stacks, but there is a precarious example on the east coast of the island of Stronsay, where the Vat of Kirbister forms a gigantic hoop of sandstone over the sea. This is also the land of the 'geo' and the 'gloup'; the geo being a narrow, sea-filled cleft which is left after the roof of a sea cave has collapsed, and the gloup being a blowhole linking a sea cave with the clifftop. It goes without saying that gloups can be as spectacular as they are dangerous.

If the Orkneys are a firth too far, you can sample the extravagance of Scotland's Old Red Sandstone without taking a ferry. Few cliff walks deliver as much drama as the one-mile hike south from Duncansby Head, the most north-easterly point on mainland Britain. I've done it in all weathers, but there's no question that a windless day of sunshine is safest and most pleasurable. The Stacks of Duncansby are – for me, anyway – up there in the Top Ten of coastal spectacles. Half a dozen stacks rear from the sea in front of Duncansby's vertiginous cliffs, but the best are the two shark's teeth that rise from rings of chalky

surf. There are other stacks on this coast, too. Just to the west of Thurso, at Holborn Head, slab-sided Clett Rock rises in wafers of Old Red Sandstone to a grassy tabletop. There's a gloup on this headland, too.

Arches and stacks are among the more temporary of our coastal wonders; they're just too fragile to last for long. A very long way from Orkney, on the north coast of Cornwall, is a set of stacks that is disappearing fast. On a wild day, wreathed in salt spray and attacked by breakers, Bedruthan Steps look like the ruins of a lost city. The 'steps' are a series of slatey stacks which have crumbled into form-teasing shapes: Queen Bess Rock took its name from its crown, ruff and farthingale, but it lost its head back in the 1980s. At low tide, you can descend a steep flight of steps to the beach and then wander through the stacks on the wet sand. They're even older than the Orkney pillars, and take their name from a legendary giant called Bedruthan, who took a short cut across the bay by bounding from stack to stack.

The cosmic antiquity of our shores, and the flair of their natural architecture, are sketched in scoured headlands and tottering stacks from Orkney to Corn-wall. But it's just a preview. The rocks that were slowly accreting into the begin-nings of Britain and Ireland got swamped by a clear, warm ocean lined with coral reefs. That was around 350 million years ago, as Britain and Ireland were crossing the equator. Those coral reefs became Carboniferous Limestone and gave us some of our most spectacular shores. It's a wonderful, theatrical rock. There's nothing reticent about Carboniferous Limestone: it's showy and makes great cliffs, islands, caves and arches.

A couple of years ago, I was lucky enough to find myself with a bicycle on the Aran Islands, the chain of pale grey reefs anchored off the west coast of Ireland. Under the hot sky, the stone shone with a silvery glare, the rectangles of walls and cottages contrasting with the crazy, fretworked coast. I kept think-ing I was pedalling an islet in the Aegean. The highest cliffs of our archipelago are constructed from this stone; in sight of the Aran Islands, the Cliffs of Moher run for 8 miles or so along the edge of County Clare, reaching a height of 700 feet. Plonked in the sea beside the cliffs, the Great Pyramid of Giza would

be dwarfed. It's a characteristic of Carboniferous Limestone to dissolve into roomy cave systems which became five-star sanctuaries for early explorers and hunters. Cresswell Crags in Derbyshire and Goat's Hole Cave on the Gower coast are classic examples.

In Wales, the munificence of that 350-million-year-old coral helped to create the bays and buttresses of Gower and it also underpins the southern shores of the Pembrokeshire National Park, where the coast path teeters along the edge of the cliffs from St Govan's Head to the 80-foot high 'Green Bridge of Wales' – arguably the most dramatic natural arch in the UK (this part of the coast is part of an MOD firing range, so check their website before visiting). The same limestone also lines the Menai Strait and it's the backbone of Great Ormes Head, the giddy windbreak that shelters Llandudno's sweep of sand. In England, those sunny reefs form the bedrock of the Northumberland coast between the Tweed and Tyne. This is a silent coast, with space by day and stars by night. When the Campaign for the Protection of Rural England published a series of maps identifying areas of the country that were least disturbed by human noise and light, Northumberland, it turned out, contained the largest contiguous 'tranquillity zone' in England. Its shore is suited to reflection.

The ancient sanctuary of Holy Island (Lindisfarne) is a spike of recycled coral, as are the sheltering promontories at Berwick-upon-Tweed and Seahouses, although within sight of Holy Island there's a sprinkling of islands that have more in common with volcanoes than coral. The treeless Farne Islands (which are really a couple of islets and two dozen reefs) are another sanctuary, but for wildlife. There are very few islands on the eastern coast of Britain, so the Farnes are particularly unusual. In summer, something like 100,000 pairs of seabirds, from guillemots to puffins, come here to nest, and four types of tern; it was an Arctic tern, ringed on the Farne Islands as a chick in the summer of 1982, that was discovered that October in Melbourne, Australia after a flight of over 14,000 miles in three months. The islands have one of Europe's largest colonies of grey seals. Why are the Farnes here? Well, back at the tail end of the Carboniferous, the earth's crust parted just enough to allow magma to ooze upward and to settle between the layers of limestone. When the limestone on top got worn away, the hard black volcanic rock was exposed as a ridge, or 'sill', running across

Northumberland and into the sea, where it reappears above the surface as the Farne Islands. This raised rib of basalt was a strategic godsend for Emperor Hadrian, who used the Whin Sill to underpin his great dividing wall.

England's third-largest contiguous area of tranquillity (the second-largest is the borderland adjacent to Wales) is a vast block of Carboniferous grits and shales in North Devon which culminates in the dark, tortured cliffs of the Hartland Peninsula. Hikers of the South West Coast Path will recognize the leg from Boscastle to Bideford as the wildest (and in bad weather, bleakest) section of the entire route. Last time I filmed at Hartland Point, the Atlantic was hurling itself at the black cliffs with demonic fury. Rain, salt spray and wind battered us as the cameraman fought to snatch essential shots.

Something pretty awful happened after the Carboniferous. There we were on the equator, welded for a while to all the other continents that make up today's world map. The new super-continent, called *Urkontinent* by its early-twentieth century German proponent, Alfred Wegener, became known as Pangaea once his theory gained traction among geologists. Pangaea was a disaster. A planet with a single ocean and a single landmass may appear geographically neat, but it was very bad news for life forms. Pangaea was so enormous that it altered the world's weather patterns. Climate in the centre of large landmasses varies dramatically between the seasons, and it's thought that the mean monthly temperature in the centre of the Pangaean super-continent may have been as much as 50 degrees Celsius higher in summer than in winter. Aridity ruled. Seas evaporated and salt blew over the land. In his wonderful geological romp, *The Hidden Landscape*, Richard Fortey strips away the greenswards around the Severn and replaces them with a desert of 'sand wastes or playa lakes crusted with white crystals and as hot as the fires of Hell'. The Permian period (it takes its name from the province of Perm in Russia) saw the greatest mass extinction in earth's history. Around 95 per cent of marine species disappeared. The corals were killed, and all the trilobites, and all but one species of ammonite. In the livid, red cliffs of Dawlish, on the main line between Exeter and Newton Abbot, you can see outlines of fossilized desert dunes, and beside the line at Langstone Rock, you can actually walk across the red, stony surface of a 250-million-year-old desert ... when the tide's out. There's a marvellous, red

sea arch, too, and on a hot day it doesn't take too much imagination to slip away to a land of searing winds and a few, blinking reptiles. Until recently, Tyne and Wear had its own fabulous sea arch from the era of the Big Heat, a stunning, creamy-coloured monolith of limestone which looked as if it had been built to commemorate the warry deeds of a Roman emperor. But in 1996 the top of Marsden Bay's arch collapsed, leaving a slender but unstable sea stack, which was demolished by the National Trust to prevent it toppling onto sightseers.

At around this time (280 million years ago), one of our boldest coastlines was being born deep under the surface of the planet. The granite of Cornwall's rocky toe and the Isles of Scilly are the top of the same great volcanic root system that forms Bodmin Moor and Dartmoor. The Isles of Scilly are only 28 miles off the tip of Cornwall, but this enchanted archipelago feels closer to the Caribbean than to Penzance. The granite has given it shining beaches and rugged capes, and villages with weather-worn walls that entice you to stay. But at Land's End, the mood of the granite is one of inviolable defiance. It was Daniel Defoe who observed that the tip of Britain 'seems to be one solid rock, as if it was formed by Nature to resist the otherwise irresistible power of the ocean.' I've never seen Land's End as the end of a land, but as the start. I'm one of thousands who've set off from Land's End to walk or bicycle to John o' Groats, and we've all propelled ourselves towards the rising sun with the westerly wind on our backs. Land's End should properly be Land's Beginning.

Some of our most iconic coastal scenery began to be formed in the aftermath of the Permian Extinction. Life returned to earth, and with it 185 million years of exotic rock-making. The epochs known as the Triassic, Jurassic and Cretaceous lasted from 250 million years ago to 65 million years ago, and gave us some eye-catching shores; dinosaur shores. The sandstones and mudstones underlying the golden beaches of Blackpool and Southport were laid down beneath the beady eyes of flapping pterosaurs on the lookout for fish or perhaps the rotting carcass of an archosaur. And because Triassic rock is relatively soft, it's been sought by rivers which have carved it into vales and estuaries such as the Tees, the Solway and Mersey.

The Jurassic has a flair for theatricality. One of the best coast walks in the country runs along Jurassic cliffs from Durlston Head to the sheer buttress of St Aldhelm's Head in Dorset, where you tread pale limestone laid down when this part of Britain was submerged beneath warm sea. Near here, I once met a man who said he'd spent 20 years extracting a plesiosaur from a cliff, and when I looked incredulous he took me to his home and showed me a skeleton as long as a room. Further west, the sea has worked with the Jurassic shoreline to produce the semicircular cove of Lulworth, and the most elegant natural arch in southern Britain: Durdle Dor. It's the extraordinary geology and scenery of Dorset and South Devon that led to it becoming England's first natural World Heritage Site. Because of the way the rocks have been folded and eroded, the Triassic, Jurassic and Cretaceous occur in visible layers along the shore; were you to walk the full 95 miles of the 'Jurassic Coast' (and thousands do), you'd be treading 185 million years of the earth's history. On the coast of Yorkshire, it is that same hard, Jurassic rock in the headlands that protected places like Filey, Scarborough, Robin Hood's Bay, Whitby and Staithes, creating roles as Roman signal stations, fishing havens, trading ports and seaside resorts. History begins with geology.

The Cretaceous bequeathed England its greatest coastal icon. I reckon I've seen England's white cliffs from most angles: I remember staring into the salt haze as a child, trying to spot them from the decks of car ferries on the way back from summer holidays; I can hear my first skylarks, hovering above the plucked grass of Cuckmere; I've cycled over the white cliffs and kayaked beneath them. I've entered them through wartime tunnels. But a couple of years ago, I got a call from the *Coast* production office asking me to take the train to Eastbourne, and to bring mountaineering gear. The next day, I abseiled with Professor Rory Mortimer over the cliff near Beachy Head. The tide was in, and far below my boots, I could see waves breaking against the foot of the cliff. As we started to slither down the abseil ropes, we passed the thin, pale brown layer of topsoil sitting on top of the cliff like almond icing. It was, Rory told me, 'wind-blown loess' – fine-grained dust that had accumulated in the draughty, frigid post-glacial deserts of Britain when the ice sheets eventually began to retreat. Immediately beneath the loess, we were hanging in front of a gigantic sheet of whiteness formed, I learnt from my companion, 70–75 million years ago.

Later that afternoon, in the company of a marine biologist called Dr Mike Allen, the true wonder of chalk became apparent. He had with him a sample bottle containing cloudy liquid, a culture of a single-cell algae called *Emiliania huxleyi*, known to its friends as 'Ehux'. A species of phytoplankton, it's very small. 'If the algae was the size of you,' said Mike, holding his bottle to the light, 'you would be as big as Mount Everest.' Peered at through an electron microscope, Ehux is one of the most beautiful life forms to have floated in the seas. It's a sphere, armoured with overlapping calcium-carbonate plates, or coccoliths, each of which looks like a child's drawing of the sun. The man who first studied them in detail was the 19th-century biologist Thomas Henry Huxley, who admitted to finding them 'extremely puzzling'. Using a hand-cranked centrifuge, Mike and I created a chalk pellet from seawater: 'When it dies', explained Mike, ' the liths go to the bottom of the ocean, and over millions of years, they form a sediment, and that's how we get the cliffs.' Simple and beautiful.

Chalk is one of England's emblems. It's our youngest real rock, and it's in chalk that we find the nodules of flint that gave our ancestors the means to hunt, to light fire and to build boats. No other rock reflects the sun in such a way. They piled it into processional ways, and circular walls, where it burned with its own light against the green hills. Chalk was the bedrock of prehistory; the explorers and settlers of the Mesolithic and Neolithic needed it like their descendants came to need coal and oil. The chalk cliffs were beacons: to sailors, the white cliffs of Flamborough Head, the quaint sea stacks off Dorset known as Old Harry Rocks, and the gleaming Needles off the Isle of Wight were signposts on the coastal sea lanes.

England's largest island, the Isle of Wight, was formed when a long wall of chalk was breached by rising seas; the Needles and Old Harry Rocks are the stubs of that wall. Beneath a cliff at the western end of the island are boulders shaped like gigantic clawed feet, and with good reason: these are iguanodon 'footcasts', formed by silt washing into the deep footprints left by 3-ton dinosaurs that had been foraging 130 million years ago, when southern Britain was a thousand miles further south.

And what of England's most emblematic cliff? 'Glimmering and vast,' wrote Matthew Arnold, 'out in the tranquil bay.' The White Cliffs of Dover might be

half the height of Moher's cliffs, but they have become a national trademark with a stature way beyond their physical scale. George Lily's map of 1546, showing the British Isles in hitherto unseen detail, marks forests, rivers and rolling mountain ranges of Scotland, but just one stand of cliffs, at Dover. Like the minarets of the Golden Horn, or the Manhattan skyline, this blinding curtain of chalk veils us from outsiders, yet tells us who we are. Dover's white cliffs are where we advance closest to the continent, and where we mark our perimeter. They are our first and last sight of home.

With curious synchronicity, Ireland and Scotland acquired their most extraordinary coastal landmarks at pretty much the same time (we're talking geological time here) that England acquired its chalk.

'Compared to this,' exclaimed Joseph Banks when he gazed upon the basalt columns of Staffa in 1772, 'what are the cathedrals or the places built by men? Mere models or playthings …' I first saw Staffa from the deck of a tallship. We'd sailed with the tide from Jura at two in the morning and after a few hours in a wooden cot I came on deck to watch the sunrise. The ship, a 92-foot pilot schooner, was buffeting through chilly spray under clouds of sail and both rails were lined with islands. To starboard lay bulky Mull, spiky Ulva and Little Colonsay. On the port side, I could pick out the distinctive profiles of Fladda, Lunga and Dutchman's Cap, with its broad brim and dented crown. But right beside us, almost within touching distance, were the black cliffs of Staffa. Banks, who had sailed with Captain Cook on HMS *Endeavour*, and who would soon be elected President of the Royal Society, could not believe his eyes. One end of the island seemed to be 'supported by ranges of natural pillars, mostly above 50 feet high, standing in natural colonnades'. Landing on the island, he found that each pillar was a near-perfect polygon. The scientist who had botanized in Labrador and Newfoundland, and explored the Pacific with Cook, was astonished by Staffa's cliffs: 'Where is now the boast of the architect?' he asked. 'Regularity the only part in which he fancied himself to exceed his Mistress, Nature, is here sound in her possession.'

Following a basalt causeway, Banks came to a cave. Each side of its black mouth, tight-packed pit-props of hexagonal basalt supported the roof of the island. When Banks asked his guide the cave's name, he was told 'the cave of

Fhinn', after the mythological Irish hunter–warrior Fionn mac Cumhaill – Finn McCool, or 'Fingal' to the Scots. Sixty years later, the cave gave its name to the overture that Felix Mendelssohn wrote following his visit to the Hebrides on his Grand Tour of Europe.

Staffa's columns are a monument to our continent's creation, for they were formed during the long, complex disintegration of the super-continent, Pangaea, and the consequent widening of the Atlantic Ocean. Back then, 65 million years ago, most of the rock-making had been done and nearly all of the raw materials which form our modern coast had been created. But as North America and Europe drifted apart, lava spewed through cracks and vents, cooling rapidly into polygons. Staffa was on one of those cracks.

There are other Staffas. In Ireland, a vast plateau of lava spilled over Antrim, and where it touches the coast in the north its contractions have formed 40,000 black, polygonal columns that have become the most visited geological showpiece in the archipelago. If visitor figures continue to soar, the Giant's Causeway will be the first igneous celebrity to receive one million admirers in a year, but there are quieter basalts. A couple of years ago, I was making a film about the 18th-century Welsh traveller Thomas Pennant, whose book led me to a polygonal showpiece above Talisker, on the west coast of Skye. Preshal Beg rises like a volcanic stub, ringed with columns, 1,000 feet above sea level, gazing west over the silvery sea. To the Welshman, struggling to pin these extraordinary columns to a chronology, they were 'the ruins of the creation', and so old that 'those of Rome, the work of human art, seem to them but as the ruins of yesterday'. We filmed up there all day, and then yomped back through the heather as the sun set over the Outer Hebrides. Islands sailed along the horizon, Barra leading a Hebridean fleet cut from Lewisian gneiss. On a lofty headland, the cameraman set up the tripod for a final shot, and as I sat on a boulder staring across the Little Minch I realized that I was perched on one of Britain's youngest rocks, looking across the water to its oldest.

The Giant's Causeway, Fingal's Cave and the White Cliffs of Dover are part of the final, climactic movement of coast-building. What followed was a geological encore written in ice and water.

*

Last year, while I was taking the first, exploratory steps with this book, I reached a place that's eluded me for ages. It's called the Inaccessible Pinnacle, and it's on the Isle of Skye. The first 3,000 feet, up the flank of the Black Cuillins, is relatively straightforward. Then you reach the flaking crest of the ridge, and sticking up from the crest is a 200-foot high rock spike. Twice in the past I'd stood on the ridge, in winter. Both times, I'd stared up at the 'In Pinn', appalled at its black, ice-glazed form, smoking with gale-force mist. Both times I went back down. Last year was different. It was summer, and I was being led by one of the most experienced mountain guides in Britain: Martin Moran. The sky was cloudless, the air still and the peaks of Skye were streaked with shining snow. After two pitches of climbing – and a lot of filming – we reached the top at sunset, and while Martin prepared the abseil ropes, I looked to the west. Far below, the blue sea clung to the Cuillins' taffeta skirts. And away on the monstrous deep first crossed by explorers in skin boats, I could see the Outer Hebrides, floating in line astern along the horizon. It was a view that had been carved by ice and then inundated by water.

On and off, ice has worked at Britain and Ireland for the best part of 700,000 years. Its effect on the coast has been profound. The deep, U-shaped sea lochs of Scotland were gouged by glaciers oozing from a gigantic ice cap. Other glaciers bulldozed material southward and dumped it in ranges of hills reaching far into what would become the North Sea. Out on the western fringes of the archipelago, a 500 metre-thick ice sheet capping Ireland bulldozed heaps of glacial junk towards the rising Atlantic. It's out here, on what is now the coast of Mayo, that the ice and water have created one of the strangest clusters of islands in the archipelago.

Clew Bay is one of Ireland's natural marvels. More a sea than a bay, Clew is a roughly rectangular inlet of around 120 square miles, scattered with 300 or so islands that are concentrated at the bay's eastern end. Thackeray thought they looked like 'so many dolphins and whales'. Gliding between them on a boat, you quickly get confused. They all look alike, with similar, smooth, rounded profiles. They are among the most impressive 'drumlins' in the world; streamlined, elongated hummocks of glacial till formed by the wave motion of moving ice. Their name comes from the old Irish word, 'droimnin', meaning

little, ridged hill. Arthur Holmes – the geologist who proposed the theory of 'continental drift' – compared drumlins to 'a basket of eggs', and more recently, Richard Fortey reckoned they could pass for enormous burial mounds. Collectively, they are often referred to as 'a swarm'. Clew Bay's drumlins became islands when the ice melted and rising seas isolated the smooth hummocks of debris.

I know it's a bit obvious, but water makes the coast. And in the making, it's both a destructive and a creative force. The place to appreciate the power of the sea is Esha Ness. Or more precisely, Grind of the Navir.

We've all seen the TV shots of gigantic breakers exploding over promenades, but the largest waves to strike this archipelago are seldom filmed. Graph plots of annual maximum storm-wave heights show that the Shetland Islands are most frequently in the firing line. West of here, the next bit of land is the tip of Greenland. Waves driven by hurricane force winds for hundreds of miles race towards a shore which drops steeply into deep water, so there is little to break their motion. The Shetlands experience some of the highest wave-energy anywhere in the world. Wave heights of 15 metres are not uncommon; a 24-metre monster was recorded in the 1960s. When the full force of an Atlantic megawave hits a cliff, the effect is explosive. Pressurized water is powered into cracks in the rock, prising the cliff apart. Detached boulders are hurled like missiles, and as the wave retreats more ammunition is plucked from the cliff. There is a place on the western shore of the biggest of the Shetlands, the island known as Mainland, which looks like one of Nature's bombsites. Even in fine weather, it's a desolate spot; a scene of utter destruction. The cliffs at Grind of the Navir – 'the Gateway of the Borer' – are 20 metres high, and have a gap in them rather like a doorway. The day we filmed here, the weather was calm and sunny and I was able to walk down the stepped amphitheatre, around ponds of seawater and peer through the portal to the sea below. In a big storm, I'd have been atomized by green water. On the edges of the amphitheatre, we could see the fresh, pink scars marking the spots where blocks had been torn free, many of them in the January storms of 1992 and 1993. Behind me, at the upper level of the amphitheatre, were three ridges of boulders that had been hurled up to 50 metres inland and upward by waves bursting through the Grind's portal.

Some of the blocks were over 2 metres across. There are several other west-facing sites in the Shetlands where these bizarre 'beaches' – or CTSDs (Cliff Top Storm Deposits) as the experts call them – have been spread across the tops of cliffs, at heights ranging from 10 to 25 metres above sea level. Just south of the Grind, the clifftops of Esha Ness have been scoured by waves, and those cliffs are an incredible 40 metres above sea level. CTSDs are reckoned to have more in common with tsunami debris than with conventional beaches. When revelations of these clifftop beaches reached the newspapers in 2004, Dr James Hansom of Glasgow University's 'coastal beach group' felt it necessary to warn the public 'not to picnic on the top of the cliffs facing deep water, at least not in a storm'.

Grind of the Navir is the strangest beach I've ever seen. An exception. But it illustrates the incredible diversity of beaches around the shores of Britain and Ireland. Our beaches come in almost every conceivable shape, size and texture, from cosy Cornish nooks wedged between headlands, to East Anglian strands which appear to stretch elastically to vanishing points on a curved horizon. There are silver sands in the Hebrides, red sands in Devon, white sands in Cornwall, and of course golden sands in Lancashire.

There is – believe it or not – a system for categorizing beach grains. It's called the Udden–Wentworth Scale, after a pair of American geologists who achieved the enviable feat of furthering science by spending a lot of time on the beach. Sand (subdivided into five sizes) is defined as a particle whose diameter is no smaller than 0.0625mm and no larger than 2mm. Further categories define boulders, cobbles, pebbles, gravel, silt and clay. Our archipelago is well-supplied with the full, Udden–Wentworth spectrum, plus a few bizarre subsets. There's a beach on the Llyn Peninsula of North Wales where the sand grains have become very well polished and rounded; when you walk on it, the sand makes a squeaking noise. Over the years, Porthor has become better known as the 'Whistling Sands'.

Where there's sand, there's often a dune, or an undulating ocean of dunes, clothed in spiky fronds of marram grass, or shady stands of conifer, planted to anchor them as sea defences. Seen in a low light, the interplay of curves is as beautiful as any set of edges you'll find on our coast. Dunes are mobile

features, blown grain-by-grain by the winds which came in from the sea once the water had stopped rising. There are ranges of dunes, like those at Bamburgh and Horsey in Norfolk, which look like stilled waves, poised to roll down the beach. And there are dunes that have colonized the coastal plain so extensively that you can get thoroughly lost; I've become so disoriented in big dune systems that I've had to climb to a high point and then head for the sea before resuming a course I think I can follow. The largest expanse of sand dunes in the UK is Braunton Burrows in North Devon, stabilized by marram grass and now home to 400 species of plants. Sand dunes have their own microclimate, and own microhabitats; they are miniature worlds. The dips between dunes are known as 'slacks', and when groundwater rises to the surface here you get damp hollows that suit meadowsweet and bog pimpernel and orchids. Level areas can grow crunchy carpets of sun-dried lichen, and spreads of moss. On windless days in the summer, butterflies tumble above rugs of thyme, restharrow and hawkweed.

Beaches and dune systems are 'constructed' features, formed by water and wind, and their shapes abide by the laws of natural mathematics. They are reminders that we live in a universe of patterns. It is on the coast that we see Nature's numbers being deployed most elegantly. Mathematicians will tell you that the most striking mathematical patterns on earth are those that can be seen in the vast sand oceans of the Sahara and Arabia. Our beaches and dunes are the best places to see these patterns without resorting to a spacecraft or a camel. Pure, unvegetated dunes will get blown into a number of patterns, among them the barchan, dome dune, parabolic dune, star dune and wake dune. Beaches are galleries of mathematical patterns. Down on the tideline are symmetrical starfish and shells taking the form of geometric spirals. There are patterns of movement in your own footprints, in the scuttling of crabs, in the wingbeats of seabirds, and in the tides themselves. The regularity of waves is created by the flow of wind over water. The ripples in tidal sand are caused by the flow of fluid. The curve on a beach is caused by the refraction of waves as they squeeze between headlands.

Nature is a habitual sorter of stones, too, and over the last few thousand years, tides, currents and waves have brought order to the enormous swathes

of glacial rubble left behind by the ice sheets. Most of the shingle beaches in Britain and Ireland are built from stone that was washed to the coast by the last surge of sea-level rise. On Chesil Beach in Dorset, the shingle has been sorted so that the stones are smaller in the west and larger in the east. On Slapton Beach, in South Devon, the sea has neatly sorted the beach into coarse sand and fine shingle. Both Chesil and Slapton are classic examples of a 'barrier beach' – a long bank of shingle thrown up parallel to the coastline, trapping a huge lagoon of brackish water. Chesil is Britain's 17-mile giant, and the volume of shingle on the beach has been estimated at between 15 and 60 million cubic metres. In the age before air travel, Chesil was regarded as one of the wonders of the world: the 18th-century French traveller J. A. de Luc, was flabbergasted by 'this prodigious accumulation of gravel' and in 1902 Lord Avebury described the beach as 'probably the most extensive and extraordinary accumulation of shingle in the world'. Actually, there are others, and in Britain, too.

On the Channel coast between Folkestone and Hastings is the largest shingle promontory in Europe; a great beak of stones jutting 6 miles into the sea. Technically, Dungeness is a 'cuspate foreland', a rare coastal feature that is created when waves approach a shore from two different directions, pushing up two spits whose tips eventually meet to form a gigantic triangle of shingle and sand. In the case of Dungeness, westerly waves sweeping up the English Channel meet easterly waves arriving from the Strait of Dover. Cuspate forelands are always on the move; in the case of Dungeness, slowly eastward.

My favourite foreland has itself become a ghost. At the outer bend of the Norfolk coast, there used to be a cuspate foreland called Winterton Ness. On Mercator's 16th-century maps, it's the only promontory on the smooth, curved coast of East Anglia. Winterton Ness used to be a crucial coastal landmark for sailors, and Daniel Defoe chose it for the opening shipwreck in *Robinson Crusoe*. But the Ness has gone, or almost. If you stand on the beach when the tide is running, you can still see its submerged outline, tripping a rank of standing waves.

It's this eastern coast of Britain that has the best spits. No other coastal feature has such a capacity to maroon the human spirit. To stand alone on the

tip of a spit is to feel the weight of the universe. Spits, like cuspate forelands, are two-dimensional and provisional. Their vertical dimension is imperceptible and they are prone to sudden demolition by storms. They're formed by the process known as 'longshore drift', the movement of beach material along a shoreline as it is continually swept by waves breaking obliquely. Small spits often form at the mouths of estuaries, sometimes with hooked tips that embrace sheltered anchorages and tidal wetlands. But it's the larger spits that are so other-worldly. The greatest of them all shadows the coast of Suffolk for 10 miles; a sinuous trail of glacial debris that has piled up in the millennia since sea levels stabilized. Orford Ness is the largest vegetated shingle spit in Europe. Scattered across it's semi-desert surface are a litter of military peculiarities, but from the top of the lighthouse the spit itself has a pleasing simplicity; in its ribbed banks of vegetation you can trace successive spurts of growth. One night in 1703, half the spit was washed away by a storm. It simply grew back, like the tail of a lizard.

Spits and forelands are the coast's oddest appendages, impermanent, ethereal places with unique human narratives. Their peculiar qualities of isolation suit those who seek seclusion: breeding birds, the military, criminals and vexed authors.

Until I saw the Severn Bore, I associated estuaries with tranquillity. I've seen Nature pull some amazing stunts: solar eclipses, double rainbows, Brocken spectres, the Northern Lights and so on, but the Severn's party trick is in a coastal class of its own. Waves – as mathematician Ian Stewart has pointed out – are gregarious. They like to travel together. The exception is the 'solitary wave', and of all the sights I've seen around our coasts the solitary wave is the most unbelievable.

Filming the Severn Bore required planning on a military scale. The wave was due at 20:58, and it was late September, so we'd be filming in the dark. The BBC had provided three camera crews, scaffolds of powerful lights and a bicycle. The plan was that I would wait on the riverbank at Minsterworth, then ad lib to the camera as the wave passed, then leap onto the bicycle and race the

wave to a bridge upstream, where I would provide a second commentary as it passed beneath my feet. I heard the wave before I saw it; a sinister whisper in the night. And then, out of the darkness, a silver breaker careered around the bend in the river. Despite all that I'd read, I was utterly unprepared. Everything I knew about physics and maths, from gravity to wave patterns, was being defied. The river was flowing backwards. As the black, rustling wall careered past, I scrabbled up the bank away from its illogical fury. In the early days of Welsh history, the Bore was known as Twrf Liant: the Roaring Wave.

The Severn Bore is created by the shape of its estuary, whose 50-mile mouth gapes at the Atlantic as if it's trying to swallow the entire ocean. Filming the first series of *Coast*, I spent a day with Dr Chris Wooldridge, a marine geographer from Cardiff University. Out in the estuary, which is about 9 miles wide at this point, Chris cut the inflatable's motor so that we could drift with the incoming tide. I hadn't realized how fast we were moving until we shot past a huge, steel navigation marker called North Buoy. It was tilted at a crazy angle by the pull of water. There is nowhere like this in Britain or Ireland. As the moon's gravity pulls the tide towards the shores of Britain, the water funnels into the mouth of the Bristol Channel, which gets narrower as it tapers eastward and becomes the Severn Estuary. By the time the tide reaches Avonmouth, the estuary is only 5 miles wide. The water has nowhere to go, and so it rises up the banks of the estuary. The Severn has the second highest tidal range in the world; the water rises and falls by more than 14 metres (a typical Mediterranean tide is only 10 centimetres). At certain times of the year the tide is so powerful that it just can't stop, so powers up the River Severn as a standing wave. It can reach a height of 3 metres.

Our archipelago has a lot of estuaries. The mixed geology, generous rainfall and partially inundated shoreline have resulted in numerous funnel-shaped river mouths exposed to the ebb and flow of tides. The UK has over 90 of them, with a combined total area that accounts for around one-quarter of estuaries in north-west Europe. They're unabashed beneficiaries of dual personality disorder. An estuary which glitters with the reflected sunlight of an inland sea at high tide, turns itself into an introverted maze of gurgling drains at low tide. They're fed continually by freshwater, yet flushed twice every 24 hours by

seawater. On their beds, they accumulate drifts of mud from inland, and drifts of sand from the sea, while their shores are often fringed by moist swards of salt marsh. Grey seals nose in from the ocean, with flounders and sea lampreys, while salmon and river lampreys head down from the land. The dribbling mudflats are home to burrow-dwelling worms and bivalves which feed redshank, ringed plover and dunlin each winter. Estuaries are winter resorts; intertidal estuarine habitats in the UK alone support about 1.7 million waders and 650,000 wildfowl.

Over on the eastern coast of England, forming a lopsided symmetry with the Severn, is the largest bay in the country; a shallow gulf pillowed with sandbanks and surrounded on three sides by secretive shores. Like the Severn Estuary, the Wash became a magnet for fishermen, merchants and smugglers. It is fed by four navigable rivers and is surrounded by the largest single area of salt marsh in the UK. Wildlife loves it. On sandbanks far from land is the UK's largest colony of common seals, who know as well as man that these vast intertidal banks are nursery grounds for fish like plaice, cod and sole. The shoreline of the Wash is famously inaccessible. And soft. But there are places where you can reach the edge of the marshes on foot and feel swamped by the vastness of the flattest coast in the entire archipelago. At the mouth of the Nene – which runs which runs across the fens like a huge, tidal canal – the stumpy lighthouse that became the home of naturalist Peter Scott stares blankly over the marshes at the receding sea. Far bleaker is the roadhead at Gedney Drove End, midway along the inner side of the Wash. Here, you can climb the grassy bank that keeps the sea from the crops, and gaze over flatlands that stood in for the fields of Dunkirk during the filming of Ian McEwan's *Atonement*. In the other direction, salt marsh vaporizes into salt haze and RAF Tornadoes bomb and strafe targets a couple of miles along the coast. For more congenial excursions into the Wash, I'd suggest one of the boat trips from Hunstanton.

Of our many bays and inlets, the Wash is probably the hardest to comprehend. Most are so kind to the eye that you never want to leave. The flooding of southern river valleys when the ice melted created some of the most beautiful coastlines in the archipelago. Sea-filled valleys like the Helford and the Dart, the Tamar and the twinkling inland sea of Carrick Roads have become

West Country icons, their flooded tributaries squirming far inland like the branches of a tree. In south-west Ireland, the flooding produced broad gulfs like Dingle Bay, Bantry Bay and Roaringwater Bay. Low plains in the south of England filled with water to create Poole harbour in Dorset, and Chichester, Langstone and Portsmouth harbours on the coast of Hampshire. In Essex, meandering lowland vales filled to form wide, short estuaries fringed with the creeks and salt marshes that Arthur Ransome used as one of his playgrounds in *Swallows and Amazons*.

Humans had been to Britain and Ireland before the Ice Age. Their flint tools, formed a million years ago when the Thames flowed past Norfolk, have been extracted by archaeologists from the cliffs at Happisburgh. But in the successive glaciations which followed, there were times when the archipelago was completely uninhabited. When temperatures rose 16,000 years ago, humans returned in greater numbers than ever before. They inherited a pattern of islands that had been three billion years in the making.

2.
Shore Harvest:
Food from the Sea

Night had pinched the light from the sky. Behind us, the glowing dots of harbour bulbs swung like lanterns in a gale. Things were not going too well. A few hours earlier, as we prepared for the shoot, the director had collided with the corner of the wheelhouse and been carted off to hospital with blood pulsing from a head wound. In his place, the film was being directed by the assistant producer, and he was already hooked over the rail losing his lunch. That just left three of us; 'If you go down, too,' grinned the sound recordist at the cameraman, 'we'll just have to make a radio doc instead!' Through the wheelhouse door, I could see the skipper, Stefan, glowing against his instrument lights. Beside him, the body language of the two crewmen suggested that they were relaxing at a pub bar. Off the starboard rail, I could just make out the granite edge of Cornwall. Somewhere over there, where cliffs, sea and night became one, lay Land's End.

Beyond the shelter of Mount's Bay, the deck began to pitch and yaw. Wind hurried out of the darkness. The boat was so damn small. All fishing boats are small. The boats I knew as a boy were cross-Channel ferries and they were enormous. But fishing boats are cockleshells. Clutching my stanchion, I struggled to imagine what it must mean to work, night after night, on the open ocean.

The first oil painting Turner exhibited at the Royal Academy showed two open fishing vessels being tossed helplessly on a rampant, moonlit sea against a silhouette of carnivorous rocks. Nature has always been at its most merciless on coasts. In the ten years between 1999 and 2008, 121 fishermen lost their lives

on UK registered vessels. Another 669 were injured and 273 fishing boats were lost. Over the same period, there were 88 'person overboard' incidents. Misfortunes liable to befall a fishing vessel include capsize and listing, collision, fire and explosions, flooding, foundering, grounding, machinery failure and 'heavy weather damage'. In the decade to 2008, there were 3,173 of these incidents – an average of six for every week. Fishermen are the last of the hunters. And hunting is still a dangerous game.

We changed course. Stefan's eyes watched the shifting electronic topographies of his screens. The boat was new. He'd designed it himself. 'We went out and spent £100,000 … It was a risk.'

Stefan spoke with a warm, West Country drawl. He'd built the boat to catch pilchards – or 'Cornish sardines'. 'We didn't know whether the fishing would work. Whether we could catch the fish or not. But we saw the stock was there when we were catching other fish. I thought we'd have a go …'

Highlander was equipped with instruments that could track a shoal deep under water. 'It's like a lion stalking,' continued the skipper. 'Which way is it going to go? Can you move faster than the shoal? Then it's bang! Hit it!'

Stefan warned us that we were heading for rougher water. I was certain we'd roll back into Newlyn in the small hours with nothing to show for the night but a deck swilling with BBC sick.

We were still wedged in our respective discomfort zones when Stefan shouted: 'We've got a shoal on the sonar!' The wheel span and we veered to port. The crewmen took their stations at the rail. The deck lights were doused. A quarter of the sonar screen was filled with pixellated magenta interference. Stefan said quietly, 'That's 60 or 70 tons of fish.' The tension was so palpable that we could film it. Stefan's eyes were everywhere at once: checking the screens, the sea, his crew.

'Right guys … Shoot!'

The drogue dropped over the side and the net snaked out. The boat swung in a circle, surrounding the shoal. Gulls shrieked, white on black. The winch hauled its unseen load. We lurched crazily in the swell (why is it that waves are ten times taller at night?). Below the rail, the water began to flash with silvery darts and then the net lifted clear of the sea, bulbous with a thrashing, mercurial mass.

The fish were scooped, 100 kilos at a time, from the net into the boat. 'We'll be going another four or five times to make a cargo,' smiled the skipper. A groan (or something like it) left my throat. We shot the nets again. And again. And the next night we went out again.

The morning after the second night we filmed Stefan's fish being auctioned at Newlyn fish market, a draughty, cavernous shed on the quay. Only a couple of boats had been out, and the building had an awkward, vacant capacity. Markets are meant for throngs, not grim huddles. The auctioneer, Robin Turner, told me that Stefan was catching half the sardines going through Newlyn each year. Afterwards, as a succulent cloud drifted across Stefan's sunlit lawn and we filmed a tiny portion of the catch being grilled on his barbecue, I promised I'd never again take a sardine for granted.

Seven thousand years earlier, a similar barbecue scene (less some of the props) was being enacted on the island of Oronsay at the southern end of the Inner Hebrides. Fish were being cooked to the gentle swash of waves on a beach. The fish were saithe and they'd been caught from boats that the men had launched from the beach. Saithe are good to eat; white-fleshed and firm.

Oronsay was a reliable source of food. It was a tiny scrap of island, with a couple of low hills at its northern end, and sheltered beaches along its eastern shore. The island is larger now that Scotland has risen a little from the water, but in those days, it covered an area of less than 2 square miles. On the eastern shore your eyes would have been drawn to four strange, shining mounds. A fifth mound could be found a short walk to the west, where the shore was protected by an islet. The mounds were gigantic rubbish heaps of shells and bones: middens. When an archaeologist called Paul Mellars came to excavate the middens in the 1970s, he found that Oronsay's inhabitants had been living off an entirely marine diet of fish, seals, crabs, seabirds and shellfish. Analysis of the ear bones of the saithe skeletons revealed that the fish had been caught in all seasons, so the islanders had been based on Oronsay throughout the year; there must have been an abundance of seafood. The discovery of bone sewing awls suggests that they were also making items of clothing. On the larger

Hebridean islands today, you'll find community shops selling Celtic jewellery, a tradition familiar to Oronsay's campers, who found time to assemble necklaces from periwinkle shells.

The pioneers who came after the ice knew the value of coasts and, thanks to archaeology, we know why. With southern Britain and Ireland sinking relative to sea level since the weight of ice was lifted from Scotland, many of the low-lying prehistoric coastal sites in the south have been lost to rising waters. But the area of Scotland where the ice was thickest – on top of the Grampians – has been rising, and with it parts of Scotland's west and east coast. And that is where archaeologists have scraped down to the very beginnings of our affinity with the coast.

The earliest site of human occupation discovered so far in Scotland was selected with prescience by a small group of hunter-gatherer-fishers who erected shelters on a bluff overlooking the Firth of Forth in what is now the desirable Edinburgh suburb of Cramond. The village has its inn, its kirk and its pretty white cottages, and more than enough history for a sunny Sunday afternoon: the foundations of a Roman fort, a 15th-century tower, and a concrete submarine defence which forms part of a causeway running out to Cramond Island. There are routes for cyclists and walkers and, on the west side of the village, the River Almond pours into the Forth and provides swinging moorings for a flotilla of yachts. It is a delightful place. Cramond's earliest campers came here 10,500 years ago because a bivouac on a bluff where a river meets the sea is a five-star site. Right beside their hearth at Cramond, they had freshwater, seafood and firewood. Customers in the Cramond Inn, tucking into pie and chips with a pint of Samuel Smith, are sharing a pleasure which dates back to the days when Britain was joined to the continent.

It was the geographer Carl Sauer who championed the coast as an optimal habitat for human beings. As the great man pointed out in his paper of 1962, we are odd among primates for failing to fit into an obvious habitat. We're not specialized predators, we're rubbish at flight and concealment, we're not very strong and we're not fast. We have no night vision and we're not adapted to forests; we haven't grown a pelt to protect us against thorns or the cold, and we sweat so much that we need constant replenishments of

fresh water. On the plus side, we've evolved to eat anything that isn't poisonous. The essentials of our natural habitat are freshwater and a diversity of plant and animal life. 'It may be,' wrote the Californian professor, 'that our kind had its origins and earliest home in an interior land. However, the discovery of the sea, whenever it happened, afforded a living beyond that at any inland location.' Think about it. All rivers (in temperate lands, anyway) end at the sea, so you don't have to walk far along a coast before finding freshwater. And there is food wherever you look. You can fish at sea; you can collect shellfish from the intertidal zone; and just inland you can hunt and gather. 'No other setting,' insisted Sauer, 'is as attractive for the beginnings of humanity. The sea, in particular the tidal shore, presented the best opportunity to eat, settle, increase, and learn. It afforded diversity and abundance of provisions, continuous and inexhaustible.'

Several hundred years after Cramond's campers gazed across salt water from their bluff at the confluence of the Almond and Forth, another group picked an identical type of location. The remains of the hut on a Northumbrian sea cliff beside Howick Burn is one of the best-preserved Mesolithic structures in the British Isles. It's 6 metres in diameter, and back then – before the cliffs got eroded – it stood like a thatched tepee 300 metres inland from the sea. Right beside it bubbled the freshwater of Howick Burn, and behind it, more than enough forest for cooking and warmth. Radiocarbon dating of hazelnuts retrieved from the central hearth has shown that the hut was erected in about 7800 BC and used for about 150 years. The rubbish midden probably disappeared with the receding cliff, but bones recovered from the hearth have revealed a mixed, marine/terrestrial diet of grey seal, molluscs, wild pig and birds, although it is thought that seafood formed the staple. The fox or wolf, whose remains also survived, was probably killed for its pelt.

To Britain's Mesolithic colonists, the coast was both a highway and a safe habitat. If they headed inland, they might have to cope with a catalogue of alarming landscapes varying from vast, trackless forests and mountain ranges, to sucking bogs and impassable torrents. On the other hand, they could travel for hundreds of miles along a coastline and yet remain within a continuous habitat, at a constant altitude (sea level), with little chance of getting lost or

running out of food. Life at sea level was relatively predictable. But these Mesolithic pioneers were not land-bound. They built boats.

A couple of years back, while filming a BBC series about William Camden's 16th-century masterwork, *Britannia*, I found myself on Lough Neagh in Northern Ireland, rowing a skin boat, a currach. Actually, it wasn't clad in skin, but in modern, tarred canvas, stretched over a lightweight lattice of hazel. The currach had been built by my fellow oarsman, Holger Lönze, and was similar to the skin boats that were used around the coasts of our archipelago thousands of years ago. These are the craft that Pliny the Elder heard the Britons were using at sea: 'coracles constructed of osier covered with sewn hides.' Although it was less than 17-feet long, our currach could, reckoned Holger, carry half a ton of weight. And yet it was so light that the two of us had lifted it from a car trailer and carried it to the water's edge. Out on the lough, as we pulled hard on two oars each, it skimmed over the waves. The currach was fast, manoeuvrable and versatile, and Holger had discovered that it was possible to build such a boat 'easily in a week'. He'd heard of a 21-foot currach from Kerry carrying 4,000 mackerel. For all their apparent frailty, they were sound seacraft. In 2007, Holger and two friends had rowed and sailed a 26-foot currach for 210 miles along the coast of Ireland, weathering a Force Six blow and 15-foot Atlantic swells.

Back in the 1970s, the explorer Tim Severin undertook a far grander experiment by successfully sailing a skin currach from Ireland to Newfoundland. Currachs are ideal for coastal waters, being easy to launch and beach, and of such shallow draught that they can float in a few inches of water. In kind weather, a skin boat paddled or sailed by skilled boatmen will traverse a given section of coastline far faster, and with far greater freight capacity, than is possible on foot along the shoreline. There are parts of Scotland's west coast where a 20-minute boat passage is equivalent to a two-day hike. When archaeologists working on the Antrim coast ran a foot v. boat trial, they found that canoeists making use of tide and currents could cover up to 5 kilometres in only 30 minutes, four or five times the speed possible on land.

At about the same time that Howick's hut-builders moved on or died out, another group were hanging out in a coastal rock-shelter on the Applecross

Peninsula in Wester Ross – a 3,000-foot high chunk of Torridonian sandstone thrust like a clenched fist at the Isle of Skye. A few years ago, when the *Sunday Times* asked me to select the best bike ride in the UK, this is where I came. From Loch Kishorn, you pedal up the switchbacks of the highest road in Scotland to the 2,053-foot summit of Bealach na Ba, the Pass of the Cattle, where the rumpled peaks of Skye and Rum drift like Scottish castaways on the far side of the blue gulf (I should add that I've also been up here on meteorologically downbeat days, when it's been impossible to focus on your feet for howling cloud). The 2,000-foot freewheel to the seashore at Applecross village brings you to the start of a 25-mile tarmac belvedere which follows the shore northwards past the islands of Raasay and Rona then jinks into Loch Torridon and reaches the picturesque waterside village of Shieldaig. (Just writing these words is making me want to rush to the rail station with my bike.) This wonderful bastion of ancient, Torridonian stone was picked out 9,500 years ago by a group who spent a winter at a rock shelter by Sand – the little beach you'll pass 5 miles after leaving Applecross village. In 2000, a team from Edinburgh University uncovered a fascinating archaeological trove. Here, too, early coasters were reaping the best of both worlds, living from the land and the sea. Along with the bones of red deer and birds was a harpoon made from antler, and tools for opening shellfish. Some of the tools probably came from the islands of Rum and Skye, a reminder that the first known visitors to Applecross probably floated across the water rather than struggled over Bealach na Ba.

The Scottish coast was also the Mesolithic departure lounge for Ireland, where the earliest-known man-made structures have been found a short walk from the sea, on a 30-metre bluff above the River Bann just outside the northern town of Coleraine. The archaeological site at Mount Sandel has a lot in common with Glasgow, Edinburgh and London; great cities which grew near the mouths of great rivers. The Bann is the longest river in Northern Ireland and it links the vast inland sea of Lough Neagh with the Atlantic. It's a lovely river. In Camden's day, it was famous for 'breeding Salmons in aboundance above any other river in all Europe because, as some thinke it passeth all the rest for cleerenesse'. The remains of ten structures – probably fashioned from bent saplings – were excavated at the Mount Sandel site. In the surrounding pits

were the bones of wild pig, a range of game birds from mallard and grouse to wood pigeon, snipe and thrush, and food from river and sea such as trout, salmon, eel and sea bass. Evidence of what might have been a fish-drying rack was also discovered.

Life was good on a temperate archipelago. To go hungry, wet or cold at Mount Sandel, Sand or Cramond, you had to be a seriously incompetent fisher-forager. Indeed, the incredibly rich coastal pickings we enjoyed from the Mesolithic onward laid the foundations for the wealth, power and cultural diversity which came with later generations. The further you travel from the coast, the more precarious life becomes. A couple of times, I've burrowed deep into the heart of continents, walking or cycling as far from the coast as it's possible to get. My cousin, Dr Richard Crane, and I rode bicycles to the place in the world most distant from the open sea: a grid reference in the heart of Asia. To get there from the Bay of Bengal, we pedalled over the Himalayas, across the widest part of the Tibetan Plateau, then across the Gobi Desert. In low-lying, coastal Bangladesh, the food available at roadside chai huts was plentiful and varied; up on the Tibetan Plateau, we subsisted on the nomads' staple of salt tea and *tsampa* (roasted flour). In the Gobi Desert, the only food available was trucked into widely spaced oases. On a later trip, I walked across Europe, following the mountain watershed from west to east. Where I started, in the Spanish coastal province of Galicia, the mix of seafood and mountain fare was mouth-watering. But by the time I got to the Carpathians, a year later, I was living mostly on cheese, milk and bread bought from or donated by shepherds. Tramping out of Turkey's dusty foothills to the first marine beach I'd seen for 17 months, I was craving seafood.

Britain's coast was a vast, open-access larder. We should view early coasters as amphibians who had developed the skills that allowed them to harvest the land, the seashore and the sea in such a way that every season kept them fed. Oronsay's Mesolithic campers were living off an entirely marine diet because the island was too small to offer much else. On larger islands, and on the mainlands of Ireland and Britain, coastal communities treated ocean and island as complementary resources. William Camden's 'singular praise' for the multitasking men of Kent stands for all who were reaping land and sea:

'For they are passing industrious, and as if they were *amphibii*, that is, both land-creatures and sea-creatures, get their living both by sea and land, as one would say, with both these elements: they be Fisher-men and Plough men, as well Husband-men as Mariners, and they that hold the plough-taile in earing [tilling] the ground, the same hold the helme in steering the ship. According to the season of the yeare, they knit nets, they fish for Cods, Herrings, Mackarels, &., they saile, and carry foorth Merchandise. The same againe dung and mannure their grounds, Plough, Sow, harrow, reape their Corne, and they inne [store] it, men most ready and well apointed both for sea and land, and thus goe they round and keepe a circle in these labours.'

Around the coasts of the archipelago, farm labourers would sail as deckhands on fishing boats once the crops were gathered; in the fleets of Yarmouth and Lowestoft, these brawny men of the land – the 'bumpkins', or 'joskins' – were admired for their strength at the winch.

Back in the Mesolithic, coasters were enjoying a similar – if simpler – balance of terrestrial and marine food. But evidence suggests that our habit of living beyond Nature's means goes back a very long way. Over on the east coast of Scotland there is a midden that begins to tell a disquieting story. Today, the self-styled Kingdom of Fife (for 500 years it was home to Scottish kings) is a gentle, green spade of farmland and baronial piles separating the firths of Forth and Tay. It's on the same latitude as the grand-standing Trossachs and Loch Lomond, but it's a world away from peaks and wild glens. Cycle trails and coast paths unravel along sheltered shores punctuated by headlands, old ports, Scotland's first university and the world's most famous golf course. Six thousand years ago, when sea levels in Scotland were higher, there was a low-lying island off the north-east tip of Fife. It must have been a productive site for marine foraging. The island has become Tentsmuir Forest, and close to the edge of the trees, archaeologists uncovered a Mesolithic midden containing a staggering ten million shells. It's inconceivable that harvesting on this scale did not affect the sustainability of the local ecosystem.

I'd always seen Mesolithic hunter-gatherer-fishers as a benign race of explorers who lived within the bounds of Nature's sensitive ecosystems. But it seems

likely that Britain's post-glacial pioneers were no more restrained in their exploitation of nature than the ravagers of the Industrial Revolution. In America, marine scientist Jeremy Jackson – together with a team of zoologists, ecologists, anthropologists and others – bored back through 125,000 years of palaeoecological, archaeological, historical and ecological records to discover that 'humans [had] been disturbing marine ecosystems since they first learned how to fish'.

From the earliest days of colonization, there are ominous signs that coastal Britons were far from green. When archaeologist Steven Mithen investigated a Mesolithic site on the Hebridean island of Colonsay, he found evidence of hazelnut harvesting 'on an almost industrial scale'. Surrounded by a series of pits that had been used for roasting the nuts, was a rubbish dump containing more than 100,000 nutshells. Pollen analysis from a nearby loch revealed that the island's woodland cover had collapsed just after the intensive harvesting. Sustainability, it seems, was less important than immediate needs. Mesolithic overexploitation also appears to have occurred on a headland at the other end of Britain, where the 'Isle' of Portland dangles untidily into the English Channel. Towards the southern end of the peninsula is a Mesolithic site that must have been a sensational billet. It's on a sunny, south-facing slope, with wide views over the sea and a freshwater spring which still tumbles over the cliff. These days, the 4-mile peninsula of Portland has a population of around 13,000, but when Mesolithic families watched the sunrise from these cliffs 7,500 years ago, there were somewhere between 2,750 and 5,000 humans living in the whole of Britain. The Portland midden suggests that the 15 to 30 people who occupied the site for 10 to 20 years had left their mark on the local wildlife. Discarded shells of *Monodonta lineata* – an edible mollusc that has disappeared from the shores of Dorset – changed in size and abundance within the midden, implying that Portland's earliest-known settlers had been foraging so thoroughly that *M. lineata* had been unable to reproduce. The fate of marine life generally can be read in the pretty spiral of Portland's mollusc.

Whaligoe, meaning whale inlet, is the most peculiar fishing port I've ever seen. It can be found a couple of hundred metres from the A99 in the Caithness

village of Ulbster. From the verge, there is no hint of the port's existence and yet on the landward side of the road the gentle slopes are speckled with chambered cairns, standing stones, the remains of circular stone brochs and forts. It's been a popular coast for some time. On the east side of the main road, a flight of steps tips over the cliff. As you go down the worn slabs that zigzag into the depths, you're entering a large 'geo' – one of the sheer-sided, sea-filled slots so typical of Orkney and Caithness. The deeper the staircase descends, the more claustrophobic the chasm becomes. At the bottom, you find yourself trapped beneath sheer walls, with a panel of daylight forming the ceiling, and a doorway of light opening to the sea. It's as if a giant has taken a claymore to the cliff.

At the foot of the steps, a lawn of wild grass sprouts from the upper surface of a stone platform. There is a rusting winch, and drystone buttresses that look from below like an Inca stairway; they're inset with lintelled recesses for lanterns. Cries of seabirds echo from the tilted bands of Old Red Sandstone. When Thomas Telford investigated Whaligoe during his tour of 1786 for the British Fishing Society, he pronounced it a 'terrible spot'. A few years later, the local minister, Reverend William Sutherland, provided a graphic image of a working day in Whaligoe:

> 'The fishermen, on this part of the coast, to get to their boats descend a huge precipice by winding steps in the face of the rock, by which some lives have been lost; and yet, from frequent practice, it is often done without assistance, by a blind fisherman in Ulbster. To secure their boats from being dashed against the rocks, particularly by storms and stream tides, the fishermen hang up their yawls by ropes, on hooks fixed in the face of the rock, above the level of the water, where they are safely suspended, till the weather is fit for going to sea.'

In 1808, Whaligoe's unlikely harbour was sheltering seven herring boats, or 'cobles', and by 1826 the number had risen to 24. The boats were unloaded by columns of local women, who carried the baskets of fish up that interminable flight of steps. There are said to have been 365 steps, one for every day of the year.

Why would fishermen – and women – go to such extreme lengths? Reverend Sutherland spoke for every haven on the North Sea coast:

'The coast is of great extent, and abounds with a vast variety of fish, which, besides what is annually exported, furnishes the inhabitants with a liberal supply during every season of the year. Salmon, trout, herring, cod, ling, haddock, whiting, mackerel, halibut, which the fishers here call turbot, skate, flounder, dog-fish, (from whose livers a great quantity of oil is extracted), a red speckled prickly fish called cumars, cuddies, that grow up to the size of a cod, and are then called seaths, sillocks, a small fish caught with the rod from the rocks in such quantities, as to be sold for a penny an hundred, are all met with in plenty; sand eels, crabs, partans, and lobsters are also caught here, though the latter not to such extent as might be for the London market, to which it is now in agitation to send them.'

Compared to the Highlanders of the interior, Sutherland's coastal parishioners had rich pickings: in their manoeuvrable cobles, the villagers of Caithness launched seasonal forays into remote, sandy coves inaccessible from land. There, they would beach the boats as silently as possible, and creep towards families of seals, which they would kill, explained Sutherland, 'with bludgeons for their oil'. On the cliffs they shot seabirds that were salted to supplement their winter food. On the coast, too, they had access to so much salt that the salt pans at Sarclet and Nybster produced a surplus that was sold at 8d–10d per peck. On beaches like the 3-mile strand on Sinclair's Bay, winter and spring storms threw up vast amounts of seaweed that the villagers would pile in great heaps and allow to rot. Mixed with dung, cods' heads, 'herring garbage' and brine, it made, Sutherland noted, 'a very strong manure'. In the parish of Wick alone, 40 or 50 tons of kelp would be cut with scythes from the rocks each year.

From Caithness to Kent, thousands of coastal communities were reaping the North Sea shoreline. The North Sea was Britain's abundant pond. At 222,000 square miles, it's substantially larger than, say, the Black Sea or Baltic, and just under a quarter the size of the Mediterranean. It is shallow, and used to be teeming with marine life – especially herring. If fish could accept awards

for services to industry, the 'silver darlings' would be the most deserving. It was their misfortune to have evolved into a 'pelagic' species, one living near the surface of the sea, and, during the spawning season, given to gathering in enormous shoals. There were three main areas where the North Sea herring spawned each autumn: 'Buchan' off north-east Scotland, 'Banks' off the east coast of southern Scotland and northern England, and 'Downs' at the eastern end of the English Channel.

From the earliest records we have, there are signs that herring were being netted in huge numbers. The annals of the monastery of Barking in Essex, which was founded in 670, recorded that a tax known as 'herring silver' was being levied on herring, and documents from Evesham monastery (founded in 709) include several references to the herring fishery. By the time the Normans landed in 1066, there were clearly a great many herring boats operating on the east coast. A hint at the numbers of fish being caught can be detected in the pages of Domesday Book. On the south coast, one of the most active fishing communities was a place called Bristelmestune, rebranded later as the Sussex resort of Brighton. Sandwich in Kent was supplying the monks of Canterbury cathedral with 40,000 herring a year; and Yarmouth in Norfolk could boast 24 permanent fishermen. But the big catches were coming into Suffolk: under Edward the Confessor, Blythburgh was paying tax of 3,000 herring a year, Southwold 25,000, Beccles 60,000 and Dunwich a whopping 68,000.

The population of England more than doubled in the two centuries following the collation of Domesday Book. Fish, a necessary staple of the medieval diet, became a major trading commodity and the North Sea assumed a Galilean role in helping to provide the country's Catholic people with a dependable, meat-free source of protein on Fridays, Saturdays, Wednesdays, on feast days and during Lent. Consumers just liked the taste of fish, too. It was the delicious fantasy of sea fish that drove a schoolboy to write, one day in the 15th century, that he wished he was 'one of the dwellers by the sea-side, as their sea fish are in plentiful supply and I love them better than freshwater fish'.

By medieval standards, the scale of the fishery business on England's east coast was extensive and complex: a web that included facilities for salting and smoking, supported by fishmongers, brokers and 'rippers' – retailer-transporters

who conveyed fish in baskets slung over packhorses from the coast to provincial centres, including London. By 1300, herring were also being shipped abroad. The creation of a fishing 'industry' brought a change to coasts, as former subsistence communities adapted to new roles as hyperactive bottlenecks between the vast offshore shoals and the equally vast inland markets. The places that prospered were those suitable for beaching boats and reaching shoals. On the coast of Yorkshire, an outlier of Jurassic limestone provided an ideal location for commercial fishing.

Picture a great plateau of rock, jutting into the ocean, buttressed by 300-foot cliffs and connected to the 'mainland' by a low isthmus of good building land overlooking a sheltered anchorage framed by a long beach of firm sand. For hundreds of years, this castle-like promontory had been a key point on the east coast. Fort-builders in the Iron Age had capped the rock with defensive earthworks, and the Romans had built a signal station on it. In the tenth century, a Scandinavian settler called Thorgils Skarthi (the Hare-lip) gave the place its modern name when he founded a stronghold, or *burh,* here. Then 'Skarthi's burh' was spotted by Norman settlers who topped the rock with a stupendous castle, ringed the town with walls and built a quay for shipping. By the time 'Scarbough' appeared on the Gough Map of the late 14th century (the oldest surviving 'road map' of Britain) the town was a fishing port of international importance, with an autumn herring fair that lasted 98 days. In an age before maritime charts and GPS, the best ports lay close to an identifiable geographical feature. As John Leland, the 'father of English topography', observed in the 1540s, Scarborough's 'slaty cliff' offered 'a very fine prospect from out at sea'. It was a superb landmark for seafarers.

A fishing community comes of age with the construction of its own harbour. I'm not alone in being sentimental about these places: whenever I walk a worn stone jetty beside a tidal pool of placid water, the memories and images flicker through the scene like sunlit fish. Boats nod at orange buoys, or recline on wet sand. Occasionally, there are soft tumuli of nets, or lobster pots tasselled with weed. At harbours like Aberdovey and Padstow, gaggles of children torment crabs with bits of bacon on string. I find myself taking photographs (why?) of those old mooring rings that rest like rusted quoits on the

stone, or of bollards that are scarred by the hawsers of boats that rotted to oblivion decades ago. There ought to be a word for the pleasurably aimless recreation of contemplating fishing harbours. 'Mouseholeing' perhaps.

Scarborough's harbour came early, built by Normans and upgraded in the 13th century by a stone quay financed by a users' levy: 6d for merchant ships, 4d for fishing ships and 2d for fishing boats. Each herring season, hundreds of ships unloaded their catches at Scarborough, where they were salted and barrelled for English markets. In 1304, a peak year for the port, no fewer than 5,237 foreign vessels unloaded 3.5 million fish. Officials claimed in 1363 that their income 'for the most part arises from fish and herrings taken at sea and brought to the town for sale.'

Scarborough's take was repeated up and down the North Sea coast, although in those early years of the herring boom, only Yarmouth could compete in terms of volume. Yarmouth was unique in the archipelago for being the only fishing town of its size to have been born on a sandbank. Some time after the Romans departed, an 8-mile long bank of sand formed across the mouth of the 'Great Estuary' that used to carry the waters of the Yare and Bure towards the sea, and it seems that fishermen set up seasonal camps on the sand so that they could take advantage of the herring shoals gathering at Smith's Knoll fishing ground, 30 or so miles to the north-east. By the 14th century, Yarmouth too had its annual herring fair and was catching an average of well over ten million fish a year.

Elsewhere on the east coast, many other ports were feeding on the shoals. Hartlepool, Whitby, Boston, Grimsby, Saltfleet and, on the south side of the Wash, Wells, Holkham, Blakeney, Cromer, Dunwich and Walberswick all had their own fleets while large foreign fleets too were chasing North Sea herring. With the invention of the factory ship by the Dutch in around 1415, catches multiplied. Each Dutch 'buss' could carry 30 to 40 'lasts' of fish – or about 300,000 to 400,000 herring, and they processed the fish at sea. By 1630 there were between 500 and 600 busses in the Dutch fleet.

The herring turned ports into bustling 'fish factories', nowhere more dramatically than in Caithness, where the 'silver darlings' transformed a back-of-beyond anchorage into the largest herring port in Europe.

The cliffs, reefs and caves carved from that looming, broken wall of Old Red Sandstone are less than welcoming if you're in a small, timber boat. But 15 miles south of the daggers of Duncansby's stacks, there is a break in the wall. It's called Wick Bay, and it's nearer to Bergen than it is to Manchester. For the Vikings, Wick was one of the closest havens on the British mainland; its Norse name is derived from '(place by) the bay'. Nearly a mile wide at its mouth, the bay tapers inland to meet the outflow of the Wick River, which drains hundreds of square miles of moor and arable farmland. On William Roy's military survey map of 1747–55, the landscape is stippled with field strips and clusters of crofts. Despite its strategic location, Wick Bay boasted just a single street of dwellings when Roy came by with his surveyors.

In the 1790s, one of Wick's most ardent lobbyists was its minister, Reverend Sutherland, the chronicler of Whaligoe. With shelter for a fishing fleet, argued the minister, Wick could feed a multitude: 'The new harbour,' he wrote, 'is not only an object of the highest importance to the town itself and its immediate neighbourhood, but to the kingdom at large.' Sutherland described the dangers of the coast and pointed out that there was no place of shelter for vessels all the way from the Orkneys to the Cromarty Firth – a distance of nearly 200 miles. For 'want of a harbour', explained Sutherland, 'many vessels have been driven ashore, and many lives lost. A harbour commodious for a number of vessels, and safe in all weather, might be made at Wick. This would be particularly beneficial during the herring fishery, which has been much retarded from the want of such a shelter.' He described an alarming day in 1791, when 34 fishing vessels had been trapped in the bay 'in constant danger of running foul of one another'.

Sutherland was a man of his time. A few years later, in 1808, the harbour was built, and by 1818 there were 822 herring boats operating from Wick. In William Daniell's aquatint of the early 19th century, you can see new buildings on the headland, a harbour jetty and a fleet of fishing vessels riding the sheltered waters of Wick Bay. Daniell caught Wick just as it was taking off. Women flocked there for work, gutting and packing the fish as soon as they were lifted from the boats. In Wick's boom years between 1860 and 1890, a thousand or so boats operated out of a harbour that was employing around 6,000 fishermen and another 6,000 shore-workers, including the 300 coopers whose job it was to construct the

barrels for the salted herring. Another thousand seamen manned the ships which exported the fish and imported salt and barrel-timber to Wick. To replenish this huge population of manual labourers, the port had 45 pubs, a distillery and a brewery.

Each century brought greater demands and more efficient means of removing fish from the sea. With each new innovation, catches increased and stocks decreased. One of the leading centres of innovation was the port that had grown up a few miles from the Mesolithic camp at Cramond on the Firth of Forth. Leith was an outlet for Scottish inventiveness. In 1820, a Scotsman called James Paterson opened a factory in Leith which could manufacture lightweight, flexible nets of cotton on a loom. That loom was then improved by another Scotsman, Walter Ritchie. Traditional handmade hemp nets were heavy and inflexible, and took up so much space on a boat that the largest yawls operating off the Yorkshire coast would typically carry 60 or so of them, but that more than doubled to 130 when skippers switched to the new, lightweight nets, which were shot in a train that could be 2 miles long. It's been estimated that the capacity of the English and Welsh herring fisheries increased fourfold in the 20 years from 1858. Faster, bigger, more stable fishing boats were also appearing. In the 1850s, the twin-masted 'Fifie' was developed on the east coast of Scotland. Taking its name from the kingdom of Fife, it was designed mainly as a herring drifter, wide beamed, with a long, straight keel, and a vertical stem and stern. Some were over 60 feet long. Fifies were overtaken in 1879 by the even bigger, faster 'Zulus', named after the then-raging Zulu Wars and designed by William Campbell of Lossiemouth.

In common with most species crashes triggered by Man, the end of the herring was hastened by a brilliant, human invention. As long as drifters depended upon the wind and tide, their catches would be limited. But in 1877, a shipbuilding company based at Leith launched a fishing boat powered by steam. *Pioneer LH854* was the brainchild of David Allan, whose yard on the Forth went on to build steam trawlers and drifters for customers in Spain, Italy, France and Belgium. It's not known whether the five Scottish steam drifters that showed up at the East Anglian port of Yarmouth in 1887 were from Allan's yard, but they caused a sensation. By 1894, Yarmouth owners were operating two Scottish-built steam drifters, the *Puffin* and *Salamander*, and by 1898, there

were 20 steamers fishing from the port. Over the next 15 years, most of the Yarmouth owners abandoned sail so wholeheartedly that by 1913, 213 drifters out of a total of 227 registered vessels were powered by steam.

Steam changed everything. Not long ago, I was a passenger on board a small fishing boat on the North Sea, and when we finished filming, the skipper turned the boat for Yarmouth. Not only was the entrance to the harbour invisible to my un-nautical eye, but to reach it, we had to sidle past various sandbanks lurking just beneath the surface. I found myself wondering how on earth skippers of sail-powered fishing boats managed to return safely to such a tricky port. Steam power made it safe to leave and re-enter harbour in most winds and weathers, while the speed and predictable range of steam drifters made it possible to exploit more distant fishing grounds on a regular basis. The new steam harvesters produced incredible catches. On one day alone, 22 October 1907, 60 million herring were landed at Great Yarmouth, and when space ran out, 30 million of them had to be sent on to Grimsby. Steam caused an integrated revolution; herring caught by steam drifters could be transferred at the quay to steam trains for rapid distribution to distant cities.

Fishing was utterly unlike farming in that both the crop and the workforce were highly mobile. The Fifies and Zulus would fish herring off the Hebrides and Shetlands in May and June, sail down the east coast to fish the shoals off Northumberland and Yorkshire through the summer, then fish from Yarmouth and Lowestoft through the autumn. Some of the boats would carry on through the winter, catching spawning herring in the Forth, the Minch, Irish Sea and the Atlantic off Northern Ireland. Fishing boats from various countries roamed the seas, following the shoals and selling their catches in the closest suitable port. With boats mingling in each others' harbours, innovations spread quickly. One of the most damaging developments – from the fishes' point of view – was the spread of trawling from the south of England. Where drift nets were suspended near the surface to catch pelagic fish like herring, a trawl net was towed across the seabed to catch demersal fish, like cod, which lived in the lower levels of the sea. Trawling was less selective than drift netting, since the trawl net tended to bag anything that strayed into its path. In the Middle Ages, fishermen had learned to attach a heavy beam across the mouth of the net. As the beam scraped across the seabed, everything in its path was crushed or scooped. Once the net

was on deck, the fishermen would pick out the saleable and bait fish, and chuck everything else over the side. For those who knew the seabed as a living garden of nutrition, 'beam-trawling' was a heartbreaking development. As early as 1376, a proto-environmentalist forcefully made the point that 'the great and long iron of the wondyrechaun [beam trawl] runs so heavily and hardly over the ground when fishing that it destroys the flowers of the land below the water there, and also the spat of oysters, mussels and other fish upon which the great fish are accustomed to be fed and nourished'.

Beam-trawling under sail was a highly specialized style of fishing. In Brixham recently I went out on a restored sailing trawler called *Keewaydin*. She's owned by Paul Welch, who had built his own 19th-century beam trawl using a baulk of oak and two welded steel frames. The idea was to test Paul's trawl. However, there are very few surviving fishermen who know how to trawl under sail. One of them, retired Brixham trawlerman Bill Wakeham, was on board. Off the South Devon coast, with *Keewaydin*'s tan sails aloft, the beam was lifted by winch over the side. The rope was paid out, and by placing a hand on it we could feel that it was bumping along the seabed. All seemed to be going well until *Keewaydin* suddenly stopped moving forward. A long, physical struggle eventually brought to the surface a smashed beam trawl and a ripped net. In the remains of the net were a large rusty anchor and a metal casing which could have been part of a torpedo. Or, as the sound recordist pointed out, a Morris Minor wing.

The original beam trawlers could only work in relatively shallow waters, where the seabed was fairly smooth. In the early days, they could be found off the south-west and south-east coasts of England, operating out of Brixham and Plymouth, and Barking on the estuary of the Thames. But in the 18th century, the beamers grew larger, and spread north. With a gaff-rigged mainsail, a bowsprit and a jib, they were known as 'smacks', and could be sailed by fewer men than the larger deepwater craft. By the early 19th century, West Country smacks were sailing up the Channel to trawl the North Sea, landing their catches at east coast ports. One of those ports was Hull, on the Humber.

With the Thames and the Wash, the Humber is one of the big three estuaries on the east coast of England. The Humber's value to local fishermen had long been its rich, estuarine habitat, and its convenience as a haven. Hull had grown up 20 miles inland from the sea, and by the early 19th century, it had

become a booming, wealthy, trading port with a population of over 22,000. But the Humber was a tricky waterway, fed by several powerful rivers and swept by funnelling tides. During the great storm of 1703, virtually all the ships that had been sheltering at the mouth of the estuary were, according to Daniel Defoe, 'driven from their anchors'. Many were lost. When Defoe's contemporary, the intrepid traveller Celia Fiennes, went out on the muddy Humber in 1698, she described how it always 'rowles and tosses just like the Sea', and rated it 'a hazardous water … more turbulent than the Thames at Gravesend'. It wasn't until Hull began to build new docks in the early 19th century, that the fishermen began arriving in numbers. In 1840, there had been seven fishing boats registered at Hull, but by 1878 there were over 400 and the port's fish trade was estimated to be providing employment for over 20,000 people.

At the exposed mouth of the Humber there was another, much smaller settlement. Grimsby had been founded by Danes in the ninth century, and despite its marshy, exposed site it had prospered through trading until its channel began to silt up in the 15th century. In 1801, its population was just 1,524. All Grimsby needed to turn itself around was engineering. The channel was deepened, and docks were built. In 1857, the Manchester, Sheffield & Lincolnshire Railway opened No. 1 Fish Dock, and to lure fishing vessels from adjacent ports the company offered a package of inducements that included reduced dock charges and railway rates, and free rail travel for fish merchants planning to develop inland markets. By 1863, six years after the dock opened for business, at least 70 fishing smacks were based at the new facility. By the 1950s, Grimsby was the world's largest, busiest fishing port.

The trajectory of the fishing industry had been set with the spread of the beamers. A rail distribution network, purpose-built fish docks, steam trawlers and drifters increased the takes of British and Irish fleets, but the effect was multiplied because there were many other countries also fishing the common pond – all serving an insatiable market for fish. There could be only one outcome. Fish stocks crashed.

The first to go were the silver darlings – Europe's largest fishery. In 1966, the North Sea yielded 1.2 million tons of herring, but the tipping point had already been passed. The herring shoals that had fed Yarmouth and Lowestoft for a thousand years had collapsed in 1955, and others followed until, by 1975, the

total North Sea herring catch had plummeted to 200,000 tons. Species being trawled from 'bottom fisheries' suffered a similar fate. The one million tons of fish landed by North Sea trawlers in 1900 had risen to 3.5 million tons by 1970, and then it dropped. Horribly. The EU's Common Fisheries Policy made matters worse: in an attempt to keep national fishing industries alive it had awarded them unsustainable quotas.

History has provided many examples of mankind's inability to limit the exploitation of resources, even when it is apparent that the eventual outcome will be ruin. Natural resources with free access to all are particularly susceptible to destruction. In 1968, the Californian biologist Garrett Hardin neatly encapsulated the human capacity for self-destruction in the theory that he called 'the tragedy of the commons'. Because each exploiter sees the negative consequences of acting selfishly as being shared between *all* the exploiters, there is an immediate net benefit in maximizing his own take. Looting is popular for the same reason. The real cost to the 'commons' is greatest when the commons in question are large and unregulated – like the atmosphere and the ocean.

The fishing commons in this case are all one. The ocean, the sea, the various straits, channels, minches, firths, bays and estuaries that wash against our shores are all part of a single body of water which covers 71 per cent of the earth's surface. That huge, many-tentacled blueness contains 97 per cent of the planet's water. It also contains 300,000 recorded species, although the actual total may be as high as ten million. The billions of livings things that contribute to those species are interconnected in fantastically complex foodwebs which span the globe. The herring larvae that hatch in the gravel beds off Yorkshire drift as clouds of plankton for four to six months across the North Sea to their nursery beds off the coast of Denmark. Today, we're demolishing those food webs so efficiently that many species of fish have reached the limits of sustainability. Even now, despite ample data about the state of fish stocks, we still take from the world's oceans 80 million tonnes of fish every year. Around 70 per cent of the world's fish stocks are now fully fished, and another 20 per cent overfished. Global wild fish catches have been falling since 1988.

The tragedy for these common seas is that the momentum of demand-driven exploitation and the difficulties inherent in counting and tracking fish have proved beyond the scope of effective regulation. Fishery protection

initiatives leave port armed with quotas, bans, buy-outs, scrappage schemes and surveys, only to berth with the news that fish stocks are in an even worse state. Looting the seas began as an oversight, but was always a violation of natural law. And now that it's a global, institutionalized violation, powered by market economics, it is not easy for politicians to address.

The effect on the coastal communities of the archipelago has been profound. UK herring catches peaked in 1913, at 600,000 tons for that year – an amount which represented about half the wet fish unloaded in Britain. Since then, it's been a sorry tale of diminishing returns. The tonnage of sea fish and shellfish being landed by UK vessels into UK and foreign ports dropped from just over 800,000 tons in 1999, to 588,000 tons in 2008. Landings of cod dived by 72 per cent between 1994 and 2008 and, over the same period, haddock landings dropped by 65 per cent. Mackerel was down 46 per cent between 1994 and 2008 and herring down by 35 per cent. Seas that once teemed with so many fish you could scoop them out with a bucket have become semi-deserts. With the exception of a few areas in UK waters, stocks of cod, haddock, plaice, sole, herring and mackerel are variously described by the UK's Marine and Fisheries Agency as being 'heavily over-exploited', 'suffering reduced reproductive capacity' and 'seriously depleted'. In government reports, it is not considered appropriate to use phrases like 'utterly stuffed', or 'maxed out', but that's the situation. In his investigation of overfishing, author Charles Clover tried to extract from marine scientists an estimate of the 'virgin stock' of cod in the North Sea before the sailing trawlers went on the rampage in the 18th century. Nobody knew, but Clover concluded that only around 10 per cent of the original spawning biomass was still in the North Sea. When stocks fell that low in Canada, cod fishing was banned entirely. In the North Sea, it continues. Cod can live to the age of 20 years and more; these days, they seldom see a sixth birthday.

In fishing the seas to death, the industry lost its future. Between 1999 and 2008, the number of fishermen fell by almost a quarter, to 12,761. The graphs all head downward. In the ten years to 2008, the number of vessels operating in the UK fishing industry shrank by 18 per cent, to 6,573, while capacity shrank by 22 per cent. Meanwhile, the UK has slipped into 'fish deficit'; we import more fish than we export, by 364,000 tonnes in 2008 – a 30 per cent

rise on the 2007 deficit and the highest for 15 years. Iceland is the UK's main supplier, then Germany and then China.

The collapse of the fishing industry is a tragedy far beyond the demise of British coal-mining or car-making, because the resource being exploited was not an inert raw material but a living ecosystem that has sustained us since fishermen used spears to catch supper on the coast of Doggerland. And it's not the fault of the fishermen. In a global market economy, exploitation is driven by demand; by the choice we make as we linger over the fish counter or restaurant menu.

From a mooring bollard at Newlyn or Peterhead, the sea looks as it did 10,000 years ago. Unlike the birds and beasts of the woods, the fish of the deep move unseen through their own, private sanctuary, and so their removal has made little superficial difference to our view from the coast. The surface of the sea still looks watery. But our seas could no longer support Oronsay's fisherfolk. Abundant seafood once gave the archipelago its food security. We are now dependants.

The lost shoals of the Atlantic and North Sea have left a coast lined with hundreds of ghost ports.

Last summer I was in Great Yarmouth with an evening to spare, and for want of anything better to do, I walked the full length of the old port, from the mouth of the River Yare to the Haven Bridge. It's a measure of how busy this place used to be, that it's a stroll of over 2 miles. Back in 1913, at the peak of the UK herring industry, 1,006 fishing vessels were based here. I passed a few, small fishing boats, but the fish wharf, where herring drifters used to moor so closely that you could jump from deck to deck, was deserted. Eventually, I came to one vessel. She had a single funnel, two stumpy masts and a wheelhouse like a pine-clad phone box. *Lydia Eva* was built in 1930, 20 years after the shoals shrank, and she hauled her last catch on the eve of war, in December 1938. *Lydia Eva* is the world's last surviving herring drifter. In summer, she's open to the public. Ten minutes away, I came to the Time and Tide museum. It was packed. Occupying a large corner site in what used to be the Tower Fish Curing Works, the museum takes you on a herring tour, from drifter to wharf to smokehouse, where 24,000

fish could be hung at a time for curing. The works used to have seven smoke-houses. There's even a reconstruction of one of Yarmouth's famous 'rows', the paved alleys no wider than a fish-barrow which ran – until the Luftwaffe removed them – like teeth on a comb between the quay and the marketplace.

It's a pity that we can't run our industries as well as the museums we remember them by. Britain and Ireland are well supplied with fishing museums and museum ships. Not so long ago, I was browsing the arches on Brighton's seafront and came across a fascinating museum full of models, paintings and prints. At the Scottish Fisheries Museum at Anstruther in Fife, the 66,000 objects that have been collected from Scotland's coasts include a 78-foot long Zulu fishing boat, and *Reaper*, a 'Fifie' herring drifter that starred in one of the BBC's *Coast* programmes. On the water at Hull, there is a restored 'side-winder' trawler called *Arctic Corsair* that you can step aboard. Almost any port that once depended upon fishing has created its own heritage centre. You'll find them at Broughty Ferry, Buckie and Cromer, Duncannon and Grimsby, Peterhead, Plymouth…

The fishing ports are a generous legacy. When the North Sea oil industry needed east-coast ports, the old fish quays of Yarmouth, Lowestoft, Grimsby and Aberdeen were vacant and waiting. Several fish quays are used by the vessels that build and service offshore wind farms. And fishing ports have been adopted by the tourist industry as proxy resorts that offer a deeper history than Victorian esplanades and funfairs. Padstow, on the north coast of Cornwall, has been reinvented with the help of chef Rick Stein. At Craster on the coast of Northumberland you can visit the works of L. Robson & Sons, who still smoke fish over fires of oak sawdust. The photogenic quays at old herring ports like Whitby and Blakeney are thronged each summer with families who come for golden views that were built with the profits from silver darlings.

At the biggest fishing ports, those built to handle fish as if they were being mined inexhaustibly from the ocean, there's a sense of desolation or opportunism, depending on whether or not the sun is shining when you visit. Filming in Grimsby's fish docks for *Coast*, I found myself gazing – a tad melancholically – across 60 acres of empty water and a mile of silent wharves. It looked like a film set before the props arrive. A year or so later, the derelict ice house became the scene of a firefight during the filming of Ian McEwan's novel *Atonement*. Wick harbour is as silent as Daniell's aquatint. It's as if the

herring boats sailed out to sea, never to return. The old herring mart with its wrought-iron canopy still stands, and so does the elegant pilot house up on the bluff. Valiant efforts have been made to bring the boats back to Wick, with some success. There are 1,366 metres of open quays and berths for vessels up to 89 metres in length. A yacht marina was opened in 2009 by the Princess Royal, Princess Anne, and summer visitors can take sea-angling trips, or go hunting (with cameras) for killer whales and basking sharks. And there are still boat trips to the sea stacks and caves. There's even a restored Fifie, the *Isabella Fortuna*. Last time I was in Wick, an old timber herring boat caught my eye. Her paint was peeling, her metalwork salt-eaten and her wheelhouse looked as if it had been ravaged by several Perfect Storms. On the signboard advertising her sale, some wag had daubed: 'NEEDS SOME ATTENTION.'

The collapse of such a huge industry doesn't just leave physical voids around the coast. When the fleets were scrapped, a culture went with them. Fishing communities had their own traditions, their own songs, stories and language. In many parts of the country, echoes are retained in place names. Hythe on the south coast of Kent, and Hythe on Southampton Water, take their name from the Old English word *hyth*, for 'landing place or harbour'. Staithes, too, on the coast of Yorkshire, is another Old English word with the same meaning. The port of Fishguard in Wales is derived from the Norse words *fiskr* and *garthr*, a yard for receiving fish. Porthcawl in Wales comes from *porth*, for harbour and *cawl*, for sea kale; the harbour where sea kale grows. Pwllheli means brine-pool. In Scotland, the language of fishing is fading with each generation, but centuries of use have left the coast dotted with labels that date back to the heyday of fishing and foraging. In Wester Ross, where Mesolithic gatherers once searched the foreshore for mussels, there's a place called Creag na' Feusgan, meaning 'the rock of the mussels'. Port na' Sgadan, on the shores of Loch Diabaig, means 'the port of the herring'. Also near Diabaig is Allt a' Roin, 'the burn of the seal'. Further south, a burn flowing into the Garry River is called Allt nam Banag, 'the burn of the finnocks' – finnocks being the young sea trout that used to swim up the river to spawn. There are many others. The fruits of the sea were also adopted in sayings. 'The herring were so good that you could eat your fingers after them' is the kind of post-prandial, lip-smacking epithet that must have been heard in many a coastal croft. Where the inlander might refer to something being as

tough as old boots, the Gaelic coaster would say 'as tough as the spotted dogfish'. The best of all worlds would be 'a herring's middle and a salmon's tail'. The old Gaelic saying that serves as an epitaph for the ocean is *Giomach is runnach is ron, tri seoid a' chuain*; 'lobster and mackerel and seal: the three heroes of the ocean.' Amen to that.

Pessimism is the enemy of invention, so I'll close this story with an encounter I had recently, on the Isles of Scilly. We were filming a new series of *Coast*, and I was out on a fishing boat off the eastern end of the island of St Martin's. At the helm was Scillonian Adam Morton. He fishes single-handed, so there was nothing I could do to help. With the practice of years, Adam both steered the boat and lifted a series of pots with the deck winch. Nearly everything in the pots went back in the water, except one lobster whose shell exceeded the metal measuring gauge. But when Adam began line-fishing, the catch abruptly improved. Within a minute, he had a good-sized pollack. Then another. And another. Ten minutes later, the bucket was full, and we were bouncing back through the swell to St Martin's. A couple of hundred metres from the jetty, I helped Adam's brother dig potatoes that he'd been fertilizing with seaweed and then we humped a tub of shiny Maris Pipers along a path to a new timber building set back from the dunes. The place was packed with customers. It's called Adam's Fish and Chips, but it's really a restaurant. The fisherman I'd been with an hour earlier had swapped his sea clothes for chef's whites and was in the kitchen mixing batter, dunking pollack fillets, crisping chips from the potatoes I'd just dug from the hill. Fiona, Adam's wife, glided to and fro taking orders, bearing wine, ferrying loaded plates.

It wasn't just that Adam and Fiona's fish and chips were the best I'd ever tasted, by far, and that I'd seen the pollack and the potatoes emerge from the sea and the soil that very afternoon, and that their journey from source to table was not measured in food miles, but food metres. No, the real point is that it's a sustainable operation, hand-lining fish that are locally available and growing spuds with nutrients from seaweed. There was something qualitatively Mesolithic about the whole experience, as if I'd been invited back 5,000 years to discover what fresh food could taste like. The sooner we treat fish as a delicacy, the sooner oceans will recover.

3.
Safe Rodes and Sure Harbours: The Story of Ports

It's a cold blustery morning in the Bristol Channel, and Steve Osbourne is on the way to work. Sheets of water are exploding against the glass by his head and his seat is doing a fair impression of a rodeo saddle. Spread on the varnished table in front of him is an Admiralty chart showing a huge wedge of blue, constrained by yellow land. The Bristol Channel is not blue of course, but mushroom-grey. Its colour is caused by vast amounts of suspended silt being stirred by the Channel's extreme tides; a soup so thick that it impairs the depth-sounding equipment on ships. 'One of my main jobs,' says Steve, 'is to reassure captains and tell them that their ships are not at risk.' Steve is a pilot, and it's his task to navigate the world's largest ships up the final miles of the Bristol Channel to port.

The pilot boat is called *Robina Fisk,* after the wife of the Chairman of the Bristol Conservancy and Pilotage Committee. She was built in Sweden to Baltic standards of resilience, with a lightweight, rugged aluminium hull powered by a pair of gigantic MAN diesels. Top-end speed is 18–19 knots, but she will touch 21 knots for shortish bursts. At 52 feet, she's about the same length as the old sail-powered Bristol pilot cutters, but three or four times quicker, and, unlike her sail-equipped predecessors, she doesn't mind windless days. We are heading for a container ship many times our size. I poke my head out of the wheelhouse to have a look at her. *Safmarine Letaba* hits the scales at 24,000 tons and is over 600 feet long. Set against the nearby farmland, her monstrous, blue hull looks ridiculously misplaced, like a skyscraper in a national park. Steve pulls a buoy-

ancy aid over his head, straps himself in and scoops his briefcase from the seat. Clipped to the rail, the camera crew and I inch our way to the foredeck. It's wet and exposed. The pilot boat cuts a curling wake towards the ship's port side. I look up and see a metal cliff topped by containers stacked five high. A rope ladder flicks down the cliff. Up in the sky, I can see the faces of two crewmen in helmets and high-vis vests. *Robina Fisk* slows to match the speed of the container ship and for a few seconds the two vessels are separated by a metre of water which races between the hulls like a horizontal cataract. Steve steps nimbly across the void onto the ladder and walks upward, briefcase over one shoulder. At the top, he turns and waves. Then he is gone and the pilot boat swerves away.

Steve will take *Safmarine Letaba* into the modern port of Bristol, a 2,600-acre dock estate 9 miles downstream of the city's historic wharves, where the Avon spills into the tidal waters of the Severn Estuary. The twin docks of Avonmouth and Royal Portbury – one each side of the river mouth – can handle ships of up to 130,000 tons and they are at the centre of a logistical hub. Rail lines run from the docks, and the M4 and M5 are close by, feeding goods to the 42 million people who live within 150 miles of the port. A few hours after watching Steve scramble up the side of the container ship, I'm standing on the concrete tabletop of Royal Portbury Dock as another ship is nudged by tugs into the largest lock in the UK. *Eternal Ace* is part of maritime history. She was the world's first advanced car-carrier, and when she was launched in 1988 she was the largest, with 14 car decks and the capacity to load 6,500 small passenger vehicles. Around 600,000 cars pass though Bristol's docks every year, along with timber from Scandinavia, fruit from Chile, TVs from Korea. But this is a modern port, and there's not a product in sight. Just containers. And new cars. Lots and lots of them. We don't have so many ports these days, but the ones that have endured shift a prodigious tonnage. More than 95 per cent of the goods consumed and produced in the UK pass through sea ports.

An archipelago does not have capitals; it has ports. Ours used to have hundreds, thousands, of them. The reason we had so many is that our mineral-rich, temperate pattern of islands produced an incredibly diverse range of raw mate-

rials and products that we could sell to our overseas cousins, and those same, temperate islands nurtured a huge population with a commensurate demand for imported raw materials and products.

Take a walk along the South West Coast Path from Bigbury-on-Sea and you reach – after 6 miles or so on the ragged rim of South Devon – a 300-foot high headland called the Beacon. This wave-hacked spike of 390-million-year-old slate is an ancient coastal vantage point that looms over the mouth of the River Erme. Walk around the corner, past Redcove Point into the throat of the estuary, and you find yourself in a sliver of paradise. The Erme is as close to 'unspoilt' as a West Country estuary can be. It's a classic ria, a river valley which has been drowned by rising sea levels. Woodland creeps down to the tideline and its estuarine beds are the spawning ground for Atlantic salmon and sea trout. There are otters here, too. In summer, families come to paddle and picnic, and at low tide hikers of the coast path can be spotted wading the river. If they're sensible they do so carefully, for there is another side to this blissful place. At high water, Erme Mouth looks like a perfect haven, but for over 2,000 years, it has been a shipwreck black spot. 'Its mouth is strewn', warned John Leland after his visit of 1535, 'with rocks and shallows, so that it is only in desperation that ships seek refuge here from storms.'

Scattered around the Erme are at least a dozen wrecks – and those are just the ships that have left a trace of their presence. One of those ships was a trading vessel which foundered around 2,000 years ago on St Mary's Rocks, the reef referred to by Leland. The ship itself has dissolved into the ocean, but in 1991, divers from the South-West Maritime Archaeology Group discovered its cargo. When the vessel went down, the islands known as 'Albion' and 'Hibernia' were teetering on the very edge of Ptolemy's inhabitable world. On the seabed at Erme Mouth, the divers found 42 tin ingots. Their source is unclear, but they may have been cast up on the slopes of Dartmoor, then traded on the Erme for amphorae of wine.

Further along the South West Coast Path is another wreck site. The walk from Start Point to Salcombe is one of my favourite hikes in Devon, a swashbuckling section of coast decorated with evocative map-labels like Frenchman's Rock, Stinking Cove, Dutch End and Abraham's Hole. The field hedges up here

are the last habitat of England's rarest resident farmland bird, the cirl bunting, and there's always a chance of spotting dolphins or a basking shark from the clifftops. In winter, when the Atlantic hurls itself at the black cliffs, every breath you take is garnished with salt. In 1977, just off a stubby headland called Pig's Nose, an instructor from a Youth Hostels Association diving school came across a scatter of Bronze Age weapons which included a complete sword, a sword hilt, four blades, a sword handle and two palstaves – farming tools which may have been imported from Brittany. The sword is remarkably preserved, and resembles no others found in Britain and Ireland, but does have features that match Bronze Age weapons unearthed in the basin of the River Seine, in France.

To make bronze, one part of tin was required for every nine parts of copper, but tin was very rare. For over a thousand years, Devon and Cornwall seem to have been the only source of tin in western Europe and the presence of tinstone – or cassiterite – in the igneous lodes of the West Country rewarded Britain with a place on one of the most important trade routes of the Bronze Age. To Herodotus, the islands beyond the continent were the 'Cassiterides' – the Tin Islands. Recycled snippets that have survived from a book called *On the Ocean*, written 2,300 years ago by Pytheas 'the Greek' of Marseilles, place Britain and Ireland well within the trading orbit of the Mediterranean. Pytheas is believed to have accomplished the earliest recorded circumnavigation of Britain, and he is probably the source of Pliny the Elder's line about 'an island named Mictis … where tin is found and to which the Britons cross in coracles.' And Pytheas is also likely to have been the source of a much longer, and very intriguing description of a tin port somewhere on the southern coast of Britain. The passage crops up in the monumental *Bibliotheca Historica* of Diodorus Siculus, who wrote of Britons 'who live on the promontory called Belerion' being very friendly to strangers, and civilized by virtue of 'their interaction with traders and other people'. These, Diodorus continues, are the tin miners and workers who quarry and melt the ore 'into pieces the size of knuckle-bones' which they convey to 'an island which lies off Britain, called Ictis'.

Not surprisingly, the location of Mictis/Ictis has been the subject of a long-running archaeological sleuthing competition, with candidates that include the

Isles of Scilly, the Isle of Thanet and St Michael's Mount. The inestimable Professor Barry Cunliffe, whose excavations and books have provided some of the most illuminating insights into pre-Roman Britain, reckons that Mictis/Ictis is most likely to be the rocky promontory of Mount Batten Point, which juts into the safe anchorage of Plymouth Sound. Whatever the answer, Mictis/Ictis is the earliest recorded port in the British Isles. And it is fitting that Diodorus, by writing of the 'civilized' Britons who benefited from interactions 'with traders and other people', was putting his Roman finger on the profound effect that a port has on the coast and its hinterland.

You don't have to look any further than Dover to see how a port shapes the coast. For those of us who grew up before Britain was connected to the continent by the concrete umbilical of the Channel Tunnel, Dover was unique among red dots on the map. Dover was the preface to a foreign adventure. Dover wasn't a place, but a feeling; the sense that you were passing from one world to another. In no other circumstances could a queue of intermittently jerking cars be as exciting as that Dinky Toy column of traffic being shepherded through customs and into the clanging hull of a cross-Channel ferry.

It was only after the burrowers bypassed the ferry route that I started treating Dover as a destination, and of course it became an entirely different place. On one of these visits, a *Coast* shoot, I came into the harbour by kayak. Paddling beside me was an extraordinary young man called Simon Osborne, who'd recently become the youngest person to circumnavigate Britain by kayak. Over 82 days, he had paddled like a latter-day Pytheas for 3,000 miles around Europe's largest island, raising £35,000 for leukaemia research. Simon had agreed to put his boat back in the water for the BBC, and we'd launched our kayaks from the shingle in Deal, 6 miles along the coast from Dover, then paddled along the Channel beneath the white cliffs. Seen from water level, in a boat so small that Simon was almost disappearing from sight each time he dropped into a trough, these cliffs are so sheer and white that they induce a kind of reverse vertigo. Glance up at them too often, and they appear to be moving; the urge to duck one's head is overwhelming. 'Sometimes', shouted Simon across the water, 'it's very intimidating when you're up against cliffs like these. You feel very small and insignificant.' Viewed from a Bronze Age boat

held together with wood sinew, the White Cliffs of Dover would have been as threatening as Homer's Wandering Rocks. As we paddled west, I found myself searching the cliff-foot for possible landing spots. When you're out on the sea in a very small, frail boat, it soon becomes second nature to look for havens. Just in case. I asked Simon about the reception he received each time he came ashore during his circumnavigation: 'It's amazing to land,' he called back, 'in small fishing ports and little villages, and get an incredible welcome from the people because they can see you've come in from the sea in a small boat.' That's how it would have been in the Bronze Age.

At Langdon Bay, just east of Dover harbour, the prow of chalk reaches 350 feet, and we piled into a confusing chop of reflected waves. Beneath the sea here, divers from Dover Sub-Aqua Club discovered in 1974 a scatter of bronze objects from a ship that went down 2,000 years ago. The nature and location of the objects suggests that this may have been a vessel inbound from the continent, which foundered as it tried to reach the sanctuary of Dover's river mouth. An astonishing total of over 300 tools, weapons and ornaments has been recovered, mainly of continental origin, many of them apparently broken in antiquity. It's now thought that this may have been a cargo of scrap metal being shipped to England for recasting. Then, as now, the mouth of the River Dour was the haven closest to the continent. Significantly, it was on the old bed of this river (buried six metres below modern roads) that archaeologists identified the most important remains of any prehistoric boat found in northern Europe – the world's oldest known seagoing vessel. Radiocarbon dating has placed the boat at 3,550 years old. This was not one of Pliny's coracles, though. The 'Dover boat' was huge. At least 12 metres long and 2.4 metres wide, it was probably propelled through the water by 18 paddlers. It was quite capable of a Channel crossing in fair weather, although it was better suited to coastal paddling. Constructed before the age of nails, its oak planks were bound together with yew wood, and were probably sealed with wax and resin. It appears to have been ritually dismembered and then abandoned up what was then a narrow side-creek of the river. In all probability, there were other Dover boats; in the 16th century, Camden wrote of 'anchors and ships planks' being 'digged there up' in the silt of the river valley. The Dover boat must have been paddled across the same waters

Simon and I were riding. We were approaching the harbour when my walkie-talkie squawked with the news that we were not going to be permitted to pass through Dover's breakwaters because we were a hazard to shipping. I was disappointed, although I did see the coastguards' point; every few minutes, car ferries were sliding through the gap and I didn't fancy our chances in a collision.

So it wasn't until we'd chugged into the harbour on the support boat, and then slithered back into the kayaks again, that I looked about from water level and realized what Dover had become. In the Bronze Age, the navigator of an incoming plank-boat would have seen little more than a few huts nestling at a river mouth squeezed between massive walls of chalk. What you see from the water now is a foreshore jammed with ramps, sheds and ships, and an incongruous row of Victorian villas. Strange, man-made apertures and emplacements pierce the cliffs, whose crest is spiked with castle ramparts, the stub of a Roman lighthouse, and the tower of a church.

The kayaks crunched onto Dover's pebbles, and I eased myself onto dry land. The summer breeze hummed with the sound of the UK's busiest ferry port; a computerized transit machine which processes 13 million passengers and two million trucks every year.

Dover has been the portal to England for over 2,000 years. On the famous 13th-century map of Britain by Matthew Paris, the island is depicted on its vertical axis, poised on an enormous, Kentish promontory which Paris has shifted westward to a point midway along the English Channel. Paris, the most prolific mapmaker of medieval Britain, turned Kent into a fulcrum and a root reaching towards the continent. At the tip of the promontory are the crenellations and tower of a castle labelled 'Dova'. From Dover, a vertical stack of place names runs up the centre of the map to the ramparts of Hadrian's Wall. Paris probably copied the place names from an itinerary, possibly Roman; Dover becomes the first of a sequence of stepping stones from one end of the kingdom to the other. Dover, writes Paris, is 'Clavis Angliae', the key of England.

Kent has been Britain's beachhead since Doggerland disappeared. Repeatedly through history, the county's triple-aspect water margin has attracted invaders,

traders, fort-builders, bathers and resort-builders. It's not that other shores didn't get exposed to similar attention, but Kent was invariably the first coast-of-choice.

Modern maps of Kent tell a deceptive story. The county used to be rimmed with natural harbours. Back in the time of the Romans and then Saxons, Thanet was an island, Sandwich was on the seashore and Fordwich was at the head of a tidal creek. These days, the sea is a 5-mile walk from Fordwich. Sandwich is 2 miles inland and fields of wheat connect Thanet to mainland Britain. Sheppey used to be a much smaller island, with navigable channels reaching Faversham, Milton Regis and Rochester. And where the great beak of Dungeness now pokes into the Channel, there was a small, hooked spit and two sheltered estuaries. For shallow-draught, seagoing vessels, Kent had many havens.

There was another factor behind Kent's prominence, too. The presence – for the best part of one thousand years – on the county's western border of the largest city in Britain turbo-charged coastal development and provided the county with ready access to money and innovation. Come the Renaissance, Kent was regilded. When John Leland was attempting to compile his huge, doomed, county survey of England in the 1530s and 1540s, Kent emerged as the standard-bearer among counties. 'Let this be the first chapter of the book,' he scribbled in one place; 'The King himself was born in Kent. Kent is the key of all England.' When William Lambarde attempted his own stupendous county survey in the 1570s he managed to write one chapter – on Kent – before being put off the project by the imminence of William Camden's county guide, *Britannia*. Camden also set Kent apart, repeating the 'key of England' quote and embedding Dover in the civilizing visit by the Romans 1,500 years earlier. To Camden, Kent was an embodiment of the county ideal, and his description of its seafaring tradition is one of the most fulsome anywhere in *Britannia*, praising the men of Margate, Ramsgate and Broadstairs for their ability to work both the soil and the sea, and for the aid they so 'lustily' provided to those ship-wrecked on the sandbanks.

Not surprisingly, the greatest cluster of early ports can be found on the coast of the county closest to the continent. Not only is Kent in sight of main-land Europe, but it has three shores – to the south, east and north – and for

sailors reliant upon wind, that could make the difference between a safe land-fall and a shipwreck. 'Cantium,' announced William Camden in *Britannia*, 'safe rodes and sure harbours for ships.' A 'rode', 'road' or 'roadstead' was a sheltered stretch of water near the shore where vessels could lie at anchor safely.

Where better, then, to start a tour of early ports than on the coast of Kent, at the English Heritage landmark on the banks of the River Stour, 4 miles from the modern port of Ramsgate?

Richborough Castle, or RVTVPIAE to the Romans, is a delectable picnic spot. There's a museum, acres of grass and the enigmatic imperial ruins of one of the most important Roman sites in the British Isles. This is where, in AD 43, the armoured cohorts of Aulus Plautius stormed ashore and invaded Britain. Nowadays, if you walk to the eastern end of the site after your picnic, you'll be unimpressed by the harbour facilities, but 2,000 years ago there was a large lagoon here, open to the sea. It was a perfect anchorage. In the centuries that followed the invasion, RVTVPIAE became a supply base for the Romans, with massive warehouses and port facilities. For the Romans, the coast of Kent was the key to controlling Britain. The Roman fleet – the *Classis Britannica* – seems to have been based at Richborough and then at Dover, 15 miles to the south. London, the busiest Roman port in Britain – and possibly Europe too – was reached by coasting along the shores of north Kent to the Thames, where wharves extended for one thousand metres along its tidal banks. A Roman coasting vessel with a freight capacity of around 100 tons came to light in 1962 in the mud of Blackfriars; in its capacious hold was a cargo of Kentish ragstone, the preferred building material in Roman London.

By the time the last cohorts sailed back to the continent, small ships and boats were a familiar sight in the natural harbours of Britain. Dover, Southampton Water, the estuary of the Exe, the muddy ports of Norfolk, and the mouth of the Tyne (which was convenient for trading with traffic on the Rhine), were all on regular trade routes. But international trade, the ebb and flow of materials, the building of new harbours and warehouses, are a function of economic activity, which is itself a function of natural resources, population size and international stability. The trading implications of the Roman collapse can be tracked in Britain by the disappearance shortly after AD 400

of newly minted coins. By 430, coinage had ceased to be a medium of exchange in Britain, and Anglo-Saxon raiders were turning the coast into a war zone. Wharves rotted and warehouses leaked.

The symbolic Saxon beachhead was Ebbsfleet, just 2 miles along the coast of Kent from the spot Plautius had chosen for his invasion 400 years earlier, and for the same reason: it was convenient and offered a sound harbour. According to the *Anglo-Saxon Chronicle*, the invasion was led by the Teutonic brothers Hengest and Horsa, who landed here with three ships in the year 449, opening the door to the mass immigration to Britain by Angles, Saxons and Jutes. The site of the Saxon invasion has changed beyond recognition. Sea-level rise, the growth of vast shingle banks and the reclamation of land for agriculture have altered the form of the coast, but the spot is marked by a timber longship called the *Hugin*, which was sailed by 53 Danes to Kent in 1949 – the 1,500th anniversary of the Saxon takeover. Under the busy verges of the A256 must have been a very good natural anchorage and landing beach; the same spot was chosen in AD 597 by St Augustine when he landed with 40 monks on a mission to convert the Anglo-Saxons to Christianity.

Over in the west, Celtic Britons held out against Saxon raiders and international trading continued for at least a couple of centuries. Broken amphorae and pottery from the Mediterranean show how beleaguered Britons and Irish all the way from the Isles of Scilly to the Clyde and along the east coast of Ireland adopted the Roman sea lanes for their own trade. Some of the goods they were landing came from as far away as Palestine, Alexandria and Carthage.

One of the best places to immerse yourself in the era of Celtic sea trade (and in the sea; the bathing and wind-surfing are great) is Bigbury-on-Sea in Devon. The beach is cut in half by the mouth of the River Avon, and in summer a ferry runs over to Bantham Sand (take your surfboard) on the far side. On the dunes here archaeologists came across over 500 fragments of late fifth- and early sixth-century pottery, including parts of amphorae from the eastern Mediterranean and tableware from North Africa. The amphorae could have been used for importing wine or oil or spices, which suggests that the Celtic elite in the West Country kingdom of Dumnonia were living well. What set archaeologists around the world buzzing was the additional discovery of

hearths shaped from beach pebbles, containing the bone fragments of cattle, pig, sheep, goat, red deer, mallard and shellfish. The implication is that trading at Bantham was conducted through lavish beach parties. Back then, it would have been an excellent natural harbour, with a peninsula jutting into the mouth of the estuary, providing a breakwater for ships seeking shelter. Interestingly, the Bantham site is just 4 miles along the coast from the Bronze Age shipwreck site at the mouth of the Erme.

It took a very long time – 300 years – for England's international trade to recover from the Roman departure, and it wasn't until the eighth century that trading ports began to reappear along our coastlines as part of the process of economic growth that was creating the first English towns. Again, the coast of Kent seems to have been leading the change; nine of the ten settlements in Kent that were large enough to be called towns were also ports, some of them identifiable by their use of the suffix 'wic'. From around the year 700, international emporia, *wics*, had been springing up around the coasts of north-west Europe. On the continental shores of the North Sea there was Sliaswich (Schleswig) and Quentovic (near Boulogne), but there was also a rash of *wics* on the coasts of southern and eastern England: in Kent, there was Fordwich (a river port on the Stour) and Sandwich (2 miles along the coast from Ebbsfleet). Both Ipswich and Norwich were Anglo-Saxon trading ports and so was Eorforwic (now York) on the River Ouse in Yorkshire. On the north side of the Solent, Anglo-Saxon Hamwic (now Southampton) grew into a port with a population of possibly 5,000 by the ninth century. By English standards, Hamwic was large, with 45 acres busy with craftworkers and traders exchanging goods with Scandinavia, Frankia and Spain. But compared to Rome or Venice or Constantinople the *wics* of Mercia and East Anglia were trading stations on Stygian backwaters, an edginess soon to be exploited by Viking raiders.

The largest English *wic* was Lundenwic, now London. For reasons that are not clear, Saxon Lundenwic developed outside the walls of the decaying Roman city, between Aldwych (in Saxon, 'old town') and Westminster. Archaeologists have theorized that the surviving Roman buildings of the abandoned city were a deterrent to Saxon town planning, or that the Saxon elite distrusted the sites of former Roman towns. Perhaps the truth is rather more prosaic: *wics* were

trading stations, and wherever you look in the world, sea traders establish their wharves where there is deep water. Berths which 'dry out' with every tide can prevent ships from coming or going for as many as 12 hours in every 24, an enormous restriction on trade. The Romans, intent on creating a hub to control a landmass, built their city at the best bridging point on the Thames, midway along a section of the river which runs straight for 2 miles. The Saxons chose a site one mile to the west of the old Roman bridge, where the Thames takes a sharp turn. Lundenwic developed where the scouring forces of the river's current and the sea's tide maintained a deepwater channel. To this day, the deep water and the best moorings on this stretch of the Thames are on the outside of this bend, beneath Cleopatra's Needle and Waterloo Bridge. Later, towards the end of the ninth century when the Vikings began to wreak havoc along British coasts, the Saxons moved back into the safety of the old Roman walls and established a new harbour, or *hythe*, at Queenhithe, just upstream of present-day Southwark Bridge. Lundenwic became – under King Alfred – the new *burh* of Lundenburh.

I took a lunch break while writing this, and pedalled through the heart of Lundenwic by way of the Strand, where Saxon ships used to be tethered against timber piles ('Strand' is derived from the Old English for 'shoreline'), then crossed the Fleet into the glass chasms of Alfred's *burh*. I passed shops selling suits and holidays and laptops to a soundtrack of diesel combustion and sirens. It's still a thrill to see it all, but beyond the *style* there's almost nothing that's new or unexpected, and nothing that's manufactured in Covent Garden or Cheapside. Items made in Portugal or China or Korea are not other-worldy; they're outsourced. The souk-like exotica of the Wessex *burh* was captured in the tenth-century Anglo-Saxon *Colloquy* of the Benedictine monk Aelfric when he listed the strange splendours being imported by Saxon merchants: *Pællas ond sidan, deorwyrpe gymmas ond gold, selcupe reaf ond wyrtgemangc, win ond ele, ylpesban ond mæstlingc, ær ond tin, swefel ond glæs, on pylces fela* … 'purple robes and silk, precious stones and gold, rare garments and spices, wine and oil, ivory and brass, copper and tin, sulphur and glass and many such things.' In unsophisticated England, imported goods were a source of wonder. These were not the 'products' on sale today in boutiques and malls; they were treasures. Aelfric's

biodegradable luxuries have long disappeared, but snatched excavations during rebuilding works in London have uncovered sharpening stones and rings from Scandinavia, pottery from northern France, the Low Countries and the Rhine, querns (grinding stones) from Germany and coins from Belgium, Normandy, Norway and Scotland.

Britain was still at the edge of the known world. In the British Library is an Anglo-Saxon map from around the second quarter of the 11th century – shortly before the Norman invasion – which shows Britain and Ireland crammed into the bottom-left corner attended by a confetti of Orkneys and Shetlands. The Med still occupies centre stage and the Americas don't exist. To continental Europeans, England was a 'developing country'; poor, backward, but rich in certain resources. Development and 'civilization' could only come to Britain with, in French historian Braudel's uncompromising phrase, 'the conquest of its countryside – its peasant "cultures" – by the towns'. Coastal trading ports were the most economically vibrant towns; symbols of foreign exploitation and the kernels of British civilization. By the year 1000, merchants from Normandy, Flanders and from the Holy Roman Empire were based at a harbour at Billingsgate and London's Third World streets were a clutter of artisans and craftsmen; men with blackened hands tapped and shaped copper and silver, fingers frisked massive timber looms and leatherworkers punched and sewed hides. The *burh* on the Thames was Britain's bridgehead with Europe, and the largest city in the land. In the grit of Saxon buildings and rubbish pits beneath modern London, archaeologists have found bits of scabbards, crucibles, inlaid knives, jewellery and shoes. Fifteen hundred years before post-modern bankers learnt how to lose billions by selling debt, London's Saxon traders were risk-taking, glamorous Masters of their Universe. Here's Aelfric's merchant: 'I say that I am useful to the king and to the noblemen and to the wealthy and to all the people … I go aboard my ship with my cargo and row over parts of the sea, sell my things and buy precious treasures that are not produced in my country. These latter I bring here with great peril from the sea. Sometimes I suffer shipwreck and lose all my wares, hardly escaping with my life.'

The heirs of Aelfric's attitude created the largest maritime power in the world.

*

The ports' boom was driven by location.

King's Lynn is the kind of place that tells you stories at every turn. When Domesday Book was compiled, 'Lena' (from the Celtic 'linn', or pool), seems to have been little more than a family of salt pans in the sandy corner of Britain's largest bay. Back then, the coast of the Wash was further south, and Lynn looked across open water at the mouth of the River Ouse. But the Wash is a strange place, for although the sea around the south of England has been generally encroaching since the ice sheets melted, in the Wash it's the land that's been advancing. Man-made dykes, river silt, and sand washed from the eroding coast of Norfolk, are slowly reducing the size of the bay; King's Lynn is now 3 miles from the mouth of the Ouse.

Lynn and its neighbour, Boston, always looked beyond the horizon. On the 14th-century Gough Map, the Wash is a vast, triangular gulf halfway along the North Sea coast of England, with a root system of fat green rivers which fan into the heart of the kingdom: past Ely and Cambridge to the borders of Wessex; to Lincoln and the Roman canal through to the Trent and south Yorkshire. In the other direction, the Gough Map shows the steepled medieval church of 'Lenne' gazing across sea lanes which connect Scotland with Kent, and England with Europe. The Wash was the busiest import/export hub on Britain's North Sea coast. Lead mined in Derbyshire made its way down the rivers Trent and Witham to the Wash, and was shipped along the coastal sea lane to London, Sandwich and Dover, Portsmouth, Southampton, Corfe and Exeter. Cloth, corn and wool were shipped from the Wash to Iceland, Scandinavia and the Baltic, Germany and the Low Countries. Imports included fish, timber, furs, wax, oil, linen, madder, wine and woad. Places buying woad from Lynn in the 1290s included a string of towns on the rivers Ouse and Nene, as far inland as Buckingham and Northampton. Lynn was also one of several ports to develop fruitful trading links with merchants of the Hanseatic League, an economic alliance of trading cities and guilds which operated from the 13th century on the sea routes between the Baltic and North Sea.

In this post-maritime age, King's Lynn is the last stop on the Fenland rail line. It's a place I keep ending up in after East Anglian shoots; dropped at dusk by film crews so that I can take a diesel multiple unit across the blacked-out

flatlands, back to London. But I've known Lynn since I was a teenager, when I cycled there from Norwich with a schoolfriend, on a valiant attempt to pedal the entire coast of Norfolk (I remember being shaken awake at midnight by a policeman searching the beds of King's Lynn Youth Hostel for a 14-year-old who'd forgotten to phone his mother with a progress report).

The medieval street pattern is mostly intact, with a roughly mathematical grid arranged with its long axis parallel with the wharves that once lined the muddy Ouse. Poke about and you'll stumble across vignettes straight from the age of Chaucer: a timber-framed merchant's house off Nelson Street; the only surviving Hanseatic warehouse in England, leaning over cobbled gutters; the spectacular Trinity Guildhall, with its chequered flint and stone facade celebrating the craft of stonemasons and the craftiness of its 15th-century merchants. Black ceramic flint is hardly the easiest or most aesthetic stone to work, but it is incredibly durable and Lynn's merchants meant their guildhall to stand for a thousand years. King's Lynn was once rated by the authoritative *Companion Guides* as 'the most romantic town in England'.

Lynn was one of the many coastal trading stations that evolved into full-blown ports during the Middle Ages. All ports needed wharves, and their construction and maintenance were funded by payments from traders. Under the Normans, shipping tolls became widespread, and by the early 11th century, London was charging harbour dues of one halfpenny for a small ship, one penny for a larger ship 'with sails', and four pennies for 'keels' and 'hulks'. But a century after the Normans invaded, Britain was still economically undeveloped compared to mainland Europe. John of Salisbury was astonished when he visited France in 1164:

'I admired with joy the wealth and abundance on all sides ... When I saw the abundance of food, the light-heartedness of the people, the respect paid to the clergy, the majesty and glory of the whole Church and the various employments of the seekers after truth, I looked upon it as a veritable Jacob's Ladder with its summit reaching to the skies and the angels ascending and descending ... Happy is the exile driven to this place.'

England matured from being an exploited source of raw materials to enjoy relative prosperity and an appetite for exploiting others over a period

measured in centuries. As a process, it was apparent to foreigners by the early 14th century, when Jean de Bel from Hainault wrote after a visit to York that he 'never ceased to marvel at how great an abundance could have arisen there'.

England was undergoing an urban – and coastal – revolution. In the 200 years to 1300, the twin requirements of trade and defence had created 140 new towns, and the urban energy was mainly coastal. Trade was a powerful economic engine. London was a port, as were the leading provincial towns of York, Bristol, Norwich and Newcastle upon Tyne, while the fastest-growing towns – Boston, Yarmouth, Ipswich and Colchester – were ports too. There was a recognition that inland river ports like Norwich, Lincoln and York were disadvantaged compared to coastal ports, and this led to new towns like Boston, King's Lynn and Hull being developed to take advantage of coastal locations. It worked. Tax returns for 1334 show that eight ports were among the top 12 most wealthy towns and cities in England. Six of those eight ports lay on the east coast, because by then the North Sea had become one of Europe's most lucrative transit systems. But the second-wealthiest port was over on the other side of the country.

Bristol was the most important port on the western seaboard of Britain. And the port itself had a trio of locative trump cards: the Avon, the river that connected the port to the Severn Estuary, was – like the Severn – subject to extreme tides. If incoming ships picked the right moment, they could be shoved up the river on the equivalent of a gigantic hydraulic ram. And when they wanted to leave Bristol, they just had to wait for the water to ebb. When the tide turned, it was as if someone had pulled the plug from the seabed. Not only that, but Bristol was an inland port, with excellent connections to the West Country, Wales and central England. And it was far easier to defend than, say the exposed ports of Kent or East Anglia.

From inland, Bristol was fed by several rivers and highways. The rivers Avon and Severn were funnels for river boats bringing iron and timber from the Forest of Dean, bales of cloth from Coventry and agricultural produce from the rich farmland at the heart of England. Carriers humped wool to Bristol from the sheep pastures of the Mendips and Cotswolds; small seagoing ships brought more wool and hides up the estuary of the Severn from South Wales, and fish and tin from Devon and Cornwall.

Overseas, Bristol's commercial perspective was utterly unlike that of London and east coast ports; Bristol looked to the Atlantic, shipping cloth to Gascony and Ireland, bringing back wine and woad, corn, linen, timber, cattle and fish. Bristol also imported fruit and sugar from the necklace of little ports along the rocky shores of Castile and Portugal and brought fish from Iceland, in return for food and clothing, needles and wax.

The merchants who kept these trade routes open had to be opportunistic. Robert Sturmy is a good example. In 1446, the year after the Italian monopoly in the Levant was broken by the expulsion of the Venetians from Egypt, Sturmy, a Bristol merchant, sent a ship called *Cog Anne* all the way to the eastern Mediterranean. *Cog Anne* delivered her cargo of pilgrims to the Holy Land, but was wrecked on the rocks of a Greek island while heading home – with the loss of all hands. In 1456, Sturmy sailed on his own ship, *Katherine Sturmy,* with 60 pilgrims bound for Santiago de Compostela on the coast of Galicia, and a year later, having spotted that the Ottoman advances in the Mediterranean were disrupting Genoese and Venetian trade, he sailed for the Levant with the *Katherine* and two caravels loaded with lead, tin and wool, and cloth. Having sold his wares, Sturmy was returning across the Med loaded with pepper and spices, when he was intercepted by Genoese, who 'spoiled his ship and another'. The adventurous Sturmy seems not to have made it back to Bristol, for his will was executed late in 1458. There were others like Sturmy. The Bristol merchant William Canynges owned ten ships and kept 800 men employed for eight years in his ships, plus a hundred or so carpenters, workmen, masons and so on. Merchant life promoted him to Member of Parliament and Mayor of Bristol. Shipping was big business. The list of vessels owned by Bristol merchants in 1480 includes about a dozen belonging to Thomas Strange, several to John Godeman and another ten to various other merchants.

Bristol was built around its quays. If you stand by the bus stops in Bristol's Broad Quay with a copy of William Smith's 16th-century map in your hand, you'll see that ships used to fill the foreground. Smith depicted seven seagoing merchantmen moored bow-on to a broad open space he's labelled 'Kay'. From the quay, he shows a town wall running east to another flotilla of ships moored at the 'Bark'. A cartouche records that the map was 'measured & laid

in platforme, by me, W. Smith, at my being at Bristoro, the 30 & 31 July Ano Dm 1568'. Smith's quays and streets are so precise that you can use his map today for a walking tour of central Bristol, plotting museums, galleries, cafés and recreational quaysides onto a 500-year-old plan of a front-line port. One of the most prominent features on Smith's map is 'Redcliff', the large church standing in green space on the outskirts of town. Inside this Gothic master-piece – whose reconstruction had been funded by William Canynges – you'll see a vault patterned with radiating ribs as fine as those on a portolan chart. In the south transept are two effigies of Canynges.

Smith's map will even lead you (should you feel up to mall exposure) past the site of the castle to a £500-million shopping centre with a glass roof equiv-alent in area to one and a half football pitches, and enough steel reinforcement to stretch from Bristol to South Africa. It's called Cabot Circus, and if you walk alertly through the streets of Bristol you will come across many other Cabots: on Brandon Hill there's a Cabot Tower, completed in 1898 to a design by Bristol architect William Venn Gough, who claimed it was copied from one on the Loire in France. Two Bristol schools carry Cabot's name, and so does one of the coun-cil wards. Local companies also trade on Cabot's reputation: Cabot Design, Cabot Engineering, Cabot Motors, Cabot Communications, Cabot Tyre Serv-ices … There's a Cabot Lounge at Bristol Airport and the Bristol Cabot Choir. There are even more Cabots in Newfoundland (but I'd better not go there).

Cabot? There were four of them, father and three sons, and they put Bris-tol – and England – on the maritime map. Their voyage of 1497 marked the moment that England staked its first claim on another continent.

We were latecomers in global domination. For thousands of years, Euro-peans had become adept at plundering their own natural resources, but eye-witness accounts of travellers like Marco Polo had stirred Europeans to greater ambition. Out east, there were spices and gold, and reportedly a Christian king called Prester John, who might be called upon to help defend Christendom. The two great superpowers of the age, Portugal and Spain, began looking for sea routes to the eastern side of Asia, the Portuguese pushing down the coast of Africa, to discover the cape which opened into the Indian Ocean; the Span-ish funding a Genoese sailor called Christopher Columbus, who attempted in

1492 to reach eastern Asia by sailing west across the Atlantic. Two years after Columbus discovered an island which he took to lie off the Asian coast, the Portuguese and Spanish signed a treaty, agreeing to divide the exploration rights of the planet between them. Portugal took the half of the earth east of a line drawn down the Atlantic, and Spain had the half to the west. Symbolically, the Treaty of Tordesillas was momentous: henceforth, the entire earth was ripe for exploitation by Europeans.

In the planetary carve-up, Britain and Ireland were spectators. When Henry VII took the crown in 1485, England had around 20 official 'ports', each of them defined as a unit of customs collection, which included adjacent harbours and creeks. The first of the Tudor kings understood that commerce was a source of power. Merchants were encouraged, and the king ordained that wine and woad must be imported by his own subjects. Henry was – in the words of the 16th-century historian of his reign, Francis Bacon – 'a king that loved wealth and treasure', a ruler whose dynastic enterprise 'could not endure to have trade sick'. The king even traded on the side: he had his own ships, which he hired for profit; he lent huge sums to merchants; and on one occasion sold a consignment of alum to a foreigner for £15,000 – about £8 million in today's money.

Henry backed the Cabots to search for a short cut to Asia. The Cabots' origins are uncertain, but it seems that John – or Giovanni – Cabot had lived in Venice for many years before coming to England. On 2 May 1497, just 5 years after Columbus had sailed west, a ship called the *Matthew* slipped her moorings and was sucked down the Avon on the ebb tide. On board were 18 crewmen commanded by Giovanni. They sailed westward, across the Atlantic. On 24 June, at 5 o'clock in the morning, Cabot's sailors sighted land. Rowing to the shore of what they took to be the east coast of Asia, they found impoverished soils and little fruit. But the wildlife was extraordinary. The land, wrote Giovanni's son, Sebastian, was 'full of white beares, and stagges farre greater than ours. It yeeldeth plenty of fish, and those very great, as seales, and those which commonly we call salmons: there are soles also above a yard in length: but especially there is great abundance of that kinds of fish which the Savages call baccalaos.' Cod. Cabot named the island 'Prima vista', or First Seen. The land he found was either Newfoundland or Nova Scotia.

Bristol became a port with two destinies: international and coastal. The sea lanes to the New World would bring vast wealth to the Avon; the coastal lanes would place Bristol at the centre of a trading operation that included the coast from Wales to Liverpool, and the West Country coast around to Lyme. By the time William Camden came visiting in the late 16th century, the port was buzzing:

'Brightstowe ... so well furnished with all things necessarie for mans life, so populous and well inhabited withall, that next after London and Yorke it may of all Cities in England justly challenge the chiefe place. For the mutuall entercourse of trafficke and the commodious haven, which admitteth in ships under saile into the very bosome of the Citie, hath drawne people of many countries thither ... And the Citizens themselves are rich Marchants, and trafficke all over Europe, yea, and make Voiages at sea so far as into the most remote parts of America.'

Ports were exciting, exotic, rich, powerful. The exchange of money and goods was conducted on a stage jostling with an international cast. Lynn in the east and Bristol in the west were utterly unlike inland market towns. Down south, New Southampton was the model Tudor port. When he visited in the early 16th century, John Leland loved it. Formidably defended by an 'extremely strong wall around it as protection from enemies', with turrets and an outer ring of water-filled ditches, the town was stuffed with the architecture of mercantile profit: fabulous merchant houses, lead conduits carrying freshwater to several parts of the town, fine marble tombs erected to commemorate New Southampton merchants, and three main streets, one of which Leland praised for being 'among the finest streets in any English town' (and Leland had seen more English streets than most living Tudors). The harbour itself was outstanding; through the Watergate, Leland found a well-constructed, square quay for shipping, which had been strengthened by driving piles into the water of the estuary. Outside the West Gate, he found another large shipping quay. Sadly, the Luftwaffe and town-planners have very successfully reduced central Southampton to civic ordinariness.

In Scotland, the trading orientation was easterly, towards Scandinavia and the Baltic. Shetlanders, who were closer to Bergen than to Edinburgh, derived

most of their income – according to George Buchanan in 1582 – by selling their homespun, thick cloth and fish oil to Norwegians, and buying in return the small, Norse, two-oared fishing boats that were so suited to Shetland waters. Larger ships trading out of the firths of Tay and Forth sailed as far as the eastern Baltic. Timbers examined in Queen Mary's House at St Andrews are found to have come from the Danzig (now Gdansk) region of Poland, whose connections with Scotland were so regular that a sizeable population of Scots had settled in Gdansk; to this day, there is a district in the city called Szkoty, and 'szot' is the local slang for a business traveller. Dundee, on the sheltered north shore of the Firth of Tay had been a trading port since at least the 11th century, and by the 14th century, may have had a population as large as 4,000. Facing the royal lands of Fife, large quantities of wine from Spain and France were imported through the town, and grain too. In return, Dundee's merchants shipped wool and hides from the mountains. There was an annual trade fair, and a castle whose presence is remembered in Castle Street. To Camden in the 16th century, this was 'a towne verily of great resort and trade', and he quotes a poem by 'Maister Johnston', the Regius Professor of Divinity at St Andrews University:

'And heere Dundee, ships under saile harbring in gentle road, / The wide worlds wealth to Inlanders both sells and sends abroad.'

Leith, on the Firth of Forth, benefited from its proximity to Edinburgh, and developed a tradition of ship-building and widespread trading. When Scotland and England were not at war, Scottish cattle, salmon and salted herring were shipped to English ports such as Yarmouth, London and Rye, in exchange for grain. Long-standing relations with France through Bordeaux and La Rochelle, Rouen and Dieppe kept continental Catholics supplied with Scottish cured fish, horses, wool and hides, in return for wines, dried fruits, cloths and silks. By the time James IV came to the throne in 1488, Leith was Scotland's principal port.

Wales had its own version of the Tay, a many-tendrilled natural harbour that opened the door to the Tudor dynasty. The entrance to Milford Haven is just a mile and a half wide, but inside, its convoluted shoreline unravels for more than 70 miles. On St Ann's Head at Milford's mouth, you can gaze from windy cliffs of Old Red Sandstone across the passage of water sailed in the

summer of 1485 by 55 ships on course to change British history. Henry Tudor's army of 4,000 Frenchmen and Lancastrian exiles landed at Dale, just inside the haven, then marched across Wales to defeat Richard III at Bosworth and claim the crown of England. These days, Milford Haven is still one of the most important assets on the coast of Britain; it's key to the diverse character of the Pembrokeshire National Park, and in 2010 it became the site of Europe's largest regasification terminal. Close up, it's not a pretty sight. But we burn gas like there's no tomorrow, and a tie-up with Qatar has created a facility that will provide one-fifth of the UK's natural gas. And apparently the Qataris have sufficient reserves to keep us supplied for 250 years. The result is five tanks – each large enough to contain the Royal Albert Hall – plonked beside a national park. During the filming of the third series of *Coast*, I found myself on the cream concrete dome of tank Number One – which felt a bit like being balanced on top of a cloud. The tanks squat above a pair of T-shaped jetties which reach halfway across Milford's blue waters. In Qatar, the gas is super-chilled into a liquid, then shipped 7,000 miles in refrigerated tankers to Milford Haven, where it is stored in the tanks until it's needed. The tanks are insulated with the same kind of stuff that we put in lofts, and when the liquid gas is allowed to warm up, it increases in volume by 600 times and is pumped along a 200-mile pipeline to join the national grid. It's a controversial site. On the one hand, the terminal will bring significant local employment, and provide the UK with energy. On the other hand, local people are concerned that the terminal could take out the entire neighbourhood if it was attacked or caught fire accidentally. And then there is the CO_2 issue. Liquid natural gas is a fossil fuel and is thought by most scientists to contribute to global warming. And yet the UK has insufficient low-carbon alternatives to fill the energy gap we currently face. Not for the first time, I found myself sitting on the fence; or in this case, on the dome.

The gas merchants came to Milford Haven because it's one of the best natural harbours in the archipelago, a place whose perfect geography was celebrated long before Shakespeare wrote in *Cymbeline* of 'blessed Milford' and had gorgeous Imogen ask 'and by the way, tell me how Wales was made so happy as to inherit such a haven.' Maybe the bard read about the Cambrian counterpoint

to the Thames in Roger Barlow's *Geographia*. Barlow, a Bristol man, was one of the most experienced maritime writers of the mid-16th century, having sailed with Sebastian Cabot in 1526, and gone on to write the first English work to describe the 'Great Discoveries' of explorers like Magellan and the Cabots. Barlow, who had seen a few harbours, rated Milford Haven as 'one of the best and goodlieste portes for shippes that is in the worlde for at all times thei may come in and owt without dainger and though thei brought nother cable nor anker thei maye save themselfes in krykkes …' With the addition of the gas terminal, Milford Haven is now the fourth-biggest port in the UK by tonnage.

One of the most striking aspects of gas terminals and container ports is the absence of human life and of shipping other than the vessels servicing that dedicated facility. Ports have come a very long way from the mixed-use havens familiar to any Tudor traveller. The gentleman-writer Richard Carew gives us a fascinating view of West Country havens in the year 1602: 'Cornwall,' he writes, 'is stored with many sorts of shipping (for that term is the genus to them all), namely, they have cock-boats for passengers, seinboats for taking of pilchard, fisher-boats for the coast, barges for sand, lighters for burden, and barks and ships for traffic.'

Ports were also out on the edge, and not just geographically. They offered rewards and bore risks beyond the dreams and nightmares of an average inland market town. Frequently, they operated on the fringe of legislature. In his description of Fowey, from about 1535, John Leland concludes that the Cornish port had gained its initial riches 'partly through feats of war, partly though piracy'. Fowey had then devoted its ill-gotten riches 'entirely to trade'. It was a business plan that had been followed by other West Country ports too. The raids and invasions, and the wrecking and the smuggling we'll witness in Chapter 5 were part of the coastal deal. And so was the continuous battle with Nature.

Before the age of dredging and concrete, the most successful ports were not just in the right place, but were immune to being blocked by mud and sand. Shipping channels could be obstructed from two directions: rivers could carry silt downstream and reduce the depth of the water, and tides could dump sand as bars and banks. The efficacy of a trading station was entirely dependent upon

its local geography, and on the resources and will of its inhabitants to keep the harbour from silting up. Sixteenth-century sources are clogged with descriptions of ports that have become inoperable, and with others that have been kept open through the diligence of their population.

As early as 1247, the citizens of Bristol are reported by John Leland to have combined their energies to deepen the riverbed leading to the town quay. On the other side of the country, the people of Yarmouth were engaged in a perpetual struggle with the sandspit being dragged across the mouth of the Yare by northerly currents. On at least three occasions, they dug by hand a shipping channel right through the spit, linking the open sea with their wharves. Dover needed continuous work to keep its wharves open to shipping. Aberdeen began fighting the tides in the 16th century. After the harbour's first crane was erected in 1582, King James VI granted a charter in 1596 to raise capital for improvements, which led in 1607 to the entrance of the harbour being deepened by the construction of a bulwark. The modification of natural harbours was a difficult, expensive, civil engineering exercise. A view of Carrickfergus on the Antrim coast of Ireland, drawn in about 1560, shows an artificial breakwater built to protect shipping lying at anchor off the town. The breakwater takes the form of a timber palisade which has been driven into the seabed at low tide, and then filled with rocks. Horizontal cross-ties of timber prevent the whole thing falling apart. Such structures could save ships and cargoes, but they needed almost constant maintenance. High-earning ports were able to build from stone. A mid-16th-century view of Newcastle, probably drawn by an Italian military engineer employed by Henry VIII, shows an apparently immaculate stone wharf running along the bank of the Tyne, where you can walk today past riverside cafés.

Many less fortunate ports found their prosperity – and their entire presence on the coast – wiped out by natural forces. Where Saxons and Normans had drained and settled the coast of Kent and Sussex, the great storms of the medieval period flooded Walland marsh, broke down the shingle barrier protecting the port of Rye, and destroyed the port of Winchelsea. The most exposed ports lay on the southern and eastern shores of England, where much of the coast is soft chalk or loose glacial detritus, and where sea levels have been rising faster than in the north of Britain and Ireland.

On the coast of East Yorkshire, there's a 37-mile stretch of low cliffs, between 3 and 35 metres in height and composed of glacial drift, known as the Holderness Coast. The North Sea is bent on pushing the land back to a line of chalk cliffs which existed two million years ago along the eastern edge of the Yorkshire Wolds. It's been estimated that the coast of this part of Yorkshire has already retreated around 3½ miles since the Romans occupied Britain; on average, the Holderness Coast is being washed away at a rate of about 6½ feet a year. Among the 30 or so towns and villages that have been abandoned and lost since Roman times are Old Withernsea, Out Newton, Dimlington, Turmarr, Northorp, Hoton and Old Kilnsea, Sunthorp, Ravenser and Ravenser Odd.

Further south, the combination of geology, currents and rising sea levels forced the coastal populations of Norfolk to adopt a flexible approach to 'settlement'. Here, on the stub of Doggerland, where the builders of Seahenge tilted their great oak into a pit on the tideline, the scouring of tides either caused spits and sandbars to develop, or they eroded the soft cliffs at a ferocious rate. They still do. The 'erosive coast' runs for 25 miles from Weybourne to Winterton, and it's here that Norfolk is shrinking fastest. On the seaward side of Cromer, there used to be a trading port called Shipden. Its arable land, meadows and woods are recorded in Domesday Book, but by the 14th century Shipden had dissolved into the sea and the tower of its submerged church had become a shipping hazard. Between Cromer and Winterton, there used to be a fishing town called Eccles. It's there on Christopher Saxton's map of 1574, but cartography has the misleading characteristic of portraying places as 'fixed', whereas Eccles had been on the move for centuries, as its inhabitants abandoned houses and quays to the advancing sea, and then rebuilt above the creeping tideline. It took a particularly destructive storm in the 17th century to remove the town entirely from the map. Despite their knowledge of the sea's appetite for land, the inhabitants of Eccles were finally caught out when, on 4 January 1604, the sea took out 2,000 acres of marsh, farmland and woods, together with the church and 66 houses. Over three-quarters of the community died.

The largest settlement in England to have been absorbed by the sea was the once-thriving seaport of Dunwich, which had grown up on a friable section of the Suffolk coast south of Lowestoft. By the 11th century, Dunwich was one of

the largest towns in Suffolk, with 236 burgesses, three churches and a population of around 3,000. As trade accelerated through the Middle Ages, Dunwich made the most of its location close to the easternmost tip of England and was able to compete with Ipswich, which could only be reached by following a river inland for 20 miles. By the 13th century, Dunwich had two marketplaces, several friaries, eight parish churches and encircling town walls. You had to be an opportunist to invest in Dunwich. Its excellent trading location meant that you could make big money quickly, hence its architectural riches. But glacial till is no match for the sea, and by 1350 the harbour had been choked by shingle and 400 houses washed away, along with windmills and shops. The last church fell in 1919. As Dunwich was evacuated, businesses relocated to the more durable neighbouring ports of Lowestoft and Ipswich.

For Tudors who believed in Britain's mercantile destiny, the blocked harbours and abandoned ports were the cause of scholarly hand-wringing. Writing in the late 16th century, William Camden wrestled to make sense of Kent's ever-shifting geography, which appeared to be as unstable as his monarch's relationship with the French. The port of Hythe, he recorded, had been left high and dry 'by reasons of sands and the Sea withdrawing it selfe from it'. Neighbouring Lympne (now nearly 2 miles inland) had been 'a most famous Port towne, until the sands that the Sea casteth up had choked and stopped the haven'. Camden hypothesized (correctly) that until its mouth had been choked, the River Rother had flowed into the sea several miles east of its present course. The storms which wrought these coastal transformations were cataclysmic: 'But in the reigne of Edward the First, when the sea a-raging with the violence of windes overflowed this tract and made pitifull wast of people, of cattell, and of houses in every place.'

One of the most extensive coastal realignments of the last 2,000 years occurred in East Norfolk, where a 4-mile wide estuary used to stretch so far inland that the Romans were able to build their regional capital on the banks of the River Tas, 20 miles from the sea. If you visit Venta Icenorum today, you'll find a rectangle of grassy banks tilted towards a stream which is barely deep enough to take a canoe, but this was once a major entrepôt for shipping grain from the conquered lands of Boudicca's Iceni. An engraved Roman gemstone

found on the site shows a trading ship under full sail, and a three-tiered light-house fluttering with flame. The 'Great Estuary' was vast, but all that remains today are whispering reedbeds patrolled by grebes and herons, and the mean-dering River Yare. As recently as the 1960s, seagoing freighters from the Baltic were still thudding up this river all the way to the wharves of Norwich, in the heart of the county.

Occasionally, it was the hand of Man that sabotaged his own ports. One sunny day a few summers back while making the first series of *Coast*, we were filming on a quintessential English village green. Cottages decorated two sides of the grass triangle, there was a white-painted pub called the Bell, and the parish church. The open side of the green offered a view across a gentle valley to the tower of another church, peeking from its bosky pillows. All that was missing was the cricketing 'tock' of leather on willow. It was a perfect picture of an inland shire. But the village was called Cley next the Sea.

These days, the sea is over a mile from Cley's village green. This is one of the 'Glaven ports', a trio of villages grouped around the mouth of the River Glaven in north Norfolk. In front of a cottage walled with knobs of flint, I talked to the author Jonathan Hooton, who explored the fate of Cley, Blakeney and Wiveton in his book *Glaven Ports*. Jonathan pointed to the mown grass and explained how ships would have been beached and unloaded, repaired and built, where children now ride bikes. Back then, the green had been one finger of an estuary which reached nearly 2 miles inland to Glandford. But there was a fateful spit, Blakeney Point, and it was moving:

'The spit grew further westwards, which to start with was very good for the port, because it afforded a lot of protection from the northerly gales. Behind this, salt marshes grew up. Local landowners started buying the marshes and seeing potential profit, and so lots of it was reclaimed as grazing land and arable land. This prevented the tide from flooding it and the channel got narrower and shallower, and that really put paid to Cley as an international trading port.'

Lostwithiel in Cornwall suffered a similar, man-made fate. According to Camden, the River Fowey was once able to carry ships all the way inland to Lostwithiel, but the channel had become 'so choked and dammed up now with sands comming from the tin-workes ... as that it is hardy able to beare the least

barge that is.' The 16th-century topographer was sufficiently pessimistic about the environmental vandalism of his generation to reckon 'all the havens in this province are like in processe of time to be choked up'.

It wasn't until the 18th century that the port-builders began to overcome the forces of Nature. It took engineering, explosives, dredgers and lots of money and men.

I was in a kayak again. It was another *Coast* shoot and we wanted to film Amlwch from the sea. We didn't go far out, but a range of several hundred metres was enough to hide the port between its ragged headlands. Paddling towards the rocks, I struggled to imagine how the skipper of an unwieldy, three-masted sailing ship could possibly steer his unmotorized vessel into such a narrow, treacherous slot in the cliffs. In a kayak, it's an exciting entry.

There was a big swell off Anglesey that day, but as the upswept prow of the kayak sliced through the heaving grey water into the lee of the headland known as Llam Carw, calm suddenly descended. The wind dropped and so did the sea, and I was soon dipping and pulling through the rain-stippled calm of the harbour mouth. It feels narrow – even in a cockleshell craft – and secretive. Inside the rocky claw of the inlet, I paddled past one, then two, then three protruding quays, each of them looming 15 slimy feet above the deck of the kayak. Everywhere, there were massive walls, ramps, old stone buildings and derelict wharves sprouting grass. Small fishing boats nodded on drooping teth-ers, and on the mud of the inner basin a two-masted tallship tilted its bowsprit at the open sea. Later, I heard that she'd been built in Russia, in 1995, and was an exact replica of the *Pickle*, the plucky schooner that had raced from the Battle of Trafalgar back to Britain with news of Nelson's victory – and death. After popular service for various film crews and sail-training schemes, this replica *Pickle* was up for sale: £350,000 for a ship of the line. There are always plenty of digressions gathering salt in old ports.

Later that day, we hiked up the long, straight track from the village of Amlwch to the crest of Parys Mountain, where we were able to gaze into a scene of multicoloured, geological chaos. The entire heart of the mountain had been

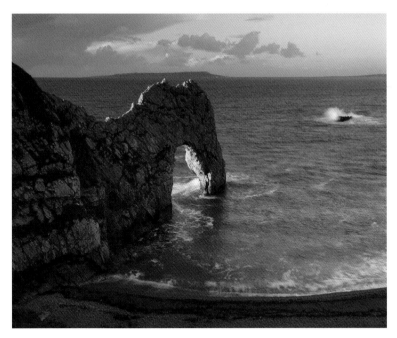

The coast of many wonders: tides and currents, the forces of waves and wind, have worked with an extraordinary diversity of rock types to create a unique and often bizarre coastal architecture. Top: the limestone arch of Durdle Dor, on the coast of Dorset; bottom right: the wave-cut chalk of Old Harry Rocks, also Dorset; bottom left: one of the shining beaches in the Outer Hebrides. This one is at Luskentyre on the Isle of Harris.

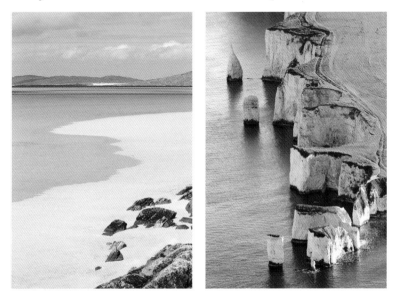

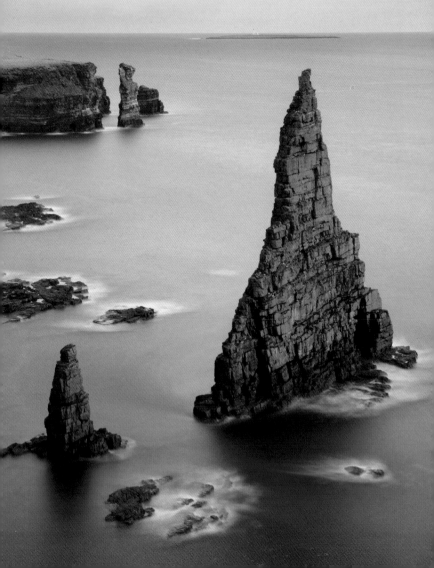

A signpost to early seafarers – the monumental stacks of Duncansby, at the north-easterly tip of Britain.

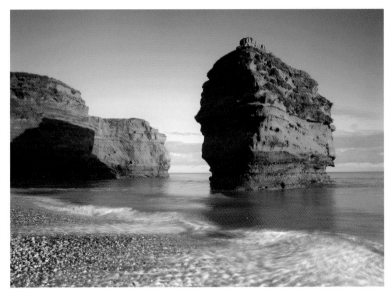

Top: the red, 240 million-year-old desert sandstone of Ladram Rock, a stumpy stack on the coast of Devon near Sidmouth.

Bottom: basalt columns formed by the cooling of molten rock. These ones are on the Hebridean island of Staffa, first revealed to the public by the 18th-century botanist Joseph Banks, who declared that such wonders made the works of man look like 'mere models or playthings'.

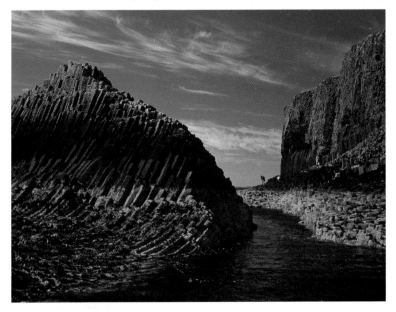

A beam trawler, the Penzance-registered *William Sampson Stevenson*, returning to Newlyn harbour.

Working the sea ... Top: the German-registered container ship, *Tokyo Express*, glides out of Southampton Docks.

Bottom: the mechanized facilities at Avonmouth Docks, outside Bristol.

Bottom: where danger and discomfort have been all but eliminated from the world of sea trade, fishing still demands extremes of human fortitude.

Top: defence relics line our shores; here, a Second World War pillbox subsides into the beach at Cromer, Norfolk.

Left: 'sound mirrors' on the shingle spit of Dungeness, on England's south coast. Scientists chose the location for its quietness. The 30-foot mirror in the foreground was completed in the spring of 1930. Its inventor, Major Tucker, anticipated that this mirror, along with its twin at Hythe, would be able to plot the location of enemy aircraft at a range of ten miles. In the background is the curved concrete wall of the experimental '200-foot mirror', completed the same year.

Bottom left: the best-preserved of the shore forts built by the Romans in the late 3rd century AD, Portchester Fort stands on a promontory in Portsmouth Harbour and was used to defend the haven for over a thousand years.

Bottom right: Deal Castle, one of the elaborate artillery forts that Henry VIII commissioned along the south coast.

removed. Screes of mineral-rich pink and ochre grit tipped over dark crags to form silver mounds across the floor of a void like the interior of a volcano. It's an apocalyptic landscape; the backdrop for *Doctor Who* and *Mortal Kombat II* – the arcade game that scooped the Bloodiest Game of 1994 award. From this visceral gouge, men have been extracting copper ore for 3,500 years and then shipping it out of Amlwch. For the first 2,500 years it was a fairly low-volume, high-value trade, but one March day in 1768 a local miner named Rowland Pugh discovered the 'Great Lode' and triggered a copper rush. In 1788, with the mines at the peak of their production, a group of investors formed the Amlwch Shipping Company and work began converting the sea-filled cleft into an efficient port. A 400-foot long platform was created by blasting away 20,000 tons of rock, a road was built and timber chutes for the ore were constructed.

When the artist-engraver William Daniell sailed into Amlwch during his ten-year circumnavigation of Britain in the early 19th century, his companion Richard Ayton noted that the coast had been 'reduced to a frightful desert', while Amlwch itself had become 'the most miserable place that [they] had ever beheld'. Ayton wrote of smelt works 'vomiting forth flames and clouds of black smoke' and of the 'total destruction of all vegetation on the land bordering the sea'. Through the drifting palls of pollution, the two travellers discerned 'black and ragged figures and ghastly countenances' of men and boys toiling around the harbour. It was, they concluded, a 'wild and melancholy aspect'. When the wind blew out to sea, the thick billows of smoke raised complaints from ships' skippers that they couldn't find the harbour entrance. On busy days, there could be up to 27 cargo ships wedged into Amlwch at the same time. Once loaded, most sailed for the Crown smelter at Swansea. Standing among the wild grasses on Amlwch's quay 200 years later, the air was clear and the only sound was the soft sigh of a sea breeze. The ships had stopped calling at Amlwch when the copper ran out.

There is only one place in Britain that can still recapture the age of trading by sail. At the old china-clay port of Charlestown in Cornwall, you can still find – if you're lucky – a pair of quaysides sprouting thickets of masts, spars and rigging. Charlestown is home port to a fleet of working square-riggers. There are three of them, *Kaskelot*, the *Earl of Pembroke* and *Phoenix*, and when they're

not away making movies or on charter you'll find them snuggled into Charlestown's crooked dock. Like Amlwch, Charlestown was built for a purpose. Local landowner Charles Rashleigh – who gave his name to the port – constructed the quays and warehouses between 1790 and 1810, and at its busiest Charlestown was a smoky hubbub of pilchard-curing, brickworks, lime-burning, rope-making, sail 'barking' and boat-building. It's quieter now, and if there is a hubbub it's the clinking of glasses from the sunny terrace of the Pier House Hotel and the happy sounds of families peeking between the decks of ships that still ride the seas under canvas.

Amlwch and Charlestown are miniaturized examples of the engineered ports that spread around the coasts of Britain and Ireland in the late 18th and early 19th centuries. On a far bigger scale, cities like London and Liverpool, Aberdeen, Belfast, Plymouth and Glasgow built stone quays, docks and locks. Very often, the men who designed them were the leading engineers of the age. Aberdeen's harbour was extended by John Smeaton and Thomas Telford. Now that their ships have sailed away, many ports have been reinvented as heritage harbours. Where coal was loaded in Swansea Docks, the National Waterfront Museum is reflected in waters decorated with a restored lightship, a tugboat and *Olga*, a Bristol Channel pilot cutter. Albert Dock in Liverpool now trades in culture, with visitor attractions ranging from the Merseyside Maritime Museum to Tate Liverpool and the International Slavery Museum. Historic ports have become architectural spaces. Warehouses have been gutted and converted into apartments and bistros; hotels steeple upward where cranes once dipped their jibs. Ropes and barrels and slimy flagstones have been replaced by benches, litter bins and rolled bitumen. Where sooty colliers berthed, fleets of fibreglass yachts are arrayed at spotless pontoons. One of the most exciting modern port regenerations has taken place on the 'Jurassic Coast' of Dorset, where the long arm of Chesil Beach forms a natural breakwater between the mainland and the Isle of Portland. Ever since the days of Henry VII, this sheltered anchorage has been of strategic importance. From 1849, the Navy built successive breakwaters to the east of Chesil's bank of shingle, eventually creating one of the largest man-made harbours in the world. When the Navy sold the harbour in 1996, they left behind a vast body of water protected from the

ocean swell but exposed to a variety of winds, which is why Portland was selected for the sailing events in the 2012 Olympic Games.

So, where did all the ships go? Well, some are still out there, but there are fewer of them, and they are much, much bigger. And because they have become so huge, they require deepwater ports and specialized logistics parks.

The Thames has seen clippers and schooners, barques and yawls. But *Marieke* is a trailing suction hopper dredger. She's not the most elegant of marine species, but she's certainly one of the most complex: 98 metres long, packed with machinery and computers, and busy laying foundations for the most ambitious port project in the UK for 20 years. *Marieke* is Belgian. From a distance, she looks like a nautical vacuum cleaner.

One of *Marieke*'s ancestors appears in a sketch of 1672, by Dutch marine painter, Willem van de Velde. It's a contraption of great ingenuity that could be used to remove gravel and silt from the bed of a shallow river. The invention of the dredger made it possible to create artificial ports. The engineers who specialized in shifting sand and mud lived and worked on the busy waterways of the Low Countries, where land and sea have been locked in battle for centuries. With their long history of channel clearing and land reclamation, the Belgians and Dutch have cornered the world market in dredging.

From the southern shore of Essex, we were ferried out to *Marieke* on a battered Holyhead tug called *North Stack*, which sidled alongside the dredger so that we could climb the side of its hull by rope ladder, while the camera and sound gear were hoisted up by line. *Marieke* was taking on cargo. From apertures in a gigantic, transverse pipe, gouts of turbid Thames water were filling her hold. Frothing, seething and spitting, it was the kind of death trap that villains get catapulted into when Commander Bond resorts to extreme violence. There was a lot of noise and brown spray, and no real deck, but a series of catwalks and steel ladders around the edge of the heaving cauldron. Incongruously, the crew had constructed a tropical bar on one of the gantries, complete with bar stools, a themed roof of netting and a battered bronze propeller, sucked perhaps, in a previous dredge. The bar didn't look as if it had

been used for months. Up the ladders, the wheelhouse was as serene, as spotless as a secure space for computer servers (we'd been invited to remove our steel-capped boots and hard hats at the door). The skipper, Bart de Vriendt, sat in a large, padded swivelling throne, surrounded on three sides by consoles and screens. He turned to greet the intrusion of a TV crew with smiling familiarity, as if he'd been monitoring every step of our clumsy ascent of hull and ladders. One of the screens was an electronic chart of the Thames, and beside it was the radar screen, dotted with other vessels. A third screen covered the ship's systems, with digital readouts of *Marieke's* speed, course, engine rpm and so on. The three screens on the left covered the machinery creating the foundations of the UK's latest port: a 3D chart of the 'dredge track', and two screens showing the status of the dredger's complex plumbing: the valves, doors, hoppers and pumps of the dredge operating system.

Off our port bow, I could see the flats of Essex. Rather further away, to starboard, the green fields of Kent climbed to a low horizon. The Thames here is about a mile and a half wide, but just upstream it narrows to half a mile. *Marieke's* job was to help dredge a deepwater channel out to the mouth of the estuary. She was dredging around the clock, with two crews on 12-hour shifts, sucking 12,000 cubic metres of sand and gravel (that's nearly five Olympic swimming pools, in case you were wondering) every 24 hours. Bart lives in Bruges, but has spent most of the last nine years dredging the world: Australia, Singapore, China, Pakistan, Qatar, Bahrain. Before dredging the Thames, *Marieke* had been working off South Africa.

'How's the Thames compare?'

'It's easier. Everything works here. The pilots know their jobs. The Thames is well maintained. All the buoys are working. It's a professionally managed fairway.'

The previous week I'd been filming for *Coast* on the Scheldt, the greatest river in Belgium. The Scheldt has seen dredging on a stupendous scale. Since the end of the Second World War, almost half a billion cubic metres have been removed from the bed of the river, allowing 1,000-foot bulk-carriers to sail 70 kilometres inland. I asked Bart which river he preferred: his own Schelde, or the Thames?

'For dredging, the Schelde is better, the material is finer. Your gravel wears out our equipment!' They'd already dredged two live bombs from the Thames, which is why *Marieke* had her own ordnance expert on board. Commanding a working dredger is rather like controlling a helicopter in permanent low-altitude hover. The vessel moves forward at one or two knots as the helmsman pulls the draghead along a precise path on the seabed. When the hopper is full, the water is drained off and the dredger moves to the reclamation site, where the sand and gravel are either 'bottom dumped', by letting the whole lot fall out of giant trapdoors in the underside of the hull, or pumped ashore through a gigantic hosepipe.

Marieke was one of many vessels being used to create 'London Gateway' on the reclaimed site of a disused oil refinery. The dredging satisfied two needs. It deepened the channel running from the new port out to the mouth of the estuary, and it provided the raw material needed to create land where there is currently water. In effect, the shore of Essex is being extended by one-third of a mile into the estuary. The ships this port is being built for are truly enormous: 400 metres long and carrying up to 14,000 containers each. The port has two parts, the wharves where containers will be loaded and unloaded, and a vast logistics park with three rail freight terminals and new road access. The dredging part of the operation means that 30 million cubic metres (or 12,000 Olympic swimming pools) have to be sucked from the deep water channel and moved to the port side.

The new port zone will be twice the size of the City of London. In civil engineering terms, it's a spectacular project. All the men in hard hats I talked to communicated the monumental zeal of their mission. 'How many times in your life', one of them said to me, 'do you get the chance to build a world-scale port?' The people behind 'London Gateway' are DP World, who come from the historic sea-trading port of Dubai, on the coast of the Persian Gulf. Under the Chairman of DP World, Sultan Ahmed Bin Sulayem, the Thames is going to get a container port capable of handling 3.5 million standard containers every year. The politicians love it. DP World have told them that the port will create direct employment for 2,000 people, with a further 16,000 new jobs indirectly linked to the presence of the new port. That's a big carrot on a part of the Essex coast that has lost its car plants and oil refineries.

The rules of port-building have changed. Where Amlwch's copper smelters spewed so much pollution onto the surrounding land that it turned into a sterile wasteland, the builders of London Gateway are taking a more considerate approach to local wildlife. As I write this, I'm looking at a late 17th-century map of Essex drawn by Robert Morden. Scratched onto Morden's copper plate is a band of marshland that stretches all the way from Canvey Island to the Isle of Dogs. With the exception of a chapel on Canvey Island, and a military magazine and fort at Tilbury, there are no buildings or villages along the marshy, southern shore of Essex; it has been a continuous wildlife sanctuary for almost all of its existence. Ordnance Survey maps from the 1990s tell a different story: most of that marshland has been drained for docks at Tilbury, a car factory at Dagenham, industrial works at Thurrock and Purfleet. Corringham Marshes are occupied by the geometric blocks and roundels of Shellhaven, with five jetties for oil tankers and a refinery so huge that its perimeter is 17 miles long. Since the hydrocracker, storage tanks and miles of pipework were removed, wildlife has recolonized Shellhaven. DP World have physically translocated 50,000 animals. Protected species like water voles and great crested newts have been moved to sites approved by Natural England, and thousands of reptiles ranging from grass snakes to adders and slow worms have been relocated to Hampshire and Mersea Island. Some of the water voles replaced a population on the River Colne that had been wiped out by mink attacks.

On board *Marieke*, environmental expert Daniel Leggett pointed to yellow buoys in the estuary that are being used to monitor disturbance to marine ecosystems. 'The whole place is full of kit,' said Leggett. 'The monitoring here is more extensive than it is for any other port in the world.' Leggett, a geomorphologist, came to Dredging International from Natural England and the Environment Agency, and has worked at all the major ports in England. By law, the marine footprint of the new port has to be compensated for by the creation of an equivalent footprint elsewhere. So two new tidal habitats have been created to replace the one being smothered by dredge material; one to the west of the new port, and the other on the far side of the estuary, on the Kent shore.

North Stack took us to the port-in-progress. The only way of getting ashore was for the tug to ram the artificial sandbank that's emerging from the side of

the estuary. We were told to brace ourselves for the impact, and then clambered over the bow, handing down tripod, camera, sound mixer, rucksacks. At the top of a steep bank, engineering monster-trucks and diggers were shifting sand, gravel and small mountains of imported Norwegian granite (the leftovers, apparently, from kitchen worktops). The thing we'd come to film was the mouth of a drainpipe one metre in diameter. *Marieke* was connected to the far end, and a torrent of seawater, sand and gravel was jetting in a thumping arc onto the edge of the growing 'bund'.

Port building has always been speculative. And this one is no different. Whether or not London Gateway shifts 3.5 million containers a year, and provides 2,000 new jobs will depend on the ships showing up. And that will depend on economics.

4.
The Britannic Wall:
Defending the Archipelago

Six camouflaged figures crouch at the cliff edge. Rifles lie between the tussocks. Two of the men wear rucksacks sprouting aerials. They are looking out to sea, clamped in headphones and speaking calmly into mikes. One of the men writes on a notepad; another settles behind a pair of binoculars. An hour later, they are still there, watching. Then a grey aircraft, barbed with missiles, banks beneath the cliff, levels its wings and flies low and fast across the water. A black dot falls, a grey geyser flashes upward from the target and the sea erupts in silver fury. The men remain inert. A pair of helicopters come out of the west, skittering over the water; rocket impacts flash on the target. On the dip-slope of the cliff, three 105mm guns begin to bang. After several salvoes they're almost invisible in their own cloud of cordite; across the kyle, peat spouts from the khaki slopes. A Harrier strafes the shoreline. Mortars lob shells. Then the Tornadoes are back for another bombing run and the three toys on the horizon – ships from the USA, Germany and UK, apparently – join in the barrage. The six on the clifftop talk to their mikes with the impassive rectitude of traffic controllers; the green and brown jags of their clothing and equipment indistinguishable from the warp and weft of peat and grass. You could walk within a hundred metres of them and not know they are there. That's all it takes these days: six soldiers with radios and good bins lurking on a clifftop. These six in the grass with their green berets are coordinating three navies, an air force and a couple of artillery units. The targets – an island called An Garbh-eilean, and the adjacent stretch of coastline – are taking a pasting.

Britain's 6,000-year history as an island has been punctuated by invasions and raids from across the water. The last invasion scare was only 70 years ago. But in those 70 years, the balance has tipped in favour of the defenders. No foreigner in their right mind would think of storming Britain's beaches while the blokes in berets still have batteries for their radios.

It was a warm and sunny day, that day near Cape Wrath. We'd waited months for permission from the MOD to film the exercise, and when we finally got the green light, I was in a fish-finger factory in Grimsby. With the series producer, Steve Evanson, I'd driven to Coventry, flown to Inverness, then driven a hire car across the Highlands to the Kyle of Tongue, where we'd grabbed a few hours sleep, then pressed on towards Cape Wrath. The exercise was being run from the cliffs out at Faraid Head, the rearing prow of an exquisitely beautiful promontory to the east of Balnakeil Bay. This corner of Scotland is about as wild as mainland Britain gets. A few miles south of Balnakeil Bay is Keoldale, where a summer ferry runs visitors across the Kyle of Durness to the beginning of the single-track road out to Cape Wrath. In the hamlet of Balnakeil there's an incongruous golf course (said to be the most northerly on mainland Britain) and a roofless church with the skull-and-crossbones tomb of Donald MacMurchow, a highwayman who killed 18 during a career of exceptional violence. Another grave slab depicts a bowman shooting a stag. Outside the ruin, Balnakeil is all light. Unusually for Britain, it has west-facing sands that are also sheltered, and so the low afternoon sun fills the bay with an encompassing calm that can bring you to your knees. At the southern end of the beach are walls which used to be a summer palace of the bishops of Caithness.

The military came to Cape Wrath during the hiatus between two world wars. On 9 February 1933, in pursuance of the powers vested in them by the Military Lands Acts (1892 to 1903) and the Naval Works Act (1895), the 'Cape Wrath Bombardment Range' was superimposed on 2,400 acres of coastal Caithness by the Office of the Lord High Admiral of the United Kingdom of Great Britain and Ireland. The previous week, the charismatic leader of the Nationalist Socialist German Workers' Party, Adolf Hitler, had become Chancellor of Germany. Seven months after the Cape Wrath range was designated, Hitler pulled his country from the Conference for the Reduction and Limitation of

Armaments. Today, the Cape Wrath range is the only place in Europe where live 1,000-pound bombs can be dropped. It's highly prized as a training facility by the forces who have been charged with protecting the UK.

During a lull in the bombardment, I'd climbed the steps of the range control tower for a chat with the officer overseeing the exercise – a naval commander who seemed at ease with the high-explosive tempest being unleashed outside the windows.

'Why's Cape Wrath so suitable?'

'It's the only place in the northern hemisphere where we can bring all three services together to train at the same time … It's pretty hostile for the troops to survive on the ground. It has difficult sea conditions for the navy to operate in. And of course it's demanding to fly. So if we can train with live munitions in this sort of environment and continue to cope, then we can probably go most places in the world …'

Headlands have always been valued for their view. The range control tower at Faraid Head had once been part of a coastal defence system designed to detect incoming Soviet aircraft. You only have to stand on the Iron Age promontory forts of Wales – Caerau, Castell Bach, Porth y Rhaw or Flimston – to see the observational value of a high promontory. Typically, promontory forts take the form of an earth bank, ditch or stone wall, cutting across a headland or protruding clifftop. Some seem to have been occupied on and off from the Bronze Age through to the Middle Ages. In their marvellous book on the coastal archaeology of Ireland, Aidan O'Sullivan and Colin Breen suggest that we should shift our perspective and see these promontory forts as 'places within seascapes' rather than 'at the edge', with roles perhaps related to the monitoring and control of sea traffic. The south and west coasts of Ireland are lined with them. Hundreds more stud the shores of Britain from Caithness to Cornwall. There are 56 on the coast of Pembrokeshire alone. These forts are the earliest form of 'coastal architecture', a limitary style that is repeated from Dingle to Orkney to the cliffs of Dumnonia. Our islands are ringed with vantage points. The best form of coastal defence was a panoramic view.

We have no way of knowing whether the archipelago's tribes used fire to flash warnings between communities, but it seems likely that they did so. The forts of the Iron Age were often intervisible. Caesar, sailing towards the white cliffs of Albion in 55 BC, knew that he'd been spotted when he 'saw the enemy's forces posted on all the hills'. Forewarned, the warriors of the Cantii were waiting on the beach for the legions to land. The encounter, when it came, was unfortunate for the Cantii, but that was a failure of military organization rather than intelligence.

For the next 2,000 years, the archipelago was indefensible. Fertile, mineral-rich Britain, rimmed with havens and landing beaches, was enclosed on two sides by a continent prone to fits of expansionism. The advantage lay with the raider-invader. Darkness and fog offered cloaks of invisibility for entire fleets and, with the right wind, an army on water could move faster than an army on land. Before the age of radar, interception at sea required intuition and luck, and more often than not, both failed. When the Roman emperor Constantius lost control of Britain in the third century, the renegade Allectus managed to anticipate the course that the Roman fleet would steer to the south coast, but Britain's temperate climate played its hand. While Allectus lurked in the creeks of the Isle of Wight, his adversary sailed right past, unseen in banks of fog. During their 400-year tenure, the Romans learnt how hard it was to hold their island coast. At various periods, they operated a triple curtain of coastal defence: a roving fleet, coastal watchtowers and fixed defences or bases. The same system was still being used in 1940.

Not much is known about the vessels Rome operated in the waters of her island province, but it seems that the provincial fleet – the *Classis Britannica* – was initially engaged in shifting troops and supplies, and in exploration and reconnaissance. Tacitus writes of Agricola using his fleet to reconnoitre harbours beyond the Forth in AD 83, and it was presumably the same fleet that completed a remarkable voyage around the north of Britain after the Caledonians were defeated at Mons Graupius. The rounding of Duncansby Head and of Cape Wrath by Agricola's war galleys is one of those great maritime moments which has passed unrecorded; they must have sailed or rowed beneath Faraid Head, and perhaps even used Balnakeil Bay as an anchorage (for those heading west,

it's the last sheltered haven on the coast before the fearsome cliffs of Cape Wrath are turned). This was the voyage that defined Britain's geography for a Roman audience; the voyage Tacitus used to encompass the form of Rome's huge island province: 'These remotest shores were now circumnavigated, for the first time,' he wrote, 'by a Roman fleet, which thus established the fact that Britain was an island.' Two centuries later, the *Classis Britannica* was all that stood between the barbarian raiders and Britain's unprotected beaches.

The Romans had been in Britain for 200 years when they began building coastal defences. Around AD 230, the first two major coastal forts were constructed at the mouths of the greatest trading inlets on the east coast of Britain: the Wash and the Thames. There's not a lot to see at Roman Brancaster today, but in AD 250 there was a walled fort here, surrounded on both sides by the allotments, paths, ditches and cottages of the *vicus* – a civilian settlement. Vessels with shallow draughts could beach close to the ramparts. At its busiest, Branoduno was dusty with cavalrymen and farmers, sailors and traders. Today, you look across a level field. Roman Brancaster has been rubbed from the landscape by stone-robbers and the plough. If you walk along the coast path to the centre of Brancaster village, you'll find some of the Roman stones in the wall of St Mary's Church.

Down in Kent near the southern tip of the Thames Estuary, the Romans built another coastal fort at Reculver. Some of Regulbio's walls have survived, but half the fort has been eaten by the sea, and the site is besieged by massed ranks of caravans. It's still well worth a visit, though, because Saxons in the seventh and eighth centuries built a spectacular twin-towered church within the Roman walls, and although the church is now a ruin (in an appalling act of vandalism, it was pulled down in 1809), the twin towers remain, precariously balanced on a sea-girt lip of land.

Forty or so years after Branoduno and Regulbio were built, another six forts were constructed at intervals along the coast of south-east England, at Burgh, Walton, Bradwell, Richborough, Dover and Lympne. In around AD 285, an additional fort was built at Portchester, and in AD 370 another was added to the chain at Pevensey. The historian Stephen Williams has taken the view that these forts matched a similar chain along the French coast, and that they

were used as bases for a powerful fleet that could be used to trap Saxon, Frisian and Frankish sea raiders. The military thinking, according to Williams, was to prevent raiders reaching the beaches by denying them access to the seas. On the British side of the system, a relay of signal stations along the East Anglian coast provided early warning of raids. These were the foundations of a virtual wall around Britain. And the pattern of defensiveness extended beyond the shore: in an early reference to naval camouflage, the fourth-century historian Vegetius writes of light reconaissance vessels being fitted with blue sails and ropes, and crewed by men in blue clothing. The shore forts had a physical magnificence and enormity which underlined a Roman determination not to relinquish their largest island. As Williams puts it, the forts were 'concrete expressions of Roman civilization facing a new, threatening world and determined to resist with all its skills and power'.

Three centuries of Romanization changed the face of Britain, and its inhabitants had much to lose through chaos. By the time sea raiders from the floodplains of the Ems, Weser, the Elbe and Eider began looting the villas of the Wash, Thames and Solent, the Romans and Britons had been mingling for ten generations. They'd become Romano-British. They'd got used to good roads and foreign imports, the amphitheatre, hot baths and the forum. Villas slumbered among vines and wheatfields and in the 280s the owner of a splendid palace on the waterfront of Chichester harbour began installing a new underfloor heating system. The get-lost shore forts were not imperial follies; they told the barbarians to forget it. When the barbarians eventually succeeded, they climbed through the ruins of the shore forts, wondering if they'd been built by giants.

Portchester – the best preserved of the coastal forts – makes it clear why men and women who had known only huts would have stared agog. Scanning the Solent from a site of nearly 10 acres, it is unique in northern Europe for being the last Roman stronghold whose walls still come close to reaching their original, 6-metre height. They are up to 4 metres thick and most of the 20 U-shaped towers have survived. At the time, Portchester's scale was monumental. Equally atmospheric is the fort the Romans built by the mouth of the 'Great Estuary' in Norfolk. In AD 280, the flint walls of Gariannonor looked out from a bluff across 4 miles of tidal water. Now, you gaze across drained

marshland and the silver thread of the Yare. Much of the fort's walling is still there, some of it tilted as if shaken by an earthquake. The north wall has gone, toppled into the estuary centuries ago. I've been up there alone as the sun sets; I've sailed past on a Broadland lugger; I've splashed along the riverbank in autumn wellies. It's a melancholy place. The veg plots, dorms and bath-house; the street corners, bars and shady apple trees where trysts were kept, have all been swept away. Now, like Reculver, Burgh Castle has been bitten by the sea and so even the memories retained in that broken square of turf and mortared stone are fading like the dying of the wind at the end of a fine day's sailing.

As the Roman grip on this huge, remote island began to weaken, the forts of the Saxon shore were complemented by a chain of signal towers erected along the coast of north-east England from north of the Wash, almost to the Tees. They seem to have been part of an integrated early warning system. The Romans had already built signal towers inland and it seems that the new coastal system was intended to protect the east-coast shipping lane and to warn of Saxon raids. It's possible, too, that the signal stations were linked to the eastern end of Hadrian's Wall, which would have helped deter flanking attacks. In design, the stations were tall, square-towered fortlets, surrounded by a walled courtyard and a defensive ditch. Archaeologists have speculated that the towers may have been as high as 30 metres. There was space in the courtyard to place an artillery piece. At night, these massive, fortified chimneys flared with yellow light. Seen from the sea, they would have given the impression that this rugged coast was systematically defended by well-organized forces. The sites of the five known signal stations – at Hunt Cliff, Goldsborough, Ravenscar, Scarborough and Filey – are not all intervisible, so there must have been intervening stations we don't know about. They are still wonderful viewpoints. Hunt Cliff is the great ramp of Jurassic limestone you see from the end of the pier at Saltburn-by-the-Sea, the Victorian resort just south of Tees Mouth. The signal station at Goldsborough stood back from the cliffs above the promontory known as Kettle Ness, 5 miles up the coast from Whitby; Ravenscar's signal station is buried beneath Raven Hall Country House Hotel, 600 feet above sea level at the southern end of Robin Hood's Bay; at Scarborough, you'll find the outline of the signal station laid out in the grass on the crest of the headland. The Filey

station was perched on the crest of Carr Naze, the narrow headland which tapers into the sea 10 miles up the coast from Flamborough Head. The historian of Roman Britain, Peter Salway, refers to the towers as 'a new sort of sentinel'. The base of a signal station from the same era has been found at Wapping, on the Thames; it must have been part of a warning system intended to alert the capital to enemy raiders coming upriver.

The Saxons had been in England for around 400 years before the first signs of organized coastal defence begin to appear again. By the 850s, the isles of Thanet and Sheppey were being used by Vikings to overwinter, and urban Saxons were being forced to leave their undefended *wics* and move into purpose-built, walled *burhs*. The most enjoyable coastal *burh* to walk around is Wareham, at the eastern end of Poole harbour in Dorset. The town is still laid out on its Saxon grid pattern, which allowed its residents speedy access to the turf ramparts at the first sight of Viking ships crossing the harbour. The ramparts stand and there's still a quayside where ships used to berth in the days before silt and progress closed Wareham to seagoing trade.

Hidden up a backwater off one of the largest natural harbours in England, Wareham was relatively well protected from Norse raiders, but most Saxon communities on the coast lived in a state of perennial anxiety. Hilltop beacons warned people to take refuge in the *burhs*. There's a shortage of material evidence relating to these beacons, but modern OS maps are dotted with clues. The Old English word for 'lookout place' was 'tot' or 'tote', and if you visit the old coastguard lookout above the Needles at the western tip of the Isle of Wight, you'll have to pass through the little resort of Totland – which translates to 'cultivated land with a lookout place'. Up on the chalk ridge above the beach and pier is one of the most sensational viewpoints on the Channel coast. The archaeologist Graham Gower has taken the *tot* connection one stage further and identified six places which have 'tot' in their names along the ancient road linking the port of Chichester with London. The string of *tot* names along Stane Street, reckons Gower, 'appear to be more than just coincidence, and may represent the remnants of a complex Anglo-Saxon communications system based on the old Roman road system'. If Gower is right, warnings could have been relayed from vulnerable incursion points on the coast, like ports and estuaries, to

Anglo-Saxon centres of settlement. In effect, the shores would be yielded but, given warning, the *burhs* could be held.

The role of ports in defending the island began to be formalized in the chaotic decades that led up to the Norman invasion. Under the late Saxon kings, a group of south-eastern ports was providing 'ship service' on royal demand. In return for exemption from certain revenue payments, the burgesses of key Channel ports supplied Edward the Confessor with 20 ships of 21 men each, for 15 days each year. These 'ship-service' ports emerged after the Norman invasion as the 'Cinque Ports': five ports awarded special status in return for providing ships and men at the king's calling. Once again, Kent was in the front line. Heading the five was Dover, and then Hythe, Romney and Sandwich. Hastings in Sussex completed the quintet. Later, the privileges held by these ports gave them a head start in the smuggling business.

The impossibility of holding the coast was demonstrated yet again in 1066. It was King Harold's misfortune to have been facing two invasions at once. He went north and defeated the Norwegians at Stamford Bridge, but in the meantime the Normans were heading for the south coast. After a night crossing of the Channel with a fleet thought to have numbered 700 vessels, the Duke of Normandy achieved an unopposed landing at around nine in the morning on Thursday 28 September. In the event, Harold's 'eyes' on the coast seem to have been a local Saxon thegn who watched the invading Normans from a hilltop and then rode north for a day and a night to convey the bad news to his king. Duke William's army of armoured knights had over a fortnight on English soil to prepare for an inevitable encounter with Harold's weary Saxon axe-wielders.

The battle that took place by the London road 6 miles from the coast at Hastings replaced the Anglo-Saxon ruling class with foreign-speaking conquerors. William's had been the largest invasion force to hit English beaches since the Roman legions had splashed ashore at pretty much the same spot 1,000 years earlier. On both occasions, to those who ruled the island the cost of an unopposed landing was – as William of Malmesbury put it – 'a melancholy havoc'.

*

Scarborough Castle has the lot: a spectacular keep, huge views and a café. A century after William landed at Pevensey, Henry II spent the best part of a decade turning one of the most dramatic landmarks on England's east coast into an impregnable fortress. On a rock famed for being 'stupendous alike in height and area and surrounded by inaccessible cliffs rising out of the sea', he built a formidably strong tower and cut a defensive ditch through solid rock. For 500 years, it remained inviolable, its silhouette a beacon to fishermen, sea traders and finally – as a ruin – to the first seaside tourists.

It's one of those historical circularities that each successive invader is ultimately obliged to create his own coastal defences. The Romans, the Saxons, the Normans, were all forced to defend the shores they'd taken. The Normans were instinctive castle-builders, able to raise a motte and bailey in a fortnight. In the 20 years between 1066 and 1086, it's reckoned that they built around 500 in England. Later, with the taming of the island, the Normans and then the Angevins began building more permanent structures in stone. Henry II's great 12th-century keep at Scarborough was one of three immense castles he built on the coast of east England. All three are run today by English Heritage. At Orford on the coast of Suffolk, Henry raised an innovative polygonal tower overlooking the River Alde, and at Dover he converted William the Conqueror's clifftop fortress into the most advanced defensive structure in the archipelago: a massive keep surrounded by two encircling bailey walls. Henry II's trio of coastal castles are exercises in individuality. The chain of castles built in Wales a hundred years later by Edward I were more methodical.

Gaze across the coastal plain from the gatehouse tower of Harlech, look at Conwy's thicket of turrets from the north-east, or Caernarfon's magisterial bulk from the bank of the Afon Seiont, and you will be sampling the most spectacular coastal castle system ever constructed in Britain. Of the eight major castles built or completely rebuilt by Edward I in the 13th century, only one, Builth, was not coastal. In their time, they must have been as oppressive to the Welsh as Hitler's 'Atlantic Wall' was to the French. Welshman Thomas Pennant's anguished cry that Edward's castles were 'the magnificent badges of our subjection' had many supporters. Now that these castles have been neutered by time and tourism, the Welsh historian John Davies would have us accept that

Edward's castles are 'a tribute to the tenacity of the resistance of the Welsh ... eloquent testimony to the immensity of the task of uprooting from Wales the rule of the Welsh'. Whether they are monuments to Welsh tenacity, or to English colonialism, or to the architectural brilliance of Jacques de Saint-Georges d'Espéranche – the Savoyard mason who takes the credit for designing most of Edward's castles – depends upon which side of the border you were born. The ring of stone was not a coastal defence system, but an expression of conquest and a means to corral the forces of the last prince of an independent Wales, Llywelyn ap Gruffudd, within their Welsh heartland.

The opening of a new era in coastal defence is remembered by one of the most dramatically-located waterside castles in England. At the mouth of the River Dart, on the southern shore of Devon, Dartmouth Castle is both a romantic relic and the murderous prototype of Hitler's Atlantic Wall. It's the earliest coastal defence in Britain designed specifically to accommodate artillery and it was built in the late 1400s just as the English were beginning to appreciate the value of cannon in fixed positions. Work started on the gun-emplacements in 1481, five years after the English king, Edward IV, had revealed his interest in weapons of mass destruction by issuing a warrant for 'bumbardos, canones, culverynes'. The castle was commissioned by local merchants who wanted to protect their warehouses and cargoes, but at the time, Dartmouth also had a wider strategic significance. This was the river-mouth that the alienated 'king-maker', the Earl of Warwick, had sailed through in September 1470, with 2,000 French soldiers, forcing his monarch to flee from the east coast port of Lynn into exile in Burgundy; Dartmouth could lose a king his crown. Once he was back on the throne, Edward determined that this superb, West Country anchorage would not facilitate another invasion. The castle's architect fitted the base of the square tower with seven huge gun-ports that could bring massive firepower to bear on the hulls of approaching ships, while smaller embrasures higher on the wall allowed small arms fire to rake the enemy's decks. The neck of Dartmouth harbour was a fire-trap. Unseen to approaching ships was a massive chain (thought to have been stolen from the Cornish port of Fowey) strung between Dartmouth Castle and Kingswear Castle on the far shore. As ships approached, the chain could be winched from the seabed to block the entrance.

Edward IV's experiment with cutting-edge coastal artillery forts in the 1480s laid the ground for the rediscovery of integrated coastal defence on a scale that would have been familiar to the Romans. The monarch behind this military Renaissance was Henry VII, the athletic, 26-year old horseman who had landed his army at Milford Haven in 1485 and then founded the Tudor dynasty by taking the crown at the Battle of Bosworth Field. Henry VII's unopposed invasion in South Wales changed the course of English history. He understood the merits of national defence, and his construction of a powerful merchant marine laid the basis for a superior navy. Bounties were paid to shipowners who bought or commissioned vessels displacing more than 80 tons, and although Henry had just seven dedicated warships by the end of his reign, they were formidable weapons. The four-masted *Sovereign* displaced nearly 700 tons and was armed with 225 breech-loading serpentines that could hurl a ball 1,300 yards. Henry also grasped the necessity of a fortified port for his navy. The first dry dock in the kingdom was built at Portsmouth in 1496, and the approaches were defended by a new tower and bulwark. Henry's son went much, much further. The adversaries were, as ever, neighbours: first France (and her ally Scotland) and then Spain.

Under Henry VIII, the south coast became a three-tier, Tudor barricade consisting of a navy, a system of warning beacons and a chain of forts. The seven ships Henry inherited in 1509 swelled to 19 by 1512, the new vessels designed as floating gun-platforms for the latest artillery. The 700-ton *Mary Rose*, raised from the seabed in 1982 and taken to Portsmouth, had an integrated weapons system capable of ship-smashing and coastal bombardment. Henry's shore defences were equally thorough. Late in 1512, the first significant Act of Parliament relating to coastal defence was passed. Justices of the Peace and sheriffs were to make sure that fortifications were constructed at 'evy landying place' between Plymouth and Land's End – the stretch of coast facing Brittany and thought to be the most vulnerable to French raids. Earlier that year, Parliament had already passed a measure intended to improve 'shooting in the longe bowe'. The precautions paid off when the French, under Prégent de Bidoux, appeared in February 1514 with a heavily armed fleet off the impoverished fishing town of Brighthelmston – later to be resurrected as a leading

seaside resort. They caused a fair degree of havoc. Buildings were torched and goods were seized, but Prégent was caught on the beach as Henry's rudimentary coastal defence creaked into action. Beacons had been lit, and as the English began to gather, the six archers of Brighthelmston's watch fired volley after volley of arrows at the withdrawing Frenchmen. Admiral Prégent was hit in the face, and according to a contemporary account, 'was likely to have dyed'.

Henry VIII's ships – with the astonishing exception of *Mary Rose* – have dissolved into biodegraded silt, but some of his stone-built, coastal forts still look as good as new, thanks in great part to English Heritage. They are remarkably modern structures, and have more in common with 1940s pillboxes than with the picture-book, perpendicular towers that Edward I had raised along the coast of Wales in the 13th century. Faced in the late 1530s with the threat of invasion by the combined Catholic forces of Spain and France, Henry embarked on a project known as 'the Device': the first co-ordinated national defence measures in English history. Coasts were surveyed, maps drawn and between 1539 and 1540, nine main artillery forts were erected at key points along the south coast. To Tudor eyes, these were formidable structures of a kind never seen on British shores. When Henry's antiquary, John Leland, visited one of these forts in the 1540s, he jotted the words 'right strong' and 'magnificent' into his notebook. In peacetime, they seem incongruous, but you only have to put yourself in the boots of a Tudor gunner to feel the chill of fear. At Portland, you can stand on the gun platform and peer along a sight-line that now covers the Olympic dinghy-sailing course. At Deal in Kent, the perfectly-symmetrical, curved bastions of one of the more spectacular forts in the chain form the centrepiece of a seaside resort. Just along the coast, Walmer Castle – sited like Deal to guard the anchorage known as The Downs – has become as popular for its magnificent gardens and Wellington-associations as it is for its Henrican embrasures. Defending the entrance to Southampton Water, Hurst and Calshot castles (English Heritage, too) have glorious views over the Solent.

In Sussex, another 'Device fort' can be found after walking for a mile over the sand from the old port of Rye. Camber Fort has a stone exterior, but is lined inside with brick. Tudor roses embellish its central tower. Far from cars and modern hubbub, this is the place to detect what it must have felt like to be

stationed along with 40 or so others, waiting for the French. The western end of the 'Device' line is in Cornwall, guarding the mouth of Carrick Roads. St Mawes is not Henry's most intelligent fort, since it's overlooked by high ground and is therefore open to attack from the land. But it's only one of a pair. From its gun platforms, you can clearly see, just a mile across the glittering water, the silhouette of its twin fort, on Pendennis Point. You'd have to be suicidal to turn a ship into these arcs of fire. Which was of course the point. Henry's forts were intended as a deterrent.

While ships and forts had taken precedence in the first part of his reign, Henry turned his attention in 1545 to beacons, after Francis I announced that he was going to invade England so that he could release Henry's subjects from Protestantism, and regain Boulogne – lost to the English the previous summer.

Henry's Privy Council re-established an elaborate early warning system, instructing that fire beacons be placed in groups of three at the coast, in pairs on adjacent hills, and singly as inland relay stations. All the beacons would be tended by 'wise and vigilant persons' who would man them on a rota basis. Codes denoted varying levels of alert: a single lit beacon meant that suspicious ships had been sighted; two beacons signified that the ships were within 4 miles of the coast – the trigger for defence forces to muster. Three beacons fired simultaneously meant that the enemy had landed and could not be resisted. On the continent, the Holy Roman Emperor, Charles V, was told that Henry VIII's beacons could raise 25,000 to 30,000 men in two hours.

With time, the beacons became as important as the forts and the ships. By the reign of Elizabeth I, they were expected to be crucial in directing her army to wherever the Spanish might land. A glimpse of life at one of these Elizabethan communications stations is revealed in the state papers of 1560, which instruct that beacons should be 'furnished with wood sufficient readye to be fyered upon any occasyon' and that firing should not be undertaken without the consent of the local Justice of the Peace. There had been several false alarms; one of them on Portsdown, above Portsmouth, when hunters smoking a badger sett had been mistaken for a beacon signal. The Elizabethan beacon system appears to have been nationwide and it's likely that the mapmaker Christopher Saxton used them as surveying points while he was compiling his atlas of

county maps in the 1570s. In his *Speculum Britanniae* (1593), the mapmaker John Norden reckoned that 'Everye parish in Cornwall, for the moste parte, hath a beacon.' Cornwall had over 30, and Devon around 90. A remarkable map of 1585, drawn just three years before the Armada was spotted in the Channel, shows the complete beacon system for the county of Kent; William Lambarde – a lawyer turned antiquary and topographer – depicted his beacons as tall posts with a ladder stretched to a great bush of flame. There are 35 of them around the coast of Kent, with another 14 inland – all of them connected on Lambarde's map by a web of linework to indicate how messages could be flashed across the county.

Henry VIII's forts established a pattern for coastal defence. Henceforth, an intelligently sited artillery platform denied an opponent access to all water within its field of fire. Each invasion scare provoked a rush to the coastal palisade. Old forts were refurbished; new ones built. By the late 17th century, the problem was the Dutch, and Charles II was having to revisit old fortifications on the east coast of England. The port of Harwich, at the mouth of the Stour and Orwell, was particularly exposed. Back in 1543, Henry VIII had put two blockhouses on the tip of the peninsula facing Harwich, but these had been superseded in 1628 by a new, square fort of earth and timber, which Charles had to strengthen with brick in 1666. A year later, the Dutch attacked the fort from its landward side, with 1,500 musketeers, pikemen, grenadiers and artillerymen equipped with portable cannon. It was the largest enemy landing on English soil since 1066, and despite an efficient, unopposed landing, the raiders were repulsed before they even reached the walls of the fort. Nature was brought to bear on the Dutch, too, for the men of Harwich had cut down the seamarks identifying the channel into Harwich harbour, so the enemy ships were unable to provide supporting fire for their troops. Ironically, two of the most spectacular coastal defences of this era – the star-shaped artillery fort at Tilbury and the citadel at Plymouth – were designed by the brilliant Dutch engineer, Sir Bernard de Gomme, who had been a staunch Royalist and supporter of Charles through the English Civil War.

During the wars, raids and landings of the following century, coastal defence was bolstered in a piecemeal fashion. And then the French sought to export

popular revolution and triggered the most extensive defensive programme undertaken in Britain since the days of Henry VIII's fort-building.

In the dark days of the 1800s, as Napoleon mustered his Armée d'Angleterre for an invasion of Britain, England's south coast was overrun with brickies. Rumours that 'Boney' was about to launch an assault with windmill-powered invasion rafts, or attack through a secret Channel tunnel and with flocks of infantry-filled balloons, played to the ambitions of Britain's military establishment. Brigadier General William Twiss surveyed the south coast for sites suitable for the construction of a new type of defensive tower, modelled on a circular bastion that had impressed Sir John Moore when he tried to knock it to bits with cannon fire from his ship. The bastion had been sited on a Corsican peninsula called 'Mortella'. In great haste, 74 'Martello' towers were built to cover all possible invasion beaches between Folkestone and Eastbourne, the section of Channel coast closest to France. Each tower was armed with a 24-pounder cannon. The Martello programme turned out to be a military white elephant, consuming staggering resources for a threat that evaporated before the towers had been completed. The Board of Ordnance ordered 13 million bricks and probably spent around £400,000 on the 74 towers. Construction began in the spring of 1805, shortly after Napoleon diverted his army towards a campaign in Austria. By 1812, another 29 Martello towers had been built up the coast from Clacton to Slaughden near Aldeburgh, and another 40 on the coast of Ireland to defend major ports like Cork, Dublin, Belfast and Bantry Bay. The Slaughden tower is now owned by the Landmark Trust, who let it as a holiday home.

Martello No. 3 is another of 25 English towers to have survived coastal erosion, demolition gangs and gunnery officers. Like a vent from the Underworld, it protrudes from an abandoned golfers' greensward on Folkestone seafront. In the manner of a borderers' bastle, the only door is several feet above the turf. Inside, is a space filled with bricked curves. Apparently the towers are not circular but elliptical, with thicker seaward walls to withstand incoming cannonballs. On the roof, a cannon mounted on a huge swivel would have covered Folkestone's beaches.

Before the end of the century, the South Coast palisade would be modified by a military programme of far greater ambition than the Martellos or Henry

VIII's great 'Device'. The cause was the collective imagination of a nation unused to prolonged peace. Napoleon's defeat at the Battle of Waterloo had been followed in Britain by a generation of military neglect and a slow decline of British influence in Europe. The vacuum was occupied by a renewed fear of invasion, which was translated into a practical response following the publication in 1860 of a Royal Commission report on the defences of the UK. The Commission, all military men bar one, advised that steam and advanced artillery had 'revolutionized' the rules of warfare in the years since Waterloo. No longer would it be militarily feasible for the Navy to blockade enemy ports, or to prevent an enemy invasion of Britain. Arguing that the cost of defending such a long shoreline with men would be prohibitive, the Commission recommended that funds should be directed at providing fixed defences for the dockyards. The Prime Minister, Lord Palmerston, backed the Commission findings, but his Chancellor, William Gladstone, baulked at the eye-watering cost. Gladstone had set his heart on abolishing income tax, but instead found himself having to raise an extra £9 million – £800 million in modern money – for a massive coastal-defence programme. Palmerston, an experienced liberal interventionist, wrote to Gladstone making it clear that failure to protect the dockyards would mean that 20,000 enemy troops could be landed on British soil without the Navy knowing, in just 'one night'. Faced with his own WMD moment, Gladstone opened the nation's wallet. The dockyard forts (or 'Palmerston's follies', as they became known) required prodigous feats of engineering and construction. Thousands of bricklayers, stonemasons and navvies followed surveyors and contractors to Portsmouth, Plymouth, Milford Haven, Portland, the Thames, Medway, Dover and Cork, sinking piles, excavating, blasting and raising scaffolding. The most publically-visible of these new artillery forts rose from the pristine grassland of Portsdown, the long hill above Portsmouth that William Cobbett and countless others had regarded as one of the best viewpoints in the south. By 1869, more than 80 forts had been constructed. Most survive in some form, and at least one was still in use during the Cold War. The most remarkable of these Victorian forts squats at the mouth of the River Wey, beside Portland breakwater. Nothe Fort is now run by Weymouth Civic Society, who have rescued it from vandalised dereliction and turned it into a world-class museum.

Palmerston's massive stone coastal defences marked the end of an era; never again would a system of fortifications be erected around UK coasts on such a singularly-grand scale.

Great Yarmouth had already played a starring role in fishing and trading history when it was involuntarily plastered across the headlines. It was November 1914. Three months after Britain declared war on Germany, Admiral Franz von Hipper launched attacks on the very same coast that the Saxons had harried during the closing decades of Roman Britain. It was a longitude thing; Great Yarmouth is the closest British port to the coast of Germany. Von Hipper's ships were able to bring long-range, 20th-century artillery to bear on a shore that still had to *see* the enemy to know that he was there. Great Yarmouth was the first British town for more than a century to suffer bombardment, and its inhabitants had no idea it was coming.

'The many who were asleep in the town,' reported *The Times*, 'were rudely awakened by the reverberation of the guns and the clattering of windows and shaking of houses.' It was a few minutes after seven in the morning. Crowds gathered on the seafront to watch 'the dropping of shells in the sea and the leaping of great cascades of water.' Through the autumn sea-haze, the spectators could see flashes on the horizon. These, they concluded, must be the source of the commotion. Some men who had walked to the end of the pier at the harbour-mouth and trained their eye-glasses on the flashes, reported seeing a large four-funnelled vessel out near the Cross Sands Lightship. In fact, there were a total of seven German cruisers out there. Unmolested, they sailed through the coasters and steam drifters, whose crews mistook them for the Royal Navy. The cook on one of the drifters cheerily waved his teapot at one of the warships. To his astonishment, the crew of the warship, responded by shaking their fists at him. Later, the fisherman claimed that the warship had been so close to his drifter that he 'could have thrown his herrings on board her'.

The next month, Von Hipper was back with his heavy cruisers. 'There are some strange ships in sight', reported one of the men from the Signal Station on top of Scarborough's cliff, 'and we cannot make out who they are.' A total of

776 shells of various calibres reduced much of the resort to rubble, killing 18 and seriously injuring 80. Twelve minutes after shells began to rain down on Scarborough, Von Hipper's ships opened up on the port of Hartlepool. Over 100 were killed, and 400 seriously injured. An hour after Hartlepool, it was Whitby's turn. Again, there was no warning. Three people were killed and many houses were destroyed.

The attacks of November 1914 jolted Britons back into palisade-mode. Not since the Viking raids had the coast been subjected to unexpected, catastrophic attack on such a widespread scale. Naval intelligence was the only means of anticipating the movements of the German fleet. At sea and unobserved, the big guns of the cruisers and dreadnoughts could rake the east coast from the horizon. Then, in January 1915, two months after the naval raids, the Germans brought an entirely new kind of war to the British coast.

Again, Great Yarmouth was selected, this time to test the efficacy of bombardment from aerial platforms. Again, there was no warning. On the evening of 19 November, Mr Ellis, a fishworker, was in his home in the road known as St Peter's Plain. It was a Wednesday. He'd just walked through to his kitchen when the front of his home exploded. Residents later described 'a report as if a big gun had been fired in the main street of the town'. Sounds were heard 'of a terrifying kind … in five or six different parts of the borough'. In the Fish Wharf Refreshment Rooms, the lady pianist was blown off her music stool and down three stairs. Troops and police rushed to the streets. A hole four feet long and three feet deep was found in St Peter's Plain. Windows within a radius of 200 yards were smashed. Mr Ellis 'simply walked out over broken furniture and jagged pieces of masonry through a gaping space which a minute before had been a stout wall'. Miraculously he had escaped with cuts from flying glass, but two of his neighbours were lying dead in the road: a shoemaker called Samuel Smith, who'd been walking along St Peter's Plain, had part of his head blown away. And the body of 72-year-old Martha Taylor was found with appalling wounds. They were the first British civilians to be killed by an air raid. Above them in the night sky, a Zeppelin commanded by a 38-year-old naval officer called Peter Strasser turned to the east and headed back over the North Sea.

Nobody knew for certain what had caused the explosions. Was it an aeroplane? Or was it, as *The Times* opined next morning, 'a dirigible'? The newspapers found themselves in a typical wartime quandary; on the one hand, they had a sensational story – the first-ever aerial bombardment of the country – and on the other, they were obliged to play down its significance for fear of triggering panic. *The Times* reported the air raid for four days in a row, elaborating on the detail of the attack, while deriding the dirigible. On 20 November, it reported: 'The East Coast has now had experience of shells fired from the sea and of bombs dropped from the air, and it is abundantly clear that the former mode of attack wreaks a far greater measure of devastation than the other'. On the 21st: 'The damage, moral and material, is not comparable with that of Scarborough and Hartlepool. The two episodes are on a different plane.' Great Yarmouth, continued the paper on the 21st, 'may have awakened with a head-ache; but it has kept its head'.

The German population was fed a rather different story: The *Deutsche Tageszeitung* hoped that many more raids would follow; the *Berliner Tageblatt* expressed the view that the North Sea was no longer a bar for German airships; the *Morgenpost* wondered what succour Great Britain could expect from her navy now that German airships could cross the water and drop bombs. British fears of an invasion, added the paper, are right to increase now that the isolation of the British Isles has been conquered.

Eyeballs had always been a limited early warning device; applied to the night sky, they were as useful as a brolly on the Somme. But what about ears? During the war, a gaggle of boffins at the Munitions Inventions Department – formed in August 1915 by Prime Minister Lloyd George – began looking at acoustic detection systems. If, it was reasoned, the sound of Zeppelin engines could be amplified, warnings could be raised before the bombs started falling. Strange trumpets were tried, and devices were placed down wells. At half a dozen sites along the North Sea coast, concave dishes were cast in concrete and fitted with microphones; another seven or so were constructed along the Channel coast of Kent. The Zeppelins kept coming; aerial slugs among the clouds, unloosing their droppings on the Tyne, and then London. When the Royal Flying Corps and Royal Naval Air Service learnt how to bring them down with

machine guns, the Germans started sending lumbering 80mph aeroplanes called *Gothas*.

It was springtime in the third year of the war when Mercedes engines were first heard above British rooftops. On 25 May, the *Gothas* killed 95 and injured 195 in Folkestone. On 13 June, they killed 162 and injured 426 in London. By the end of the war, 670 people had been killed by bombs, and 1,960 injured, a fraction of the 745,000 killed and 1,700,000 wounded overseas, but enough to have convinced the military that aerial bombing successfully breached Britain's island defences. Post-war research into acoustic detection brought the boffins to the quietest place they could find on the south coast.

There is a peace that comes with great levels. Think of the salt marshes of East Anglia, or the Solway. At Dungeness, a desert plain of shingle reaches to the horizon. It was to the flecked levels of Denge Beach that the poet and film-maker Derek Jarman moved in 1986, surrounding Prospect Cottage with his 'Garden of Eden', decorated with bouquets of beach debris and salt-resistant plants. I came to Dungeness one autumn dawn with the *Coast* film crew and a team of acousticians from Loughborough University. It was cold and draughty, and everyone was a little tense. Richard Scarth, author of *Echoes from the Sky*, was waiting in the carpark. Richard led us across a footbridge to a set of extraordinary concrete structures. One of them looked like a gigantic bowl, raised on its rim. Another took the form of a long, curving wall. With a bucket, Richard and I bailed a lake of water from the first structure, while the acousticians rigged up microphones, an amp, cables and a laptop. Then we waited for the bomber.

The 'sound mirrors' of Dungeness had been constructed in the 1930s by Dr William Sansome Tucker, a research physicist from London's Imperial College, who had enlisted in the Royal Engineers and spent the war years working on sonic gun-ranging devices on the western front. After the war, Major Tucker headed a team of boffins who were trying to develop a device that was more effective than the human ear at detecting the approach of enemy bombers. Tucker's sound mirrors were Britain's first line of defence against the horrors visited on Folkestone and London in 1917. The experimental mirrors were generally spherical or paraboloidal. An operator with a stethoscope listened at a 'trumpet' placed at the focus of the mirror.

One of the perversities of war is that Tucker's sound mirrors required tranquillity. Extraneous sound cluttered the signal and so the mirrors had to be sited on sections of coast which weren't polluted with industrial or vehicular hubbub. Then, as now, the least disturbed part of the coast closest to France was the vast wedge of shingle protruding into the Channel opposite Boulogne: the largest shingle foreland in Europe. Denge – as it was known then – was a peculiarly quiet sanctuary on an otherwise hectic coast. It was just what Tucker needed. By the late 1920s, he'd erected sound mirrors at several locations around the British coast, but in 1927, the Superintendent of the Air Defence Experimental Establishment proposed that 'acoustical mirrors' should be erected at Denge. Three of the mirrors are there today. The BBC's plan was to find out whether they still worked.

Our 'bomber' was a Tiger Moth biplane. It came in from the sea at 1,000 feet. Sure enough, I was able to detect the Tiger Moth's air-cooled, four-cylinder piston engine through the headphones long before it was audible to the naked ear. Loughborough's 21st century acousticians were impressed. Tucker's sonic experiments continued to the late 1930s, but as faster planes began to appear on the horizon something more adequate than concrete hearing aids was required. With the Luftwaffe mustering, Tucker's sound mirrors were replaced by radio detection and ranging: radar.

In their quest for peace, Denge's sonic boffins did stumble across a universal truth. 'It is recognized,' noted the Superintendent of the Air Defence Experimental Establishment, 'that we cannot get complete silence anywhere …'

Nowadays, Weybourne is the kind of place that makes you want to linger as you tour the Norfolk coast. There are cottages made from beach pebbles, a pub called The Ship, a bowling green, a village shop and a toppled priory that was founded in the reign of King John. But Weybourne had been popular well before Augustinian canons recognized it as a congenial spot. Low, lumpy hills wrap around three sides of the village, and on the fourth is the sea, so the village is in a gentle coastal dell. A stream runs down from the hills, and astride its waters, long before the Normans arrived, Anglo-Saxon families had settled. The

compilers of Domesday Book found a thriving little place they called Warbrune and Wabrunna, *burna* being a spring or stream. There were a couple of mills, woodland for ten pigs, some meadows and grazing for goats and 60 sheep. The right to hold a market here was granted in the early 14th century, and the fishing must have been good, for the shore shelves so sharply that you can beachcast from the pebbles. You still see fishermen there; lonely silhouettes at dusk. The beach is known as Weybourne Hope, and it marks a transition on the Norfolk coast; look to the east and you'll see collapsing ochre cliffs, but to the west, there is just a low shingle bank. Weybourne Hope is an invasion beach:

> 'He that would Old England win
> Must at Weybourne Hope begin.'

It's an old saying whose origins are lost in the dusk of our invasion history, and no invader has ever tried a beach landing on this part of the coast. For centuries, however, Weybourne Hope was seen as the Achilles heel of East Anglia. Admiralty Chart C28 explains why. Where much of the Norfolk coast is protected by offshore sandbanks, there is a gap between the Sheringham Shoal and Haisborough Sand. A fleet slipping through this gap would find itself in relatively deep water until it was in leaping range of the beach at Weybourne Hope. Where much of Norfolk is backed by cliffs, or by the reed swamps of Britain's largest wetland, the hinterland at Weybourne is well drained, with a road running straight and true to the city of Norwich.

It's worth taking a walk up the hill to the west of Weybourne. It's called Muckleburgh Hill. Paths snake up through the oaks and sycamores to a grassy crown that dominates the low coast. The hill is part of a great bank of gravel and sand left behind by the ice sheets and it gives you 20,000 years of history in a sweep of the eye. This was where the ice stopped grinding southward; Muckleburgh is a glacial frontier. These low hills were also part of a range that ran out into Doggerland; you could once walk from here to Denmark. The Elizabethans understood the vulnerability of Weybourne, and it worried Churchill, too. 'Still,' he wrote to the First Sea Lord in October 1939, 'it might be well for the Chiefs of Staff to consider what would happen, if, for instance, 20,000 men were run

across and landed, say, at Harwich, or at Webburn Hook, where there is deep water close inshore ...'

Although Churchill was always more doubtful about a German invasion than his ministers, the coast defences thrown together in a frenzy of civil engineering at the opening of the Second World War were formidable. Under General Ironside, and then Field Marshal Brooke, the coast became an 'extended crust' behind which ranged highly mobile units that could be moved at great speed to counter-attack invading forces where required. Behind the crust, stretching in a long, wavering line from Edinburgh to Kent, and then west to the Bristol Channel, was the General Headquarters Line, an anti-tank barrier supported by various fixed defences such as pillboxes. The coastal crust was not expected to repel the invading Germans, but it would – it was hoped – delay and disrupt for long enough to organize the counter-attack.

Never has the English coast been subjected to such a dramatic military makeover. Just as navigation buoys had been removed from the Thames during earlier wars, coastal signposts were dismantled and place names painted out. The beaches themselves were mined and obstructed with barbed wire, and steel obstacles were planted to rip the hulls from German landing barges. On roads and level ground, concrete cubes and 'dragons' teeth' were placed to impede the charge of tanks. Next time you're at Winterton on the coast of Norfolk, have a look at the anti-tank blocks which lie on the beach like scattered dice. On one of them, privates Russell and Wells scored their names into the wet concrete as invasion loomed.

The most visible survivor of Churchill's defensive wall is the ubiquitous pillbox. Something like 28,000 of them were built to hinder Hitler's advance, and although the casual observer of these stained concrete hulks might regard them as exhibiting a certain, repetitive uniformity, the full spectrum of designs is diverse. Architecturally, pillboxes may not be as *sofisticato* as the works of Palladio or Wren, but they rouse the passions of a certain kind of individual. Usually male. There are at least eight basic types, and then variations within the standard model. The Type 24, for example, is the most commonly found pillbox, often used for beach defence. It's an irregular hexagon, with embrasures for rifles and light machine guns and an internal Y-shaped anti-ricochet

wall. Most Type 24s were constructed to a bulletproof standard, with 12-inch walls, but a later variant was built with shellproof walls up to 50 inches thick. Each type of pillbox was structurally unique: the Type 22 was a regular hexagon (there are quite a few of these on the Cowie Line in eastern Scotland); the Type 23 was rectangular, with an open section for anti-aircraft defence; the Type 25 was circular (the delightful walk to Cuckmere Haven in Sussex will take you past a couple of these); the Type 26 was square (there's a good one of these near St Catherine's Chapel, Abbotsbury, Dorset); the Type 27 could be octagonal or hexagonal, but always had a central well open to the sky, for anti-aircraft weapons; the Type 28 was a monster with a chamfered roof and an embrasure large enough to fit a 2-pounder anti-tank gun. Beyond the pillboxes, there was an architectural cornucopia of structures known generically as 'hardened defences', which ranged from a small metal rotating turret to the bizarre Pickett-Hamilton Fort, which could be raised hydraulically from the ground to fire upon attacking troops. Some of these defences were site-specific: the Dover Quad, which has an overhanging roof to protect its occupants from strafing, is found only around Dover, and the Essex Lozenge pillbox near Langenhoe is unique to the sea walls of Essex; buried within the wall, its twin-aspect embrasures could fire out to sea, and also inland. Pillboxes were erected at breathtaking speed. One contractor was asked if he would construct 200 coastal pillboxes in three weeks. In Southern Command alone, a total of 1,052 pillboxes were built along the coast, and of these, 247 were the thicker, shellproof type. A standard Type 24 pillbox required 5 tons of cement and 20 cubic yards of ballast. Wooden shuttering for the poured cement had to be constructed on site. Around 6,000 pillboxes still litter our landscapes to this day.

So 1940 was the last time an invasion fleet gathered to attack British beaches. The Luftwaffe's failure to win air superiority convinced Hitler that he should postpone Operation Sea Lion. The defensive strategy of Ironside and Brooke, not so very different to that of Henry VIII, would probably have worked had it been put to the test. When the Royal Military Academy Sandhurst played out the Sea Lion invasion as a war game, German forces were successfully impeded at the various stop-lines and had to surrender after the Royal Navy cut off their lines of reinforcement and resupply.

Sea Lion marked the end of our traditional invasion narrative. The new generation of weapons that emerged from the Second World War took no note of shorelines; the coastal parapet, manned for thousands of years, could be overflown with impunity. Today, pillboxes appear as curious as Martellos and brochs. The exfoliated concrete relics of the early forties are the concluding monuments to a coastal palisade that had been evolving since the Bronze Age. Mute and unloved, they topple down eroding cliffs or lurk in tangles of bramble. I sampled the spirit of pillboxes last year, when night-time rain drove my son and me into an isolated Type 24. We unrolled our sleeping bags and catnapped on its unforgiving floor till dawn. It was an eerie, disconcerting experience and by the time the first light of day broke on the long edge of the North Sea, we both agreed that we'd rather have got wet.

The Cold War brought more discreet structures to the coast. Hostilities were rekindled while the cement of the Britannic Wall was still fresh. Only four years after the German surrender in 1945, the Soviet Union tested a plutonium bomb they named First Lightning, and just a year later, war erupted on the Korean peninsula. Once again, alarm bells rang in the UK defence establishment. Initially, the specific danger was the Soviet Tu-4 bomber, a clone of the American B-29 Superfortress, with a range of 4,000 miles and an atomic payload. Under the codename 'Rotor', the UK government constructed 66 radar sites along two principal coastal chains, east and west. The Faraid Head range control tower I described at the opening of this chapter was once one of those radar stations. Most of the Rotor sites are now derelict or demolished, but at Kelvedon Hatch in Essex, you can still descend into a bunker complex intended to house up to 600 personnel in the event of nuclear war. A similar bunker is open to the public near the old fishing port of Anstruther, in Fife. Yet again, the east coast, the coast that had led the way in herring fishing and trade, found itself on the front line. It's on the protruding shore of East Anglia that nuclear weapons have left their strangest coastal legacy. Between Lowestoft and Harwich, the ribbed shingle of Orford Ness is scarred with concrete pagodas once used to test the firing mechanisms of nuclear bombs. You can take a National Trust ferry out to the Ness from the shadow of Henry II's polygonal castle at Orford. For those interested in migrating birds, nuclear bombs and tranquillity, it's a unique day-trip.

The association of invasion with traumatic regime change is embedded in British memory. Successive landings of Romans, Saxons, Vikings and Normans created the tradition of a violable shoreline; a door that could never be securely locked. Incoming forces bent on momentous causes could land at hundreds of available locations. Henry Tudor's disembarkation at the head of a polyglot force of Lancastrian exiles, French and Scots at Milford Haven on the ragged coast of south-west Wales triggered a chain of events that set the course of modern British history. When William III sailed for Britain in 1688 with an army of Dutchmen, he came ashore at Brixham, in the south-west of England; by April the following year, he was being crowned with Mary at Westminster Abbey. These days, stories of invasions, raids and incursions are revivified by local histories and pageants, reminding all who care to listen that peace on a coveted island is provisional.

The last foreign force to land on British soil arrived off south Wales in four ships at 4pm on 22 February, 1797. It was a glorious evening, the sea was calm and it was, as historian Norman Longmate has pointed out, 'a perfect day for an invasion.' Under the deft leadership of their commodore, Jean Castagnier, 1,400 French troops were ashore by 2 in the morning. Not a shot was fired against the invaders. Perhaps the incursion might have achieved its objective, of taking the ports of Chester and Liverpool and of raising revolutionary insurrection in Britain, if its Chef de Brigade, an equivocating American colonel, hadn't failed to follow the landing with a rapid move inland. But Colonel Tate allowed Castagnier's troops to eat, loot and drink themselves into insubordination and the enterprise fizzled out. Tate is remembered in coastal folklore for being repulsed by Welsh countrywomen who wrapped themselves in their traditional red cloaks and deceived the French into believing they were facing the massed ranks of the English army. A similar tale is told at the Devon port of Ilfracombe, which Tate had passed en route to south Wales. Legend has it that local women led by one Betty Gammon paraded on War Hill above the port, convincing the French that Ilfracombe was thick with redcoats. Redoubtable locals have always been essential to invasion mythmaking; in a later war, they'd be formalised as the Home Guard.

Landscapes have memories. The legacy left by our long history of island defence is the Britannic Wall, this intermittent palisade of peculiar coastal

structures stretching from the Shetland Isles to the Isles of Scilly. Relics of the palisade crop up most frequently on the east and south coast, where we face the European continent, but you can come across them almost anywhere, and often by chance. Out for a run one evening near Brixham, I was following the South West Coast path when I suddenly stumbled (I do a lot of that) upon Battery Gardens, where anti-aircraft guns and a battery of 4.7 inch Naval guns had been sited after the debacle at Dunkirk. More recently, filming on the Hebridean island of Benbecula, I was shown a concrete hut base. Once it had supported the NAAFI for an airfield launching RAF planes against marauding U-boats. One of the most popular coastal ambles on the Isles of Scilly is the two-mile 'Garrison Walk' outside Hugh Town. En route, you pass a 17th century gunpowder magazine, a quaint pyramidal-roofed sentry box in stone, the 16th century Star Castle (seen from above, it is indeed star-shaped), a cast iron cannon, an 18th century battery and a Second World War concrete pill box. And that's not the half of it.

Among the species of man-made structures around our coast, those built for defence have the least consistent architecture; Victorian seaside resorts conform to a pattern, and so do fishing ports and caravan parks. But coastal military structures arise from bizarrely varying templates. Compare, say, the stilted anti-aircraft 'Maunsell forts' in the Thames estuary with Henry VIII's coastal 'Device forts'; the Maunsell forts look like terminally-rusted versions of the Martian fighting machines in H.G. Wells' *War of the Worlds*, while Henry's neat stone forts seem to blend into their promontories as if they'd been designed from the start as visitor attractions. The military relics decorating our coast have relinquished their barbs and opened their gates. Disarmed, they're not disused; coastal catacombs once trembling with discomfort and fear have been transformed into places of interest and calm; parapets once manned by twitchy gunners have become promenades for photographers and picnickers; anti-aircraft sites have been cultivated into gardens. Individually, these structures tell a story about a particular era and a coastal locality; collectively they are a monument to the vulnerability of some highly prized islands.

5.
Salt Water Thieves:
Wrecking and Smuggling

Britain's newest national park includes a section of coastline; that emblematic edge of perpendicular chalk topped by sheep-nibbled baize which rises and falls in waves over the Seven Sisters west of Beachy Head in Sussex. In summer, it is one of the best walks on the Channel coast. But one violent November day in 1822, these cliffs were crowded with spectators who'd turned out in a gale to enjoy a disaster. A wreck wasn't just an opportunity to line your pockets; it was a chance to appreciate catastrophe from a safe distance (other types of catastrophe, like wars, plagues, famines and fires, were too inclusive to be fun). Richard Ayton – the man who provided the text for William Daniell's early 19th-century views of the coast – found himself in the right place at the right time. He was in the neighbourhood when he heard that a Dutch vessel, the *De Jonge Nicolaas*, had run aground near Beachy Head. By the time Ayton reached the clifftop, the ship was barely distinguishable through the surf:

'A great concourse of people from the neighbouring villages and farms had been brought to the spot by tidings of the accident; shopkeepers, great and small, artisans, high and low; farmers, ploughmen, shepherds, and fishermen – everybody, and his wife and children too – all of whom conceived that they had, at least, a contingent interest in the vessel and her rich contents. No one could possible stay at home on so tempting an occasion. Withered and forgotten old women, not seen abroad twice in a twelve-month, emerged into life, and were out in the world again; mothers with infants in their arms, and large families clinging to their aprons – veteran paupers from the poor-house,

stumping about on sticks and crutches – all found time, and strength, and resolution, enough, to join the crowd, on this great day of invitation.'

From the clifftop, they had a clear view of the vessel breaking up 150 feet below. The masts, loosened from below, fell slowly, taking with them rigging and the remains of her tattered sails, then a great wave 'completed her destruction at a blow; it struck her, and she disappeared, scattered into fragments, like a cask with the hoops knocked off; no vestige of her whole bulk being again visible, except now and then a timber-head, sticking up like a black post in the hollow of a sea.'

What followed, even making allowances for Ayton's well-developed imagination (a recent attempt to become a playwright had faltered when no theatre manager in London could be tempted by his 'admirable farce on the subject of Craniology'), was a feeding frenzy:

'On the ebbing of the tide, there was "a rush", as at the opening of the doors at a theatre, for good places or prizes under the cliffs, and we immediately found ourselves amidst the ruinous litter of the wreck. No one asked now – where is she? – She was every where. I never saw a vessel in so short a time so completely broken up. To the extent of a mile and a half, the beach directly under the cliff was strewed, without the clear space of a yard, with her fragments and her cargo. A person not familiar with such sights would have supposed that here were materials for a dozen ships; and the pipes of wine, three hundred in number, lying in clusters of four and five, as far as the eye could see them along the beach, seemed cargo enough to have filled them.'

The casks of wine and brandy were broken open by the mob. Children, and even the dragoons sent to chase off the crowds, drank themselves insensible. At no point does Ayton mention the crew of *De Jonge Nicolaas*.

This wasn't a wrecking on a remote coast far from 'civilization'; *De Jonge Nicolaas* foundered only 60 miles from the centre of London. And the year was 1822. Months earlier, Britain had repealed the death penalty for over a hundred crimes and Charles Babbage had proposed to the Royal Astronomical Society a sophisticated mechanical computer he called the Difference Engine. Less than 20 miles from the rending hull of *De Jonge Nicolaas*, an elegant pier was being built in Brighton, for the appreciation of well-to-do coastal promenaders.

Sussex wasn't just a wreckers' coast. It was thick with smugglers, too. In 1813, the landscape painter Joseph Farington was told that Hastings had 400 fishermen, 100 of whom were also smugglers engaged in running brandy, gin 'and other articles' across the Channel, the temptation being great, explained his informant, because 'that which is purchased in France for 10 shillings could produce in England 60 shillings'. Birling Gap and Crowlink Gap, two of the 'dips' in the Seven Sisters, had long been used by smugglers to convey contraband inland. The year before *De Jonge Nicolaas* struck Beachy Head, a smuggling gang had shifted 300 kegs of 'Holland's gin' through Brighton in broad daylight while the Customs House officers were watching a sporting event.

This was, however, the end of the road for the mayhem-makers of Sussex. In the six years after the wreck of *De Jonge Nicolaas*, a lighthouse was built at Beachy Head, and Parliament repealed nearly 400 Customs Acts. The coast would soon be a much safer place.

Beach scavenging has been second nature to coastal Brits ever since the earliest hunter-plunderers erected bivouacs near our shores. Several years ago, I spent ten days with my family playing Robinson Crusoe on an uninhabited Hebridean island. We had tents, cooking gear and food, but one of the first things we did was to search the island's tideline. Peering behind boulders and scrambling into rocky crevices, we scoured the place. We hadn't talked about doing this. It just occurred, instinctively, as if our sudden isolation from humanity had tripped a foraging circuit. Within an hour or so, we had planks for seats, several lengths of scratchy nylon rope, and 30 or so floats from fishing nets. One of the ropes found an immediate use, securing the tent as it fought to become airborne in a gale that collided with the island that night. Later, the floats were strung by the children onto another rope, to create a 50-foot long beaded necklace. Had we been on that island a hundred years earlier, and come across a wrecked ship, I've no doubt that we'd have torn it to pieces and built a storm-proof cabin.

The ocean is a generous provider, and our archipelago is an unusually efficient receptacle. The incredibly long, intricate coastline works like a gigantic

toothcomb fitted to the lee shore of the north Atlantic. Prevailing westerly winds propel debris for thousands of miles to our shores, where it is sifted and streamed by patterns of bays, headlands and currents, then deposited at the tideline in neat, linear crops. To the nomads who first explored the islands, the foreshore was one of the more fruitful parts of their unexplored landscape. Stalking game, building shelters and lighting fires, they also needed timber and flint, stones for hearths, and rocks for windbreaks. Beaches promised driftwood and fishing, and must have been prime sites for settlement. It's thought that the Neolithic houses at Skara Brae on Orkney, sunk into their middens as if crouching from Atlantic gales, were roofed with whalebone or driftwood. The scavengers of Skara Brae, and countless other coastal communities scattered along the fretted periphery of our prehistoric archipelago, were making use of 'natural' debris: tree trunks, sea beans, rotting whales and so on. These organic leftovers had died in the water, or been torn from distant shores by storms. To happen upon a minke or 60-foot pine was – if you needed building materials – good fortune; they didn't 'belong' to anyone. That changed when the wreckage of ships and cargoes began to get washed ashore.

The coasts of Britain and Ireland could not be more suitable for relieving ships of their cargoes. The west and north coasts are notorious for their reefs; the east and south coasts for their sandbanks. There are tide races that can make a ship go backwards and a whirlpool off Jura that can turn a ship around. And then there is the weather. Sitting in the path of Atlantic westerlies, Britain and Ireland are exposed to barometric oscillations that can deliver a gale on one day, and a clear sky the next. Blizzards and fogs add to the helmsman's challenges. Most ships that founder in our waters, do so through an 'Act of God', the legal term given to an accident caused by uncontrollable natural forces.

Prehistory left no records of coastal salvage. But the habits of millennia gain a momentum of their own; generations of coastal dwellers who had scoured the foreshore for Nature's cast-offs, were superseded by generations who regarded wrecked ships as equivalent bounty. Pots and ingots, planks, splintered masts and loose oars were hauled up the beach and appropriated as if a bill of sale had been concluded. Wreck plunderers overlooked the

distinction between a log and a plank; the sea was a neutralizing agent that dissolved all records of ownership.

I have a confession to make. For as long as I can remember, I've used a weather-beaten oak plank as a shelf in the various studies I've colonized since I started writing books. The plank came in with the tide to a beach in Norfolk. In lugging it for miles along the wind-whipped sand, I thought that I was being a good, green citizen, rescuing a piece of battered timber from biodegraded oblivion. But it turns out that I was breaking the law. Being man-made, my plank falls within the definition of 'wreck material', and according to Section 236 of the Merchant Shipping Act 1995 I should have reported my find to the Receiver of Wreck, whose job it is to investigate the ownership of wreck items, both in the interests of the salvor and the owner. The owner has one year in which to come forward and prove title to the property. In a typical year, well over a thousand reports are sent to the Receiver of Wreck covering items ranging from gold nuggets to watermelons. Anyway, I have now downloaded from the Maritime and Coastguard Agency website the 'Report of Wreck and Salvage', and will drop it in the postbox this lunch time, not without a stab or two of anxiety. Having just spoken to the Receiver of Wreck (who turns out to be an incredibly helpful maritime archaeologist), I have to face the fact that, if the owner of my plank comes forward, I will have to bid adieu the bookshelf, which is of considerable sentimental – and practical – value.

The Receiver of Wreck is the current embodiment of a legislative process that has its origins long before the birth of Christ, when Phoenicians and Greeks formulated 'sea laws' to protect the interests – and lives – of the maritime community. Rhodian sea law (it was developed on the island of Rhodes, in the Aegean) was a practical, regulatory device intended to handle the outcomes of collisions at sea and the obligations of a ship's master to the owners of his cargo. In various forms, Rhodian sea laws mutated across the Mediterranean, but it wasn't until the 12th century that they reached northern Europe as the *Rules of Oléron*. By the time the rules were drawn up, in about 1160, on the island of Oléron off the west coast of France, the plundering of wrecked vessels had become a socially divisive – and legislative – issue. Article XXIX of the *Rules* states that the lords of territory adjacent to the coast 'ought to be

aiding and assisting to the said distressed merchants or mariners, in saving their shipwrecked goods, and that without the least embezzlement, or taking any part thereof from the right owners.'

Clearly, by the 12th century, the appropriation of 'shipwrecked goods' was not uncommon. By this time, boats had been in continuous use around Britain's coast for at least 5,000 years. Together with the gradual increase of ships being used for trading and fishing, there were invasions and wars, which boosted the volume of shipwrecks. It's fair to assume that the broken parts of vessels (and their cargoes) owned by Romans, Vikings, Saxons and Normans were not repatriated. Not voluntarily, anyway.

The sheer quantity of shipping that has been cast onto our shores is staggering. The wrecks of 55,000 ships have been recorded around the coasts of Britain and Ireland, and that of course is not the full tally of lost vessels. When I called Richard Larn, who runs the *UK Shipwreck Index*, he hesitated for a moment, then said: 'Well, if you forced me to make a "guesstimate", I'd say that there are another 25,000 wreck sites, and those are just the ships, not boats.' So, something like 80,000 ships have been lost around the shores of this archipelago.

In seaside bookshops, pubs and tea rooms, you'll find the ghosts of these lost vessels, in framed sepia photographs, in local histories and in the recycled timbers of the buildings themselves. Several years after I did a wreck-dive on a ship called *Missouri*, I was walking the cliffs of Holy Island, thinking about the blizzard on the November night in 1886 when the ship foundered. Nowadays, this rocky corner of Anglesey is part of the 125-mile Anglesey Coast Path, and in many ways it's the high point (literally) of the entire circuit of the island; after the path leaves the beach at Porth Dafarch, it ticks off South Stack lighthouse, then the summit of Holyhead Mountain – the highest point on Anglesey – and then the solitary promontory of North Stack, with its white-painted fog signal station. From the carpark at South Stack, a flight of steps zigzags down the cliffs (keep an eye open on the way for the stone resting place that was hacked from the bedrock for Queen Victoria to take a breather) to the giddy footbridge that straddles the chasm between Holy Island and the storm-battered rock that acts as a perch for one of Britain's more spectacular lighthouses. The lighthouse keepers' buildings

are open to the public, and on one of the walls is a map of North Wales, annotated with shipwrecks. For every wreck, there is a symbol showing the approximate silhouette of the ship, with her name and a date. There are so many wrecks that the cartographer has had to provide numbered keys for sections of coast which are too crowded to accommodate every lost vessel. On the congested western shore of Holy Island '*Missouri* (1886)' is squeezed between '*Mersey* (1894)' and '*Jane and Betty* (1836)'. Totting up all the wrecks littering the coast of Anglesey, I came up with a total of 173; an average of 1.4 wrecks for every mile of Anglesey's coast path. But there are far worse coasts than this.

Larn's database of wrecks reveals that the fantastically rugged, storm-battered coasts of western Ireland and western Scotland are relatively wreck-free, while the greatest concentration lies along the busy trade routes of the North Sea coast, the English Channel and Bristol Channel. The south coast of Cornwall is packed with 23 shipwrecks per mile, while the treacherous Goodwin Sands off the coast of Kent have 28 wrecks per mile. But the most deadly coast of all has been that of County Durham, with a staggering 43 wrecks for every mile of shoreline. You'd think that every beach between Tenby and Tynemouth would be so packed with shipwrecks that it would be impossible to spread a towel for interlocked spars and heaps of hulls. But they've all gone. Or virtually all of them. So, where did they go?

Experiments run by English Heritage have come up with a startling answer. Trials were conducted on the wrecksite of HMS *Colossus*, a 74-gun warship that went down off the Isles of Scilly in 1798. Blocks of wood cut from various species of tree were left at the wreck, and then inspected at intervals by teams of divers. They found that blocks of softwood disappeared entirely after only four weeks; blocks of oak and elm were still there after one year, but heavily bored. The sea is greedy for wood. Larn reckons that within 125 years of a timber ship sinking to the seabed, virtually all the timber would have gone, and after 150 years there would be no timber at all.

There was of course another force at work: human scavengers. Wreckage that reached a beach would always be recycled. On coasts with the highest rates of shipwreck, the spoils of the sea could deliver an annual harvest. The five-fold increase in the tonnage of shipping entering London between 1600 and 1686 was

reflected in a wreck bonanza around the coast of the archipelago. New words made their way into the English language. 'Jetson' (sometimes 'jetsen', and later 'jetsam') was a contraction of 'jettison', and described goods that had been thrown overboard to lighten a ship in distress. 'Flotsam' (or 'flotsen', 'flotson', or 'floteson'), meant wreckage found floating on the surface of the sea. The east and south coasts of England were particular beneficiaries of this surge in seaborne bounty.

Timber ships could disintegrate in minutes. Hulls designed to withstand an even spread of water pressure simply sprang apart if the weight of the ship was suddenly concentrated on a single section through impact with a rock or a sandbar. Richard Ayton saw it happen more than once. The day before he and William Daniell sailed (with hearts in mouths) through a gale into the lethal rocky gullet of Aberystwyth harbour, a Portuguese ship inbound from South America to Liverpool had been caught by the same gale and driven onto the lee shore. After he landed, Ayton found her stranded on a bank of pebbles close to the harbour mouth, 'with one of her sides battered in from stem to stern, and with her masts, and sails, and rigging scattered in dismal ruin about her'. Daniell's aquatint of the scene shows the vessel surrounded by knots of curious sightseers. Three figures are seen peering over the rail of the wrecked ship, as if they have just explored the interior. Close by, Ayton came across a second ship, a small brig from Ireland, which had been wrecked in the same storm. She was, Ayton wrote, 'so completely dashed to pieces, that we saw but few fragments of her remaining'. Although the crews of both vessels had been saved, Ayton records that the cargoes 'were entirely lost'. He doesn't say to whom.

Any wreck was valuable: at the very least, a timber ship provided building material. Cargo was a bonus. In every case, haste was essential. Booty had to be removed before it was dispersed or destroyed by the sea, before anyone else could nab it, and before the authorities arrived. Daniel Defoe seems to have a remarkable insight into the process of wrecking. His extended description of Robinson Crusoe's scavenging trip to his wrecked ship is observed with the eye of a man who had watched – or taken part in – the stripping of a stranded vessel. Crusoe's ship lies on a sandbank, her hull 'bulg'd' and partially filled with water. He swims around the wreck twice, then scrambles 'with great difficulty' up a rope (anyone who has tried climbing a wet, free-hanging rope will

know what he means) he finds dangling from the forecastle. Once on board, he tells his readers that his 'first work was to search and to see what was spoil'd and what was free'. The next part reads like a tick-list for wreckers: Crusoe fills his pockets with biscuits, 'to eat as I went about other things', and he takes a 'large dram' of rum from the master's cabin 'to spirit me for what was before me'. Then he gets down to the business of asset stripping: spars of wood, yards and a couple of topmasts are cut free and dumped overboard so that he can build a raft (the first necessity of a wrecker is a small, manoeuvrable vessel upon which the booty can be loaded); then he finds and empties three seamens' chests which he can use to pack edible salvage: bread, rice, three Dutch cheeses, five piece of dried goat's flesh, some European corn which had been used as feed for chickens kept on board. He also liberates several cases of bottles and 'five or six gallons of rack' (the word comes from arrak, the fermented sap of coco palm, or rice and sugar drunk by ships' crews). He takes clothes to replace his own, and then the carpenter's chest ('much more valuable than a ship loading of gold would have been at that time'). Assorted swords, pistols, fowling pieces, powder horns and a bag of shot are located, and he finds the ship's store of gunpowder and helps himself to a couple of barrels. The inventory is completed with a couple of saws, an axe and a hammer. Crusoe is interchangeable with the father of any impoverished coastal family suddenly confronted with a once-in-a-lifetime chance to stock up with survival kit. As one of Defoe's biographers, John Richetti, has pointed out, Crusoe was an archetype of heroic individualism and self-reliance; the universal survivalist whom we could all admire for his ability to fashion a future from the wreckage of misfortune.

The best harvests were on accessible beaches close to hazards on a busy shipping lane. Over on the eastern side of Britain is one of the archipelago's most innocuous coasts. Most of Norfolk's shoreline is a gentle sweep of soft sand, interrupted here and there by salt marshes and creeks, and backed by low, crumbly cliffs or oceans of undulating dunes. You'll search in vain for anything resembling a real rock. It all looks deceptively innocent. Yet Admiralty Chart C28 is littered with wrecks. They're scattered across Scroby Sands, where wind turbines now turn in the sea breeze; they're strewn over the seabed beyond

Middle Cross Sand; there are too many to count between Winterton Ness and Haisborough Sand. This gentlest of shores is one of the most dangerous in the British Isles. Between Winterton and Cromer in Norfolk, where offshore sandbars have crippled ships for centuries, Defoe was amazed to see that the 'country people had scarce a barn, or a shed, or a stable; nay, not the pales of their yards, and gardens, not a hogsty, not a necessary-house, but what was built of old planks, beams, wales and timbers, &c. the wrecks of ships, and ruins of mariners' and merchants' fortunes'. Walk this coast today, and you won't find any of Defoe's wreck-timbers, although there is one place, on the edge of the dunes at Winterton Ness, where scores of beachcombers (my own family included) have contributed over the years to a fantastical flotsam-and-jetsam beach installation. It stands like a bric-à-brac shrine at the very place where young Rob Kreutznaer staggered ashore after being shipwrecked in the opening pages of *Robinson Crusoe*.

The gulf separating mainland Scotland from the Orkneys was particularly productive since it was the sea route between the North Sea and Atlantic. It was also obstructed by reefs and islands, and swept by ferocious tides. From Duncansby Head you can gaze across the sea lane to the island of Stroma, a low, dark plate at the eastern entrance to the firth. Until 1962, Stroma was inhabited, and so regular were the shipwrecks that plunder became a staple. The same can be said for the coastal towns at the eastern end of the English Channel. Deal and Ramsgate enjoyed a productive relationship with Goodwin Sands, the 10-mile sandbank lying 6 miles offshore, right in the coastal shipping lane. More than 2,000 ships are thought to have been wrecked on the Goodwins. In his *Britannia* of 1586, William Camden refers to coastal folk from Thanet who are 'wont to bestir themselves lustily in recovering both ships, men, and Marchandise endangered'. It's unclear whether Camden is condemning them as wreckers, or commending them as salvors. A century later, Defoe was more definite. When he describes the wrecking of ships on the Goodwins in his book *The Storm*, he records that there were boats in Deal belonging to 'Persons, who made use of them only to Plunder and Rob, not regarding the Distresses of the poor Men'. A contemporary of Defoe, the Reverend John Lewis of St John's Church in Margate, expressed 'a thousand pities' that the men of the

little harbour had grown 'apt to pilfer stranded ships and abuse those who have already suffered so much' – a practice known locally as 'paultring'.

The coast of the West Country has always provided rich pickings, too. A rugged, stormy peninsula that had to be rounded by those sailing between the Channel and Irish Sea, its navigational hazards were notorious. It's often the case that wreckers' beaches are the most incongruous, and this is especially so in Devon and Cornwall where stretches of sand that were once harvest grounds for plunder have become idyllic holiday beaches. Gorran Haven, a delightful little Cornish fishing village with a sandy beach set between serrated cliffs on the South West Coast Path, was the setting during a freezing, February gale in 1838 for a double wrecking. First, a French ship loaded with valuable hardwoods was driven onto the rocks at Chapel Point. Coastguards courageously rescued the crew, but they were still at the wreck site the next day when a second ship, the *Almond*, hit the Gwinges, a lethal reef that lurks a mile off Gorran's sweet sands. *Almond* was loaded with brandies from the Charente, and she burst to pieces in five minutes, but her stern and her cargo were quickly washed to the beach, where – according to the *West Briton* newspaper – 'a regular scramble ensued'. This wasn't surprising, for Gorran Haven's tiny population were suddenly confronted by 300 to 400 casks of brandy. The paper reported that order was restored once the coastguard showed up, but it was a bit vague about the final number of casks that were eventually rolled into safekeeping.

Thurlestone Beach in South Devon is also a lovely spot on a calm summer's day. It's owned by the National Trust who are doing their best to balance the demands of locals and holidaymakers with those of the sea, which is busy eroding this west-facing shore. If you happen to be reading this on Thurlestone Beach, you might be lying on the very spot that was soaked in the warm, crimson blood of a dying wrecker as his vitals were severed by honed military steel. It happened on a Wednesday night in January 1753, and as is often the case booze was involved. A Dutch ship loaded with wine, brandy, coffee and herbs was driven onto the sands. The morning after the wreck, the local landowner's agent rode to the beach and managed to arrange salvage for much of the cargo. But word spread, and by the Saturday the agent reported to his master (to

whom the salvage was due) that 'not less than ten thousand people' had turned up 'from remote parts in order to plunder the remainder of the cargo'. Soldiers were summoned from Plymouth and one of the ringleaders of the wreckers was killed 'by accident … falling upon one of the soldier's bayonets'. This, the agent reported with no evident regret, 'gave a damp to the rest of the rioters'. In the village of Thurlestone, it's still possible to see window lintels that have been cut from 'recycled' ship's timbers. All around our coasts there are buildings constructed in part by shipwrights. Last year, I was filming on Anglesey with geologist Dr Margaret Wood, who told me while we chatted beside some volcanic lavas that beams in her cottage had been linked with a wrecked Armada ship; experts had analysed nails embedded in the timber, identifying them as 16th century and forged in Cadiz. Beach timber is still a staple for coastal communities. Whenever a ship spills a cargo of cut timber, there's a rush for the beaches followed by a building boom in garden sheds and fences.

Off the major shipping lanes, a shipwreck could be a once-in-a-lifetime gift that would be remembered fondly for generations. At its most harmless, a good wreck provided remote coastal communities with an unexpected windfall. The son of the lighthouse keeper on Skerryvore reef remembered that local families lived 'for months … in a style few could enjoy in those days' after an American liberty ship loaded with calico, flour, dried eggs, oranges, plywood and tools was sunk off Mull in 1942. The year before, when the 8,000-ton SS *Politician* ran onto a reef north of Barra in February, the 264,000 bottles of malt whisky in Hold No. 5 attracted boats from all over the Outer Hebrides, and even the mainland. Author Bella Bathurst was told by one of those who climbed into the oily water of the hold, that the sunken ship had been a wartime 'godsend'. It was the broken *Politician* that Compton Mackenzie converted into his wreckers' romp, *Whisky Galore*.

Two factors turned 'innocent' wrecking into murder and mayhem. Alcohol and poverty. The madness that overcomes an impoverished coastal community suddenly confronted by lottery winnings scattered across its beach has been recorded many times. The excess, the hysteria, were peculiar to the event, not the age. The crowd that Richard Ayton saw getting plastered on liberated booze below Beachy Head in 1822 was not an unusual wrecking scene. A few

years before the wreck of *De Jonge Nicolaas*, there was a mass expiry in Cardigan Bay, after a French brig dragged her anchors and came ashore near Penbryn. Her entire cargo was quickly removed by locals, who proceeded to drink it. Seven died from excess alcohol and the Bishop of St Davids was petitioned to educate his parishes in the 'unchristianlike enormity of plundering wrecks'. At around this time too, in January 1821, a ship called the *Rebecca* – of Liverpool – was wrecked in Dingle Bay while sailing from Galway to Dublin with a cargo of wine from Oporto. Twenty pipes and 40 hogsheads of wine reached the shore. In the mêlée that followed, two pipes and six hogsheads were – according to the *Hibernian Journal* – 'staved or plundered by the peasantry', who also stripped the captain and crew of their money and possessions as they staggered ashore. The yeomanry showed up, shots were fired, and one of the wreckers was 'seriously wounded'.

You didn't want to get shipwrecked on the coast of Ireland in the first half of the 19th century. In less than 50 years, the population had leapt from under five million to over eight million, and extreme poverty was followed by the potato famine. There were too many mouths to feed, and a ship strewing cargo across the local beach could make the difference between life, death or emigration. When a barque laden with timber hit rocks off Connemara in December 1832, the *Connaught Journal* congratulated the coastguards for saving the vessel and her cargo 'from two sources of destruction – the ocean and the anxiously expectant populace'.

It was extreme poverty, too, that produced appalling savageries at Streedagh Strandon the coast of Sligo. Today, this is the kind of place that feeds the soul space and peace. Behind the beach are ranges of superb dunes and there are fossil corals in the limestone. When a strong south-easterly lifts a westerly swell, surfers float like absent-minded seals, waiting for their wave. One morning in September 1588, this beach was strewn with hundreds of bodies and the shattered remains of three great ships. If we are to believe the words of one of the Spanish survivors, Streedagh was the scene of a maritime atrocity.

The *Lavía*, *Santa María de Visón* and *Juliana* had sailed with the Armada to invade England, but in the aftermath of their rout in the Channel the three merchantmen were forced to return to Spain 'the long way round', through the

North Sea and along the Atlantic coast of Ireland. On 20 September, they were caught by a huge storm and ran for shelter in Donegal Bay, where they waited anxiously for an easterly wind – a surfers' wind – which would carry them out of the bay. What they got was a westerly gale. Their anchors failed to hold on the sandy bottom, and all three vessels were pulverized on Streedagh Strand.

The locals couldn't believe their luck. Clinging to the disintegrating poop deck of *Lavía*, Captain Francisco de Cuellar was horrified to see that the crowd on the beach were not saviours, but 'enemies who went about dancing and skipping with glee at our misfortune'. Sailors who managed to reach the beach were being stripped and left naked on the sand. Many of the officers and gentlemen were bearing jewellery and coins. De Cuellar himself was wearing a gold chain and had 45 gold crowns sewn into his clothing. Out where the surfers linger, the squadron commander, Don Diego Enriquez, ordered his crew to nail a deck over the ship's boat, and then, with three others and 16,000 ducats in jewels and crowns, he attempted to ride the breakers to the beach. The boat capsized and was hacked open on the sand by the wreckers. Enriquez, recorded de Cuellar, 'expired in their hands, and they stripped him, and took away the jewels and money'. De Cuellar (who escaped from Ireland, after an extraordinary series of misadventures) reckoned that over a thousand men drowned that day. Others were killed on the sand, or died of cold and exhaustion.

More than 30 ships were wrecked on the coasts of Scotland and Ireland as the remnants of the Spanish Armada (or 'the Spanish floating Babel' as the Tudor writer Richard Carew put it), attempted to sail back to Spain. The Armada ships were a wrecker's dream, for this was more than an invasion force. The commander of the fleet, the Duke of Medina Sidonia, was bringing with him an army of occupation, and many on board the 130 ships had their personal wealth with them. The true scale of these riches was revealed when scuba divers recovered treasure from another Armada ship that had been wrecked on the Irish coast.

Benbane Head is a turning point on the 150-mile Causeway Coast Path; the most northerly point of mainland Northern Ireland. Last time I was there, the sea was like glass, and even though it was windless, I couldn't bring myself to walk near the edge of the cliff. But I did want to look at the rocks. Lying on my

stomach, I inched forward until I could see the razors of basalt that project into the shipping lane. *Girona* rounded this headland, probably under oars (she was a galleass, heavily armed and equipped for rowing and sailing), in desperate weather on the morning of 26 October 1588. She was carrying the survivors of two other Armada shipwrecks, and there were 1,300 men on board. Heavily overloaded, she struck the rocks west of Benbane Head. The local Irish chieftain, Sorley Boy MacDonnell, was said to have recovered two chests of goodies and some cannon. But *Girona* withheld her true treasures for another five centuries. It wasn't until 1967 that a Belgian diver called Robert Sténuit was guided to the wreck site by local place names: Spanish Rock, Spaniard Cave and Port na Spaniagh. Sténuit brought to the surface over 12,000 items, including hundreds of gold and silver coins, six gold chains, crosses, rings, 12 portrait cameos of Byzantine caesars and a fabulous gold salamander, studded with rubies.

A few years after the *Girona* went down, when Shakespeare came to write *Richard III*, it was as if he had donned a diving mask and explored the wreck himself: 'Methoughts I saw a thousand fearful wracks;' dreamed Clarence in *Richard III*,

> 'A thousand men that fishes gnawed upon;
> Wedges of gold, great ingots, heaps of pearl,
> Inestimable stones, unvalued jewels,
> All scatt'red in the bottom of the sea.
> Some lay in dead men's skulls; and in those holes
> Where eyes did once inhabit, there were crept,
> As 'twere in scorn of eyes, reflecting gems,
> That wooed the slimy bottom of the deep,'

Wrecks are the tenner on the pavement. What do you do? Take the tenner along to the local police station, or stick it in your pocket? But there was a time when wreckers went a lot further, and caused the owner of the metaphorical tenner to spill his entire wallet on the pavement. It was the 12th-century *Rules of Oléron* that first alluded to deviant wrecking: the premeditated luring of ships towards a coastline, so that their cargoes could be stolen. Those behind this

development seem to have been the very people charged with protecting the lives of seafarers: the pilots whose job it was to guide ships into ports. Pilots, reads Article XXV, 'like faithless and treacherous villains, sometimes even willingly, and out of design to ruin ship and goods, guide and bring her upon the rocks, and then feigning to aid, help and assist, the now distressed mariners, are the first in dismembering and pulling the ship to pieces; purloining and carrying away the lading thereof contrary to all reason and good conscience.'

These pilots are the first proactive 'wreckers' to appear in Britain's documentary waters. Seen at a distance, it seems a totally abhorrent crime, akin to hot-wiring traffic lights for the contents of crashed cars, but in the context of the time, the nobbling of sailors for their cargoes was not an exceptional crime against humanity. Henry II, who was on the throne of England at the time of the *Rules of Oléron*, had cut off the noses and ears of the daughters of Welsh princes (he blinded and castrated their brothers), and his son, Richard I, thought it perfectly acceptable to behead 2,700 Turkish hostages during the Third Crusade. They were beastly times, but nevertheless, the murder of entire ships' crews seems to have been a depravity too far; the *Rules of Oléron* stipulated that local lords caught profiting from a deliberately wrecked ship would be tied to a stake in the centre of their house, which would then be burned about them and turned over to a marketplace for hogs; pilots caught wrecking ships would be hung from gibbets erected at coastal vantage points. The rules made clear that deliberate wrecking was barbarous and ungodly. Practitioners were 'accursed' and 'inhuman', and deserved 'a most rigorous and unmerciful death'.

The threat of being strung up on a gibbet in sight of passing ships did not have much of a deterrent effect, however, for an English charter of 1410 referred to 'evil-disposed persons bringing ships to destruction by the showing of false beacons.' Legislators over the following centuries tried to protect seafarers from their own kind: as late as 1753 – when refined Georgians were discovering the pleasures of sea-bathing – an Act of Parliament had to be passed, stipulating the death penalty for 'any person or persons [who] shall put out any false light or lights with intent to bring any such ship or vessel into danger'. It doesn't seem to have worked, though, because a hundred years later, the Malicious Damage

Act had to tackle the same crime, although by now the punishment was penal servitude, with the option of whipping.

On the wrecking coasts of the archipelago, it's not the Irish, or the men of Norfolk who have come to be associated with ship-luring, but the Cornish. The reasons are several. As is so often the case, the character of the landscape has been transferred to the character of the people. The frequent characterization of the coast of Cornwall as 'cruel', 'wild', 'rugged' or 'merciless' has tended to settle on the shoulders of its inhabitants. And there is no doubt that the county's remote geography, with its own language, Celtic history, mythology and well-documented system of self-governance, has kept it apart from the cultural 'mainland' of England. There's a widespread belief that the Cornish 'are different'. Part of that difference is vested in thousands of years of resilience. It's a hard land, a granite land, surrounded by some of the most challenging waters in the archipelago. The Cornish have had to be resourceful farmers and exceptional seamen. There's no question that both qualities have been applied to recycling wrecks and their cargoes. Back in the early 18th century, the nation's wreck expert, Daniel Defoe, singled out the 'voracious country people' of Cornwall for being the most desperate wreckers in Britain, 'a fierce and ravenous people; for they are so greedy, and eager for the prey, that they are charged with strange, bloody, and cruel dealings, even sometimes with one another; but especially with poor distressed seamen when they come on shore by force of a tempest, and seek help for their lives, and where they find the rocks themselves not more merciless than the people who range about them for their prey.' Defoe stops short, just, of slandering the Cornish as criminal wreckers.

It's the fit between the tempestuous coast and the voracious wrecker that sustains the reputation. The Cornish wrecker was embellished and exported in literature and folklore. As late as 1906 he showed up in Leipzig as the subject of Ethel Smyth's opera *The Wreckers* (Smyth had been born in Sidcup, but had researched her opera on several tours of Cornwall and the Isles of Scilly). It is the extreme immorality of deliberate wrecking that made it so suitable for mythologizing. The image of the cruel, granitic Cornishman waving a lantern from a headland while the master of a storm-tossed ship bears down on fanged rocks under the impression that he is entering harbour, has kept many a reader on the

edge of their seat. Daphne du Maurier's mad Uncle Joss is the archetypal ship-killer, and Jamaica Inn, up on the misty heights of landlocked Bodmin, is the place that has come to symbolize the community of wreckers: the murderers who held shipwrecked women and children under water until they drowned; the entrepôt for the 'death wagons' loaded with brandy and tobacco, 'bought at the price of blood'. I must be one of millions who have pulled into the car park of Jamaica Inn, up on the A30, and bundled squabbling children into the fug of the Smugglers Bar, then sat there vainly searching the summer throng of chip-fed motorists for a face that might fit that of a psychopathic wrecker.

But Cornwall's reputation as a wreckers' county is not borne out by the facts. It does have a particularly wild and lethal coast, which is also the longest of any county in England, and although something like 3,500 ships have been cast onto the shores of Cornwall and the Isles of Scilly in the last 700 years, there are higher densities of shipwrecks elsewhere in England. The basalt-jawed silhouette on the headland with a lantern was concocted by Victorian roman-tics and circulated by Methodist ministers, who used 'wreckers' as examples of sinful souls they'd rescued. Cornish maritime historian Helen Doe takes the view that in Cornwall the luring of vessels to their doom by use of false lights 'has, as yet, to be proven'. Bella Bathurst, who explored the subject thoroughly in her book *The Wreckers*, estimates that no more than one or two per cent of all British shipwrecks were deliberately caused by those on shore. On that reck-oning, around 1,600 ships have been deliberately wrecked around our shores. So it could be worse, unless you happen to have been on one of them.

The Golden Age of Scavenging continued through to the 20th century, when it was boosted by the casualties of war. Eventually, it was not legisla-tion that cut the practice, but the law of supply. These days, the number of vessels wrecked on British shores is down to a tiny fraction of the annual totals of a century ago; over the last ten years of available records, the annual number of UK-registered merchant ships lost at sea is under two. Over the same period, UK fishing vessel losses averaged 27 per year. In 1909 alone, 1,303 vessels were wrecked on the British coastline. Satellite navigation, more reliable engineering and more rigorous training have reduced the likelihood of running a ship onto rocks. On the rare occasions that a ship finds itself in

trouble, services like Trinity House and the Maritime and Coastguard Agency swing into action to contain both the damaged vessel and its cargo.

Wrecks still induce a macabre curiosity. A rusting capstan below a Cornish cliff carries an echo of terror beyond the experience of landlubberish lives. Last year, I was on the beach at Rhossili on the Gower in South Wales. A barque called *Helvetia* was thrown ashore here during a November storm in 1887, and today a few of her ribs still protrude from the sand at low tide, studded with barnacles and rusted bolts. Rhossili Beach is a big place; from the Second World War emplacements up on Rhossili Down, it looks like the edge of the Namib Desert. And these ribs from the lost ship keep drawing your eyes, and your feet. I was one of many that morning to leave a set of footprints that led to *Helvetia's* broken skeleton. And I'm sure that I wasn't the only one who touched her battered timbers and conjured up the hell of that November night. We do like a good shipwreck.

Now and again, the wrecker who lurks within is revived for a spontaneous, mob event. When a ship spills its cargo, the scavengers gather. In January 2007, the container ship MSC *Napoli* was beached in Devon's Branscombe Bay to prevent it breaking up at sea. Containers packed with all kinds of goods from disposable nappies to car parts were washed onto the beach, where – in the time-honoured tradition of wrecking – crowds gathered to liberate the contents. A Mr Gareth Topping described to the BBC how teams of eight to ten men lifted BMW motorbikes out of a container: 'As each one came out the front wheels were put on, then they were taken down to the beach and over the cliffs.' Police Constable Steve Speariett from Branscombe reckoned that around 50 BMWs were removed in one night. The press reaction to the wrecking depended upon the distance of that paper's main office from the beach. In the distant shipping city of Liverpool, The *Daily Post* covered the story under the headline 'Anger as "Mad Max" wreck scavengers loot beaches' while Devon's *Exmouth Journal* ran an interview with a man who'd recovered a new motorbike from the beach, headlined 'Jack bags a BMW!'.

Elegant *Olga*. She's a 100-year-old, gaff-rigged, pilot cutter, 56 feet from bowsprit to transom, with a deep keel and a big spread of four sails. She's fast,

she's manoeuvrable; she can be run onto a beach. She's the kind of boat smugglers used.

We'd been at sea for an hour or so when the skipper, Matthew Senior, pointed to the distant shore of Gower: 'That's Pwlldu!' I stared, then asked Matthew to point again. As the helm swung over, I could just about make out a pale interruption in the cliffs. Pwlldu. A smugglers' beach. As *Olga* sliced through the swell, I began to see the details: a steep bank of shingle framed by bluffs; smothering trees; the roofs of two houses. I stepped over the gunwale into a small rubber boat, and a few seconds later was leaping for the beach. By the time I'd dried my feet and laced my boots, *Olga's* cream sails were sliding from sight behind the headland.

There was a log on the beach, and I sat for a while listening to the tranquillity: the gentle rush of the waves, the cawing of distant crows from behind the trees. Smugglers liked tranquillity; it meant they were a long way from the law. Pwlldu wasn't a big-time smugglers' haunt, but local author Heather Holt has discovered that it was used for a while in the late 18th century by William Hawkin Arthur who ran the most successful smuggling gang on Gower. Contraband was landed at Pwlldu, and at another cove half a mile to the east, then taken up the Bishopston Valley on packhorses. In 1786, 14 Revenue officers surrounded Arthur's headquarters at Great Highway, but they were rushed by 50 or so men armed with weapons ranging from pokers to building bricks, then rolled in farmyard dung. Today, the cove to the east of Pwlldu is labelled on Ordnance Survey maps as Brandy Cove, and the track Arthur used for running his contraband inland is Smugglers Lane. Smuggling has left a far wider imprint on maps than wrecking. It was a local industry that required the repeated use of the same places.

While wrecking is opportunistic, smuggling is premeditated. But both have been viewed as a coastal birthright. Smuggling by coastal folk was a form of fiscal rebellion; a rejection of laws cast by the rich and powerful in distant cities. And it had much in common with the 'social banditry' that historian Eric Hobsbawm defined in his celebrated monograph *Bandits*, as a practice pursued by those 'not regarded as simple criminals by public opinion'.

We have a smugglers' geography. Program a computer to devise an optimal coast for the transhipment of contraband goods, and it would produce an island with a long, sharply indented shoreline, reliably obscured by fogs and squalls and equidistant from a number of overseas trading nations. To activate the computer model, all you have to do is charge a tax – a customs levy – on the import and export of goods. The screen would light up with thousands of hyperactive threads linking the island to its neighbours, each thread representing a shipment beyond the gaze of tax-collectors.

Avoiding taxes and tolls by the clandestine shipment of goods is an old game, and in British waters it must go back at least 2,000 years. Strabo tells us that in the days before the Roman occupation of Britain, the profits from taxes on commercial trade were already so great that there would be no financial advantage to Augustus in invading the island. Even then, there must have been traders who'd opened tax-free routes between Britain and Gaul. Smuggling is the corollary of legal dues. The re-establishment of organized trade under the Anglo-Saxons also provided the motivation to ship contraband. With trading *wics* came officials whose job it was to levy tolls on behalf of the king. One of these officials, a *wic-gerefa* – a reeve or royal administrator – is mentioned in a late seventh-century charter, which has led to the supposition that King Hlothere of Kent was setting up new international trading centres to trade with Frisia. Hlothere's Kentish *wic-gerefa* seems to be the first customs officer recorded in Britain. From a century later, there's a fascinating glimpse of underhand trading practices embedded in a remarkable letter from the Frankish Emperor Charlemagne to his 'dearest brother', the Mercian king Offa. The letter (the first known correspondence between European kings about trade) was written in 796, and includes a passage seeking to resolve complaints about undersize Frankish millstones and English cloaks that were too short. Charlemagne also informs Offa that Mercian merchants are mingling with pilgrims to avoid 'the established toll at the proper places' – an early reference to smuggling. It seems likely that the Anglo-Saxon kings were as vexed by tax avoidance as later rulers, but it wasn't until the heavy tax impositions of the 13th century that smuggling really took root around our coasts.

History has shown that rulers with big ideas can be dangerous. And so it was with the English, when a king with a war habit found himself in need of very large sums of money. Faced with a huge hole in his revenue stream, Edward I turned to England's greatest export, wool, and to the merchants who were making a fortune shipping it across the Channel to feed the Flemish cloth industry. In the April parliament of 1275, Edward imposed duty of half a mark for every exported *sack* (364 pounds) of wool and each 300 wool *fells* (sheep skins with the wool on them), and one mark for every *last* (200 hides) of leather. The merchants took the hit, and the royal finances were £10,000 a year better off. That's around £120 million in modern money. Edward went on a tax-and-spend binge. By 1290, taxes raised from the Church, and from various 'movables' such as animals and corn, were bringing in £117,000 (£1.3 billion today) – up from £82,000 in 1275. No previous monarch had devised taxes on this scale and regularity. Such taxes, as historian David Carpenter has pointed out, had 'the power to transform the king's financial position'. Each time Edward faced a crisis, he raised the taxes; at the end of his reign, he hiked the wool tax fivefold. Merchants derisively labelled it 'maltolt' – 'unjust taxation' – but the wool delivered about £110,000, or £1 billion, to Edward in three years.

The unintended consequence of Edward's tax wheeze was the severance of the coast from its hinterland. For the next 600 years, the shorelines of the archipelago would be another land. Some would say that the coast has never been completely reunited with the state.

Smuggling began as a bankers' crime, but it spread quickly to every port and cove in the land. The king wanted bankers' money; bankers wanted to maximize their take. But the two requirements were inconsistent with creating a governable society. At the time, Edward's bankers were the Riccardi of Lucca, an immensely powerful family from Lombardy, Italy. Edward entrusted the Riccardi with managing the entire system of customs revenues. You have to imagine a current Chancellor of the Exchequer handing over the Inland Revenue to a big high-street bank, to grasp how Edward's bankers were licking their medieval chops. The Riccardi were not caught with their fingers in the till for a while, but as early as 1275, the year Edward imposed his swingeing wool tax, 13 Florentine merchants were fined a whopping £2,877 (£35 million)

for failing to pay tax on 5,743 sacks of wool they had exported to Flanders. They were pardoned by the king, his leniency related perhaps to the huge contribution Florentine merchants were making to his exchequer.

Customs duty would not, of course, raise any revenue if merchants succeeded in wholesale evasion, so a permanent staff of customs officials was created in 13 major ports. Key posts were taken by those most familiar with local trading practices, who happened to be the local merchants. Each of these ports would have at least two collectors. Foreseeing the scope for corrupt practices, each port would also have a controller, whose job it was to watch the collectors. There would also be searchers, a tronager ('keeper of the woolbeam'), clerks, porters and boatmen. Each group of officials would also be responsible for the adjacent coast and smaller ports. As a system, it could not have been more suitable for the fertilisation of corruption.

The story of smuggling is an epic in three acts. The first act opens in the turbid mists of the Thames, in the 25th year of Edward I's reign. A vessel called the *Fynch*, out of Colchester, is slipping down the estuary, bound for Flanders. The shipper is a man called Henry of Arderne. On board the *Fynch* are several consignments of wool. Ten sacks are being shipped for an anonymous trader who has paid Henry 40 shillings per sack (the equivalent of the customs due) to convey it across the Channel. Henry is also carrying some of his own wool, hidden in casks of Rhenish wine. Another of Henry's customers is paying him 20 shillings to export two sacks and a *poke* of wool. The records don't relate how the *Fynch* was seized, but we do know that Henry was pursued for some time through Flanders and eventually ended up in London's Fleet prison, from where he was allowed to ransom himself for a fine of 30 marks, payable in instalments. Henry of Arderne is the earliest English smuggler whose adventures – and fate – are known in any detail. He would be the first of many.

In those early years, most smuggling was conducted as a trading fraud through major ports. The Mr Bigs were bankers, merchants and shipowners; their lackeys were ordinary porters and sailors. The contagion spread with

astonishing rapidity. As early as the 1290s, the king was forced to issue royal writs appointing officials 'to collect, receive and guard' customs revenue at London, Bristol, Hull, Boston, Yarmouth, Ipswich, Southampton, Newcastle and Lynn. Customs frauds at Jarrow on the Tyne had become so outrageous that wool exports were banned altogether. Foreigners made life for the customs doubly complicated: while English ships could be seized and their owners traced, ships from abroad could raise their anchors and sail away. One foreign merchant who had his hides seized at Boston on the Wash had the temerity to purchase a writ of trespass against the customs, and demand the return of his contraband. The repeated requests for advice from Boston officials suggest that foreign smugglers were sailing circles around them. One of the more hilarious escapologists was a merchant from Brabant, whose cargo of leather was seized after a small boat was spotted in the dark making for his ship, which was moored downriver. The merchant's excuse, that he had been sailing from London to Yarmouth, where he had intended to declare the hides had he not landed accidentally at Wrangle, near Boston, was supported by a London jury – who had a record of supporting free trade at the expense of the Crown.

Smuggling through ports required a full palette of criminal aptitudes, from stealth and subterfuge to bribery and retainers. The detention of one Nicholas Curteys in September 1339 sheds a little light on the methods required. The scene of the crime was the Wool Wharf, in London. Curteys had a vast consignment of wool that he wanted to ship to the continent, and so his warehouseman, Walter Gylmyn, engaged a group of labourers to do the heavy work. Under cover of darkness, the men must have spent several hours carrying the woolpacks through the silent streets of the city to the wharf, where they were stacked in three Flemish ships. Curteys assumed that the operation had gone smoothly, for the ships left on the ebb tide. But ten days later an enquiry was being held at the Wool Wharf, and Curteys was accused of smuggling. The first jury was unable to come to a conclusion, but a second jury composed of dockers found him guilty. It seems that the dockers wanted retribution for Curteys' use of unauthorized labour.

Between the ports lay a coastline of limitless possibilities. Tidal estuaries were ideal, and so were navigable river mouths. Sheltered bays offered anchorages where a seagoing ship could idle while being loaded or unloaded onto

boats. On calm nights, ships could even linger off exposed beaches, while long-boats worked as lighters. One of the earliest gangs of smugglers to make use of a discreet precinct of coastal geography operated among the confusing barrages of sandbanks on the northern side of Lancashire's Morecambe Bay. The Cistercian abbey of Furness was both isolated and close to the sea, and for several years in the early 15th century, the abbey's monks used a 200-ton ship to illicitly export large quantities of wool to Zeeland – where wool fetched a higher price than it would at the official staple at Calais.

From the earliest days of smuggling, the 'Costa del Crime' was the Channel coast, between the North Foreland of Kent and the Solent. This was the closest part of Britain to the continent, and its shoreline was a helpful combination of creeks, river mouths, beaches and cliffs. Many of the beaches shelved steeply, which hastened the unloading of seagoing vessels, and the cliffs were invaluable landmarks and lookouts. Inland, a fairly dense population had led to the evolution of a dense maze of roads and tracks ideal for moving contraband from ship to customer. One of the earliest recorded sightings of a smuggling vessel was the discovery in the 1430s of a ship loaded with contraband leather in a lonely creek on the Isle of Thanet. In the early 1450s, the man responsible for watching part of this coast was the searcher based in Poole, a customs official called William Lowe. It's a measure of the accessibility of the south coast that Lowe was able to range along the shores of three counties, from Dorset, along the edge of Hampshire, to Sussex. In the autumn of 1452, he seized a Dutch ship loaded with contraband being smuggled by 15 Dorset merchants. And in 1453, he arrested a ship called the *Jesus* while it was loading a large consignment of contraband wool at the shingle beach at Rustington, a small village a couple of miles east of the sheltered mouth of the River Arun on the coast of Sussex. Lowe seems to have been a highly effective official, but the night he seized *Jesus*, he was intercepted in a Chichester alley by the London wool dealer whose bales he had confiscated. As Lowe recalled later, the wool dealer 'smote me with a dagger in the nose, and through the nose into the mouth'. It must have hurt.

For over 300 years, smuggling developed in a fairly haphazard way around our coasts. Not only did the customs system fail to eradicate the illegal import

and export of goods, but it provided successive generations of smugglers with a flawed adversary against whom they could hone their techniques of free trade. By the middle of the 16th century, smuggling – or 'fraud' as it was then known – was beginning to alter the entire trading economy of the British Isles.

The second act opens in the bustling port of Bristol. It is the 1530s. The wharves are thick with rigging and the polished flagstones rumble and clatter with carts and sleds unloading olive oil and wine, woad and iron. The babble of tongues include Basque, Portuguese, French and Irish. In the warehouses along the wharves are the piles of cloth and lead, leather and grain that make up the bulk of Bristol's export trade.

It sounds like a perfect model of mercantilism. But behind the scenes, the mercantilists were on the make. When the historian Evan T. Jones compared the ledgers of a 16th-century Bristol merchant with the customs records, he made an interesting discovery. The entries in John Smyth's ledger for his exports of lead and cloth matched those of the custom house. But the records for his exports of leather and grain did not. He was smuggling. When Jones looked at the 1544–55 accounts of William and Robert Tyndall, he found that they had been at it, too; according to the customs account, the brothers had exported 160 hides on a Basque ship called *St John*, but their own accounts revealed that they'd actually loaded the ship with 445 hides and 12 dozen calf skins. When Jones applied his forensic skills to John Smyth's ledger for February 1541, he discovered that fraud extended beyond the merchants. Smyth had his own ship, the *Trinity*, which he had licensed to carry 100 quarters of wheat, and yet in February he had loaded it with 306 quarters, together with 180 quarters from a merchant called Francis Codrington. Another 18 quarters had been loaded by the ship's master. The total cargo of wheat on board *Trinity* was five times larger than the customs had licensed. Included on Smyth's accounts were payments in cash or kind to four men, three of whom have been identified by Jones as customs searchers. Smyth was paying bribes, too. As Jones points out, Smyth was running what appears to be a regularized smuggling business, with profits in the fraud being shared among merchants, mariners and customs officials.

Smyth's meticulous ledger for February 1541 also records that he loaded 70 ox hides, 101 cow and steer hides and 127 dozen calf skins, none of which had cleared customs. In all likelihood, he loaded his vessel out in the Bristol Channel, beyond the sight of prying eyes. Implicated in the operations of Smyth and the Tyndall brothers were, concludes Jones, 'at least five customs officials and 32 merchants, ship's masters, and suppliers from Bristol, Gloucester, Caerleon, and the upper reaches of the Severn estuary.' Equally astonishing is the status of the characters involved: 12 of them were sheriffs, mayors or Members of Parliament. The reason, of course, was money. It's virtually impossible to put figures on the profits from smuggling, but Jones reckons that Smyth's net profits on grain exports were between 50 and 150 per cent, and on leather, 84 per cent. To Smyth and the Tyndalls, the economics were a no-brainer: the direct costs of exporting grain and leather legally were 20 times more than the cost of bribes. Smyth was a fairly typical merchant. Jones concluded that during the 1530s and 1540s, smuggling in Bristol was 'an extremely profitable, large scale, and highly organized business, which was responsible for the great bulk of export profits'.

Over on the other side of the kingdom, things were just as bad. In the 1950s, when Neville Williams researched his inestimable history of smuggling, the most culpable provincial port to emerge from the Tudor mists was the entrepôt at the mouth of the far-reaching Ouse. 'Of all the outports,' decided Williams, 'King's Lynn was at this time the worst.' During his archival excavations, Williams was able to identify Lynn's Mr Big, a very bent merchant called Francis Shaxton. Like so many of the top smugglers, Shaxton's past is murky. In 1565, he had been a searcher and sealer of all the worsted cloth being manufactured in Lynn. Thereafter, he seems to have turned his energies towards the port's staple trade, corn, which he smuggled to the continent with great success. Everyone in Lynn was playing the game. One of Shaxton's partners in crime was a customs official called Thomas Sydney, who shipped at least four cargoes of contraband corn with Shaxton in one year alone. Robert Daniel, the customs searcher at Lynn, charged a fixed rate of £3 (or £650 in today's money) for cargoes to be smuggled from the port. Richard Downes, a sacked customs clerk, sneaked into the Lynn custom house, borrowed the seal of the port for long enough to have a cast made

by a Dutch goldsmith, and then set up his own shadow custom house which issued counterfeit receipts ('cockets') and customs clearances. The customs controller, William Ashwell, seems not to have noticed that Downes was running a duplicate custom house. But then Downes was Ashwell's son-in-law.

For Lynn's merchants, dodging customs was second nature. When the inevitable enquiry was called by the Exchequer Court, who couldn't help but notice the pitiful revenues being collected by one of the busiest ports in England, it transpired that Shaxton had bought at least 120 of Downes' blank cockets (Downes was charging 13s. 4d, or £145.00 at today's value, for each forged document). Shaxton also admitted that whenever he registered a coastal shipment, he would send the cargo abroad. One of his fellow merchants, James Bourne, confessed to running smuggled goods to Amsterdam and Calais. The profits were considerable. Oliver Dawbeney sold a single shipment at Antwerp for £500 – or £109,000 in today's money. Williams reckons that 16,000 quarters of smuggled corn left Lynn in the summer months of 1565. As Jones found in Bristol, smuggling was no bar to civic recognition. Shaxton, the most successful east coast smuggler of his generation, the owner of at least five ships, was twice elected Mayor of Lynn.

The evidence strongly suggests that smuggling was endemic in Britain's provincial ports during the 16th century. London was included. By the 1560s, cloth had replaced wool as the staple English export, and in 1565 Sir William Cecil, who as Master of the Court of Wards and Liveries had responsibilities for the collection of royal revenues, orchestrated a swoop on the office of the surveyor of customs on cloth exports. In eras before the office shredder and 'delete' key, the fraudster's friend was the wax taper. Cecil had ordered seals to be fixed to the doors of the surveyor of customs, so the surveyor, Thomas Coleshill, instructed his 'young and slender-hipped' servant John Horneby to scale a ladder and squirm through the window of the room containing the incriminating documents. The bonfire of the documents was so ferocious that the building almost burned down. Young Horneby was sent to Italy for a couple of years, beyond the reach of investigators.

The Coleshill affair symbolized the systemic inability of the customs operation to collect revenue, and the full span of its capacity to corrupt, sucking in

all from local fishermen looking for occasional tips to officers of state. The Elizabethan data-gathering machine helped to embed smuggling at the core of the country's economy. Money could be made with minimal exertion by adjusting numbers in columns.

Where Tudor protectionism had fostered a culture of fraud in the ports, events of the following century encouraged a viral conversion to smuggling around the entire coast of Britain. To grow as an economic force, smuggling needed increased state intervention and a boom in international trade, which is just what happened through the 17th century. Customs duties increased and so did the variety of taxable goods available to European consumers. For centuries, British smugglers had been making money from the export of wool, grain, leather and lead, but the 17th century saw a boom in home demand for all kinds of fabulous foreign luxuries, from tobacco and brandy to tea and silks. Smuggling became a contraflow operation, conducted on a massive scale by organized gangs. Shifting cargoes of contraband at night between shore and sea – and vice versa – required cunning, boats, horses, communications, substantial manpower and organizational ability. Individually, smugglers had to be able to sail, trade and fight. As Williams puts it, the 17th century saw the emergence of 'the new model smuggler.'

In reality, it was an ugly business. Smuggling was a gang operation; mutable knots of freetraders attracted every colour of humanity, from well-to-do merchants and seasonal fishermen to jailbirds and local psychopaths. Some saw smuggling as a coastal birthright; the exercising of their free will to trade. For others it was the quickest way to build a new house or ship. For many, it was the only way to feed the family. Whole communities were sucked in. On Folkestone Beach, smugglers' wives pelted officials with stones when attempts were made to round up the masters of seven ships caught smuggling wool to Calais in 1669. Within the customs service itself, corruption was contagious. When in 1682 the Board of Customs completed an investigation into corruption in the major ports between Swansea and Poole, they found officials in every port they visited were making money on the side from smuggling.

Having unleashed an economic reaction that lay beyond its control, the state attempted to maintain its grip on the coasts by launching new countermeasures.

'Land-waiters', whose unenviable – and largely ineffectual – job it had been to intercept smugglers on land, were supplemented in 1680 by customs cutters that would sail the coasts on the lookout for suspicious ships. Initially, there were only ten cutters to cover the entire coast of England and Wales, but it marked the opening of a much deeper battlefront, on water as well as on land. To intercept smuggled goods that had slipped past the cutters, a mobile force of riding officers was created in 1698. Initially there were just 290 officers, concentrated along the 'smuggling coast' of Kent, Sussex and Hampshire. Each man was designated 4 miles of coast to cover, and had to patrol on horseback up to 10 miles inland, by day and night. The officers were armed, and expected to keep a log of their investigations. In one of the more comical sequences I've filmed for *Coast*, I was put on a horse on the cliff paths of Gower, in South Wales, to re-create the routine of a riding officer. The horse, a genial performer from a local riding school, behaved perfectly, and the riding above Three Cliffs Bay was sensational. But if I'd been up there three hundred years ago, alone and at night, waiting for the crunch of boots and laboured breathing of armed smugglers climbing the cliff, I'd not have been as relaxed. Some time after Riding Officers were formed, the Customs Commissioner, Sir William Musgrave, complained that some of them were 'agents and collectors for the smugglers and … not resolute enough to prove any serious obstacle to large bodies of armed smugglers'. Sir William, presumably, had never spent a night alone on a clifftop in Kent.

Fast, manoeuvrable smuggling vessels began to evolve, crewed by outstanding seamen. The front line was still the south coast of England, less than one day's sailing from the continent. In the centuries since Edward I's tax initiative the customs dodgers had learnt how to use the only two major headlands between Dover and Portsmouth. The low-lying shingle spits of Dungeness and Selsey Bill extend a good 5 miles into the English Channel. The wonderful air of seclusion you can still enjoy at Dungeness (and less so at Selsey, now that it's been part-colonized by housing) was valued by smugglers for another reason: out on these headlands, they could trade undetected. The tip of Dungeness Point is only 27 miles from France.

Behind Dungeness, Romney Marsh was the main breeding ground for Kent and Sussex smugglers, or 'owlers'. The origin of the name is obscure, but it's

probably a corruption of 'wooler'. The marsh was covered with sheep, and once they had been shorn each spring, it was reported that 3,000 woolpacks would be shipped out of Lydd and Guldeford, and 'sent off hot into France'. In the 1670s, 20,000 packs of wool were being shipped from Romney Marsh to Calais every year. The entire marsh seems to have been a smugglers' sanctuary, while its towns acted as smugglers' administrative centres. Lydd and Guldeford were reported to be entirely populated by smugglers. In 1688, the Mayor of Romney released ten men who had been caught by the persistent investigator William Carter as they carried wool on horseback through the marsh. Later that night, Carter attempted to interrupt another smuggling operation in Lydd, but was chased all the way to Guldeford Ferry by a mob of 50 owlers. Being pursued by a criminal gang across the empty marsh must have been terrifying. Carter was saved by boatmen at the ferry. Had they not 'took us in', he related later, 'we might have been destroyed'. Dungeness was lawless. In 1692, 14 of the Mayor of Hythe's men attacked customs officers who had seized wool from one of his barns. At his trial, the mayor succeeded in convincing the jury that the wool had been intended for 'some other part of England', and he was acquitted.

Selsey Bill was no better. Back in the late 17th century, Selsey was as indifferent to tax regimes as the Cayman Islands are today. Selsey was a virtual island, and its notoriously difficult relationship with the sea gave it an edginess that unnerved visitors and attracted smugglers. A Selsey farmer was reputed to have pocketed a profit of £10,000 (£1.5 million) in six years of part-time smuggling, and one local skipper ran a weekly ship to France and back for five years. So many smuggled goods were arriving at Selsey that a column of wagons left for Sussex every night. Selsey's inhabitants bragged that it was 'the best spot of ground in England for the smuggling trade'.

By the early 18th century, another tipping point was approaching.

The third act opens on Scotland's eastern edge, in the park-like kingdom of Fife, whose low, sheltered shores have proved so popular among prehistoric foragers, golfers, scholars and flyers. Out near Fife Ness, you come across a calm, inscrutable port called Anstruther, known among discerning travellers

for its excellent fishing museum and affordable yacht marina. Transplant Anstruther to Cornwall and the August airs would be sticky with dairy ice cream. But because it's in Fife, it's a secret. That is one of the reasons smugglers liked it too.

On 9 January 1736, a baker called Andrew Wilson was enjoying a drink in Anstruther with two 'associates' and an Edinburgh innkeeper called George Robertson. The four men were – according to the *Historical Antiquities of Fife, Vol II* – engaged 'on one of their smuggling expeditions'. After concluding their business in Anstruther between 10 or 11pm, the four men rode along the coast to the neighbouring fishing village of Pittenweem, where they repaired to Widow Fowler's inn for more drink. While there, they were told that the collector of customs, the supervisor of excise, and their clerk, were all sleeping upstairs. Wilson – who had 'suffered much' from seizures by revenue officers – 'formed the mad design of reimbursing himself, by robbing the Collector'. While Robertson waited at the foot of the outside stairs, cutlass drawn, Wilson stove in a panel on the bedroom door. The terrified collector of customs jumped out of the window in his nightshirt, and the smuggler helped himself to about £200 – around £29,000 in modern money.

Like so many of the smugglers who made it into the history books, Wilson was a fairly inept criminal (the smart smugglers were never caught – or recorded). The baker was arrested in bed next morning, surrounded by the stolen money. With word spreading of their arrest, Wilson and Robertson were locked up in Edinburgh's Tollbooth. Facing the death sentence, the two men tried to escape, having cut through the window bars with a smuggled saw. But Wilson, 'a burly man', we are told, became stuck in the window. In the church, on the way to the gallows, the two smugglers tried again, and this time Robertson – aided by the crowd – sprinted free while Wilson held onto three of the guards with his arms and teeth.

Wilson was strung up in Edinburgh's Grassmarket and hanged. For most other criminals, that would have been the end of the story, but Wilson was a smuggler; a local hero. Stones were hurled at the executioner and the troops. The commander of the guards, a Captain 'Jock' Porteous, panicked and ordered his men to open fire. Flintlocks crashed and the Grassmarket filled with smoke and

screams. Then the soldiers reloaded, and fired again. Several of those who were killed or wounded had been shot more than once. Charles Husband, a servant at Holyrood House, was shot in the brain, neck, body and left hand; Archibald Ballantyne was shot several times in the head and body; John Anderson, a drover, was shot in the head and body; Edward McNeil was shot in the head; Margaret Gordon, a servant, was shot in the head. Seven are thought to have died and a dozen or so wounded. In the words of the prosecutor, all had been 'maliciously slaughtered'. Porteous was sentenced to death, but when rumours of a pardon began to circulate, a vast crowd of Edinburgh's citizens (one report puts the figure at 4,000) broke into the Tollbooth, dragged Porteous through the streets in his nightshirt, and hanged him from a shop sign in the Grassmarket.

A spot of local retribution by a drunken smuggler had led to eight deaths, 12 injured civilians, and a major civil insurrection. Nobody was prosecuted for murdering Captain Porteous, or for breaking into the Tollbooth. Westminster was outraged but did not have the nerve to confront Scottish public opinion. Eventually, the city of Edinburgh was fined £2,000 (around £300,000 today), which was paid as a pension to Porteous' widow.

The 'Porteous Riot' of 1736 marked the beginning of a new era. From the early 18th century, high duties on the import and export of goods, together with a deluge of prohibitions and trade controls, converted countless coastal communities to smuggling – organized by gangs with an increasing capacity for extreme violence. Stealth was replaced by armed confrontation as smugglers outnumbered, outgunned and outwitted the excise men. As the authorities attempted to counter a tsunami of coastal crime by passing new laws and policing the ports, the smugglers utilized thousands of miles of deserted shoreline. The geography of smuggling altered from one of hot spots to an unbroken crime zone. The nature and volumes of contraband changed too. By the mid-18th century, the smuggling of wool and spirits was dwarfed by tea smuggling. For the coasts of the British Isles, this was another transformative moment. Historians have called the 18th century the 'golden age' of smuggling.

You could put your finger on virtually any section of our coast and find a blood-curdling smuggling story from the 18th century. The coasts of the south-east had become a no-go perimeter. The East Anglian coast was terrorized by

smuggling gangs who could muster teams of 80 men on a beach. Contraband being shipped up the Yare to Norwich would be protected from excise men by villagers armed with cudgels and pitchforks. The customs officer at Aldburgh nearly lost an arm to a smuggler's sword, and when a couple of officers from Yarmouth boarded a Dutch brigantine loaded with brandy, the ship made off for Holland and the two officers were never seen again. When three smugglers from Ipswich were finally caught in 1733, they were sprung from their cell by fellow smugglers.

In Ireland, disrespect for British customs duties was even more extreme than it was in Scotland. Smugglers were the creative wing of the nationalist cause. Custom houses were broken into so that seized goods could be recovered, and the locals, unsurprisingly, could seldom help the authorities trace the perpetrators. Informers met grisly ends. In Kinsale, a man who accused a sea captain of shipping woollen cloth illegally to Portugal was murdered by a group of unemployed weavers from Cork. It was in Cork, too, that a meddling customs officer was led with a halter around his neck through the streets to the Cork Exchange, where the smugglers cut out his tongue and nailed it to a door. The smuggler who related this grisly episode had been brought in 1745 as a witness before a British parliamentary commission. For nine years, he had run wool to France and brought back brandy, tea, gin and cloth. He claimed that one Breton sloop carried over 1,000 packs of wool (240 pounds in each) to France every year, from small coastal villages near Cork. The authorities were virtually powerless. Customs officers were killed, terrorized or bribed. After the captain of a 20-gun ship called *Salamander*, stationed at Cork to intercept smugglers, was presented with a handsome gold box he allowed his seamen to help run the wool. In another case, an Irish smuggler was dismissed by a jury on the grounds that he had violated an English law, not an Irish one.

Occasionally, disrespect took a comical turn: in July 1735, the *Dublin Evening Post* reported that a custom house officer had seen a suspicious-looking man carry a cask into the vaults of St Mary's Church. When the officer returned with back-up in the form of several fellow officers, a constable and a gauger, the sexton reluctantly admitted them to the vault, where the

gauger pierced the cask and 'tested the liquid matter ... and declared it was fine rum'. The sexton ventured otherwise, and suggested that the customs officers open the cask. They did so, and, 'to their great disappointment', discovered that the cask they'd tasted contained the bowels of a man who had recently been embalmed. At the distance of three centuries, you can still hear the smugglers guffawing behind the gravestones.

Smuggling gangs had come to Wales, too, with Aberystwyth the entrepôt for Irish contraband. The revenue were outclassed; if they boarded a ship at Aberystwyth, 'great gangs of smugglers generally came in the night to the number of forty or fifty in a body, went on board, locked up the officers in the ship's cabin, and then unloaded the goods'. So organized were the smugglers of Swansea that they were able to arrange for customs officials to be summoned for jury service while contraband was run into the harbour.

On the coast of Kent, smuggling gave rise to specialized boat-building. The Kent smugglers realized that the best way to outrun revenue cutters was to carry their contraband on windless days (and nights) aboard very fast rowing galleys. Known as 'centipedes' and fitted with up to 24 oars, these lightweight beach-launched boats could cross the Channel in as little as a couple of hours.

The south coast of England was almost lawless. One of many spots to contemplate the changing of times is the Custom House café on the quayside in the old trading quarter of Poole. From an outside table, you can sit in the sun and watch the ebb and flow of harbour life. The café itself occupies the ground floor of the old customs and excise building, whose ruddy, symmetrical facade and double sweep of steps impose a sense of order – as its Georgian architect intended – over the somewhat chaotic comings and goings of street and quay. To one side are the 15th-century walls of a stone-built woolhouse, and on the other, the topsides of various moored vessels. In front of the café tables is a replica of the 'staplecross' or 'town beam', once used for weighing cargoes. On the far wharf, Sunseeker motor yachts are parked to catch the eye of passing bankers.

The custom house was built in 1813 to replace a building that had suffered an infamous humiliation. On an October night in 1747, 30 or so smugglers carrying swords and firearms clattered along one of the alleys that still cut through to the quayside. Inside the custom house was 2 tons of tea, 39 casks of

brandy and rum, and a small bag of coffee – all of it seized the previous month when a cutter called *The Three Brothers* had been intercepted in the Channel. The smugglers wanted their booty back. They forced their way into the custom house, loaded their horses, and made off into the night. The custom house raid at Poole was incredibly brazen. But it didn't end there. Many of the smugglers belonged to the Hawkhurst Gang, and they had a reputation to uphold.

The story of what happened in the aftermath of the Poole raid is recorded in the stark legalese of a court transcription dated 17 January 1748. The jury heard that Daniel Chater, a shoemaker from Fordingbridge, and William Galley, an excise man, were riding from Southampton to Chichester so that Chater could testify against one of the Hawkhurst smugglers who'd taken part in the Poole raid. But when the two men stopped at a public house called the White Hart at Rowland's Castle, the proprietor, Elizabeth 'Widow' Paine, suspected that Chater and Galley 'intended some Mischief against the Smugglers', and she tipped off the Hawkhurst Gang. Seven of the gang strode into the pub, led by William Jackson. From that moment, Chater and Galley were doomed. They were forced to climb onto the same horse, then had their legs tied beneath the horse's belly. As the horse began to walk down the road, Jackson shouted: 'Lick them! Damn them! Cut them! Slash them! Whip them!' A blizzard of pain slashed Chater's and Galley's bodies as they toppled from the saddle, so that their heads dragged along the road. They were hauled back into the saddle, and a second time lashed by blows. Again, they slipped beneath the horse's belly. Now each man was tied onto a separate horse behind one of the smugglers, while the others battered them with the butt ends of whips, which were filled with lead. Galley fell again, and was now thrown over the pommel of the saddle while the beating continued. Eventually, the excise man hit the road for a final time, and died. His body was buried in a fox earth the next morning. Chater survived another two days, chained to a beam in an outhouse used for storing lumber and fuel. On the evening of the third day, the gang took the shoemaker to a disused well, tied a rope around his neck, and suspended him from a railing for 15 minutes, then turned him over and dropped him head first down the pit. When one of the smugglers thought he detected the sound of Chater breathing, they dropped stakes and stones down the well. The two bodies were

found seven months later, Chater's being identified by his wife. She recognized the belt on his trousers.

When two of the Hawkhurst Gang, Thomas Kemp and William Grey, were brought to trial they refused to concede that smuggling was a crime, although they agreed that robbery was illegal. Another member of the gang, James Bartlett, admitted that he had been a smuggler for many years, 'but did not see any great crime in that'.

One of the Hawkhurst smugglers died in jail the night he was sentenced, and the other six were hanged and their bodies strung in chains from gibbets at prominent spots on the roadsides as a deterrent to other smugglers. Two of them were strung up on Selsey Bill, so that they could be seen from passing ships.

The hanging of the Hawkurst Gang was widely publicized, as were the gory details of their crimes. A wedge was tapped into pubic opinion, separating informed moralists from inveterate smugglers. It was hard to sympathize with the torturers of Chater and Galley. Smugglers became an obvious target for the peripatetic evangelist John Wesley, whose God-fearing sermons were drawing huge crowds in England's cities and towns. In Cornwall, Wesley found plenty of lost, coastal souls. Today, you're not likely to get pelted with rotten eggs and stones in St Ives (although a seagull nicked my pasty last time I was there), but that is what happened to Wesley when he preached to the locals about the 'detestable practice of cheating the King'. But the smugglers were being elbowed into the societal undergrowth.

It was at this time, too, that the forces ranged against the smugglers were buttressed by two new services that would come to symbolize a new moral code for the coast. The Preventative Water Guard was formed in 1809 to coordinate with customs cutters at sea and with riding officers on land. Using oared gigs and galleys based at 151 stations around the coast, their role was to prevent the running of contraband, but they were also given responsibility for saving lives should a ship be wrecked in their district. The Water Guard was also an anti-wrecking force, tasked to 'ensure that none of the cargo of the wreck is run or secreted in any manner so as to evade payment thereof'. Funded from the end of the Napoleonic Wars by the Treasury, its weakness was a lack of training and organization. Among those who felt that the Water

Guard was not effective enough was a Captain John McCulloch of the Royal Navy, who had noticed that the Kent smugglers tended to wait for bad weather – when the water guard would be indoors – before running contraband in their fast galleys. McCulloch, who accused the Water Guard of indiscipline and connivance with smugglers, proposed to the Admiralty a new force, the Coast Blockade, which would set an armed cordon along the coast. Based in Martello towers and secure watch-houses on the coasts of Kent and Sussex, 'the Warriors' – as they quickly became known – were aggressively efficient. In Rye, they intervened in a deal struck between customs and smugglers, and seized an entire consignment; in Deal, they were reported to have driven smugglers from 96 houses. Confrontations with the Coast Blockade tended to leave blood on the beach. In Herne Bay, a midshipman lost his life after confronting 60 smugglers unloading brandy and gin. Three months later, a running battle developed at Margate, the flashes of gunfire seen 'along an immense line of coast'. By the end of the battle, three sailors and a midshipman had been wounded. The toll on the smugglers was never verified, but the quantity of blood along the route of the battle suggested that some had been 'severely, if not mortally, wounded'. Two months later, an even bigger battle took place at Sandgate, just outside Folkestone, when 400 smugglers were spotted by the duty seaman of the Coast Blockade. The master-at-arms, a Thomas Moore, led five seamen in an attack on the smugglers, and was shortly reinforced by an Admiralty mate called Lowry and three more seamen. In a fierce firefight, the little troop drove the smugglers inland and secured the ship, although Lowry ended up with a ball in his thigh, and two seamen were also wounded. Eleven smugglers were thought to have been killed during the battle, with a further two dying later from wounds.

In taking the fight to the smugglers, the Coast Blockade had crossed a line in the sand. Running firefights in English seaside resorts were not popular with the navy, or with the locals, many of whom had been supported by smuggling from birth. In 1831, 'the Warriors' were abolished, a measure, sighed the *Sussex Advertiser* with evident relief, 'the reverse of one calculated to excite regret in this part of Sussex'. In the naval dockyard of Devonport, the local paper's parting shot at the Coast Blockade was to insult it as 'a most obnoxious service'.

The bloody night-time battles created a new organization. In a government report of 1821, the Water Guard and Blockade had been commended for being the 'two most important and effective' organizations to have confronted the 'flagrant degree of audacity and violence shown by the smugglers'. The Preventative Water Guard, their cruisers and the riding officers were amalgamated into a new force called the Coast Guard, to be controlled by the Board of Customs. And on their abolition in 1831, the Coast Blockade became part of the Coast Guard, too. It would take time, but the Coast Guard would develop into HM Coastguard, the organization that has come to represent safety and order around our coasts – the unintended consequence of the interminable struggle against tax dodgers.

The life story of one particular seafarer neatly encapsulates the twilight years of the smuggling economy. His name was John Rattenbury. A few years ago, I was looking for a secluded coastal nook for the weekend, and picked Beer from a map of South Devon. It was out of the way, small, flanked by cliffs, it lay on the coast path and it had a delightful inn. Perfect for me, and for John Rattenbury, who used it as a bolt hole between innumerable smuggling adventures. Rattenbury was unusual. Not only did he commit his life to print, but his career as a smuggler marked the end of contraband's golden age. Born in Beer in 1778, Rattenbury kept notebooks that were used to compile his *Memoir*, published in 1837. It's a fascinating little book, packed with madcap escapades as our hero catapults between smuggling runs, piracy, gunfights, shipwrecks, sea battles, chases with revenue cutters and several arrests. The pages reek with gunpowder and brandy, and there's more than a whiff of Daniel Defoe. But towards the end of the book there are hints of a man in search of absolution. Rattenbury eventually retires to Beer, with a wife and four children, and takes over the public house. While not exactly a Damascene conversion, we're asked to trust that John is essentially a good man. The reformed Rattenbury watches from the cliff above Beer for ships in trouble, and then sails out to offer his services as pilot. He saves ships, and lives. But the debts pile up, he can't make ends meet, and so he goes back to smuggling, running contraband between the Channel Islands, France and the West Country. John's final smuggling trip is thwarted outside the Devon village of Newton Bushel, when riding officers

intercept him as he's carting 20 tubs of brandy. He escapes into the night, and turns for good to fishing and piloting. 'Thus ended my career as a smuggler,' he writes, 'a career which, however, it may be calculated to gratify a hardy and enterprising spirit, and to call forth all the latent energies of the soul, is fraught with difficulty and danger.'

Although Rattenbury's *Memoir* has been seen as a 108-page confession, at no point does he suggest that he is 'bad', or 'criminal'. His lifelong adversary is not the king, or the state, but 'those indefatigable picaroons which everywhere line our coasts'. The activities of the customs have been a pesky, 600-year blip on the smooth running of free trade. 'Rob Roy' Rattenbury (as he calls himself on the title page) could see already that smugglers had won the war. By the 19th century, Wesley's Methodists had brought God to the coast, and Adam Smith's *Wealth of Nations* had brought free trade to the ports. In 1826, nearly 400 Customs Acts were repealed. Smugglers had cheated the state of unquantifiable revenue, but in doing so had showed how free-market economics could put Britain at the centre of the largest empire the world has ever seen.

They left in the night. Six centuries of wraiths melded into the moonshadows. They didn't really leave, of course. They're still out there, imagined and real. Whenever I find myself at a twilit cliff or creek, it's not hard to hear the rattle of hemp in a block or the sighs of loaded horses. A few years ago, I spent a couple of days exploring the inner reaches of Carrick Roads, alone in a small, open sailing boat. At night, I nosed the boat into a creek, dropped the anchor, unrolled my sleeping bag and lay on the hull-boards while the tide ebbed and flooded. It was one of the creepiest, thrilling nights I've spent under the stars. I seemed to wake every hour, peering over the gunwales at the dark trees climbing above the creek, an ear cocked for the creak of rowlocks.

The sea smuggler of old has become part of our coastal imagination, romantically packaged as a social bandit rather than despised as a murderous cheat. His restitution as an aquatic Rob Roy was hardly necessary, since there will always be a constituency ready to support the flouter of centralized taxation. 'I like a

smuggler,' wrote the essayist Charles Lamb, long after the Hawkhurst Gang swung from the gibbet. 'He is the only honest thief. He robs nothing but the revenue, an abstraction I never greatly cared about.' Smuggling exaggerated the sense that society itself was an island, surrounded by a 'coast' which bore little relation to the mores and laws of inland communities. Sailors, with their tradition of fishing and trading, wrecking and saving, and of being first to be called to the fleets, were not like those who worked the land or kept account books. The men of the sea were a breed apart. Smuggling moved them – and the coast – even further from the centre.

The wraiths have left an architecture that is everywhere and nowhere. Which coast paths have not been trodden by a smuggler? Which caves never used to conceal a tub or two? How many of the quaint cottages between Rye and Fife were beds for men-of-the-night? Folk tales and smuggling rumours infest every coastal village. They left little architecture of their own; they were like pilot fish; they fed off the host. The structures they used were part of the landscape. The Gower cave I abseiled into recently was walled in the Middle Ages to create a pigeon loft, but the locals will tell you that it was used for contraband. As I hung from my rope, it made sense: the interior is cavernous and dry; the cave is invisible from anywhere but the sea, and right below it is a shingle beach just wide enough for a longboat. The geological wonder of Smoo Cave, up near Cape Wrath, naturally has its own, dark tale, of a pair of revenue men who were lured by boat to the cave's inner chamber, where they were capsized, to drown in the dark. I've lost count of the number of smugglers' tales I've come across in coastal hideaways. While filming the first series of *Coast*, I was led along a dank tunnel beneath the houses of Robin Hood's Bay in Yorkshire. The tunnel was built as a drain for the village, but it would also have been a convenient passage to shift contraband from the beach. I was shown blocked-up passageways thought to connect upward to a couple of old pubs.

Smuggling thrived for ten times longer than the Industrial Revolution yet left remarkably few monuments. In Old Hunstanton churchyard, there are the weathered gravestones of Private William Webb, 'shot from his horse by a party of smugglers' and of 'poor William Green, an Honest Officer of Government, who in the faithful discharge of his duty was inhumanly murder'd by a gang of

smugglers in this parish'. One of the pistols lost by the Hawkhurst Gang after the 'Battle of Goudhurst' can be seen in Maidstone Museum. It has four notches on the barrel. The true cost of the battle for free trade were the men and women who went to early graves.

Smuggling has become a coastal attraction. What do we make of Gunsgreen House, recently opened to the public? Gunsgreen stands above the water of Eyemouth harbour, on Scotland's east coast. It is a monumental five-bay house of red sandstone and white harling, built to plans thought to have been drawn by James and John Adam. Inside, you can still see the original wood panelling, and hand-painted Chinese wallpaper. The man who built the house in around 1735 was John Nisbet, a merchant. Or was he? For it's widely believed that the fortune that funded his chinoiserie came from contraband.

Lamb anticipated the popular complicity. There's money to be made through association with smuggling. It's impossible to imagine inner-city pubs naming themselves 'The Hoody's Arms' or 'The Burglar's Den', but there are any number of pubs and inns around the coast that commemorate tax evasion. In Anstruther, the source of one of Scotland's bloodiest smuggling episodes, The Smugglers Inn on the harbourside is popular with golfers; there's a 'Smugglers Barn' in Bembridge on the Isle of Wight (and a smuggling museum on the island, at Ventnor); a Smugglers Haunt near Wimborne; a 16th-century, thatched Smugglers Den at Cubert near Newquay, and another Smugglers Den in Morecambe. For years, there was a Smugglers Roost in Rustington, the Sussex village that remembers the capture of the *Jesus*, in 1453. The brewers have jumped on the wagon, too, with hefty bitters like Smugglers Ale from Skinner's, and a beer called Smuggler, brewed by Rebellion.

Smuggling never went away but, with the age of road haulage and air travel, it did cease to be a wholly coastal activity. In his memoir of the 1930s to 1950s, H.J. Browning, OBE, 'Formerly Deputy Chief Investigation Officer, H.M. Customs and Excise' (as he bills himself on the title page of *They Didn't Declare It*) spends much more time at aerodromes, and in pubs and courtrooms, than he does on beaches. As Browning points out, smuggling revives whenever duties revive or illicit markets prosper. At various times in recent decades, nylons, watches, cigarettes, spirits, diamonds, guns, drugs and people have slipped

through the customs net. Browning ascribed his many successes to new levels of international cooperation that had fostered a universal loathing for the smuggler. The drug smuggler locking a cache into a suburban garage isn't a romantic, 21st-century Rattenbury; he's a cause of human despair.

The ubiquity of modern smuggling has helped to create a truly enormous counterforce. The UK Border Agency, formed in 2008, brought together work formerly carried out by the Border and Immigration Agency, customs detection work at the border from HM Revenue & Customs, and UK Visa Services from the Foreign and Commonwealth Office. It's a global organization with 25,000 staff. On an island now dotted with airports, surrounded by ports and connected to the continent by a rail tunnel, the border agency has to be everywhere at once. People traffickers, drug smugglers and illegal immigrants are singled out for their financial cost to the country, and for the human distress they cause. Mass production and cheap labour beyond the EU deluge the borders with a bewildering cornucopia of counterfeit goods that include footwear, cigarettes, jewellery, hair straighteners, DVDs, mobile phones and fake medicines, much of it passed on to unsuspecting customers who buy from websites and auctions. In one year alone, 50,000 fake replica football shirts were seized, worth about £1.2 million. UK government estimates put the business losses to counterfeiting at £11 billion a year.

A quick scan of smuggling activity over the four weeks prior to the typing of this sentence reveals the non-stop nature of modern smuggling. In the last month, one of the UK Border Agency's five patrol boats (which are still referred to as 'cutters') seized 300 kilos of cocaine packed into 11 rucksacks that had been tied to a buoy off the Isle of Wight – a smuggling technique that is at least a couple of hundred years old. On the same day, the agency announced that 33 kilos of cocaine had been discovered at Heathrow, and that five people had been arrested in Sydney, Australia. The following day, the agency announced that it had found eight Afghans, four Iraqis and four Vietnamese people hiding in a British-registered lorry in Calais, bound for the UK. The next day, another announcement; this time it's a lorry driver who'd been arrested at Dover's Eastern Docks with three holdalls containing 'white powder and a number of tablets' which gave a positive reaction to amphetamine sulphate and ecstasy –

street value £1 million. The list goes on: cocaine at Newcastle, cash at Stansted, 25 foreign nationals found in a British-bound lorry at Dunkirk, two Spanish men jailed after attempting to smuggle 33 kilos of cocaine (street value almost £8 million) off a cruise liner in Southampton, 800 kilos of cannabis concealed in a trailer of concrete slabs at the port of Harwich, 26,000 euros hidden inside a woman's bra as she passed through the port of Holyhead. As I write this, a former chief executive of a football club is starting a five-and-a-half year sentence for smuggling 21 million cigarettes through the port of Southampton. The seized cigarettes were all lit; burnt in a power station to contribute electricity to the national grid. Smugglers may have been evicted from their innumerable coastal niches, but in leaving the shores they've been driven beneath the surface of the entire mainland.

6.
The Saviours: Beacons, Lighthouses, Lifeboats and Coastguards

Five, then ten metres we sank beneath the sea's ceiling, weighted by 28 pounds of lead and an 83-cubic-foot air cylinder. Scuba diving is one of those dreams that never lasts long enough. Up there, in the real world, it's all a jostle of waves and wind and awkward gear; down below, you share a silent netherworld of zero gravity with mute and wonderful life forms whose stories are far older than the beasts of the forests or the air.

A field of long golden fronds rose to meet our fins, and in a small clearing of sand, a somniculous starfish repositioned one of its limbs. Stewart Tattersall, my diving instructor, slowly finned his way over the waving tendrils, then tipped downward, over the lip of a broken cliff. Ahead of him, a dark triangle formed on the seabed. Revolving like a curious seal, he circled the structure, then reached out and tapped it with the hilt of his knife. Through the silvery bubbles I heard the unmistakable 'clonk' of metal, rather like a church bell that's been tapped with a bare knuckle. It was a wreck.

Missouri was only five years old when she went down. And she was big; 425 feet from prow to stern. Deep in her guts pounded a 600-horsepower steam engine, and she carried four masts to make the most of Atlantic westerlies. Bound for Liverpool, she'd left Boston loaded to the Plimsoll Line with 395 head of cattle, 3,000 bales of cotton, 4,000 sacks of flour, palm oil, tallow and general provisions which included bacon, walnut logs, bales of leather, drawing chalk and a Canadian-made bellows organ. The ship's master was 45-year-old Captain Reuben Poland, a Sussex man who had gained his

Master's Certificate at the age of 27. Eleven days out of Boston, on Sunday, 28 February 1886, *Missouri* rounded Fastnet Rock off the southern tip of Ireland, and began the final leg of what had been an uneventful voyage; it was the fourth Atlantic crossing Captain Poland had made in *Missouri* since Christmas. Up on the Old Head of Kinsale, the Irish coastguard watched the four-master pushing north-eastwards through the weather towards St George's Channel. At 8pm, Captain Poland took a bearing on Tuskar Rock and ordered a change of course to NE by E¾E. To allow for the building gale, he added another compass point.

On the seabed off Porth Dafarch, Stewart finned across the wreck. The eroded carcass of the ship lay across the rocks. I followed, over ribs and plates with rivet holes large enough to take a thumb. A boiler loomed out of the glittery void, and a mooring bollard sprouting mauve foliage. In dark metal caves, spider crabs sent irritable semaphore messages with their pincers. I ran my fingers along a bone of brown iron, raising a pollen cloud of rust.

Captain Poland's mistake had been to add that extra compass point for leeway. He had also underestimated the eastward pull of the tide. There was another factor, too. At 1pm, sleet and snow began to flicker through the rigging. To make things more difficult for the watch, sudden squalls whipped icy spray across the decks. By 3.30am, the lookout was finding it so difficult to see that Captain Poland reduced the *Missouri*'s speed by half. He knew that the coast of Anglesey was off the starboard bow, but at night, and in heavy seas and a blizzard, there was no way of precisely judging the distance. At 4.15am, he changed the ship's course slightly to the north and ordered a depth sounding. Before the lead could be cast, the sky was lit by the flash of a gun. It was the Holy Island coastguard. With a rending of iron on rock, and her propeller thrashing full astern, 5,000-ton *Missouri* collided with Wales.

Missouri had the good fortune to be wrecked in a humanitarian era. Every one of her crew was rescued by a 'breeches buoy' – a cloth seat slung from a rope which had been hurled to the foundering ship from land. Some of the cattle were saved too, although they fetched just a pound a head at market. After having his certificate suspended for six months, Captain Poland went on to weather another eight years on the East India run, and survived another

stranding, to retire in 1894 as a Knight of the Cross. By the time *Missouri* went on the rocks, the balance had shifted in favour of survival.

Wreckers and smugglers are opportunists driven by poverty or greed. The counterforce is more complicated and more enduring. The marking of sea lanes and navigational dangers, the creation of sea charts, the building of lighthouses and the saving of lives at sea are a set of parallel narratives which have evolved over thousands of years. The wish for safer seas is a primitive human instinct.

It's a story that begins with sticks and memory. The Mesolithic boaters who explored the archipelago carried in their neural databanks information about currents and winds, depths, reefs and sandbanks, anchorages and fishing grounds. To this day, fishermen create virtual seabeds in their heads, layering information derived from their ancestors, from local stories and from first-hand experience. Recently I spent the day with a fisherman called Tony Haggis, who has spent 35 years on the North Sea: 'You have this unseen knowledge of what's under water,' he told me. 'I know what the seabed of the Thames Estuary looks like, but I've never seen it.' Research by two marine historians, Adrian Osler and Katrina Porteous, has provided some fascinating insights into the way fishermen around the Farne Islands imagined their fishing grounds. Fishermen, Osler and Porteous learned, 'mentally navigated this ground by means of a complex network of stories, references and information, identified not by date, but by occurrence'. So the following line becomes enough to locate a place: 'We shot 5,000 mussel-baited hooks [here] and got 133 stones of haddocks the day Jimmy Stephenson's Mam and Dad were married.' Each fisherman carried a set of mental coordinates drawn from his own life story and from 'the accumulated knowledge of generations who had, hook by crook, almost literally felt their way along the sea-floor'. These were not coordinates that could be read from sonar screens, GPS or Admiralty charts. They existed in the unprogrammable minds of men in oilskins. During the filming of *Map Man*, I met a shepherd who took me for a walk over the Welsh mountain of Plynlimon, to show me the thickets of landmarks that carried names known only to him and his fellow shepherds. None of these place names could be found on Ordnance

Survey maps, and yet collectively they formed the 3D topography that Erwyd Howells carried in his head. Fishermen attach similar kinds of place names to the apparently blank sea. The sketch maps drawn by Craster fisherman Bill Smailes reminded me of the homemade maps shown to me by Erwyd the shepherd. Smailes' labels varied from topographical notes like 'SOFT' and 'WHITE SAND CORNER' and 'IRON SKERES' to 'event' labels like 'GORDON ARCHBOLD TRAWLED HERE OFTEN' and 'BRITISH SUB'.

All of these neural sea charts required 'seamarks': conspicuous objects on land both to guide fishermen in navigation and to identify dangerous sea passages. The story of how these seamarks evolved, from natural features like prominent cliffs, tall trees and odd-shaped hills into man-made lighthouses and then virtual, electronic seamarks, effectively redesigned the coast. It was a process that took thousands of years, and it turned a ragged-edged, lethal archipelago into a pattern of defined sea lanes.

Although the evidence has long disappeared, it seems likely that the archipelago's earliest boatmen embellished the shore with man-made seamarks: stones perhaps, heaped on a headland, or solitary trees left unfelled to act as markers. In estuaries and shallow, tidal bays like the Wash and the Essex backwaters, sticks were used. Tony Haggis told me, as we passed a tree branch rammed into a mudbank on the backwaters behind Walton on the Naze, that the branch had been placed there by his brother. 'There are several types of mud on the backwaters,' Tony explained. 'That's 'sticky-mud … If you get your boat stuck on that, you'll be waiting for the next tide.' John Naish, who has written the definitive history of seamarks, reckons it likely that early man marked the edges of mudbanks and shallows with 'conveniently shaped birch branches'.

Marking the sea itself was far more difficult than erecting seamarks on land, and yet it was essential if ships were to be warned away from dangerous banks and rocks. On busier estuaries, ships were guided in and out of harbour by beacons and buoys. Naish has suggested that the first systematically marked channels in British waters were those of the Wash, where Hanseatic traders of the 13th century were having to navigate regularly through the shifting shallows off Lincolnshire and Norfolk to reach the booming ports of Boston and Lynn. Marks being used at the time on the far side of the North Sea included birch

withies, and beacon poles topped by a range of symbols such as bundles of birch twigs, wicker baskets, small barrels and wooden crowns. Floating buoys were also in use, constructed from watertight barrels and anchored by cable and stone.

To get into Boston, a ship's master had to cross the Wash using a channel known then as the Norman Deeps, at the far end of which a maze of mudbanks separated five or so narrow channels, only one of which led to Boston. The others would wreck your ship. These days, Boston is the perfect place for a winter walk. Behind its Georgian county elegance it hides an international history. This was the place that the earliest Pilgrim Father tried to leave in 1607; the place that gave its name to the American port that sees itself as the unofficial capital of New England. This was the port that was second to London for wool exports; the port that built the highest church tower (not counting spires) in England. When you visit, don't fail to call at Fydell House, whose one-time owners made their money from wine. Back in the 13th century, so much produce was passing through Boston that it was collecting one-third of all customs duties payable to the Crown. Some of the port's wealth went into building St Botolph's – the 'Boston Stump' – whose enormous silhouette served as a seamark for ships trying to thread-the-needle among the mudbanks of the Boston Deeps. The church was completed by 1390, but it wasn't until 1520 that the 272-foot tower was added. It's visible from far out in the Wash, which you can see from the top of the tower (365 steps; choose a clear day and be amazed). In his inestimable guide, *England's Thousand Best Churches*, Simon Jenkins (who rated St Botolph's as one of only 18 churches in the country worthy of five stars) described the Stump as 'a wonder of medieval engineering'. It's also the most magnificent man-made seamark in Britain. Besides building their marine cathedral, the Bostonians also marked the channels through the Wash. When Elizabeth I granted the port the rights to impose fines and levy tolls on shipping, her charter referred to beacons and marks 'all which things are nowe almost utterly decayed' and commanded that marks be restored to the main channels.

Between the ports, medieval mariners were on their own. In this era of diesel engines and GPS, the challenges facing ships' masters a thousand years ago are hard to comprehend. Vessels 'coasted' our shores, staying in sight of land as much

as possible. Most of these vessels were fairly small, weighing in at less than 200 tons, and carried rudimentary navigational equipment. Anybody who has sailed Britain's coast in a modern yacht will marvel at the seafaring skills these mariners employed. On vessels with no means of propulsion other than wind (and, if they were smaller vessels, oars), they had to work with winds and tides in order to make any progress at all. Get either of those elements wrong, and a ship could find itself in difficulties very fast. British coasts were rimmed with hazards ranging from shifting sandbars across harbour mouths to submerged rocks and sea mists which could prevent a helmsman seeing beyond his bowsprit. Being caught by fog while coasting the busy Tyne–Thames route could be fatal, as the entire shore was lined with cliffs or sandbanks. You had to use your ears. Skirting the cliffs of Yorkshire in fog, seafarers used to listen for the mews of colonies of seabirds, whose eerie shrieks carried far across the water. (When tourists began slaughtering the Bridlington colonies for sport in the 1860s, the East Riding MP complained that many more ships had been wrecked since the cliffs fell silent.) Seabirds were vital guides, too, for boats attempting to reach islands in bad visibility. The writer and natural historian Martin Martin was saved by seabirds during his nerve-wracking voyage to St Kilda in 1697. With a storm building after 16 hours with no sight of land, in a boat being pulled the wrong way by adverse wind and tide, one of his crew spotted 'several tribes of the fowls of St Kilda' flying over the sea on a course south of the boat. The oarsmen altered course and 'rowed to a miracle'.

Away from a home port, a mariner depended upon memorized, or written, sailing instructions, whose purpose was neatly summarized in the heading written by Scottish pilot Alexander Lindsay, on the pilot book, or *rutter*, which he prepared for James V in about 1540. Lindsay informed the king that for every section of the coast he was describing, he'd covered 'fyve thinges':

'*The course of tydes*
The tyme of floode and ebbe
The strykinge of costes
The kenninges from one foreland to an other
The havens, rodes, soundes and daungers.'

A local fisherman would carry all of this information in his head. A ship's master taking a longer voyage would have to have written instructions, or take with him a pilot of Lindsay's calibre. Each of the 'thinges' on Lindsay's lists provided essential clues to a ship's whereabouts and course. Many parts of the coast have their own tidal 'signature' which a pilot would recognize. You only have to pass the Portland tide race once to know that it's unique on the south coast of England. The 'strykinge', or angle of a coastline, would help a pilot tell where he was, and so would the distance – the number of 'kenninges' – between headlands. The final 'thinge', the precise location of harbours, anchorages, navigable channels and dangers such as sandbanks, bars and rocks, would determine whether a ship reached its destination.

Of the many 'thinges' a pilot was constantly computing on a long voyage, recognizable seamarks were uniquely meaningful. They told him instantly and unequivocally where he was. And whenever there is the slightest doubt about a ship's position, there has never been a pilot who has not experienced a rush of relief – however mild – when it has been confirmed by an identifiable seamark.

From the earliest days of long-distance trading, natural seamarks were supplemented by man-made coastal structures. When Pytheas sailed from the continent to circumnavigate Iron Age Britain, the seafarers of these islands knew nothing of the gigantic statues of the Mediterranean. Pytheas, from the Greek colony of Marseilles, would have known of the Colossus of Rhodes, a statue in the form of a man so huge that Pliny reckoned few could make their arms meet around the girth of the thumb. The Med was rimmed with man-made structures which doubled as seamarks: temples, columns, obelisks and statues stood against the sky. On Rhodes alone, there were – according to Pliny – a hundred statues so large that they 'would each have brought fame to wherever they stood'. In Pytheas' home port, the temples of Artemis and Apollo stood on the headland above the harbour, guiding ships into the haven.

Quite how Pytheas managed to navigate around the entire coast of Britain without being wrecked is a mystery lost in the past, but it must be presumed that he was guided by local pilots for at least some of his voyage. Coastal tribes used familiar headlands and bays as waypoints, and the silhouettes of their promontory forts and fortified homesteads as seamarks, and perhaps the

outlines of standing stones too. In the West Country the Lizard, Cape Cornwall and the dark cliffs of Tintagel had been points of reference since at least the Bronze Age. Richard Carew, writing in the early 17th century, records that Tintagel's 'Black Head' was 'well known to the coasting mariners'. Camden's *Britannia* of 1586 records that Winterton on the coast of Norfolk was 'a point or cape very well knowne to sailers'. In the far north, Pytheas must have seen the finger-like outlines of many brochs rising from the shoreline. These strange, tapering stone towers could reach a height of at least 15 metres and were large enough to contain several dwelling rooms and storage chambers. Many stood near the coast, and their ruins are scattered through the Western Isles, Orkney and Shetland. The best of them by far is on the tiny, uninhabited island of Mousa, off the east coast of Mainland, in Shetland. It's one of the most remarkable archaeological sites I've ever seen; 13.3 metres high, windowless, with a spiralling staircase set into the wall. Peering from its 2,000-year-old upper storey, it's thrilling to imagine the tiny scrap of Pytheas' sail gliding by on a beam wind.

You don't have to spend long in a small, open boat at sea to realize that the most useful seamarks are those which project above the horizon. A while back, I was filming in a traditional sailing currach off the coast of Ulster, and the only shoreline feature I recognized all day was the silhouette of Dunluce Castle whose ragged battlements projected like a signpost above the land. On another, more pampered occasion, I found myself gazing over the starboard rail of a large ship while making a circumnavigation of Britain. In my cabin, I had a complete set of Ordnance Survey maps for England, Scotland and Wales, yet when we sailed past the coast of East Anglia – a coast I know well – I struggled to find ports I'd visited countless times. Visibility was excellent, and with binoculars I could see individual houses. But the entrances to rivers and estuaries were invisible; they just melded into a low, grey continuum of land. The only way I could fix them was by plotting the angles between intermittently spaced stubs of church towers that appeared in silhouette above the low, grey horizon.

By the Middle Ages, the shores of Britain and Ireland had accumulated numerous buildings that functioned as seamarks. Ships heading north for Berwick-upon-Tweed would look out for the monastery on Holy Island, just as ships heading around the coast of Galloway would keep watch for St Ninian's

Chapel on the Isle of Whithorn. One of the most spectacular ecclesiastical seamarks in the archipelago was the magnificent Anglo-Saxon church at Reculver, close to the tip of Kent – for thousands of years a turning point on coastal trading routes between the Channel and the Thames. Since the eighth century, navigators had been able to use the alignment of Reculver's two enormous towers to avoid running onto the sandbanks lying off the Isle of Thanet. Even William Camden, a confirmed landlubber, knew of 'the steeples whereof shooting up their lofty spires stand the Mariners in good stead as markes whereby they avoid certaine sands and shelves in the mouth of the Tamis'.

Alexander Lindsay's 16th-century Scottish *rutter* is a fascinating insight into the kinds of seamarks that a pilot was logging. He grouped his navigational information around sections of coast between identifiable capes, islands, bays and river mouths. Several of them – such as Filey Brigg, Flamborough Head, the Farne Islands, Duncansby Head, and the firths of Forth and Moray – are topographical celebrities that we've already met in this book. Lindsay also included a scattering of man-made seamarks: Bamburgh Castle, the monastery of Holy Island, the steeple of Crail church in Fife, Duart Castle guarding the Sound of Mull, and St Ninian's Chapel on Galloway coast. While we were filming the first series of *Coast*, we ran a little experiment using Lindsay's *rutter*. James V had demanded the pilot book because he intended to sail with a heavily-armed fleet from Leith on the Firth of Forth, around the top of Scotland to the Western Isles, where he planned to suppress the Lords of the Isles. We took a copy of the *rutter* to the Isle of Raasay and boarded a traditional wooden Hebridean working boat helmed by David Croy, from the Orkneys. David (favourite hero: Ernest Shackleton) is one of the directors of the Raasay House outdoor centre, and apart from being great company in a small boat he's a brilliant sailor. The boat, a seagoing *sgoth,* was a heavy beast with a flared prow, benches for six oarsman and a single, dipping lugsail.

Lindsay's instructions for navigating Skye's Inner Sound were as follows: 'From the Burnt iland to Kilark southest to south, v myle … Iff ye will ly betuixt the Brunt Illandis and Kyilark, hold the est syd of the rod against Castelle Strome and ye sall fynd lxxx fadomes. In the west syd ye sall find no ground. Kyilark is a narrow passage, and betuixt it and Kyilra is a good road …'

Out in the sound on board the *sgoth*, it all made sense. 'Burnt iland' was the Crowlin Islands and 'Kilark' was Kyleakin. Both are very obvious seamarks. To find a safe anchorage between the two, Lindsay suggested that a ship's master follow the east side of the 'rod' (or 'road', meaning the sound) and look out for 'Castelle Strome'. These days, Strome Castle is little more than a few, tatty walls balanced above the sheltered water at the mouth of Loch Carron, but back in the 16th century, it was one of the most striking seamarks on this coast: a lofty tower house built on a commanding bluff.

It was only at the end of my day with David Croy that the *rutter* revealed a value beyond navigation. As the *sgoth*'s triangular tan sail slid towards the modern concrete arc of the Skye Bridge, I realized with some amazement that the entrance to Loch Alsh was completely invisible on the course we were sailing. It was a real Platform 9¾ moment. Only the *rutter* (and the 20th-century bridge) suggested that you could sail a ship any further than Kyleakin. In the king's fleet that day in 1540 there must have been a few quickened pulses as the ships bore down on what seemed to be a dead end, only to find that the *rutter* was right, and that a hidden passage led through to the Sound of Sleat and the southern Hebrides.

With the exception of several ports, a few castles, a church and a chapel, the seamarks listed in Lindsay's *rutter* are all natural features. But further south, a more formalized process of seamarking was about to begin. In 1566, an Act of Parliament awarded Trinity House – a corporation of 'Shipmen and Mariners' charged with pilotage on the River Thames – the powers to set up 'So many beacons, marks and signs for the sea … whereby the dangers may be avoided and escaped and ships better come into their ports without peril'. By 1600, there were at least 20 man-made seamarks at various black spots along the coast of southeast England, and various sections of coast had been charted. On a very fine chart drawn by one Richard Poulter in 1584, the sandbanks of the Thames Estuary are shown in astonishing detail. Furthermore, their basic geography corresponds well with a modern Admiralty chart, despite the relatively crude surveying equipment available in the 16th century, and the passage of time that has seen sandbanks migrate. Many of Poulter's sandbanks had fixed markers to warn shipping. He's drawn a symbol like a long-handled lollipop on the edges of Foulness Sands and

Maplin Sands, which together formed the lethal, northerly edge of the main ship-ping channel for vessels entering the Thames from the north. Three other 'lollipops' mark the southern edge of the estuary's shipping channels, poking up from Margate Sand off Kent, on what is now known as Middle Sand, off the Isle of Sheppey, and on Grain Spit. Four of the same warning markers appear on Thames sandbanks shown in Dutchman Willem Blaeu's magnificently detailed chart-atlas of 1608. The main channels along the Thames Estuary appear to have been identified with tall posts driven into the seabed.

Meanwhile, the coast itself was being modified in ways that were not being recorded on maps. At the end of the 16th century, a row of oak trees was planted on the high ground between Frinton and Walton-on-the-Naze so that seafar-ers could take a compass bearing when nearing the passage into Harwich harbour (the trees stood, according to Samuel Pepys, until they were felled in 1673 and turned into woodwork for Charles II). As trade and shipping increased, greater efforts were made to mark the entrances to harbours. Paint-ing buildings white increased their conspicuity from a pitching deck in a squall, and coastal churches occasionally found that rebuilding costs were defrayed by local merchants; when the 60-foot tower of St Eval Church in Cornwall collapsed in the 1690s, Bristol merchants helped to fund a new one.

The real boom in beacon building began in the 1700s, and by the end of the 18th century, many were being constructed in stone. One of the first of these was a pointed granite obelisk raised in 1683 on the tip of the Isles of Scilly facing Cornwall, warning ships running around Land's End not to stray too far to the west. The St Martin's 'obelisk' is 36 feet high, and although it carries three fetching red stripes today it was originally painted white. If you find yourself near Padstow in Cornwall, there's a wonderful coast walk along the Camel Estu-ary to Stepper Point, where a strange, stone 'chimney' rises 40 feet from the clifftop. It's a seamark (although this one is known as a 'daymark'), erected after one Henry Price Rawlings drew attention to the 96 vessels that had been lost at or near Padstow between 1800 and 1826, many of them attempting to navigate into the difficult mouth of the estuary. Another, more elegant, example from 1864 stands in a field by the hamlet of Brownstone, on the eastern side of the entrance to the River Dart in Devon.

Over on the east coast of England, the problem wasn't rocks so much as sandbanks. One of the most interesting seamarks to visit is the Naze Tower, which now stands perilously close to the brink of the crumbling Cheddar-coloured cliffs a mile outside the little resort of Walton on the Naze on the Essex coast. There are four things I like about the Naze Tower. It's got a great story to tell; there's a café on the ground floor, there are exhibitions by local artists on the other floors; and there is a sensational view from the top. It's privately owned and run with passion by Michele Nye Browne, who has turned a neglected monument into one of the highlights on the coast of East Anglia. Michele's tower is the only seamark of its kind in the country. There's been a tower here since at least the time of the Armada; a manuscript map in Essex Record Office drawn by John Norden in 1594 shows a symbol like an upended Lego brick standing on the Naze, but it was not nearly as high as the 86-foot octagonal monster that was erected, brick by brick, between 1720 and 1721 when the volumes of shipping using eastern ports – and running aground on eastern sandbanks – had reached record levels. A tower on the Naze was essential for ships trying to find the notoriously elusive channel into Harwich. Last time I climbed the 111 steps to the roof, the view was the best I've ever seen from here: with binoculars I could pick out Orford Ness lighthouse, pin-sharp 20 miles to the north-east, several stumpy Martello towers along the Suffolk shore and a monstrous container ship sliding past Harwich on the way to Felixstowe. Naze Tower has had several lives: back in the 18th century it probably had a fire beacon on its roof; during the Napoleonic Wars it was used as a lookout and signalling station; then the Royal Navy took it over as a semaphore tower for practising sea manoeuvres. When the German fleet was rampaging through the North Sea in 1914 it was a lookout again, and then, during the Second World War, it suffered the indignity of having a gigantic radar dish bolted to its roof. As if that wasn't enough, the Americans plonked a communications beacon on the tower during the Cold War. When it was finally sold off by Trinity House the first private owner was Roy Bradley, of Roy Bradley & The Nitwits, who once played a summer season at Clacton – not to be confused with the 1940s jazz band Sid Millward and the Nitwits, who played the London Palladium.

*

One January when lighthouses still had 'keepers', I walked with a small group of friends and family to Cape Wrath, which must have the most remote lighthouse on mainland Britain. There are two routes to Cape Wrath. From the east, in summer, a passenger ferry then minibus will run tourists across the Kyle of Durness and then along the single-track road to the cape. And then there's the route from the south, from Blairmore. It's one of the toughest coast walks in Britain. The first few miles to Sandwood Bay follow a well-trodden track, but thereafter it gets difficult. There are streams to ford, and interminable tracts of heather, bog and rock. It's a round trip of around 25 miles. That winter's day, after we'd walked for many hours with wet feet, the tip of the lighthouse crept into view; a beacon of encouragement above the desolate moor. I will never forget it. One of the lighthouse keepers had seen us coming. We wished him a Happy New Year, and he handed round mugs of tea. And then we turned around for the long yomp south, and left the keepers at their cape.

Lighthouses tell us that the coast is ours. They mark our perimeter with flashing lights. They're the only architectural constant on the coast. Their generic shape means that we know immediately what they're for. Totems, obelisks, emblems of care, they bid us to pay homage. So we hike over cliffs and along promontories, drawn by a slender, white beacon which grows bigger and bigger until we stand, necks craned towards at a delicate glass rotunda that has saved more lives than any can count.

Seamarks such as towers and headlands are also known as daymarks because they're unusable at night – or in poor visibility. The great breakthrough in seamarking the archipelago came with the multiplication of 'light towers'. But artificial light required systems and political stability. The man-made daymarks like obelisks and towers required very little maintenance and continued to function through war and pestilence. But a lighthouse requires fuel, an operational team, food and services for the team, and military security. The story of East Dudgeon lightship serves as a sad illustration.

During the Second World War, British lighthouses and lightships were periodically attacked. Lightships received particular attention, since they were suspected of observing and reporting German shipping movements. The most notorious attack of the war occurred on a Monday morning in January 1940

– in the depths of the coldest winter since 1895 – some 20 miles north of Cromer in Norfolk, when the East Dudgeon lightship was bombed and machine-gunned by a Junkers 88. One of nine bombs hit the ship, and the eight-man crew took to the surviving lifeboat, which they tried to row 25 miles westward to the Wash, eventually capsizing on a sandbar close to the Lincolnshire shore. Only one man, John Sanders, survived.

The dead of East Dudgeon became martyrs to the cause. The Germans claimed that the lightship was a 'British naval patrol vessel', but in the House of Commons, Prime Minister Mr Chamberlain used the attack to characterize Britain's enemies: 'Such acts of pure gangsterism', he told the house, would have 'little, if any, practical effect on the outcome of the war … the horror and disgust which they excite in the minds of all decent peoples only make us the more resolved to carry on the struggle until civilization is purged of such wickedness'. Within months, the incident had been turned into an Ealing Studios propaganda film, produced by Alberto Cavalcanti, who had the lightship's mate muttering 'You dirty bastards' at the diving Junkers. After that, permanent crews were removed from lightships, but by the end of the war, 27 lightsmen had been killed, and 20 lightships lost to enemy action.

Lighthouses were less vulnerable, but on Fair Isle, an assistant keeper's wife was killed by a machine-gun bullet in December 1941, and a couple of years later a bomb missed the lighthouse but demolished the adjacent building, killing the principal keeper's wife, daughter and a visiting soldier. All three keepers of the lighthouse at St Catherine's Point on the Isle of Wight were killed in June 1943 by German bombers attempting to destroy a radar site. The keepers had been sheltering in the lighthouse engine-room.

So, a lit coast had to be a peaceful coast, and it was the militarily tempestuous nature of the seas around Britain and Ireland that delayed the establishment of permanent lighthouses for hundreds of years. When did the first lights show on the coasts of the archipelago? Lights must have been used to guide vessels home since the earliest days of settlement. Being ambushed at sea by dusk is a daily condition for boats dependent on wind and weather. The Cornavii of northern Scotland, the Auteini of western Ireland, the Iceni on the rump of old Doggerland, must all have used fire beacons to bring in their vessels at dusk.

Down in the West Country, the Dumnonii had particular cause to erect navigational aids, for the fortunes they made from trading tin depended on the safety of their havens. William Camden speculated that there may have been a 'watch-tower' at Land's End, 'from whence, by the light of burning fire, there was a signe given unto sailers'. How many more wrecks of tin-traders like the one at Erme Mouth, would there have been if the Dumnonii hadn't provided navigational aids along their lethal coast? Pytheas would certainly have been familiar with light towers. The one at the entrance to the trading port of Alexandria was the forerunner of many that would soon mark the approaches to ports around the Mediterranean. Built on the island of Pharos to a design by architect Sostratus of Cnidos, it was over 400 feet high with a fire basket at the top that – according to the historian Josephus – could cast a light over 300 stadia, or about 33 land miles. Pliny records that the light tower on Pharos had three purposes: 'to provide a beacon for ships sailing by night, to warn them of shallows and to mark the entrance to the harbour.' It seems that from these earliest days, the fires in light towers were shown intermittently, or as 'flashes', perhaps by using screens to blank the light. The danger with showing a *continuously* burning light was that – as Pliny points out – 'it may be thought to be a star since the appearance of the fire from a distance is very similar'.

The light tower of Pharos was so well known and valued that it became the model for others. 'Similar beacons,' writes Pliny, 'now burn brightly in several places.' He mentions fire towers at Ostia, the harbour city for Rome, and at Ravenna on the Adriatic coast. But there were many more. In fact, given the thousand-year hiatus in European lighthouse-building that would follow the collapse of the Roman Empire, it is remarkable how well-lit the Romans had made the Mediterranean. There were at least five lighthouses on the west coast of Italy, three on the east coast, another on Sicily, one at Fréjus on the Côte d'Azur and another on the Syrian coast, a couple on the north coast of Africa, five on the coast of Turkey. On other oceans, they built three on the Atlantic coast of Spain, and three on the channel separating the continent from the islands of Britannia.

Around the middle of the second century AD, the Romans built a pair of light towers at *Dubris*, their main port in Britain. The two towers, on cliffs on

either side of the river outflow, guided ships into the tricky entrance of Dover harbour. One of the towers still stands, enveloped by the walls of Dover Castle. For me, it's as remarkable as the broch on Mousa. Spare a day if you can to explore old Dover; there are few places on the coast of Britain that can boast a Bronze Age boat, a Roman lighthouse, a Norman castle and various tunnels, casements and guns from wars with Napoleon, the Kaiser and Hitler – not to mention a very pleasant beach and enough shipping to keep a boat-spotter content for an entire summer's day. Today, the octagonal, 13-metre stump of the lighthouse at Dover is the tallest surviving Roman building in Britain; originally 24 metres high, its position atop the cliff gave it an elevation of 115 metres above sea level; on a clear night, its light was visible on the coast of northern France. A similar Roman lighthouse at Bononia (Boulogne) gave the commanders of the two most important Roman ports on the Channel a means of almost instant communication.

The signalling stations built by the Romans along the north-east coast of England must also have been invaluable guides to vessels using ports between the Wash and the Tyne. There's an intriguing suggestion, too, that a Roman lighthouse once stood at Reedham, in east Norfolk. These days, the village is 6 miles from the open sea, but 2,000 years ago this was the tip of a promontory between two of the inner arms of the 'Great Estuary' that had been so vital to Roman trade and security in East Anglia. Vessels searching for the mouths of the Yare and Wensum – the two rivers leading to Roman settlements at Caistor St Edmund and Brampton – would have been helped greatly by some kind of beacon on this promontory (I once sailed into a fog bank near here, and visibility shrank to a couple of boat lengths). Evidence for a lighthouse here is so slim that I hesitate to mention it, but if you have a look at the walls of St John the Baptist Church in Reedham, you'll see reused Roman tiles and stone. But the titbit that really tickles the imaginations of Great Estuary buffs is a report in an 1855 edition of *Norfolk Archaeology*, that a Mr Leighton had discovered 'the ground-plan or foundations of a circular tower, which he believed to have been a Roman Pharos'. (While you're in the church, have a look at the east windows, whose modern glass is etched with a map of the Yare Valley.)

The departure of the Romans interrupted the evolution of lighthouses for hundreds of years. Raiders from over the water tended to drive people inland, and the showing of coastal lights invited trouble. Visiting Vikings are thought to have destroyed many beacons and hermits' chapels. By the Middle Ages, however, the conditions for a lit shore were returning. The demand and payment for beacons came from merchants wearied by cargo loss, while the organization of the lights was frequently met by the rapidly expanding Catholic Church. The number of religious houses in England mushroomed from 50 in 1066 to around 900 by 1300, many of them on the coast. Monasteries, convents and hermitages became light-keepers whose fuel costs were often met by local merchant-mariners. The archaeologist D.B. Hague has found documentary, or structural, evidence of 17 medieval lighthouses around the shores of Britain and Ireland, eight of them on the Channel coast.

There were at least two medieval lighthouses on the coast of Ireland, using – believes Hague – peat or coal as fuel. One of them still stands, at Hook Head on the south-east coast. For lighthouse baggers, this is a must-see. It's the oldest operational lighthouse in Ireland and Britain, and its modern keepers have provided a visitor centre, café and craft shop. The Welsh monks of St Dubhan had been maintaining a beacon here for hundreds of years, but it was a Norman lord, William Marshal, who paid for the light tower to be erected in the early years of the 13th century so that trading ships could be guided into the mouth of the River Barrow and thence to New Ross, the town he had built. By day, the tower functioned as a seamark, and by night the monks were paid by Marshal to tend a fire in the tower. The 'prety high towre' on Hook Head was sufficiently rare for it to be described by William Camden, who attributed its construction to 'the merchants of Rosse what time they were in their prosperity, for their direction and safer arrivall at the rivers mouth'.

The most curious medieval lighthouse to have survived in England is the stone tower that stands 773 feet above the southernmost tip of the Isle of Wight. The tower was built in the 1320s by Walter de Godeton, who was under threat of excommunication following the plundering of a cargo of wine when a ship from Picardy went down on St Catherine's Point. De Godeton was forced to erect an oratory and tower, and to provide an endowment for its upkeep. The

oratory has gone, but the tower has somehow survived. With its finned buttresses, geometric apertures and tapered roof, de Godeton's lighthouse looks a bit like a petrified rocket, although it's known locally as 'the Pepper Pot'. The walk up here is wonderful (and included in a 5-mile circuit on one of the National Trust's downloadable walks), and on a clear day, the view from the tower is aerial. And this was de Godeton's error. In its height above the sea, the tower stands taller than Canary Wharf in London, so in most weathers the light from a coal fire would have been invisible from water level. As a lighthouse, it was about as conspicuous as a candle on top of Scafell Pike.

The evolution of lighthouses is littered with errors, experiments, occasional catastrophes and technical breakthroughs. And until the 19th century, that evolution was driven by ecclesiastical and then private enterprise. Although the Seamarks Act of 1566 gave Trinity House powers to set up 'beacons, marks and signs for the sea', the enormous cost of building and servicing an entire system of lighthouses was way beyond the means of a cash-strapped welfare organization. Until the 19th century, the Crown issued patents or grants to private individuals whose motive for erecting towers was driven by the suitability of a sea passage for the charging of tolls. The problem with private enterprise was that those motivated to build lighthouses did not always understand the needs of those who would be relying upon them for navigation.

De Godeton's folly was one of many lighthouses that didn't work. If you extend your walk over St Catherine's Down to include the coast path that rounds the Point, you'll pass the gleaming octagonal stump of the modern lighthouse. It was once 40 feet taller, but the lantern was so often shrouded in mist that in 1875 it had to be shortened – at considerable expense. My favourite lighthouse folly stands on Beacon Hill on Lundy Island. The granite lighthouse itself is 96 feet high, and Beacon Hill is over 450 feet above sea level. The lighthouse cost £10,276 19s 11d to build and was fitted with two flashing lights – an innovation when it was completed in 1819. Unfortunately, the flashes were so fast that they could be mistaken for fixed lights, and on a foggy November night in 1828, La Jeune Emma – en route from Martinique to Cherbourg – ran onto Lundy's rocks having mistaken the flashing lighthouse for a fixed light off Île d'Ouessant, at the tip of Brittany. Thirteen people died, among them the niece

of Empress Josephine. Lundy's lighthouse also suffered from De Godeton Syndrome: it was so high above the sea that mariners frequently complained that the lantern was lost in cloud. In 1897 it was abandoned, and two new lighthouses built on Lundy, one at each end of the island, with lanterns just 173 and 157 feet above high water. Last time I climbed the elegant, cantilevered spiral staircase to the vacant lantern gallery of 'Old Light', I found a pair of deck chairs balanced precariously on the iron platform that had once carried the fateful revolving light. It made an incredible conservatory.

The financial risk and engineering ingenuity required to erect lighthouses changed gear in the late 17th century when the first attempts were made to build lighthouses on offshore rocks. In terms of civil engineering, they were literally outlandish, and they created the cult of the lighthouse builders. Men like Winstanley and Smeaton, the Douglasses and Stevensons, became the Brunels and Telfords of wave-dashed reefs.

Henry Winstanley was the pioneer; a man whose inventiveness, technical mastery, physical courage and leadership skills would have placed him in an astronaut's suit were he born into the 21st century. A bailiff's son, he'd risen to become clerk of works at the Earl of Suffolk's palace, Audley End, but had also created his own 'palace of inventions' just down the road – filling his house with mechanical contrivances and tricks that he charged visitors a fee to endure. One of his inventions dropped victims into the basement. Money also accumulated from a 'Mathematical Water Theatre' he created in London. Winstanley was already a rich celebrity in 1695 when he went into lighthouses. Two ships he had invested in had been lost on a reef 14 miles off Plymouth. Eddystone Rocks were a notorious death trap lurking in the sea lane used by ships entering and leaving the English Channel. At high tide they were almost invisible and tidal streams could pull a ship off its course and towards the reef. It took a man with Winstanley's imagination to dream of erecting a building in such a place. At the time, the 1690s, there was no other 'rock lighthouse' in northern Europe. The Industrial Revolution had yet to engage first gear and it still took several days to travel overland from London to Plymouth. Winstanley designed a fantastical structure decorated with balconies and gantries that he anchored to Eddystone's reef with iron bars bedded in molten lead.

Construction was interrupted when Winstanley was taken prisoner by a visiting French privateer, but he was close to completion in the summer of 1698, when Celia Fiennes rode her horse through Plymouth en route for Cornwall. Eddystone was the talk of the port for being built 'on a meer rock in the middle of the sea'. Winstanley raised a taper to his candles on 14 November 1698. In the five years that it lit the reef by night, not one ship came to grief on Eddystone, but Winstanley's wonder was swept away during the notorious storm of November 1703. Tragically, he was inside at the time.

Winstanley had proved that it was possible to light one of the most notorious rocks in British waters. He was a national hero. To Daniel Defoe, he was 'the famous Mr Winstanley'. Although he'd recovered only half of the tower's £8,000 (equivalent to £850,000 today) cost from dues by the time he was killed, he'd also demonstrated that even the most expensive lighthouses had commercial prospects. Now, no mariner doubted the value of a light on Eddystone, and a new timber tower, shaped like a cone, was financed by Colonel John Lovett (who devoted his wife's £5,000 dowry to the project) and designed by John Rudyerd, a London silk merchant. They reckoned to make £7,000 a year from dues. Their tower was lit in July 1708 and survived until 1755, when it burned down (the Plymouth Superintendent couldn't decide whether the cause of the fire was a leak in the keepers' stove or the three pints of gin the keepers had been resupplied with that evening). By this time, there'd been a light on Eddystone for 52 years, and it was now regarded as indispensable, so Trinity House moored a lightship by the reef while a new tower was commissioned. Only five months after Rudyerd's timber cone went up in flames, a 31-year-old civil engineer called John Smeaton began surveying the surface of the reef with a theodolite so that plans could be drafted for a new set of foundations.

Smeaton was still at the beginning of a long, productive career, and his reputation at this stage rested on his instrument-making and designs for drainage schemes and windmills. He'd been proposed for election to the Royal Society in 1752, and was regarded as a reliable, innovative thinker. His Eddystone tower was utterly unlike its two predecessors. Built of stone, it was based on the profile of an English oak tree. The flared base gave the tower a low centre of gravity and dissipated the hydrodynamic forces of breaking waves. But

Smeaton's genius was in recognizing that mortar was insufficient to bind masonry blocks being pounded by forces of up to 3 tons to the square foot. His blocks were shaped like an elaborate three-dimensional jigsaw, dovetailed laterally and vertically into adjacent blocks and courses. At eight in the morning of June 1757, he lowered the first, 2¼-ton block of stone onto its prepared bed on the reef, and just over two years later, in October 1759, its two counterbalanced chandeliers were lit. Smeaton's tower stood for 130 years, and was only replaced when it was discovered that it was being undermined by a cave in the rock on which it stood. By this time, the residents of Plymouth were so sentimental about their guardian that they paid for the tower to be dismantled and shipped to Plymouth Hoe, where it now stands beside the statue of Sir Francis Drake. The views from the lantern room are superb, and considerably less hazardous than 'Smeaton's Stump' which still pokes from Eddystone reef like the empty plinth in Trafalgar Square. One calm day, I leapt from an inflatable boat and climbed the rusted iron rungs to the top of the stump. The geometry of Smeaton's interlocking blocks was completely obscured by seagull guano that I hadn't the patience (or will) to excavate, but I did unfurl my umbrella and salute the great engineer.

On another occasion, I made a less successful attempt to land on Bell Rock, the reef of Old Red Sandstone 11 miles off the east coast of Scotland, in the sea lane between the firths of Tay and Forth. The *Coast* team had gone out there in a fishing boat, and then transferred to an inflatable for the last few hundred metres. But the swell was erratic and, to cut a long story short, the inflatable got stuck on the rocks and one of the fishermen had to jump over the side. With the tide ebbing, and an unwelcome vision of being trapped on Bell Rock for 12 hours, all hands heaved, paddled and revved until we were free, only to become wedged on another part of the reef. The 'piece to camera' I delivered was suitably tense.

The lighthouse on Bell Rock is a rugged monument to Scottish engineering and organization. These days it looks fairly well worn, and is disfigured by an unflattering hairnet to prevent birds crapping on the lantern glass. But this is the oldest existing rock lighthouse in the British Isles. It first showed a light in February 1811, and was designed by a young Scottish engineer called Robert Stevenson and a civil engineer called John Rennie, in the early years of the

Northern Lighthouse Board, which had been set up in 1786. Stevenson was an engineering prodigy. At the age of 19, he'd worked on the erection of a lighthouse on Little Cumbrae, in the Clyde Estuary, and in 1794 the NLB had employed him to superintend the construction of a lighthouse on the notorious Skerries in the Pentland Firth. But Bell Rock was an entirely different order of challenge; at high water, the reef was submerged by 16 feet of sea, and the combination of weather and tides meant that the engineers would have just 250 hours a year to work on the rock itself. Stevenson and Rennie settled on Smeaton's concept of a tapering tower built from interlocking stone blocks. To make the most of their work 'window', they built a temporary stilted barracks on the rock, and a railway to move supplies and stone from the landing area to the construction site. In four years, the job was done. Stevenson never looked back. The NLB had been freed in 1789 of its obligation to obtain an Act of Parliament for each lighthouse, which speeded the marking and lighting of Scottish coasts. Before he finished Bell Rock, Stevenson was appointed Engineer of the Board and stayed there for 35 years, during which time he was responsible for the design of a further 23 lighthouses.

During the 19th century, over a dozen more lighthouses were erected on lethal rocks and offshore sandbanks. Skerryvore, Fastnet, Bishop Rock, the Smalls, Wolf Rock and Longships have become synonymous with extreme weather. They're all well over a hundred years old, and are all standing, seemingly immune to every passing hurricane. Smeaton's undermined, 59-foot tower on Eddystone was replaced in 1882 by a 161-foot colossus designed by the Engineer-in-Chief of Trinity House, James Douglass, who had already built the Smalls, and Wolf Rock. His Eddystone tower, nearly three times the height of Smeaton's, required the meticulous assembly of 2,171 pre-cut blocks.

The tower James Douglass built was the first Trinity House rock lighthouse to be converted to automatic operation and its smooth running is now monitored from a semicircular nerve centre on the third floor of a modern concrete building shaped like a lighthouse, overlooking Harwich Harbour on the coast of Essex. Through the glass of the operations centre, there's a continually changing view across the busy mouths of the Orwell and Stour, as container ships, yachts and motor cruisers slide to and fro past moored light vessels and

various other tethered boats and ships. In the foreground is the Trinity House depot and wharf, where brightly coloured buoys stand in readiness; blue and yellow for marking wrecks. Inside the operations centre, four men sit at banks of screens that display the intimate details of every lighthouse at the press of a key. Systems can be checked; green means all is well; magenta means there's a communications failure requiring immediate action. 'We're expected', operations officer Gordon Head told me, 'to have 99.8 per cent availability of major navigational aids.' If a main light in a lighthouse fails, it automatically switches to a second main light, and if that fails as well, there's an emergency light. 'As soon as something goes off,' I was told, 'we know about it.' As well as lighthouses, the Harwich ops centre also monitors eight solar-powered light vessels and maintains 450 navigation buoys, around 50 of which are fitted with automatic monitoring systems. Trinity House is also responsible for marking all wrecks in English and Welsh waters. Trinity House ships are, as Gordon put it, 'undertakers of the sea', but with a difference: instead of a sedate hearse, they have vessels like *Alert*, a rapid intervention vessel that is always within six hours of Dover Strait. The scale of each shipwreck has increased with the size of the vessels. Speed is essential. In 2002, when the car carrier *Tricolor* sank beyond UK waters in the English Channel, the wreck was struck two days later by a German cargo ship called *Nicola*, and then by a Turkish tanker called *Vicky* – which was carrying 77,000 tons of gas oil. This multiple pile-up in the Dover Strait shipping channel 'brought into sharp relief', noted Trinity House, 'the effective responses required to adequately and quickly mark such new dangers and prevent collisions'.

In Harwich that day I was shown an extraordinary screen. It displayed a map of Britain. Around the coast were hundreds of short lines representing the track over the previous 24 hours of every vessel of over 300 tons. Heading in all directions were oil tankers and fishing boats, cruise ships, general cargo vessels … the lot. The English Channel was almost solid with traffic. The 'ring of safety' around the archipelago's shores now includes 350 lighthouses and a range of light vessels, buoys, beacons and navigational aids that can be monitored and operated by remote control from digital hubs in Ireland, Scotland, Wales and England. The digitized calm of the Harwich ops room was a world away from

Hanseatic days when a shipman would be squinting into a February squall trying to pick out a barrel buoy, headland or church tower.

On 13 March 2008, the Royal Mail issued six new stamps commemorating the courage and professionalism of the crews of RNLI lifeboats and HM Coastguard helicopters. The issue was called 'Rescue at Sea', and the stamps showed lifeboatmen and winchmen engaged in activities far beyond the deepest fears of most post office customers. Later that day, in the House of Commons, MPs congratulated the Royal Mail and recorded in an early day motion its 'particular praises' for the inclusion of the Barra Island lifeboat. Leading the new issue was the first-class stamp, which showed the orange superstructure of Barra lifeboat riding an explosion of silver spray. The MPs also recorded with sadness that the funeral had taken place the previous day of Iain (or John as he was sometimes known) Allan MacNeil.

A few springs before Iain died, he ferried two families on his charter boat to an uninhabited island in the Outer Hebrides. One of the families was mine. The weather was not ideal, and having taken the regular ferry to Barra, we were stuck there for two days while high winds and rain lashed the bay. Every couple of hours, we'd walk down the road from the hostel to Iain's house and he'd shake his head. Finally, he said that it was worth a try, but that we'd be turning back if the swell was too great to land on the island, which had no harbour or jetty. To get ashore, we'd have to shuttle to and fro in a small tender between Iain's boat and some rocks. I'd never been out in a small boat in such ferocious seas. The boat pitched like a crazy fairground ride. The kids were huddled in the cabin, passing the bucket. In the wheelhouse, Iain had seen it all before, and much worse. He'd known these waters for 70 years. The wheelhouse was fitted with all the electronic aids, compass, charts and so on. But the location of the worst swells and squalls were in Iain's mind, filed away after decades of sailing some of the most treacherous waters in the northern hemisphere. He took the boat around the edge of the island, to the tiny bay we'd picked from the map. When he saw it through the streaming wheelhouse glass he just shook his head and said 'We can't land there ... we'll try the other end.' On the map back in London,

our bay had looked by far the best bet, reasonably sheltered and backed by level ground – ideal for tents. Pounded by big seas, it was unapproachable. At the other end of the island, Iain nosed the bow into the lee of a low, rocky promontory and suddenly the wind and swell muted. In 15 minutes of shuttling with the tender, he landed nine of us and stores for a fortnight. Then he was gone.

Later, I learnt a bit more about Iain. He's been called 'the most respected seaman on the west coast of Scotland'. He'd been the coxswain of the Barra lifeboat. He'd been the boatman who'd run supplies out to Barra Head lighthouse, a destination with such huge and unpredictable swells that the Northern Lighthouse Board forbade 'alongside landings' on the pier, so supplies and men had to be lifted from the boat by a small crane. In November 1979, Iain had been the coxswain on Barra's Barnet Class lifeboat when it was called out to assist a Danish coaster called *Lone Dania*. Winds were gusting to Force 12, and the waves were around 30 feet high (that's taller than a two-storey house), with a 10 per cent chance of them rising to 60 feet. An investigator later described the seas as 'diabolical', and the coxswain of the Islay lifeboat, which was also trying to reach *Lone Dania*, said that the weather was as bad as any he'd seen in 17 years of lifeboat service. Both lifeboats capsized, but righted successfully due to a Royal National Lifeboat Institution balloon modification that had been introduced following earlier lifeboat losses.

Lighthouses may be the most visible monuments to the 'ring of safety' that has been laboriously, ingeniously constructed around the archipelago's coast, but they are only part of the story. Today, the RNLI provides, on call, a 24-hour lifeboat search and rescue service within 100 kilometres of the coast. Some 4,500 volunteer lifeboat crew members man over 230 lifeboat stations. The RNLI also employs 700 seasonal lifeguards and can call upon helicopters from the RAF, Royal Navy and HM Coastguard.

Long before the lifeboat was conceived as a dedicated rescue vessel, men and women were risking their lives to save sailors in difficulties. There is one document which supplies ample evidence that a tradition of sea rescue had engrained itself in the responses of mariners by at least the early 18th century. Daniel Defoe's first book, *The Storm*, is a first-hand account of the extratropical cyclone that careered across southern Britain on the night of 26 and

27 November 1703. It was the worst storm to hit Britain that millennium, and in just six hours it caused the death of more than 8,000 people, including one-fifth of the seamen serving the sovereign fleet and hundreds (perhaps thousands) who'd been caught on board trading vessels and fishing boats.

Defoe compiled his book after soliciting eye-witness accounts from those caught in the storm, many of which contain references to rescues at sea, and allusions to the expectation of rescue. The overriding impression is that seamen rescued other seamen if they possibly could, and there are several references to guns being fired – the signal a ship would send if it required immediate assistance. It was a night beyond anything that has been seen in British waters since. From Yorkshire to Wales, ships were dismasted, pulverized, capsized. Helplessness shrieks from Defoe's pages. Off Yarmouth, merchant ships and men-of-war 'fir'd their Guns for Help, but 'twas in vain to expect it; the Sea went too high for any Boat to live'. In Milford Haven, one of the most sheltered havens in British waters, guns also fired to no avail. Off Harwich, a man-of-war went down, but rescuers risked their lives and 'by the help of smaller Vessels most of her Men were sav'd.' Three ships foundered off Spurn Head, and here, Defoe records, 'all the Men but one [were] saved'. Five men and a boy survived when a ship from Brighton sank. At Lyme Regis, a privateer from Guernsey was driven ashore 'but three Men saved of the 43.' On a battered ship off Southampton, a seaman called Miles Norcliffe recorded that his captain was sending to the shore some survivors they'd rescued, 'that were almost dead, and ere taken up Swimming'.

In Defoe's Britain, seamen rescue seamen, but he – like William Camden a century earlier – questioned the selflessness of 'country people'. In a harrowing description of the scenes on Goodwin Sands that night, the people of Deal in Kent stand alone in *The Storm* 'for their great Barbarity in neglecting to save the Lives of abundance of poor Wretches'. The Goodwins lie just 6 miles off Deal, so those on shore could see what was happening. Visible through the tempest at dawn were crowds of shipwrecked seamen on the sands, desperately signalling for help in the certain knowledge that they would all be drowned by the rising tide. In Deal, only one man, a mariner's outfitter called Thomas Powell, was moved to respond. Powell, who was also the Mayor of Deal, first

tried to persuade the men of the custom house to send out their boats, but they 'rudely refus'd', either to send their men, or to loan their craft. Seeing that some of the 'Common People' about him were affected by the plight of the stranded seamen, Powell offered anyone who'd help five shillings for every man rescued. Surrounded by 'a crew of stout honest Fellows', the mayor commandeered the customs vessels and 'several other Boats' and with his volunteer crews he managed to rescue 200 from the Goodwins before the incoming tide drowned those who were left. For Defoe, celebrated these days as the pioneer of 'realist fiction', *The Storm* is a brilliant piece of journalism that captures the horror of the moment by placing the reader in the quavering shoes of the appalled towns-people who must decide between the possibility of losing their own lives, and the certainty that others will lose theirs. It's the universal challenge that every lifeboatman would come to face, on every call-out.

Defoe was being unfair to the men of Deal – who had understandable reasons for being hesitant in the face of the worst storm anyone of that generation had seen. For many men, there had always been a selfless reason for staying on shore; that of having to provide for a family. In a serious gale on 3 November 1825, during which several ships were wrecked on the south and east coasts, the boatmen of Deal made it into the pages of *The Times*, by rowing no fewer than seven boats out to the Goodwins in an attempt to save the crew of a 400-ton ship that had been swept by 'tremendous' seas onto the sands. Swamped several times by breaking waves, and with oarsmen 'nearly worn out with fatigue', the rescue boats persevered to within two cable lengths of the wrecked ship, but were eventually driven back to shore. The entire crew of the ship was lost. A witness (addressing perhaps Thanet's reputation for barbarianism) told the newspaper that 'for many years' he'd observed 'the praise-worthy exertions' of Deal's boatmen, and their usefulness 'in endeavouring to save the lives of their fellow-creatures, at the imminent hazard of their own'.

There's ample evidence that such heroic rescue attempts were not unusual, and by the 1820s they were frequently being launched by the officers and men of the bodies established to combat smuggling. During that storm of November 1825, several boats from Lowestoft and Gorleston rowed to the

rescue of a brig that had been blown onto Corton Sand. In 1821, three officers of the Coast Blockade tried to launch their galley through a storm to reach a Dutch *galliot* foundering off Hastings. Two women, three children, three crewmen and the ship's master could be seen clinging to the rigging of the mizenmast and foremast. When one of the crew was spotted struggling in the sea, an Admiralty midshipman called Mr Drake swam out from the shore towing a rope, the other end of which was held by a Mr Barniston, 'who was up to his neck in the surf'. Drake succeeded in reaching the drowning seaman and tied the rope around his waist so that he could be hauled ashore. Meanwhile, the blockade officers and some seamen had managed to launch their eight-oared galley and row it through the breakers towards the ship, but they were capsized and had to swim for their lives. They recovered their galley, hauled it along the shore and then tried again, rowing out through huge surf, where they were capsized a second time. Tragically, the ferocity of the storm increased and all those clinging to the wrecked ship were swept away as the masts toppled. The following year, again in November, officers and men from the Coast Blockade stationed at Dymchurch in Kent, dragged their galley for three-quarters of a mile along the beach, then launched it through 'tremendous surf' in an attempt to reach two men and a boy on a wrecked sloop. It was a heroic effort. The blockade men had stripped off their clothes in case they had to swim. Winds were 'blowing a hurricane' and their boat was 'several times swamped'. Yet they had almost reached the sloop when 'a most awful surge' struck the wreck and threw it over, drowning the crew.

On the broken cliffs of Anglesey, one day in February 1824, it was customs officers who led a valiant rescue attempt when a brig out of Cork ran onto the rocks after it failed to make the safety of Holyhead harbour. There were women and children on the brig, and their cries could be heard through the thunderous surf. The customs men saw that, if the mainmast could be felled, it would fall to the rocks and form a bridge to the shore. But there was no axe on the brig, and then the rising tide forced the rescuers back from the rocks. Several had drowned by the time the brig broke free, to be swept onto another rock, which the customs men managed to reach. A rope was thrown and six men were saved before 'a dreadful crash ensued, which shivered the vessel to atoms'.

These spontaneous responses to the victims of shipwrecks were the other side of the wrecking coin. The organized reactions by blockade and customs officers, and by the men of Deal, were an institutional lifeline reaching out from many parts of the coast. The balance was tipping, from the wreckers towards the wrecked. Formalized rescue services began to appear as early as 1730, when a boat was stationed on the beach near Formby, ready should ships entering the Mersey find themselves in trouble. And in the 1780s, at Bamburgh on the coast of Northumberland, a far-sighted philanthropist named Dr John Sharp introduced a package of measures to protect seamen from the Farne Islands and the treacherous coast to north and south. Key to his concept was a 'coast-watch' system, with observers keeping an eye on passing shipping and beach patrols ready to help shipwrecked mariners. When North Sea fogs shrouded the coast, a gun was fired from the battlements of Bamburgh's castle, and Sharp also provided chains which could be used to haul ships to safety. The chains were 'to be lent gratis to any person who has occasion for them, within 40 or 50 miles along the coast, on giving proper security for their return' and they can be seen today in the castle. It was Dr Sharp – a true visionary – who paid for a rescue boat to be kept at Bamburgh. The boat was the work of an Essex-born inventor called Lionel Lukin, who in 1785 had taken out a patent for an 'unimmergible' boat with cork gunwales and watertight buoyancy chambers. Lukin regarded himself as 'the original inventor' of such a boat, and so did William Wouldhave, a parish clerk of South Shields, who entered a competition to design a rescue boat for the mouth of the Tyne following the disastrous wreck of a collier in 1789.

The Lukin/Wouldhave vessel was constructed by a Tyneside shipwright called Henry Greathead. It was a sensational success. When the travel writer Richard Warner visited Bamburgh in 1801, he realized that he was seeing the future: 'A new invention has lately been adopted at Bamborough-Castle, called the life-boat; a name it has received from the generous purposes to which it is applied – that of rescuing the perishing sailor from the fury of the ocean.' Greathead, noted Warner, had built similar 'life-boats' for South Shields, Sunderland and Holy Island. 'Its form', continued the travel writer, 'is that of a long spheroid, thirty feet in length by twelve feet over; either end pointed, and this is calculated to row both ways, an oar serving the purpose of a helm. About eighteen inches

below the gunwale a strong lining of cork covers the whole of the inside, which gives the boat such buoyancy as enables it to live in any water. The crew usually consists of about twenty men, and the capacity of the boat enables it to receive ten more.'

Warner was told that when the South Shields lifeboat had been sent out in a 'horrible gale of wind', many on land thought it would sink, but 'floating like a feather upon the water, it rode triumphantly over every raging surge, and smiled at the horrors of the storm'. Readers of Warner's entertaining tour of northern England and the Borders were told that Greathead's lifeboats had already saved 'many hundred distressed sailors' and that this new 'service of saving the shipwrecked ... well deserves the *civic crown*'. Which is pretty much what happened. Greathead called his boat the *Original*, and by 1804, 23 of his lifeboats were operating around the British coast.

The new humanitarianism of the early 19th century produced one of the world's most successful rescue organizations. In 1824, a couple of years before smuggling was driven back from the coast by the repeal of nearly 400 Customs Acts, a meeting chaired by the Archbishop of Canterbury was held at the London Tavern public house in Bishopsgate. A resolution was passed, forming the National Institution for the Preservation of Life from Shipwreck. Its objectives, which were spelled out in an advertisement placed in *The Times* six months later, were ambitious and expensive. Beyond saving lives at sea, the institution wanted 'reward to those who are instrumental in rescuing lives in cases of shipwreck; immediate necessary assistance to persons rescued from shipwreck [and] relief to widows and families of persons who perish in attempts to save the lives of others.' By the end of the year, nearly £10,000 had been donated, a sum equivalent today to over £8 million.

The history of the Royal National Lifeboat Institution is like a long, two-strand rope, one composed of extraordinary acts of seamanship and courage, and the other of technical innovation. I was given an insight into both when we filmed the first series of *Coast*. It was a cold, blowy, mid-November morning and we'd got up early to meet the Liverpool University rowing team on the banks of a muddy creek just off the Ribble Estuary. In the water beside us was *Queen Victoria*, a magnificently restored, 34-foot, 'pulling and sailing' lifeboat

that had first taken to salt water in 1887. Dressed in a cumbersome cork life jacket and a sou'wester, I took my place on one of the benches, surrounded by strapping athletes half my age. Each oar was the size and weight of a telegraph pole. With ten people pulling, the boat shifted at quite a pace, particularly when we were sucked by the ebbing tide through the mouth of the Ribble. It was out here, on 9 December 1886, that a barque called the *Mexico* was wrecked, with catastrophic consequences. Four days earlier she'd sailed from Liverpool bound for South America, but gales had driven her back towards the coast of Lancashire, where she'd struck a sandbank in the Ribble Estuary. The captain of the ship ordered the burning of blue distress lights, which were spotted from the shore. Three lifeboats were launched into the furious night: the *Charles Brigg* from Lytham, the *Laura Jane* from St Anne's and the *Eliza Fernley* from Southport. Despite having three of her oars broken, the *Charles Brigg* managed to get alongside the *Mexico* and rescue the crew of 12. *Laura Jane* capsized and her crew of 13 drowned. *Eliza Fernley* had been hauled by horses 4 miles along the beach before being launched towards the wreck. She too capsized. That night, 27 lifeboatmen were lost, leaving 16 widows and 50 orphans.

To find out how hard it was to propel 3 tons of lifeboat flat out, we rowed *Queen Victoria* through a measured mile, using a GPS unit. It was knackering. In one of those ironies that is less alarming after the event, our Victorian lifeboat was then snatched by the tide, and despite increasingly strenuous efforts to row her clear of the tide races we eventually broached on a sandbank, and had to be rescued by a modern Mersey Class lifeboat. The following day I was invited to jump from the lifeboat into the Irish Sea so that I could experience on film a rescue drill. Although I was wearing a wetsuit beneath my clothes, the water was so cold that it took me just a few minutes to become a helpless rescuee, floating face-up, trying not to inhale splashes of salt water (which apparently is what drowns most shipwreck victims). The swell was so large that I spent much of the time feeling very alone at the bottom of grey troughs. It was only when I was lifted onto a crest that I could see the lifeboat, which had withdrawn some way for the purpose of authenticity. I wouldn't say that I was actually worried, but when I was raised by the swell for long enough to detect a bow-wave rising from the lifeboat, I did exhale the smallest sigh of relief. They circled, I delivered my

'piece to camera' (with no need to exaggerate the sense of drama), they circled some more (for the wide shot), and then an RNLI inflatable appeared alongside. I was grabbed by enormous hands and rolled into the RIB, which surged to the lifeboat, where I was lifted in a soggy bundle onto the deck then propelled into the cabin, wrapped in a blanket and handed a hot drink. Since the RNLI was founded in 1824, its crews have saved more than 137,000 lives.

Filming in helicopters is always a bit tricky. There is never quite enough space for a cameraman, sound recordist, presenter and director to operate without becoming contortionists, and the racket of air-rush, engine and rotorblades plays havoc with microphones – especially when the helicopter is flying with its side door open. On this occasion, we were swaddled in one-piece yellow immersion suits, a thousand feet above the sea, off the coast of Lewis in the Outer Hebrides, and I was trying to interview a chief pilot of Stornoway Coastguard's Search and Rescue Team. John Bentley had been flying this 'patch' for ten years as part of a team that covers 2,900 miles of coastline up to 240 miles out into the North Atlantic. One day they could be responding to a road traffic accident, and the next rescuing the crew of a fishing vessel. 'It's a very hostile coastline,' the pilot told me through the headphones, 'due to the weather, the swell, the Atlantic just constantly battering it. Regularly here, 70 to 80 mile an hour winds … It goes from flat calm to completely wild … It becomes very dangerous very quickly.'

Through the windscreen I could see the western edge of Britain, the edge that faces the open Atlantic; a ragged brink of wave-chewed, three-billion-year-old rock, twisting and turning around bleak, khaki moors puddled with lochans and fjords. Through the other side of the windscreen, just ocean. Like so many men and women who are used to operating in extreme environments, John's low-torque delivery suggested he was describing somewhere very ordinary:

'The further out you go, the swell becomes larger and more consistent. The biggest I've seen is probably about 80 foot.'

In the din of the helicopter's cabin, it was hard to compute what John was saying. The image of that fishing boat on the toppling super-wave in *The Perfect Storm* slid across my retina.

'We can fly this in pretty much the worst possible conditions … But we also have to know when to stop.'

As it happened, the helicopter had stopped just six weeks earlier. Over six days in January 2005, two exceptionally deep depressions had raged in from the Atlantic, the second producing gusts recorded at 106mph and causing a storm surge. For 16 hours, winds were at hurricane force. The coastguard helicopter was grounded for the first time in 18 years of operation.

John brought us to a hover above a clifftop while the winchman clipped me onto the cable and lowered me into the downdraught. Dangling in mid-air between the churning helicopter and the upturned faces on the ground, I sensed for a moment what it must feel like to be plucked from oblivion by the coastguard.

On the ground were Willie MacRae and Dave Woods. Willie owns a local building firm and Dave runs a parcel-delivery service to the islands. They're both volunteer members of the Stornoway Coastguard Auxiliary Service. While we drove in their coastguard truck along the sunlit coast road, they talked about the storm that had struck the Hebrides six weeks earlier. They had been out all night, assisting the other emergency services. Giant waves were pulverizing the coast and the storm surge sent seawater rushing inland. Houses were flooded, electricity cut off, fishing boats torn from their moorings. In the midst of it all, Willie and Dave were asked to rush oxygen to an elderly woman trapped in her house 10 miles outside Stornoway. 'We started helping the ambulance boys,' explained Willie, 'because they were working to capacity.' Dave continued: 'Four o'clock was the deadline. She had enough oxygen to keep her going till four in the morning … We *had* to get there … .' I wondered about how they handled the pressure, as volunteers, but they wouldn't be drawn. 'It's just a job you get on with,' said Dave. What about their families, their wives, I asked, what did they think of their husbands being out all night in such a dangerous storm? Willie nodded to Dave in the driving seat: 'His wife was annoyed that he went out, and mine wanted me to stay out longer.'

They dropped me at the coastguard operations room in Stornoway, where Duncan MacKay, who'd been watch manager that night, took me to a huge Admiralty chart of Scotland. The ops room reminded me of other ops rooms: ordered,

prepared, arranged with screens, charts, phones. Duncan pointed to the southern end of the Outer Hebrides: 'Barra was the worst affected … winds up to 124 miles per hour. Uist area was about 114, and then the area of Lewis in excess of 100.' It was one of the busiest nights the Stornoway coastguard had ever had; they were called out to five life-threatening incidents. 'The phone was continuously ringing. Treble nine calls coming in. Because of the severity of the storm, there were people in trouble all over the islands. It went on for so long. It never seemed to end. Going on and on and on. We had a debrief about half past nine in the morning and we said well, it's gone well … No lives have been lost. Little did we know that a family of five were lost in Uist. Nobody knew at that time.'

Next day, I went down to Uist, to the road along which the McPherson family had been driving in two cars when they were swept away by the sea. At seven in the evening, they'd left their house on the coast as it was being battered by the storm. Two of the local coastguard officers took me to the spot. Bev Campbell and Donald MacLennan had joined the search. They knew the McPhersons personally. On a windless evening we walked along the narrow road as the sun settled over the ocean. It was one of the saddest walks I've ever taken. The McPhersons were coming along the road in their car, trying to reach the shelter of a neighbouring bungalow. When they'd been reported missing, the community, the rescue services, had combed the area, wading, paddling rubber boats across the flooded land. We reached a narrow causeway, with water on both sides, and a bunch of white roses tied to the wire fence. Donald looked across the water: 'It was five, five people in all … Grandfather, mother and father, and two children … Three generations wiped out in one go … A very sad occasion. Very.'

The sense of loss was palpable. Only six weeks after the storm, the poignancy was made all the more bewildering by the calm the softening sun was bringing to peaceful, tidal marshes which had so recently been the setting for violence and tragedy. 'Looking at it now,' said Bev, 'it's a beautiful place … Beautiful area; beautiful place to bring up a family. And you just can't imagine something like that will happen. Hopefully we'll never have to experience anything like it again.'

In the peace of that Hebridean evening, it was all too clear how far we'd come in a couple of hundred years. HM Coastguard have transformed our

shores and waters, and yet their presence is barely visible. Their modern roles –
to respond to vessels or people in distress on the sea or coastline; to respond to
reports of maritime pollution; and to provide safety education to everyone from
mariners to schoolchildren – make them the hub of a safety network many of
us take for granted. On UK coasts, the call to report a child drifting out to sea,
or the Channel 16 call to report a flooding engine-room, will be directed to one
of 19 Maritime Rescue Coordination Centres like the one at Stornoway. There's
one at Dover, too, on the cliffs to the east of the port. There are screens in there
like no others in the country. On them, you can see ceaseless processions of ships
passing to and fro along the English Channel. It's a bit like watching a CCTV
image of slow-moving traffic on a motorway, except that most of the blips on
Dover's screen take a very long time to come to a halt should the need arise.

When I first saw those screens at Dover, I tried to imagine what would
happen in the English Channel if the coastguard were not monitoring the traf-
fic; as an accident prevention body, they have become essential. During the
19th century, an average of 1,800 ships were being wrecked on the coast of
Britain every year. That, as Ian Cameron, author of *Riders of the Storm* points
out, means that a ship was being wrecked roughly every six hours. Deaths at sea
were far more than those on the road today, where the total number of fatali-
ties in Great Britain is running at around 3,000 a year (the total number of
road casualties of *all* severities is, however, an appalling annual average of
250,000 – which is a far higher figure than any annual figure suffered at sea).

Most mishaps these days seem to be caused by human error. A cursory trawl
through a recent, five-year period of prosecutions by the Maritime and Coast-
guard Agency reveals a range of incidents. The skipper of a 2,000-ton cargo vessel
that grounded off Dunoon was arrested after being breathalysed by Strathclyde
police. After the *Gerhein G* ran aground near the Kentish Flats in the River
Thames, her master explained that he had been temporarily incapacitated after
an insect stung him on the ear. Fishing boats sank or collided after their skippers
fell asleep or left the wheel to make a cup of tea. A cargo ship called *Stroman
Asia* sailed up the English Channel against the direction of traffic flow, causing
six 'close quarter situations'. Her Italian master was fined £14,000. A French
yachtsman named Koch, skippering a bright red trimaran, the *Sopra No 8*, made

a similar, costly, error. He left Brighton bound for London's Canary Wharf, but sailed for nearly 18 miles north-east along the south-west traffic lane, meeting 21 other vessels coming down the lane and crossing with two others. Seven of the vessels had to take evasive action. Koch was fined £15,000 and £2,600 costs. The RMS *Mulheim* ran onto rocks at Sennen Cove after her chief officer 'became unconscious' at the bridge, and the following day, as RMS *Ratingen* was approaching Shoreham, the local pilot became aware that the ship was not responding to radio calls as it sailed through the anchorage. Having boarded the ship by climbing over the gunwale, the pilot found the master on the bridge, fast asleep.

Today, there is not one mile of the archipelago's coast beyond the reach of rescue services; a phenomenal reduction in coastal risk that took two centuries to achieve. An electronic device the size of a paperback book makes it possible for Coastguard screens to monitor the locations of all fishing vessels over 15 metres in length, and all vessels of any kind that weigh more than 300 gross tons. The Automatic Identification System (AIS) is compulsory for these vessels, but they can be fitted to small fishing boats, yachts and other leisure craft too. These days, you have to make a conscious decision to be invisible at sea. Assuming that an AIS is fitted, or that the correct location of a mishap has been transmitted by other means to the Coastguard, assistance can be on its way within minutes. The key to rescue at sea is a correct set of coordinates. The latest suites of electronic devices, from AIS to GPS to DSC (Digital Selective Calling) make it possible for nearby ships, or lifeboats or helicopters to head straight to a vessel in distress. Systems are also in place to react to oil spills, or stray drums of chemicals. On cliffs and beaches, coastguards with specialized apparatus can pluck a victim from quicksand or a cliff ledge.

Much of the coast would still be recognisable to a Mesolithic boatman; the archipelago is still rimmed with the same tide-races, reefs and sand-bars, and it's still prey to the same storms. But there are fewer excuses for running into trouble. And when human error or the forces of nature do conspire to cause an emergency, there are teams who know how to respond. It's a remarkable turnaround after the eras of mayhem and murder brought to the coast by wreckers and smugglers.

7.
Wish You Were Here!
How We Learned to Play With the Sea

There is a beautiful beach on the coast of Assynt, in north-west Scotland. It is at a place called Clachtoll, a Gaelic name that roughly translates as 'stone hollow', a reference perhaps to the rocky shores of the little lochan around which the original community must have constructed its crofts from the oldest stone in Britain. The beach is a gentle smile of silvery sand about two hundred metres wide, framed to the south by a low, green hill, and to the north by a broken promontory punctuated by the stub of a ruined broch. The campsite behind the beach has been a favourite for several generations of Scottish holidaymakers.

The last time I put up a tent at Clachtoll, my children insisted that I swim with them across the bay. It is of course imperative in these situations not to betray any discomfort, or to suggest to your offspring that swimming in Arctic waters is anything but wholesome. So I swam manfully; parentally. I say 'swam' but I don't really swim so much as flounder on an approximate course. But given the right motive (ritual humiliation and fear of drowning) I can flounder quite fast. In fact, I could be quite a plausible swimmer but for the need to keep my head above water to prevent my spectacles sinking, and an aquatically inconvenient rigidity in my arms and legs – caused, I suspect, by a surfeit of marching while in the school combined cadet force. Out in Clachtoll Bay, the icebergs, the oblique ranges of monstrous waves and the ridiculously distant destination – a rock halfway to Newfoundland – chosen by my kids, required a particularly frantic version of my customary marching stroke. I did make the rock, but was

so cold on arrival that I had to instigate a game of competitive press-ups (hah! no contest there) in order to restore circulation to my limbs.

It isn't just the physical difficulty I have with sea-swimming, but the thought of what lies below. A couple of years ago, I was lured into salt water by the author of *Scott of the Antarctic*. David Crane (no relation) lives just above the tidemark at the tip of a remote Scottish peninsula. We were only a few metres from the rocks, but there was a mid-Atlantic swell and the seabed was so distant from sunlight that the water was the colour of Quink. Sea-swimming is testing enough when you can see the bottom, but when you can't it becomes unnerving. Especially if you choose that moment to remember the kraken in *Pirates of the Caribbean*. The thing is, no matter how often I tell myself that I'll never be tricked into salt water ever again, the forces always prove irresistible.

Human beings have been swimmers for thousands of years, but our natural amphibious habitat is freshwater. The banks of rivers and lakes were places to camp and to hunt. The four great rivers in the Garden of Eden were the source of life, and the River Jordan – mentioned more than any other river in the Bible – was the place where peoples met and miracles occurred. Man learnt to swim in rivers. Being able to cross a river, or a narrow lake, was one of the basic bushcraft techniques in the Mesolithic survival manual. The hunter-gatherers who made their way through the rising waters of Doggerland towards the smudged horizon of Britain knew how to swim. You can see them today on the cave walls of Egypt's Gilf al-Kebir plateau, propelling themselves through the lost rivers and lakes of the Sahara at around the time that Britain was emerging from the ice. And you didn't even have to be a swimmer to cross a body of water; an inflated animal skin (like the ones being used by Assyrian soldiers on a bas relief in the British Museum) made a very effective buoyancy aid if you hadn't quite mastered the finer points of front crawl. In medieval England, swimming was one of the virtues required of knights. Not that swimming, in those early days, was something a family did for fun on Saturday mornings. Swimming, when it crops up in early texts, is heroic not recreational. Men swam to win battles and to defeat sea monsters. Odysseus swam to save his own life; Beowulf swam for pride. Back then, nobody heroic would pull on a pair of

Speedos and swim *for fun*. Especially in salt water. Thalassophobia is older than Doggerland. Homer's Aegean is not the clear-watered, snorkelling paradise we know today, but a quickly provoked fury; a monster that almost drowns Odysseus after his raft capsizes. The 'great abyss' in the book of *Genesis* was an immeasurable aquatic mass that symbolized the unknowable. The ocean was the fearful void; an unfinished project; the primordial gunk that had yet to find a form suitable for Creation. It was chaotic and prone to sudden angers that rent its tortured surface and engulfed the land in catastrophic floods. There were no oceans in Paradise.

While the fathomless ocean was incomprehensible, the stuff that it was made from could be contained in a vessel. To the ancient Greeks, seawater was the most cathartic of all waters; purer through its constant motion and saltiness than the freshwater of any lake or stream. Freshwater was polluted with the dirt that had drained from land and body, while the sea purified all that it washed. Dolphins and octopuses on decorated vessels unearthed in the Minoan palaces of Crete are thought to refer to the use of seawater during purification rituals. The seashore was a cleansing zone; the place where Man could lose the noxious miasma of terrestrial existence and start afresh. It is on a shore that Achilles instructs his Myrmidons to 'wash off their defilement'. I know what that feels like: when I reached the English Channel after walking from the Scottish border, I sank into the clear water of a rock pool cut into Dancing Ledge at the foot of Purbeck's cliffs. It was the most sensational experience I'd had in two months of yomping up and down dale and vale. Later, I discovered that local prep schools had used the pool at Dancing Ledge for ritual bathing, back in the bad old days of canes and cold water.

Seawater cures came of age with the Romans. Pliny the Elder, writing his encyclopaedic *Natural History* in the first century AD (thus predating by a couple of thousand years the branding of the Costa del Sol), reckoned sunshine to be 'the best of the self-administered remedies'. Lying on the back was 'good for the eyes, face and coughs'. Pliny pitied the Greeks for their lack of hydrotherapy, but he was a keen disciple of Asclepiades, whose five rules of 'self help' – fasting from food, abstinence from wine, massage, walking and outings in the fresh air – have chimed with every Age of Obesity. The formalized treatments emerging from the

Bay of Naples included seawater treatments for psoriasis and rheumatism, sea voyages for tuberculosis and hot seawater for muscle pain and for knitting fractured bones. Seawater baths were constructed throughout the Roman Empire. The 'M. Crasus Frugi' whose name was found on an inscription near the Herculaneum Gate in the ruins of Pompeii, was one of Europe's spa pioneers. Although his baths have never been discovered, the inscription advertised that his *Thermae* consisted of two chambers, one filled with seawater and the other with freshwater. Later, when Emperor Nero had a Michael Jackson moment in Rome and built himself a colossal new palace, he installed seawater baths. Baths were often oriented so that sunshine flooded through the windows. In faraway Maldon, a damp outpost in the island province of Britain, a legion commander called Cassius Petrox sought to re-create the therapeutic qualities of the warm Mediterranean by detailing his slaves to take seawater from the estuary and heat it for his baths. Back then, the Blackwater Estuary was less brown.

Little is known of British bathing habits in the centuries after the Romans left, although a monk on the Northumbrian coast in AD 731 wrote that there were both salt springs and hot springs in England, and that 'the waters flowing from them provide hot baths, in which the people bathe separately according to age and sex'. In his book of 1702, Sir John Floyer, a Lichfield physician and leading advocate of sea-bathing, claimed that 'the Common People' on the Lancashire coast had long believed that bathing in the spring tide during August would cleanse and protect against future illness, a tradition that Britain's leading seaside historian, J. K. Walton, considers had 'quasi-magical overtones'. A visitor to the Ribble Estuary was told by one of the bathers that the water washed away 'all the collected stains and impurities of the year.' Walton builds a case (based in part on another account which suggests that Lancastrians 'of the lower class' were visiting the coast before the 1760s) that sea-bathing had been practised on and around the Ribble Estuary for some time before the upper classes began dipping their toes in the briny. As late as the 19th century, the traveller Richard Ayton was told that each August and September on the Lancashire coast, '(There) is physic in the sea – physic of a most comprehensive description, combining all the virtues of all the drugs in the doctor's shop, and of course a cure for all varieties of disease'.

The belief that seawater was in some way magical, or invested with health-giving properties, seems to have persisted throughout the British Isles. As late as the 18th century, diseased men and beasts were still being 'dipped' in the Severn Estuary, and until the 19th century, country people in Caernarfonshire and Aberystwyth would be called on fine nights by the blowing of horns so that they could head down to the beach and bathe. Information collected by the author Edmund Gilbert suggested that sea-bathing had been practised on various south coast beaches from Deal to Exmouth, long before the 1750s. And up in the far north of Scotland, the 17th-century Hebridean explorer, Martin Martin, came across a bizarre belief in the efficacy of salt water. There is no way of knowing whether the 'singular remedy' for colds practised by a forester called John Campbell on the Isle of Harris had been conceived by himself, or handed down by his forebears. 'He walks', reported Martin, 'into the sea up to the middle with his clothes on, and immediately after goes to bed in his wet clothes, and then laying the bedclothes over him procures a sweat, which removes the distemper.' On the island of Benbecula, Martin came across people who rubbed their breasts on a special stone because it was 'a good preservative for health'. It probably felt gneiss.

When did we first smile at the feel of sand, soft beneath a foot sole? The beach – *bache, bayche, baich*, perhaps identical with Old English *bæce* or *bece*, for brook or stream (*OED*) – has always been a place of no fixed form; a zone of transition where Nature wears its moods and histories most transparently. A beach is a threshold, a book, a larder, a grave. It's impossible to know how the earliest islanders related to the spreads of shingle and sand that separated the seaways from forest and grassland. Did the families who filled the middens of Skara Brae with shellfish ever pause on the shore as we do today, and wonder at the *beauty* of the place; the play of sunlight on the shallows? Did they too relish the altered topographies of the coast, with its edge-of-land verticalities and strange symmetries of dunes; its anthropomorphic spits and headlands? Did they run and splash, and peer at their reflections in rock pools? Did they yelp, like us, at passing dolphins? We do know they had an eye for form: the ivory bead, stippled like a seashell, that was found in the rock shelter of La

Souquette in south-west France, was carved between 32,000 and 34,000 years ago, when 'Britain' was part of a landmass connected to Asia and Africa. We probably played on beaches long before our land bridge was severed but early Britons didn't construct concrete carparks and esplanades for future generations of archaeologists to decode. Whatever fun they derived from our shores was zero-impact and 'green'. Their footprints dissolved in the tide.

It was the historian of medieval England, Doris Mary Stenton, who pointed out that the practice of going on a medieval pilgrimage was 'the contemporary parallel to a modern holiday'. As it happened, most of the principal shrines in medieval Britain were on, or close to, the coast – and spectacular coasts at that. The early pilgrims who made it to the island of Iona off the coast of western Scotland, or to the island of Lindisfarne (Holy Island), off Northumberland, or to Walsingham, an hour's easy amble from the bright sands of north Norfolk, would have found themselves gazing at some of the most sublime coastal views in the archipelago. To this day, Lindisfarne, Iona and Holkham Bay have remained must-see sights on the British coast. Having prayed at their shrines and applied for purgatorial remission, did some pilgrims top off their hikes with a day on the beach?

We do get a tantalizing peek into the coastal sensibilities of the medieval mind in the manuscripts of Giraldus Cambrensis – Gerald of Wales – whose 12th-century account of his journey around the periphery of Wales is still a best-seller. In his autobiography, the peripatetic scholar and churchman mentions that he played as a boy on the beach below his father's castle at Manorbier, on the coast of Pembrokeshire. Gerald and his three brothers had time for what he calls 'childish play … in sand or dust'. The sand is presumably the sand of the beach, and the play, he writes, involved drawing and building the shapes of towns and palaces (Gerald himself preferred to make churches and monasteries – which caused his father to give him the nickname 'Bishop'). On summer days, you'll find 21st-century children playing on the same sand below the de Barri battlements. There's a patch of good skimmers, too; water-worn discs of Silurian mudstone. It is one of the loveliest spots in Wales. Dyfed was Gerald's ideal landscape: 'particularly attractive,' he wrote in his *Description of Wales*, 'because of its flat fields and long sea-coast.'

Gerald was unusual, a privileged child whose veins ran with the blood of a Norman adventurer and Welsh princess. Most boys in the Middle Ages didn't grow up in castles and make sandcastles on the beach. At the time, nine-tenths of the population lived in the countryside, and most of them were preoccupied with the day-to-day business of working the land, either for themselves or for their master. Through to the 16th century, the coast was portrayed in books and on maps as an edgy, physical presence: the outer ring of an island's defence, irregularly dotted with havens for fishing boats and trading vessels. And beyond the island's uncharted rim lurked hostile warships, shifting sandbanks, tide races and tempests that could reduce a fleet to kindling in the course of a winter's night. The coast of John Leland and William Camden was a marginal place, far removed from the protected pleasures of court and garden. The brief digression on seashells in Richard Carew's early 17th-century *Survey of Cornwall* is a rare example of coastal appreciation. Carew felt at home on a beach: 'The sea-strand is also strewed with sundry fashioned and coloured shells', he wrote, 'of so diversified and pretty workmanship as if nature were for her pastime disposed to show her skills in trifles.'

But the scholars who dominated the print market of 16th-century Britain were not, on the whole, looking coastwards. Had Leland been as interested in observing the behavioural patterns of coastal communities as he was in recording the numbers of arches in bridges, we would be better informed about the early days of seaside sensibilities. Historians have never been assiduous in recording the everyday lives of 'ordinary' folk; the greater population whose gritty existence was played out a long way from the libraries, chambers and halls of formally educated scholars.

The Tudors have a habit of colonizing disproportionate chunks of British history, so it's unsurprising that they've taken credit for leading the way down the shingle towards rational sea-bathing. The first British book to promote medicinal bathing was published during the reign of Elizabeth I, by the rabidly anti-Catholic Dean of Wells, Dr William Turner. His two-volume *Herball* included a section on 'the natures and properties, as well of the bathes in

England, as of the other bathes in Germany and Italy'. In fact, the only British baths he mentioned were the neglected Roman conduits at Bath. Tudor society, he complained, was squandering vast sums of money on cockfighting, tennis, partying, banquets, pageants and plays, and yet the 'noble baths' of Bath had not had 'one groat these twenty-nine years'. What the dean wanted was a development budget to turn the collapsing Roman baths into a modern amenity; a health resort. He wasn't alone. Britain was a nation in pain. The commonly suffered ailments Dr Turner was treating included intestinal worms, 'knobbes & hard lupes' caused by 'French pockes', infertility, premature birth and – particularly common among the overfed elite – 'The vayn appetite of goyng to stoole, when a man can do nothing when he cummeth there.'

While the likes of Willoughby and Chancellor were sailing off in search of the North East Passage, pioneering sufferers of gut-rot and pustules were exploring Britain for its healing waters. Springs that had been frequented by the Romans 1,500 years earlier were renovated, and new ones discovered. In about 1570, a bathing hall and lodging were constructed at Buxton's Roman spring by the 16th Earl of Shrewsbury, and at around the same time, a Mr William Slingsby came across a spring surrounded by strange encrustations in the wooded hills west of Knaresborough in West Yorkshire (by the time Celia Fiennes came this way, in 1697, the 'Tuewhit Well' – named after the peewits which were found feeding there – had become absorbed into the celebrated spa of Harrogate).

In parallel with the quest for new mineral springs, Tudor Britons were beginning to dip their toes in the sea. The scamper down the beach was led by an educationalist and footballing Old Etonian called Richard Mulcaster, who had risen through humanist ranks to become the first headmaster of Merchant Taylor's School, then the largest school in the kingdom. Mulcaster's treatise of 1581, *Positions wherein those primitive circumstances be examined, which are necessarie for the training up of children, either for skill in their booke, or health in their bodie, etc.*, included the first comprehensive description in print of football rules, and a section on swimming. 'The swimming in saltwater,' advocated the headmaster, 'is very good to remove the headache, to open the stuffed nosethrilles, and thereby to helpe the smelling.' Mulcaster also reckoned that

swimming was 'a good remedie for dropsies, scabbes and scurfes, small pockes, leprosies, falling awaye of either legge, or any other parte'.

Books like Mulcaster's were yet another hole in the hull of 'popery', urging young Tudors to regard natural waters for their medical, rather than magical, benefits. Springs that had been habituated by pilgrims seeking miraculous cures began to be visited by patients whose physicians – versed in rediscovered Latin and Greek texts – regarded minerals as medically beneficial. The Tudor quest for strange waters became a mass endeavour when William Camden published the first edition of *Britannia*, in 1586. *Britannia*'s success meant that Camden was able to release new editions of his masterwork with astonishing frequency, adding springs and spas as they were discovered and developed.

An early hint of interest in the coast's perceived medicinal value can be detected in the unpublished notes of Henry VIII's travelling antiquary, John Leland, who mentions that a Kentish judge had built a house near the sea after being advised by his physicians that Herne in Kent was an 'exceptionally healthy area'. It's hard to say how much of the Tudor awareness of the health-giving attributes of the coast had been the recent discoveries of their own empiricists, and how much had been inspired by classical texts. Leland – fresh from three years in scholarly Paris – knew his classics backwards, and had perhaps detected the odd reference in Homer and Pliny to sea-bathing and solar therapy. In Tudor Cornwall, the antiquarian Richard Carew was unequivocal about the benefits of being close to the coast. The sea air, he wrote, 'is cleansed as with bellows by the billows [Carew also fancied himself as a poet], and flowing and ebbing of the sea, and therethrough becometh pure and subtle, and by conse-quence healthful, so as the inhabitants do seldom take a ruthful and reaving experience of those harms which infectious diseases use to carry with them.'

Despite Carew's enthusiasm for Cornish sea-air, it wasn't the dairy-cream coves of the West Country that first came to the notice of the frail, poxed and blocked, but the bleaker, open strands of the east.

A sweepstake taken in the early 17th century on the coastal towns in Britain most likely to attract sea-bathers would probably have backed England's two great herring ports: Yarmouth and Scarborough.

The North Sea? Yes, the North Sea. I was going to swim in the North Sea last summer, not through choice, but because my father, who was then 82, had announced that he was going 'for a dip'. In practice, this meant that he was going to fall forwards into the waves, splash heroically for a few seconds and then run back up the beach to grab a towel and a thermos. But it wasn't the kind of challenge I felt able to decline, although on second thoughts I did, and watched him from the shelter of the dunes. I should say that I've often swum in the North Sea, having grown up 20 miles from Norfolk's endless curve of sand. The water's warmer when you're young. Four hundred years ago, the water was also clearer. In the centuries before trawling, when the North Sea was rich in oysters, mussels and bivalves of every size, a healthy ecosystem filtered and trapped the sediments that make it look like latte today.

Yarmouth was used to eminence. The settlement created by fishermen on a sandbank at the mouth of the Yare had grown into a prosperous port and for hundreds of years its near-impregnable walls had provided enviable security. The Duke of Norfolk, writing in 1545, reckoned it unequalled on English coasts: 'the prosperest towne, the best builded with moste substancyll howses, that I Know so near the sea in all your Majestie's realme.' Thirty or so years later, William Camden took the trouble to visit Yarmouth while collecting material for *Britannia*. When the book was published in 1586, readers learnt that Yarmouth was 'a very convenient haven … beautifully built and passing well fensed' with walls. Camden had seen Yarmouth at the height of one of its cycles of prosperity; between 1570 and 1640, the town would be virtually rebuilt. It was during this period, in 1619, that a local man, Sir Henry Manship, completed one of the earliest town histories in Britain.

Manship – who knew his philosophers – reminded his readers that there were four qualities that 'every well-founded Town or City' should possess: 'a wholesome air, fitness for war, meetness for traffick, and waters convenient.' Yarmouth ticked with a flourish the last three boxes, but in satisfying the box labelled 'wholesome air', Manship produced a claim that no other port could match.

Yarmouth, you see, was closer to Paradise than any other town of note in the kingdom. According to the great sixth-century expert on Paradise, Isidore of Seville, heaven on earth could be found on the eastern side of Asia, and there-

fore, argued Manship, the winds which blew in from the east blessed Yarmouth before any other place in Britain (he was naturally ignoring the fact that Yarmouth's historic rival and neighbour, Lowestoft, was actually the easternmost town). From the east came 'the first light of heaven, and the first rising of the sun … which, therefore, first in the east doth disperse the mists and vapours from off the earth, whereby it purgeth and cleanseth the air; and the beams of the sun following, do make all things fruitful and pleasant.' These paradisical breezes 'be wholesome in the beginning of the day, for they come of air that is subtle and temperate; and that the air of east lands and countries is clear and pure, and also dry and temperate, between cold and moist; therefore, such a wind maketh waters clear, and of good savour, and they keep and save bodies in health by temperature of their quality.'

Yarmouth was indistinguishable from the Garden of Eden, 'the land of promise which did flow with milk and honey'. As Manship pointed out, the physical form of Yarmouth could not have been more perfect, too, for this was a linear town, stretched north to south, 'in the whole longitude thereof', along the coast. Such an orientation gave the entire population (and any visitors) maximal exposure to Edenic benefits. 'It must needs,' Manship concluded, 'that Yarmouth is a town as wholesome for situation, as any town in this kingdom.' Manship added that he knew of many patients who had been referred by physicians in Cambridge 'to take the air of the sea' in Yarmouth. Apparently they had all 'recovered health very speedily'.

Well, so far as I can tell, Manship's work of 1619 is the earliest reference to a town on Britain's coast aspiring to the role of a health resort. Gazing down upon the summer holidaymakers through the plastic bubble of a revolving cabin on Yarmouth's big wheel, you'd have to agree that Manship was ahead of his time. He was right about the Edenic climate. The coast of Norfolk shares (with the south-east) the warmest, driest climate in Britain, and the highest levels of sunshine. But paradoxically, being closest to Paradise did have one serious drawback: in being so far east, Yarmouth was a very long way from inland towns and cities, and the roads to Yarmouth were notoriously prone to flooding. But there was something else, too. Seven years after Manship finished his book, a constipated woman in East Yorkshire stole his thunder.

It was in 1626 that a Mrs Farrow (or Farrer) of Scarborough came across a spring surrounded by a curious stain. She found it at the foot of the cliff half a mile or so south of the harbour. Curious, she drank from the spring and discovered that it 'opened the Belly'. Spontaneous bowel evacuation on a beach might not sound an agreeable coastal pastime, but it propelled Mrs Farrow into the history books. She had stumbled across a chalybeate – or iron-bearing – spring.

Everything about Scarborough had aligned it for public consumption. Pictorially, it was splendid, with its soaring buttress of limestone cliffs protecting a sweep of glistening sand. And there was reassurance in a location successively occupied by Romans, Norsemen, Normans and generations of successful fishing families. Through the ages, first-time visitors had loved the place. Riding by in the 1540s, John Leland had filled his notebook with admiration for the ancient town. To the young humanist schooled in Paris, Scarborough was a wonderful spectacle, well defended by sea and wall, with a 'beautiful' parish church completed by extravagant belfries, a harbour and an 'exceptionally good castle' poised upon 'a sheer crag'. Forty years later, William Camden put Scarborough in print, describing Henry II's towering keep as 'the greatest ornament' on the North Riding coast, 'a very goodly and famous thing'. Scarborough was waiting to be discovered by the travelling generation. It just took Mrs Farrow's funny tummy to make it happen.

Word quickly spread that the mineral waters on Scarborough's sands were an efficient purger. What began as a trickle turned into a flood. Physicians throughout the Ridings began sending their patients to the new spring. In 1660, one of them – a Dr Robert Wittie from Hull – published a book called *Scarbrough Spaw*, in which he described in great detail the chemical constituents of Mrs Farrow's waters, 'good', he claimed, 'against diseases of the head, as the Apoplexy, Epilepsie, Catalepsie, Vertigo', as well as a cure for 'the jaunders both yellow and black, the leprosie'. And it wasn't just the twitching and poxed of polite society who could be helped by a trip to Scarborough, for its waters were also a cure for less visible ailments: 'the Sovereign remedy against Hypochondriack Melancholly and Windiness.'

William Daniell's 19th century aquatint of a Portuguese ship wrecked at Aberystwyth after it failed to navigate the narrow, unmarked harbour channel during a gale.

The ribs of the barque *Helvetia*, still visible at low tide on the sands of Rhossili on the Gower Peninsula in south Wales. She ran aground during a November storm in 1887.

Wreckers recover cargo washed ashore from the crippled container ship *MSC Napoli* after she was beached at Branscombe Bay, Devon, in January 2007.

Top: an innocent waterfront so typical of the archipelago, but for centuries coastal communities like this were subsidized by wrecking and smuggling. In common with many east coast ports, Anstruther, in Fife, owed its existence to herring and trade, but it also played an infamous role in smuggling history.

Left: a treasure the wreckers failed to find – the ruby-studded salamander pendant retrieved in 1968 from the wreck of the overloaded Armada ship *Girona*, which was driven by a veering wind onto the rocks of Antrim on 26 October, 1588, with the loss of around 1,300 lives.

Bottom: Kent is closer to the continent than any other county and its shores were infested with smugglers. Conveniently for the men of the night, the largest shingle promontory in Europe protrudes into the Straits of Dover, just west of Folkestone. Dungeness was bleak and dangerous.

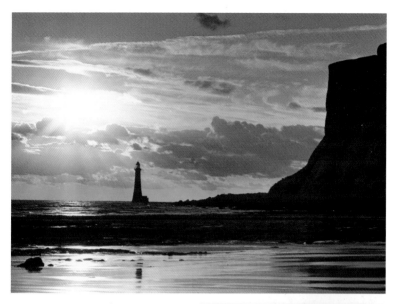

Top: the last traditional 'rock tower' lighthouse built by Trinity House was completed at Beachy Head in 1902 after 3,660 tons of pre-cut Cornish granite blocks were lowered down the Sussex cliffs. The lighthouse was automated in 1983 and is now monitored from the Operations Control Centre in Harwich. Trinity House provides and maintains nearly 600 aids to navigation, ranging from lighthouses and buoys to sat nav devices.

Right: an early attempt at making the shipping lanes of the English Channel less hazardous. Walter de Godeton's 'Pepperpot' was erected in the 1320s as a navigational seamark above St Catherine's Point on the Isle of Wight.

Left: the lifeboat is arguably the most potent symbol of a safer coast. Wreckers and smugglers have been replaced by a charity whose 40,000 volunteers are dedicated to saving lives at sea. Today, 235 RNLI lifeboat stations form rings of reassurance around the UK and Republic of Ireland. Since the RNLI was founded in 1824, its lifeboats and lifeguards have saved more than 139,000 lives.

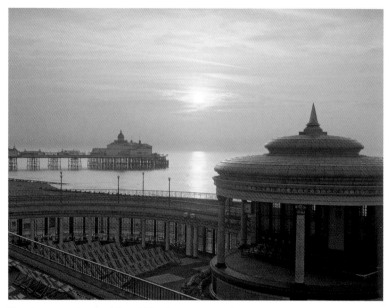

Top: the coast reinvented for middle-class escapees from teeming, polluted towns, with pier and promenade for absorbing sea air and observing the wilderness of the ocean. Raw nature touched its zenith with every sunset. This is Eastbourne, the 'Empress of the Watering Places'.

Bottom: Brighton has one of the finest Victorian bandstands in Britain. It was recently refurbished at a cost of nearly £1 million and is a popular venue for summer concerts, poetry readings, photo shoots and exercise classes.

SEATON. DEVON

GUIDES AND ALL INFORMATION FROM THE SECRETARY
OF THE SEATON DISTRICT CHAMBER OF TRADE. OR
THE CLERK. SEATON URBAN DISTRICT COUNCIL. SEATON. DEVON.
CORRIDOR EXPRESSES & CHEAP FARES BY
SOUTHERN RAILWAY

Top left: the poster as a beacon to toiling factory workers; paradise at the end of a railway line.

Sands of change: Scarborough [bottom] was the first coastal health spa in the country, a place where the leisured classes could drink from a purging spring and experience the sensation of walking on firm sand. Beaches have proved adaptable playgrounds [top].

A coastal Stonehenge: the prehistoric circle at Calanais.
above Loch Roag on the Isle of Lewis.

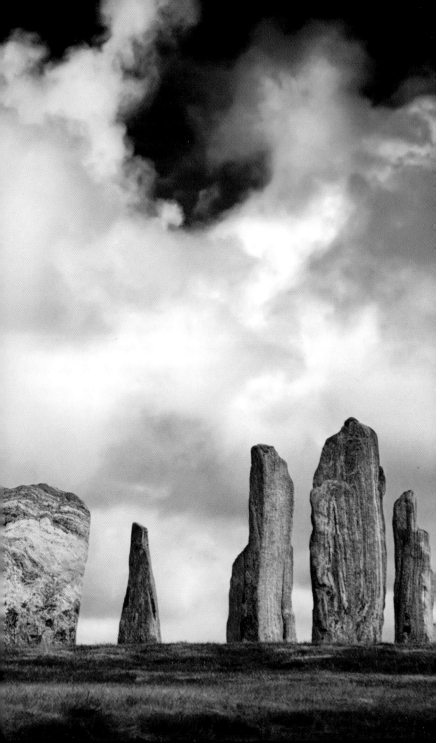

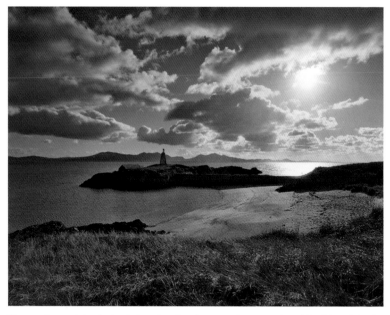

The coast as an islander's window: top: the view past the seamark on Llanddwyn Island to the peaks of Lleyn; bottom: one of the life-size, cast-iron figures erected on the beach at Crosby by sculptor Antony Gormley. He calls this work 'Another Place'.

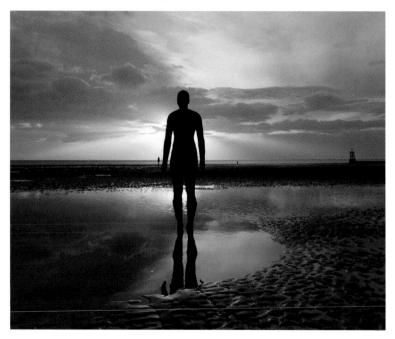

Wittie put Scarborough's spa – 'the best of them all either Germane or English' – on the map. His book, published in London, was a runaway success with the constipated classes. When Bishop Gibson updated Camden's *Britannia* in 1695 he gave Scarborough a thousand-word billing at the head of the chapter describing the North Riding of Yorkshire (elsewhere in *Britannia*, Brighton got half a sentence). 'The Sea-coast,' raved Gibson, 'is eminent for Scarborough.' Pilfering material from Wittie's book, the bishop gave his readers a detailed description of the nature and location of the mineral spring on the sands, 'arising upright out of the Earth like a boyling pot'. On the county maps that accompanied Gibson's new edition, Scarborough appeared in prominent lettering. Wittie's book went into a second edition, and health tourists began diverting to North Yorkshire. Scarborough became the first coastal health resort in the country.

Celia Fiennes was probably fairly typical of the well-connected class of leisure-travellers who made the long ride to Scarborough. For at least a decade, Fiennes had been riding to and fro across southern England, visiting spas and mineral springs. But she had never travelled this far from home. Viewed from Salisbury Plain in the summer of 1697, North Yorkshire was a foreign country. And the approach to Scarborough was not lacking in excitement; sea mists had clamped the 500-foot crest of the Yorkshire Wolds in a spooky, impenetrable murk, 'so thick in some [places] you could not see the top', and then she'd had to descend from the Wolds 'by a steep and hazardous precipice on one side and the way narrow'. But it was worth it.

Scarborough, Fiennes announced delightedly, was 'a very pretty Sea-port'. Her rides had occasionally touched the coast in the past, but she wasn't moved by the seashore as a spectacle. To the Puritan granddaughter of the 8th Baron and 1st Viscount Saye and Sele, the English coast was a place to make self-improving observations on industry, or on shipping, or on the price of cod. She wasn't a gal to bare her calves and frolic in the surf. At Swanage, destined to become a Victorian seaside resort, she'd primly noted 'a sea faire place not very big' and 'a flatt sand by the sea a little way'. When she visited Norwich, she hadn't troubled to divert to Yarmouth. Until she crossed the Wolds, the only frivolous beach pursuit she'd recorded (although one suspects even this had

been motivated by curiosity in natural philosophy) had been at Seacombe in Dorset, where she'd 'pick'd shells'.

Scarborough was different. On the edge of North Yorkshire, Fiennes discovered something new: a coastal town that delighted both body and mind. Mrs Farrow's spring worked a treat, its brackish, salty constituency making it 'purge pretty much'. But Scarborough had other qualities, too. Fiennes liked the way the port was built 'on the side of a high hill', and compared Scarborough's long harbour pier to the famous Cobb at Lyme Regis. She explored the ruins of the castle and seems to have come across the base of the Roman signal station; she counted 70 sailing ships passing the headland, attended a Quaker meeting and gave top marks to Scarborough's salted cod.

But the highlight for Fiennes was the beach: '400 yards all a flatt, and such good sand as you presently walke on it without sinking, the sand is so smooth and firme; and so you may walke 5 or 6 mile on the sand round by the foote of this ridge of hills, which is the poynt by which all the Ships pass that go to Newcastle, or that way.'

This is the only passage in her journals that shows a 17th-century traveller revelling in the pleasures of the beach. And of course it was an accidental discovery; to reach Mrs Farrow's celebrated spring, Fiennes had to walk out on the beach at low tide. Those who'd travelled to the spa to take its waters quickly found that, as Fiennes put it, 'all the diversion is the walking on this sand twice a day'.

The diversity of pleasures Fiennes found at Scarborough – the firm sands, healthy air and water, local seafood, historic ruins and the stirring spectacle of passing ships – would become a seaside staple for the next generation. Between the lines of her journal, the reader can sense the pleasure she's deriving from 'the seaside', but she has no means of expressing it. She is one of the elegant visitors spotted in Dutch seascapes of the late 17th century, amused but detached from the workaday shore, which at that time was still, as the historian Alain Corbin puts it, 'the site of the fishermen's labour and an extension of the public space of the village.'

*

Fiennes was riding a book as well as a horse, and that book was *Britannia*. The late Tudor fad for healthy living, sport in schools and humanist ideals had coincided with a cornucopia of books and maps describing the coast of the British Isles. The maps of Saxton and Mercator, and Camden's encyclopaedic county guide, *Britannia*, zoomed so close to sea-level that you could pick out individual villages and rivers; every bay and estuary. A generalized fascination with coastal waters became more focused. With Saxton's county map of Norfolk in one hand, and Camden's description of Norfolk in the other, you could assemble a mental image of the coast, and work out how to reach it.

It's too easy at this distance to underestimate the influence that Camden's *Britannia* had on the travelling public. *Britannia* was not just another travel guide; it was the *first*. And when Bishop Gibson revised *Britannia* in 1695, over 100 years after it was first published, there was still nothing to touch it.

For Celia Fiennes, *Britannia* was the topographic Bible, the book she turned to every winter, as she planned her next ride. Fiennes was the first recorded woman to visit every county in England. With her contemporary Daniel Defoe she was in the vanguard of the Age of Mobility. The 17th century had been a period of accelerated change. Since the birth of her father, Nathaniel, in 1608, England had, in the words of historian Christopher Hill, catapulted into the modern world 'of banks and cheques, budgets, the stock exchange, the periodical press, coffee-houses, clubs, coffins, microscopes, shorthand, actresses, and umbrellas.' It was also the century of road maps and guidebooks. A revolution in surveying, geographical fieldwork, map-making and printing had brought the coastline to thousands of private libraries.

Gibson's *Britannia* of 1695 described an archipelago ringed with a glittering necklace of ports, fishing villages and strange sights, all of them ripe for exploration. Who could not be tempted by *Britannia*'s tiny hamlet of Antony, 'remarkable for its neatness, and a fish-pond which lets in the sea, from when it is furnish'd with fish, both for use and pleasure'? Or by Mount Edgcumbe, a few miles away, 'pleasantly situated, with a prospect of the winding harbour beneath it'. (Both are now owned by the National Trust.) Or the promontory on the Glamorganshire coast, known by passing sailors as 'Wormshead Point' – complete with a 'small cleft' through which a visitor could hear, with an ear

lain close, 'the deep noise of a prodigious large bellows'. For every county in the new *Britannia*, Robert Morden had provided a road map. And for those who couldn't read a map, a printer called John Ogilby had published, in 1675, a road atlas which described each route as a strip of information similar to a modern satnav screen.

By 1700, any Briton of means could take to the road. The intricate network of rutted through routes which had been used for centuries by merchants, civil servants, pilgrims, soldiers and economic migrants suddenly became available to a post-Civil War generation of proto-tourists, eager to examine their own land. While the men went off to the continent on 'Grand Tours' (often returning, suggests Fiennes, to bore the crinolinette off their spouses), an adventurous woman could set off for the unexplored shires. Browsing her *Britannia* at home on Salisbury Plain during the winter months of 1697, having returned from her ride to Yorkshire, Fiennes was able to plan a journey which would have been inconceivable a century earlier; from her home in Wiltshire she intended to ride her horse to the Scottish border and then down to Land's End and back to the plain. But that's another story.

Sea-bathing was about to become fashionable. In the same year that Celia Fiennes walked on the sands at Scarborough, the Lichfield physician, Sir John Floyer, published *An Enquiry into the right Use and Abuses of the hot, cold and temperate Baths in England*.

At the time, health books were dropping through the presses like a dose of salts and Floyer was one of the more prolific medical writers of the age. His first book, *Φαρμακο-Βασανος: or The Touchstone of Medicines, discovering the virtues of Vegetables, Minerals and Animals, by their Tastes and Smells*, had been published in 1687. A leading advocate of cold bathing, his book on the uses and abuses of water was followed by a treatise on asthma and then, in 1702, by a work which tapped an eager market.

In *The ancient Ψυχρολουσια revived, or an Essay to prove cold Bathing both safe and useful*, Floyer made the point that Britain was an island, and was therefore surrounded by a gigantic, cold bath 'which will both preserve our Healths,

and cure many Diseases, as our Fountains do'. Sea-bathing, he suggested, should be taken as nine or ten dips, at least two or three times a week. Immersion should last for no more than two or three minutes at a time.

It would be anticipating history to suggest that Floyer's book sent a nation dashing into the surf, but he was one of several medics practising in the early 18th century who paved the way for an exodus from Britain's sordid innards to its purer periphery. By 1722, his book had reached its fifth edition. Sources provide sporadic sightings of sea-bathers: a Mr Nicholas Blundell of Crosby Hall, near Liverpool, recorded in his journal that on 5 August 1708, 'Mr Aldred & I Rode to the Sea and baithed ourselves'. One year later, his children were dunked in the sea to treat 'some out breacks'. In 1718, in Whitby, a customs officer called Samuel Jones penned a rhyme which praised 'dipping in the Sea' as a cure for jaundice. In Lincolnshire, on a coast notorious today for its beach-side caravan parks, a Mrs Massingberd of Gunby recorded in May 1725 that the neighbourhood had received two titled visitors who had come 'to bath in ye sea'.

The intermittent trickle of health migrants to the coast was accelerated by a perfect storm of calamities in the 1720s. It was a catastrophic decade. Heavily in debt from an ill-judged war, Britain was taken for a ride by the money men, who caused one of the worst financial crashes in history, the bursting of the 'South Sea Bubble'. This was followed by successive pandemics – mainly flu and smallpox – which killed and disfigured hundreds of thousands. Britain was hit by a mortality crisis. By 1730, the total population had shrunk to around 5.2 million, probably less than it had been in the mid-1650s. In towns and cities, services and standards collapsed. In London, Lord Tyrconnel raged that the reeking streets made its citizens look like 'a herd of barbarians, or a colony of hottentots'. The capital, he continued, 'abounds with such heaps of filth … as a savage would look on with amazement'. Long before the crises of the 1720s, cities were frequently blanketed in smoke and damp smogs. As early as 1676, a study of mortality in London, published by John Graunt, asserted that the low life expectancy was caused by 'Fumes, Steams, and Stenches' which led to an urban environment 'less healthful than that of the Country'. The revulsion felt by Tyrconnel and his type encouraged many to escape to the cleaner airs of the country at every opportunity. In Bath, which

was set in a topographical smog-bucket, funds were raised in the 18th century to improve a road which led to a hill where invalids could breathe cleaner air, and road tolls were waived for anyone wishing to visit 'a Region free from Smoak and Smell of the City'. The 1720s maelstrom clogged spas with health-seekers, and the overspill headed for the coast. The sea was pure and unaffected by the ills of humanity. It was both a refuge and a source of awe.

Sadly, the thoughts of local fishermen, as they watched the upper classes frolicking in their harbours, have passed unrecorded, but it must have been a bizarre spectacle. And remunerative. In 1732, one of Scarborough's visitors provided this helpful vignette:

'It is the custom here not only for gentlemen but the ladies also, to bathe in the open sea. The gentlemen go out a little way in boats called cobbles, and jump in direct from them. The ladies have the conveniency of dressing gowns and guides, and there are little houses on the shore for them to retire and dress in.'

The 'little houses' were almost certainly the strange contraptions seen in a view of 1735 drawn by John Setteringham: Scarborough's entire beach appears to have been invaded by health-seekers in frock coats or long dresses. Parked at the water's edge is a four-wheeled cabin – a prototype bathing machine – from the door of which emerges a naked man, his eyes fixed on four bathers who appear to be in an advanced state of saline ecstasy.

The novelty of these beach scenes was captured in this little ditty from 1732:

'Now loosly dress'd the lovely Train appears,
And for the Sea, each charming Maid prepares,
See kindly clinging, the wet Garment shows,
And ev'ry Fold some newer Charms disclose;
While, void of Ornament and borrow'd Grace,
Thro' ev'ry Limb, we native Beauty trace.'

Scarborough accumulated the paraphernalia common to popular spas: the public assembly rooms were built in the 1720s, and then a coffee house and a bowling green. A theatrical season opened in the early 1730s. By 1735, Scar-

borough was offering 'Guides, Rooms, and Conveniences' for ladies interested in sea-bathing.

Down south, well-to-do citizens of Britain's squalid capital were faced with a vexing logistical difficulty. Swilling about in the Thames Estuary was plenty of salt water, but the banks of the estuary were invariably muddy and the water was the colour of sewage. If that wasn't bad enough, the marshes on the north side of the estuary were a notorious source of malaria, and those on the southern, Kentish side were, in the words of Daniel Defoe, 'foggy' and 'unhealthy'. To the average Georgian hypochondriac, taking a dip in the Thames would have been as appealing as a modern Sunday stroll on the hard shoulder of the M25. So London's health fanatics had to look beyond the Thames. Unsurprisingly, they turned south, to the Channel coast.

One can imagine the owners of Camden's pricey *Britannia*, leaning over its revelatory county maps, dividers poised. If they had swivelled a radius around the City of London, they'd have found that the closest point on the Channel coast was a place variously known as Bright Helmston (by Daniel Defoe, who mentions that it's commonly known as Bredhemston), Brighthelmsted (by Gibson in the 1722 *Britannia*), Brighthemiton (by the mapmaker Robert Morden), and Brighthelmston by its parishioners. All of these variations derived from the Old English place name 'Bristelmestune', the 'Farmstead of a man called Beorhtwald'. By the 1780s, it was appearing in print as Brighton.

Brighton, trashed by the French during their punitive raid of 1514, was familiar to readers of Defoe's *Tour* as a bit of a dump; 'a poor fishing town, old built, and on the very edge of the sea' – an unfortunate location in Defoe's view, because coastal erosion had wiped out over a hundred houses in the previous few years. Before long, reckoned the author of *Robinson Crusoe*, the sea would 'eat up the whole town'. Another visitor from the 1720s, an antiquary called John Warburton, left a vivid description of a community in the process of obliteration:

'I passed through a ruinous village called Hove, which the sea is daily eating up … A good mile further, going along the beach, I arrived at Brighthemstead, a large, ill-built, irregular market town, mostly inhabited by sea-faring men,

who choose their residence here, as being situated on the main, and convenient for their going on shore, on their passing and re-passing in the coasting trade. The town is likely to share the same fate with the last, the sea having washed away the half of it; whole streets now being deserted, and the beach almost covered with walls of houses being almost entire, the lime or cement being strong enough, when thrown down, to resist the violence of the waves.'

On a coast infamous for its towering chalk cliffs and sinister shingle spits, Brighton was a rarity, for it had an accessible beach that had been used by fishermen since at least the Domesday Book census. This wide, south-facing sweep of clean, fine shingle was just a pebble's parabola from the coast road linking Newhaven with Shoreham, a celebrated ship-building port with a highway to London. Like most places on the shores of Sussex, it had a long history of smuggling.

Another beach that caught the eye of Londoners lay at the mouth of the Thames, where the Isle of Thanet pointed like a finger at the continent. Margate was familiar to many in the capital as a small port whose coastal trading sloops – hoys – sailed with cargoes of Thanet grain to the city markets. Boasting its own jetty, Margate was also a cross-Channel port, with a stagecoach service to and from London and a reputation for smuggling and wrecking. Margate was much smaller than Brighton, appearing on Morden's late 17th-century map as a single street of dwellings. But it did have 4 miles of firm sand. Hoys that had delivered their grain to London began bringing sea-bathers back to Margate, and as early as 1729, a Margate man with the wonderful 18th-century name Zechariah Brazier, was reported to have launched a bather into the bay from 'a simple machine, a cart'. This was probably a primitive, mobile changing-room similar to the one pictured at Scarborough. In 1736, a Mr Thomas Barber placed an advertisement in a Kent newspaper promoting sea-bathing in Margate. Barber, a carpenter by trade, had constructed a bath fed by seawater, complete with an adjoining room for bathers of both sexes who did not care 'to expose themselves to the Open Air'. He was also offering lodgings.

In the same year, the rector of Buxted, a small village in Sussex, came to Brighton for a month with his wife. On 22 July, Reverend William Clarke settled down to write a letter to his friend Mr Bowyer:

'We are now sunning ourselves upon the beach at Brighthelmston,' he wrote. 'Such a tract of sea; such regions of corn; and such an extent of fine carpet, that gives your eye the command of it all. But then the mischief is, that we have little conversation besides the *clamor nauticus*, which is here a sort of treble to the plashing of waves against the cliffs. My morning business is bathing in the sea, and then buying fish: the evening is riding out for air, viewing the remains of old Saxon camps, and counting the ships in the road, and the boats that are trawling.'

Reverend Clarke's letter is the earliest description we have of what would become the classic 'seaside holiday': a congenial mix of bathing, sightseeing and sea-gazing. Clarke's epistolary nugget captured the migratory urge that was rippling through cities and shires. The society emerging from war, economic crash and plague had changed for good. The lack of a rigid 'caste' system in 18th-century England had created one of the most plutocratic societies in Europe; a body of five million whose soul was located in the 'middling sort', the middle classes. The ruling elite continued to indulge in conspicuous spending, but it would be Adam Smith's 'nation of shopkeepers' who transformed English coasts with a tsunami of seaside excitement. In Scotland and Ireland, less recreational histories were being played out: in 1745, as bathing machines and promenading gentry mustered on the beaches of Yorkshire, Kent and Sussex, an army of Highlanders fought to the death on Culloden Moor. And in Ireland, the population was reeling from bad harvests, famine and epidemic disease. Wales also had yet to be 'discovered', and was still afflicted by grinding poverty and appalling roads. A commentator wrote in 1770 that he had 'never heard of any one traveling in Wales for pleasure'.

But down in the balmy latitudes of 1750s England, sea-bathing was stoking the local economies of Brighton and Margate, and beginning to change their nature as coastal communities. Some began to see the South Downs as the Great Divide separating the civilized communities of the Weald from the increasingly wild and unruly foreshore of the Channel. One of them was the pretentious rector of Worplesdon in Surrey, Dr John Burton, who took a journey from Oxford to the Sussex coast, and then wrote about it in Latin and Greek. The 'village' of Brighton, he decided, was 'not indeed contemptible as to size, for it is thronged with people, though the inhabitants are mostly very

needy and wretched in their mode of living, occupied in the employment of fishing, robust in their bodies, laborious, skilled in all nautical crafts, and, as it is said, terrible cheats of the custom-house officers.' Burton – who quipped that Sussex livestock had long legs because they'd been stretched whilst being pulled from the impassably muddy roads – complained that he'd been kept awake at Brighton's Castle Inn by drunken sailors who were singing and clapping, and by local women 'quarrelling and fighting about their fish'.

By the mid-1700s, sufficient numbers were showing up in Margate each summer for bathing machines to have become a seasonal fixture. Popular history has it that a Margate man called Benjamin Beale developed the fully refined model of the bathing machine in 1753, although a drawing of a machine thought to be similar to Beale's, has been found inserted into a history of the Isle of Thanet, published in 1736. (The dates and step-changes in bathing-machine R&D matter enormously to historians of Scarborough, Margate and Brighton, who have spent at least a century vying for their town to be recognized as Britain's earliest seaside resort.) The machine in the Kentish drawing of '1736' has large wheels and a raised chassis to allow it to be towed by a horse into deep water. On the rear of the machine is a hinged, concertina canopy, or 'modesty hood', which allowed the bather to descend unseen into the water by way of a flight of retractable steps.

The seasonal migration to beaches was still underpinned by the medical profession, and in particular by a book published in 1750. Dr Richard Russell's *De Tabe Glandulari* was translated two years later into English as *Dissertation on the use of Sea-Water in the diseases of the Glands*. Russell's back-to-nature philosophy insisted that the sea, 'the omnificent Creator of all Things, seems to have designed to be a kind of common Defence against Corruption and Putre-faction of Bodies'. The sea was divine, mystical, and its working miraculous. Whether it was gonorrhoea or constipation, the sea would sort it out. Russell's insistence that the sea could provide all the benefits of spa water, and more, played to a market in search of ease. His treatise went through several editions and remained a standard reference for a century.

The old notions of the implacable deep were wafted to the horizon by a new faith in the shallows. Fear had been overcome by reason; by the balneal

revolution. The beach had become a place for the likes of Reverend Clarke to sun himself and listen to the 'plashing' of the calming sea. After the Romans, the Saxons, the Vikings and Normans, the beaches were being stormed from the land, by civilians in search of respite. The seashore had found a new role.

I didn't really get the point of Brighton until I pedalled there from Clapham Common along with 30,000 others. Generally, I'm with Robert Louis Stevenson in accepting that it's a richer cause to travel hopefully than to arrive, but RLS never biked to Brighton. The warm slipstream of English downland is followed by the Cresta Run of all freewheels down to the minarets of the Royal Pavilion and that caramel ramp of rustling shingle that frames the still, blue mirror of the Channel. In *Breakfast in Brighton*, the author Nigel Richardson asks himself why he's there, and decides that it's not the *place* but the *idea* of Brighton; a notion of 'light and happiness'. *Brighton*! When the Monopoly of metropolitan life rolls the wrong numbers and you have to default on the rent in Old Kent Road, a ticket to Brighton is the Get Out of Jail card.

In telling the story of seaside resorts, all roads lead to Brighton. Sussex was waiting to be explored. The leisured classes were being equipped with the first tools of mobility. Maps had become more accurate, more portable and more informative. Emanuel Bowen's county series was bound into a book on England's natural history. The prolific Holborn engraver and publisher, Thomas Kitchin, issued maps in multiple formats, among them his *Small English Atlas* and *Pocket Atlas*. The new maps retained the copperplate beauty of northern Renaissance cartography, but now marked roads, post halts and distances. They distinguished between market towns and borough towns, and they identified places where fairs were held. They were explorers' maps; maps for Grand Tourists seeking an alternative to Tuscany.

These 18th-century maps are the last pictures we have of pre-resort Britain: a Britain rimmed with little fishing villages and ports whose business had always been the sea. Sussex is particularly poignant. This was a coast set to change more than most, and along with Kent (also at the forefront of the seaside revolution) it had attracted some gifted cartographers. In 1778, Yeakell

and Gardner released a map of Sussex at the astonishingly large scale of 2 inches to the mile. It was a Google Earth moment. Nobody had ever been able to look at Sussex from above, house by house, beach by beach. The detail was incredible. It's a map of painful innocence; the last snapshot of a coast about to be inundated with resort development. Brighton is a tight-packed square of half a dozen lanes running back from the beach, and it's separated from the hamlet of Hove – a single street of a dozen buildings – by fields and pastures. To get from Brighton to Chichester, you had to take a ferry across the River Adur at Old Shoreham, and then cross the Arun at Arundel because there was no bridge downstream. Bognor Regis doesn't exist and 'Little Hampton' is a hamlet at the mouth of 'Arundel Haven'. 'East Bourn' is a village inland from the sea and the site of Brighton's 127-acre marina is still an empty beach backed by chalk grassland. Today, a virtually continuous strip of tarmac, brick and concrete runs for 40 miles from Seaford to Selsey Bill. The resort revolution brought the biggest changes the coast has ever seen. Nothing – not fishing, nor trading, nor defence of the archipelago – had ever altered the physical or social structure of the shore so profoundly or as fast.

To germinate, resorts needed good bathing and roads. Proximity to a city or large town, good communications and the patronage of a society figurehead all accelerated growth. Some coasts were more attractive than others. The warmest shores were those in the south, and the sunniest and least rainy were those in the east. There were local issues, too: strong currents, extreme tides and muddy foreshores made sea-bathing impossible and the proximity of river mouths reduced the salinity of the sea.

Central to any emerging resort was what Defoe described as the 'new fashion'd way of conversing by assemblies'. One of the novelties of assemblies was their role as a public space for women to mingle with men, but also for people of different backgrounds to mix over card games, tea and dances. Another primary institution was the 'circulating library', a fashionable new bibliographic service that seems to have been pioneered by an Edinburgh bookseller called Allan Ramsay, who in 1726 began renting books to customers who wanted to avoid the cost and inconvenience of owning them. You didn't drop by a circulating library to pick up a copy of Cowper or to find out what Hogarth had to

say about Restoration England; circulating libraries specialized in 'light romantic novels' of the kind that provoked Sir Anthony Absolute in Sheridan's *The Rivals*, to condemn them as 'an evergreen tree of diabolical knowledge'. New resorts had to have an assembly room and circulating library.

Brighton was the first south-coast town to experience a makeover. Patronage in the first instance came from the author of the seminal seawater best-seller, Dr Richard Russell. Roads, drunkards and fighting fishwives notwithstanding, in 1754 Dr Russell put his money where he placed his pen, and built himself a house in Brighton. In the same year, assemblies began to be held in the Castle Inn. By the end of the 1750s, Brighton had a library and a coffee house. A theatre is recorded in 1764, and in 1769 Dr John Awsiter built a bath-house on the beach, supplied with seawater pumped into copper tubs. Instead of becoming the Sussex Atlantis, this dishevelled fishing town became – in the words of the *Gentleman's Magazine* in 1766 – 'one of the principal places in the kingdom for the resort of the idle and dissipated, as well as of the diseased and infirm'. The appearance in September 1783 of the dashing, 21-year-old Prince of Wales put Brighton on the aristocratic itinerary – and his return the following year, having been advised by his physicians that sea-bathing would cure his swollen throat glands, amounted to royal patronage; in 1786, the prince leased a farmhouse overlooking the beach, and the following year workmen began converting the building into a regal residence. But the edginess was still there. Brighton was a lot wilder than Kensington. Seaside entertainment included prizefighting, bear baiting and cockfighting, and the smugglers were still busy. One night in 1794, long after Brighton began investing in spa-type facilities, the town's revenue officers disturbed a smuggling gang who abandoned 400–500 tubs of gin when they were driven off the beach by local troops.

Margate, the little port at the mouth of the Thames Estuary that had been importing sea-bathers on its grain sloops since the early 1700s, also began to acquire the trappings of a resort at around the same time as Brighton. By 1765, the skippers of five hoys were charging half a crown for the passage from London's Wool Quay to Margate, each sloop carrying 60 or 70 passengers – although they were known to carry twice that number. Margate's development was driven by William Camden's 'industrious amphibians' rather than royal

patronage. A community which had turned its opportunistic hands to fishing, farming, trading, wrecking and smuggling, was quick to welcome wealthy Londoners who'd taken a sudden fancy to firm sand. Mitchener's Tavern on the seafront was enlarged and fitted with hot, salt-water baths, and over two years spacious, elegant houses were built around two new squares, together with an enormous assembly room that opened with a subscription list of 930. On one of the squares, a Miss Brasier opened a 'ladies boarding school'. Bettison's Library was chock-a-block with bookworms and the 'indifferent playhouse' became so inadequate that a brick and slate theatre was built on the corner of Hawley Square and opened in the summer of 1787.

Margate was for the 'middling sort' who liked liveliness and order. A full day would include a walk on the pier, a hot bath in one of the bathing-houses, a dip in the sea, breakfast in a coffee room, a pony ride over the downs followed by a seat at a cricket match and then an evening juggling dinner with the theatre or perhaps a masked ball at Benson's Hotel, or some rounds of whist or a kind of gambling known as 'raffling'. And of course there was always the shipping to appreciate: the spectacle of frigates or a man-of-war out in the roads, and the hoys disgorging their cargoes with every tide (a *Times* sketch writer sniffily watched one of the sloops 'vomiting out its sick' after it tied up in 1795). Demand frequently outstripped supply; if passengers disembarking from a hoy found the town full, they had to sleep on the vessel. By 1801, there were fireworks every Tuesday, Thursday and Saturday, a ball in the Assembly Room every Tuesday and a masquerade at the theatre every other Wednesday. During August, a Mr Hardie came down from London to deliver lectures on Experimental Philosophy, with reduced ticket prices for ladies and gentlemen who arrived in pairs – an arrangement which Mr Hardie knew would suit young couples requiring release from parental observation.

Margate created its own aristocracy. In 1792, the medical philanthropist Dr John Coakley Lettsom of Camberwell in London founded his vast Sea-Bathing Infirmary on Canterbury Road for the treatment of 250 patients of reduced means – or 'the Diseased Poor'. Behind a stone-built classical facade was a solarium devised to treat tuberculosis with sea air and sunlight. Lettsom, a kindly man who had once found a post in the army for a highwayman who

had held him up outside London, was instrumental in establishing an identity for Margate that set it apart from princely Brighton. Healthy Margate brought its own brand of royalty. When the most famous tragedienne of the age, Sarah Siddons, swept into town at the end of the season in 1796, Margate swooned. The mesmeric 'Queen of Drury Lane' could freeze an audience with her eyes; the price of boxes in the Theatre Royal rose by 20 per cent, part of the pit was converted to boxes and ladies were requested to dress without feathers to prevent the stage from being obstructed. After playing in *Jane Shore* and *The Gamester*, Mrs Siddons was obliged to stay on in Margate for one more show, which had to be billed as the 'Positively Last Night'. Who needed royalty when you could get Mrs Siddons?

Implicit in the resort revolution was a blindness to world affairs. A resort, after all, was a sanctuary from concerns. The pell-mell rush to build on the beaches took little note of the social shear-zones that were being created between people with coastal genealogies that stretched back for generations, and the seasonal invasions of richer, city evacuees. On the Isle of Thanet, impoverished farmworkers watched their local port being colonized by new-build frivolities while their own families went hungry. In the summer of 1800, mobs descended on the resort lofting an effigy of a corrupt miller, then surrounded the jail demanding the release of two of their number. Margate's magistrate caved in and the mob then stormed the marketplace and forced stallholders to sell at fixed prices. It was a tricky moment for Britain, floating alone against Bonaparte's poised Armée d'Angleterre. Revolution was blowing in from the sea. An anonymous contributor to *The Times* reported that he'd attended a lecture by William Cobbett in the coastal village of East Bourn (as it then was), where the audience of farm labourers had been told that 'revolution must inevitably take place'. To reformers like Cobbett, sea-bathing resorts were a form of cultural colonialism. The interests, the ideals, the architecture of the elite were being superimposed on communities that had always subsisted on the literal and figurative periphery of society. Places like Margate and Brighton became arenas for cultural extremes. The farmworkers and militia who had a face-off in Margate market were drawn to the sea-bathing resort as inevitably as the Mods and Rockers of the 1960s.

Elsewhere on the coast of England, other ports were copying Margate. At the gates of the West Country, the Dorset port of Weymouth had been receiving health tourists since the 1750s. As a historic port with a fine reputation (Defoe had found it 'a sweet, clean, agreeable town') Weymouth was ripe for adaptation into a seaside resort. Beside the harbour, it had a beguiling sweep of pale, fine sand that was sheltered from the prevailing winds by the huge promontory of Portland. Like Scarborough, it had good history, in the form of a fort built by Henry VII and flourishing trading quays at the mouth of the River Wey. Weymouth was the same distance from Bath as Brighthelmston was from London, and Bath's doctors had been sending patients to the old port for some time when the trickle of seasonal migrants was stimulated by a fabulously wealthy, though ailing, entrepreneur who had made a fortune by reforming postal deliveries and then a second fortune by reforming quarrying techniques around Bath. Ralph Allen had always been ahead of the curve. He'd provided Bath with a 'Mineral Water Hospital' for the impoverished sick who could be seen in increasing numbers on the pavements around the spa, and as early as 1731 (fully a century before steam passenger-railways took off), he'd pioneered the use of flanged cast-iron wheels on the rail wagons he'd commissioned for moving stone from his quarries above Bath to the Avon. Allen had everything a Georgian entrepreneur could wish for, apart from his health. Advised to bathe in the sea, he settled on the best beach he could reach in a day. He liked Weymouth a lot, and in 1750 he bought himself a large townhouse facing the harbour. No. 2 Trinity Street became a celebrated summer house and Allen's presence put Weymouth on the seaside map. The house still stands, its Georgian bays gazing across the picturesque harbour at the bustle on Customs House Quay.

Weymouth's development was accelerated by the visit in 1789 of George III. The king's health was deteriorating: he'd attacked the Prince of Wales during dinner in Windsor Castle, and a rumour had circulated that he had engaged an oak tree in a conversation, thinking it was the King of Prussia. But in the summer of 1789, he had recovered sufficiently to embark upon a royal tour of the south of England. When he reached Weymouth, the local band had waded into the sea playing 'God Save the King', and the monarch had taken a royal dip

from a bathing machine. In 1800, work commenced on the embanking and walling of a new esplanade, and in 1804 George bought Royal Lodge. Land was reclaimed from the sea for new houses, a statue of the king was erected and in 1816 the Royal Terrace was built. Together with the various buildings specifically dedicated to the seasonal influx of visitors, a new waterworks was constructed, and a church and chapel, and a steamer service opened to the Channel Islands. In the space of 50 years, Weymouth was physically transformed from a trading and fishing port into a booming resort.

Resorts rippled to and fro along the Channel coast. West of Worthing, an innocuous stretch of sand in the lee of Selsey Bill caught the eye of a loaded entrepreneur, Sir Richard Hotham. Like Allen at Weymouth, Hotham had made a fortune or two from business: initially as a hatmaker, and then as a member of the East India Company, where he had managed four ships. He'd also dabbled in property development. Suffering ill-health in his early 60s (not helped, presumably, by the lethal summer of 1783, when more than 200,000 people died as a result of inhaling droplets of sulphuric acid that had drifted in clouds over Britain after a catastrophic volcanic eruption in Iceland), he was advised to take the sea air, and so in 1784 he travelled to Sussex, where one of his ships' captains owned a farmhouse close to a village called South Bersted, which lay about three-quarters of a mile from the sea. Down near the beach, Sir Richard fell for a tiny, one-street hamlet called Great Bognor. To the east of the hamlet, a little brook meandered through meadows to the beach, whose waters were protected on one side by a reef known locally as Bognor Rocks, and on the other by a shorter reef known as Middleton Ledge. Remote from London, on the edge of a level plain dotted with hamlets engaged in farming, fishing and smuggling, Sir Richard set about building a resort. From the local customs and excise riding officer he bought a piece of land and a farm, and in January 1787 he began converting the farmhouse into a 'commodious mansion'. Eventually, he owned 1,600 acres. He built terraces of houses that he christened 'Hothampton Place' and 'East Row'; Hothampton Crescent contained 50 rooms and was topped by a dome that sat above the tea room like a gigantic lid. By the time he died in 1799, Hotham had turned a patch of farmland into an annexe of London. Today, it is called Bognor Regis.

Perhaps the most remarkable 'greenfield' resort took root between the Isle of Wight and the Isle of Purbeck, where the sheltered bay to the east of Poole had been smugglers' ground for centuries. Between the two promontories of Sandbanks and Hengistbury Head, a distance of 10 miles, the coast was deserted. Behind the shoreline was a wild tract of heath crossed by rough tracks and a few streams that made their outfall into the sea through narrow gullies called chines – which were used by the smugglers to move contraband from the beach. In the churchyard at Kinson, there is a gravestone to one Robert Trotman, who was shot and killed on the beach in March 1765. These beaches and heaths were also home ground for the notorious Dorset smuggler of spirits, tea and fine wine, Isaac Gulliver. Out on the heath at the same time as Gulliver was a Captain of the Dorset Rangers called Lewis Tregonwell, whose job it was to patrol the cliffs east of Poole. Once the threat of invasion receded at the end of the Napoleonic Wars, Tregonwell bought from Sir George Ivison Tapps, Lord of the Manor of Christchurch, 8½ acres of land at the mouth of the largest of the chines between Sandbanks and Hengistbury. Tregonwell's raised plot lay above the west bank of a stream, looking down on a number of decoy ponds that had been created to attract wildfowl so that they could be trapped and killed. The OS map for 1811, published the year after Tregonwell bought his plot, shows the ponds, the house and the stream entering the sea at 'Bourne Mouth'. By the ponds was a solitary house that had been used in the past by smugglers; a boy called Joseph Manuel was once kidnapped and beaten there before being shipped to the Channel Islands, accused of being an informer for the revenue. Stroll through the Pleasure Gardens beside the tinkling Bourne today and you'll pass the spot where young Manuel was hammered by the smugglers. Tregonwell built himself a fine house and several villas that he let out in the summer to visitors who wished to go sea-bathing. To shade his guests from the sun while they walked to the beach, he planted hundreds of pines and laid the 'Invalid's Walk'. Suspicions that Tregonwell's purchase of a plot on the chine at Bourne Mouth had not been unrelated to an interest in 'free trade' were rekindled in the 1930s when workmen discovered an underground chamber on the site of the thatched lodge Tregonwell had built in for his butler. 'The situation of this underground hiding-place,' suggested *The Times*, 'is ideal for the hiding of contraband, being easily

reached from the valley of the Bourne stream, which provides an opening in the cliffs to the seashore.' By 1851, Bournemouth ranked 69th on the resort list, with a population of 695 and growing. Tregonwell's house can be seen today, forming a wing of the Royal Exeter Hotel. The Bourne stream is now the centrepiece of the Pleasure Gardens.

In the gaps along the south coast between Margate, Brighton, Bognor and Weymouth, bathers began to appear on other beaches. Each summer, visitors were showing up at Deal, Dover, Folkestone, Hastings and Worthing. The prime minister, William Pitt, took a house in Ramsgate so that he could bathe in the sea (there was an unfortunate incident here in 1795, when one of Lord Radnor's servants strayed out of his depth, and drowned).

On the east coast, the fishing and trading port of Yarmouth also began to develop its beach. In 1759, a bath-house was built, with water pumped by horse-mill from the sea to a pair of 15-foot baths, one for gentlemen and one for ladies. Dressing rooms were attached to each bath, and an advertisement of the time promised 'Great Variety of convenient Lodgings in the Town'. Over a century had elapsed since Sir Henry Manship had so presciently listed Yarmouth's healthy attributes, but this bustling port was much better connected to the rest of Britain by sea than by land. A horse-drawn 'flying machine' in the 1760s, leaving Bishopsgate in London at 7am, would take three days to reach Yarmouth, by way of Newmarket and Norwich. The Yarmouth coach, according to one Sylas Neville, makes modern trains seem luxurious: 'They are indeed vile carriages,' he complained, 'shake one intolerably except upon carpet ground & are very weighty to the horse.' After such a long journey, bad weather at the beach was less tolerable. Yarmouth was better suited to local sea-bathers from Norwich and the surrounding market towns. Among those who trekked to Yarmouth as the south coast beaches were beginning to enjoy regular seasons, was the rector of Weston Longville, a small village 8 miles north-west of Norwich. In his diary for May 1790, Parson Woodforde recorded that he took his family in the coach to Yarmouth for a few days. Although they were 'highly pleased with Yarmouth and the Sea View', the beach excursion was rather less successful: 'the sea rather rough,' he noted, 'the Wind being high and very cold we found it.'

Some of the most vivid pictures of emerging resorts come from the pens of a growing band of what Corbin labels 'scholarly travelling gentlemen' – first-generation tourists who travelled the shires with notebooks and sketchpads on missions of self-enlightenment. The Honourable John Byng was an archetypal 'STG', an ex-Lieutenant-Colonel in the Foot Guards and 'a gentleman born' (as he describes himself), who ranged his kingdom on horseback, roughing it in local inns, crawling through ruins, chatting to rustics and pressing wild flowers and grasses between the leaves of his journal. Byng toured the south coast in 1788, riding through Rye, Winchelsea, Hastings and Brighton, thus leaving us with snapshots of four coastal communities in the throes of change. Rye (which had yet to be popularized by tourism) had such a 'dirty sea-port inn with a wretched table', that Byng was forced to abandon plans to spend the night in the town; Winchelsea charmed him with its sea views, excellent inn and ecclesiastical ruins; in Hastings, he took a walk on the beach and sat for a while in the remains of William the Conqueror's castle, enjoying 'the freshness of the sea breeze'. And then the tour reached its coastal climax, by calling at England's most notorious seaside resort.

Byng tried his best to despise Brighton. What he observed was 'a fashion-able, unhappy bustle, with such a harpy set of painted harlots as to appear to me as bad as Bond Street in the spring, at three o'clock p.m.' Just 30 years had elapsed since Richard Russell had built his house here, yet the retired soldier found a clamorous resort with all the cultural amenities of a small city. The assembly rooms were, he judged, 'magnificent', and *Henry IV* was being performed at the Playhouse. 'Nothing,' he reported, after stuffing himself in the Castle Inn, 'could be better than our dinner and the two bottles of claret and port that Windham and I soon sucked down, and then sighed for more wheatears after the many we had eaten dressed to perfection.' The painted harlots didn't deter him from staying on until after seven in the evening, and then riding back to Lewes in the dark. Evenings in Brighton, explained Byng, were characterized by 'plenty of bad company, for elegant and modest people will not abide such a place!'

In the north of England, a new resort was emerging from the sands of Lancashire. The coast between Wales and the Lake District was incised by the

four great sea inlets of Morecambe Bay, the Ribble, the Mersey and the Dee; estuaries with vast intertidal zones beset by quicksands. But between Morecambe Bay and the Ribble the currents had created a sandy, west-facing beach. Behind the beach, black, peaty pools glistened on marshes whose sluggish streams tended to spill after heavy rain. The area was known as 'the Fylde' or 'the plain', and its only settlement of size was Poulton le Fylde, an Old English name meaning 'farmstead by a pool'. The largest of Fylde's dark pools was Marton Mere, and beside its outfall into the sea there stood a couple of dozen thatched cottages. Used as a seamark by sailors, the cottages appeared on a navigational chart of 1736–7 as 'Blackpool Town'. The beach was firm and gently shelving. And the sunsets could be spectacular. Local people had been coming here for generations, but around the time the chart was printed this strip of sand beyond the marshes began to attract a wider market.

Like Brighton, Margate and Scarborough, Blackpool Town suddenly became busy: by 1780, there were four hotels, four ale houses and a stagecoach service from Manchester. By 1783, stagecoaches were bringing visitors to Blackpool from Halifax, Bolton, Blackburn and Preston. By 1788, the town had 50 houses, a post office, a theatre, two bowling greens and a wine house. That was the year William Hutton printed 720 copies of the first tourist guide to the town. He called it *A Description of Blackpool in Lancashire, frequented for Sea-Bathing*, and it sold so well that it was still being printed 30 years later. Reading it today, on a seaside promenade that fronts a town of 140,000, makes you realize how much can change in a couple of centuries:

'Although about fifty houses grace the sea bank, it does not merit the name of a village, because they are scattered to the extent of a mile. About six of these make a figure, front the sea, with an aspect exactly west, and are appropriated for the reception of company; the others are the dwellings of the inhabitants, which chiefly form the back ground. In some of these are lodged the inferior class, whose sole motive for visiting this airy region, is health.'

Blackpool was one of the first places to attract in large numbers the employees of manufacturers. The nearest town was Preston, then emerging as a major industrial centre at the lowest crossing point on the Ribble. Just up the coast at Morecambe (according to Richard Ayton) the beach was being

frequented by 'manufacturers from the inland towns, come for the benefit of the physic of the sea'. On the other side of the Ribble Estuary, where the sands ran unbroken all the way to the Mersey, the foundations of another resort were being laid by the innkeeper of the Black Bull in Churchtown, an isolated village in the marshes 16 miles north of Liverpool. 'The Mad Duke', as fiddle-playing William Sutton was fondly known, thought that he'd capitalize on the fashion for sea-bathing by building a bath-house a couple of miles outside the village. Sutton followed this with his 'Original Hotel', opened in 1798, to take advantage of the new Leeds and Liverpool Canal, which passed close by. It was a smart idea. Like Blackpool's, the beach here is sandy and gently shelving. Two landowners, Miss Bold and Mr Hesketh, leased parcels of land behind the beach to developers and by 1851 Southport was the tenth-largest resort in England and Wales, with a population of 12,915.

Scotland was playing catch-up on the pleasure scene. The Rising of 1745 had delayed the development of tourism, but the late 18th century travelogues of Thomas Pennant and then Johnson and Boswell had opened the country to vicarious travellers. Union with England had created a vast new market, the Scottish Enlightenment was flooding Edinburgh with new thinking, and by the 1790s hardy Scots were experimenting with sea-bathing. One of the early resorts was Broughty Ferry, the northern crossing point on the Firth of Tay, on the shortest route between Dundee and Edinburgh. Although 'the Ferry' consisted of little more than a few fishermen's huts, its connections meant that access was – by Scottish standards – excellent: three coaches a day ran from Dundee, and as sea-bathing took off a Sunday steamboat service operated for bathers and day-trippers.

By the end of the 18th century, around 50 settlements around the coast of England, Scotland and Wales had developed seasonal symptoms of being a resort. The first phase of resort building lasted from the 1750s until the Napoleonic Wars, when Adam Smith's prediction that war would create a 'seller's market' was proved true. Along with iron foundries, coal mines and naval shipyards, the coast found itself a new market. Boney showed Brits that war could be good for domestic tourism. As redcoats fought the Grande Armée in the blood and dust of Spain, the stay-at-homes in blockaded Britain began

turning to coastal resorts for relief; for distraction from income tax and from battlefield losses heading towards 200,000.

It's difficult in this Age of Easy-Everything to recapture the other-worldliness of stepping for the first time onto a pleasure pier. There's a tantalizing hint in Book XXXVI of Pliny's *Natural History* that the ancient Greeks had experimented with walking on water way back before Britons had learnt to make pottery on a wheel. Apparently Sostratus of Cnidus, the architect who designed the Med's first lighthouse, was also 'the very first to build a promenade supported by piers'. Was this a stilted causeway across to the island at Cnidus? Or a pier for ships? Did the wealthy citizens of Cnidus walk upon it at sunset and watch turquoise fish and scuttling crabs? Two thousand years later, when walking on water came to Britain, it changed the form of the coast.

In the early days of the resort era, a pier was more than a novelty; it offered an extraterrestrial, sensory experience; an abrupt transition to a place beyond terra firma. Visitors to the coast had always been able to make their way to the end of harbour piers, but these were bustling, grubby workplaces littered with trip-hazards, and in any case they were usually stubby affairs, frequently hooked like forearms around an anchorage. The Cobb at Lyme Regis was one of the best-known harbour piers in the British Isles. Leland describes it, and so do Camden and Defoe, and it was one of the highlights on Celia Fiennes' first tour. She was mesmerized by its 'halfe moon' form and by the way that form altered with the coming and going of tides. But in those days, the Cobb was separated from the mainland by a stretch of open water; it was beyond the reach of casual travellers, who had to gaze at it with bemused detachment from the mainland. Piers were part of the port story, not the resort story. Writing of Ramsgate in the 1720s, Defoe records the presence of a 'Peer', but tells us nothing beyond its role as a shelter for ships fleeing storms in the Channel.

In the hundred years between Defoe's literary *Tour* and Turner's artistic excursions, the workaday pier became a portal to the sublime. The prototype can still be seen at Ryde, on the Isle of Wight, its timber planking parting the waves in a feat of early 19th-century civil engineering. Ryde's pier was intended

as an artificial harbour. The town had a wonderful beach, but the shallow dip of the sands prevented ships berthing at low tide. Arriving passengers had to be rowed to offshore sandbanks, then carried across the flats on the backs of brawny sailors. The building of a pontoon helped, and then on 30 July 1812, as the Duke of Wellington fought Marshal Marmont at Salamanca, a decision was made at the first meeting of the Ryde Pier Company to build a modern, timber-planked pier that would allow ships to berth at low tide. Two summers later, the pier was opened. By later standards it was a thread-like structure, just 12 feet wide and one-third of a mile in length. One year on, a new pier was opened at Margate. Customers were charged one penny to walk on the pier for as long as they wished, and when the weather allowed, they were serenaded by an orchestra. It was, claimed a guide of 1831, 'one of the most inviting marine walks which fancy can imagine, or experience realize'. For Margate, the pier sealed an extraordinary period of expansion; between 1800 and 1831, the population had more than doubled to 10,339.

The construction of piers for purposes beyond utility opened an era of coastal invention. The assembly rooms and libraries for purged gentlefolk were inland spa traditions that had been transposed to the seaside, but the pleasure pier was an entirely coastal creation. No longer were the cliffs and promontories of Nature the only vantage points. Piers released the tourist from the past. Laid as straight as a rule above the waves, a pleasure pier was a world away from the crooked, storm-battered harbour piers that had evolved over centuries. This was a structure as level as a cricket pitch, free of obstructions and railed for safety on both sides. Where travellers from earlier generations had been forced into boats to experience the sea, the modern tourist could promenade in absolute safety above the same waves. The act of walking, and the purity of sea air lifted fresh from the ocean rather than fouled by land, played to the needs of health tourists. A pier took the promenader closer to the wilderness of the sea. Out there in the briny wind with the salt on their lips and the muscled ocean at their feet, admiration of raw nature was heightened, and so was the self-esteem of the intrepid promenader. Coastal views could be enjoyed, and on west-facing piers the setting of the sun too. A walk to the end of a pier was rather like climbing to the top of a tall tower; it provided a vantage

point from which the world could be viewed at a distance, and from without. A pier created the illusion of reaching for the horizon; of stretching for the unattainable. Removed from terrestrial reality, the viewer could reflect at a distance on themselves and their times. Thomas Hardy's 'prospect impressed' girl on the Cobb at Lyme stood for all sea-gazers.

No other man-made structure so extravagantly matched the recreational whims of the age. The French historian of human sensibilities, Alain Corbin, identified this as a critical moment in the Romantic consumption of the seaside. In French resorts like Dieppe, the embellishment of existing quays with terraces and pontoons was an organic process that enabled bathers to 'harmonise the space in which they moved with their longing for the shore'. But in England, something else was going on. On the north side of the Channel 'space was becoming attuned to impulse'.

It took a man who specialized in chains to show that the pier could become a defining spectacle. Captain Samuel Brown had made a name for himself by encouraging the Royal Navy to switch from using hemp rope to iron chain for anchoring warships. After he retired from the navy in 1812 he set up a company to manufacture chains, some of which were used to build his first bridge, over the Tweed at Dryburgh. Although the bridge collapsed, Brown had better luck with his 'Union Bridge', also on the Tweed. The bridge still stands (and I do recommend a visit). It's a measure of Brown's genius that when it was opened in 1820 this was the longest wrought-iron suspension bridge in the world. But it was the new steamer pier at the historic port of Leith, on the Firth of Forth, that turned him into an inspirational coastal architect. A fantastic structure, the Leith pier consisted of a 4-foot wide, 650-foot long timber walkway suspended from chains slung between a series of timber towers. At the seaward end, steamships could moor against piles driven into the seabed. Each suspended span looked a bit like an Inca rope-bridge, and traversing the swaying footway in a wind must have been a test of nerve. Brown's pier opened in August 1821 with much hullabaloo, its first steamer being the *Tourist*, which ran services to Aberdeen and London. Captain Brown immediately found himself in demand down south, where Brighton was prospecting for a designer who could create a landmark.

Brighton's growth had been even more extraordinary than Margate's. Between 1811 and 1821, the population had more than doubled, from 12,012 to 24,429. Around 50 coaches were arriving daily from London. But Brighton had to have a pier if it was going to cater for the potentially huge twin markets of cross-Channel traffic and its popularity as a leading marine resort. Like Ryde and Margate, a pier would serve a dual role, both as a jetty for shipping and as a promenade for tourists. Plans had been delayed by the Prince Regent, who didn't want his bathing water polluted with soot from steamships, and by the 'long-shore aborigines' (as they were dubbed by one of the pier's Victorian historians) who made a fortune out of ferrying passengers ashore in small rowing boats known as punts. The proponents won the argument, and at the end of 1821, a *Prospectus* was issued proposing the formation of the 'Brighton Pier Company'. To build the pier, the company chose Captain Brown. The design Brown produced for Brighton seafront was far more elaborate than his timber-and-chain walkway at Leith, and it became one of the wonders of Britain.

Brown's unique 'chain pier' was suspended from four pairs of cast-iron towers modelled on the gateways at Karnak in Egypt. The pier head was paved with 200 tons of Purbeck limestone and the pier itself – of English iron – stretched 1,154 feet out to sea. In 1823, on a November day of uncommon brilliance, 5,000 well-wishers crammed onto the pier while another 30,000 watched from the esplanade as bunting flew, speeches were made, the bands of the 7th Hussars and 58th Infantry boomed and trilled and the guns of a revenue cutter fired a royal salute across water packed with flotillas of boats. Reviewing the opening ceremony in December 1823, *The Times* couldn't decide whether Brown's 'splendid work of art and science' was ' a national monument' or a 'novel invention'. It was, the paper told its readers, 'a pier of such beauty and accommodation, as stands unrivalled in the world'. Such a pier could be used for berthing ships and for launching rescues to vessels in distress when beach-launching was too dangerous, while to 'the man of pleasure and the valetudinarian, it offers a marine promenade unequalled; and in its present infancy, there is no calculating on the general and numerous purposes to which it may be applied.'

Artists rushed to record this reworking of Nature's coastline. In Constable's painting, the chain pier rides like a futuristic, ruled line along the horizon,

completely at odds with the chaotic foreground of flotsam, beached boats and the dashing of waves and local folk. Turner's painting is absolutely still, the pier floating in a golden light between heaven and ocean; a work-in-progress reaching into the Channel towards an unseen continent. There's a sense, in both paintings, of the pier stretching the imagination. Those seeing the sea for the first time were travelling to another place. From the start, the seaside had been an other-worldly excursion. The sight of the open ocean, the immensities of blue and gold and the sensation of salt wind on inner-city flesh, were utterly transporting. With pleasure piers, resorts departed from the utilitarian architecture of port and fort, and from the neo-classicism of spas. Brighton, already the 'Queen of the Watering Places', was in a realm of its own. Several years before Brown surveyed the beach for his chain pier, the architect John Nash had begun creating a 'Pavilion' for the Prince of Wales, on the site of the farmhouse the prince had leased 30 years earlier .

Nowadays, the plastic beachwear and T-shirts amplify the fantastical architecture of the place. The Royal Pavilion is not just from another time, but from another place. Stand by the grass of the eastern lawns and you're a blink away from Uttar Pradesh. Inside, you leave the hubbub of urban Brighton for the exotic East; a world decorated with dragons and bamboo, and a banqueting room with a ceiling of palms against a blue sky, and a silver dragon clutching in its claws a one-ton, falling comet of chandelier glass orbited by lotus-flower lampshades. The table is still laid for the absent prince, who liked to sit midway along one side, where he could better appreciate his guests. The great kitchen's roof is held up by painted palms of cast iron. Chinese landscapes decorate the music room. There's more than enough chromatic exuberance to remove the viewer from the greyest of English days. When he saw the Royal Pavilion for the first time, William Cobbett, predictably, had a sense-of-humour failure: 'Take a square box, take a large Norfolk turnip and put the turnip on the top of the box. Then take four turnips of half the size and put them on the corners of the box. Then take a considerable number of bulbs of the crown-imperial and put them pretty promiscuously about the top of the box. Then stand off. There! That's a Kremlin.' But Cobbett couldn't have anticipated that the pavilion would end up like a jewel encased in a vast sprawl of brick and

tarmac housing a quarter of a million souls; what he saw was an extravagant abomination erupting from the finest chalk grassland in the south-east.

In the same decade that saw smuggling dealt its legislative sucker-punch by the repeal of 400 Customs Acts, and the sea lanes gaining their guardian angels in the form of the Coast Guard and the National Institution for the Preservation of Life from Shipwreck, seaside development crossed a threshold. The coast had become a place for fantastical creations. Nobody could compete with a royal pleasure palace, but the 1820s saw a spate of building styles utterly alien to English shores. Grand terraces and public buildings were imported from inland cities and spa towns, and superimposed on fishing and farming communities that had been evolving for thousands of years. There is an architectural arrogance to many of these buildings, which were intended to obliterate all memory of vernacular coastal form. Through the 1820s, the chalk downland on Yeakell and Gardner's map of Brighton was torn up for the footings of multistorey developments which dwarfed the surviving dwellings of fishermen's Brighthelmston. A new road, King's Road, was laid along the seafront in 1825, connecting the Royal Pavilion and chain pier in central Brighton with the chalky cliffs of Georgian stucco rising round a new development called Regency Square. Meanwhile, on the other side of town, Thomas Read Kemp was creating exclusive terraces of porticoed townhouses modelled on Nash's new facades around Regent's Park in London. Urban terraces were similarly descending on beachfronts from Devon to Deal. In the old Devon port of Teignmouth, tourists had taken to hanging about on the quays, watching the fishermen and the 'Amazons of Shaldon' – the muscular women who hauled nets, naked to the knee. In 1787, a teahouse had been built on the Den, an area of level ground facing the beach, and this was followed in 1825 by the colonnaded assembly rooms and a crescent of three-storey houses with balconies and sea-view windows. When the low-lying scrap of Hayling Island, just east of Portsmouth, was connected to the mainland by a bridge in 1825, the developers rushed in, raising a library, baths, hotel and esplanade. But they overestimated the market, and Hayling proved a slow starter; to this day, the massive, four-storey sweep of Norfolk Crescent remains half a crescent. At St Leonards in Sussex, balconies and colonnades appeared on four-storey terraces plonked onto a shore that had known only cottages and fishing shacks.

The momentum to develop was unstoppable, and those who objected to the reinvention of ancient coastal settlements could do little but watch with appalled fascination. To Cobbett, the standard-bearer for downtrodden rural England, the eruption of seaside resorts around the edge of his beloved shires was a blight fed by loathsome financiers from the 'Great Wen'. Riding through the fertile cornlands of the Isle of Thanet in September 1823, Cobbett couldn't bring himself to enter Margate because it was 'so thickly settled with stock-jobbing cuckolds'. Just then, in the 1820s, Margate was on a unique trajectory. On the back of its historic sea-trading links with London, the resort was in the throes of an unparalleled tripper boom. Between 1812 and 1846, 2.2 million people arrived and departed by water; an annual average of over 60,000. In the three years up to 1846, when steam packets had joined the shuttle service, several hundred were pouring into the resort every day.

Cobbett's rant against the city cuckolds clogging Margate was as ineffectual as semaphore in an August heat haze. The year after he took his summer ride through the grainlands of Thanet, workmen began excavating the chalk cliff at Margate to create a fort-like complex of seawater baths that would provide a sheltered alternative to the beach down below. The Clifton Baths, completed in 1828 for £15,000 (around £750,000 today), were the first example of a sea-bathing establishment to be dug from cliffs; the first time local topography had been substantially modified to create seaside facilities.

Nobody, not even Cobbett, could have foreseen the extraordinary invasion about to be unleashed on the British coast.

The railway, the bicycle, the motor car and the aeroplane were technical responses to collective surges in hypermobility. But the railway was first, and its effect on the coast was overwhelming and permanent. From the 1830s – with the opening of the line between Manchester and Liverpool – railway companies began demonstrating how to shift huge numbers of passengers in a single conveyance at the same time. Mapped through time, the evolution of rail routes in Britain looks like a spatially challenged drunkard's attempt to draw a spider's web with a pen that keeps running out of ink. Rail connections between inland

cities and the coast developed in a fashion that would make a command-economist throw his phone at the wall. At a time when there were no rail links to any ports on the coast of southern England (or Wales, or Scotland), no fewer than five railway companies were bidding to connect London to Brighton. When the line opened in 1841, only one other town or city – Southampton – on the entire Channel coast was linked by rail to London.

Brighton was the first resort in the country – indeed one of the first coastal towns in the entire archipelago – to be linked by rail to a city. The opening of the line on Tuesday 21 September 1841 drew crowds equivalent to those who had watched the opening of the chain pier 18 years earlier. For those used to making the Brighton run by horse-drawn carriage, it was an astonishing spectacle. Coupled behind the steam engine at London Bridge station were 13 carriages – three of them filled with directors and their friends. Every station on the route was decked in flags and *The Times* reported that the last mile of trackside into the resort was lined with a 'vast number' of Brightonians. The new station was jammed with over 3,000 celebrants who heard the band of the Scots Greys play 'God Save the Queen' as Brighton's first rail visitors were disgorged through a veil of smoke and steam. The run had taken just 2½ hours.

Scarborough and Yarmouth were connected to main lines next, and Blackpool and Lytham on the Lancashire coast. Coastal lines in Westmorland and Cumberland, and along the north and south coast of Wales, ran past beach after beach – few of them 'discovered'. By the time the first bout of rail mania stuttered to a rest in the mid-19th century, a skeleton of trunk routes fed by numerous branch lines had been laid, totalling 7,500 miles of track.

The public response to a new rail link could be astonishing. When the Dundee and Arbroath Railway opened in 1838, the beach at Broughty Ferry on the Firth of Tay was inundated with refugees from Dundee's soot and grime. A wharf that could boast a few huts and three line-fishermen in the 1780s suddenly became a boisterous summer resort. Over a period of seven months in 1839, an incredible 61,876 third-class tickets were issued for the 15-minute journey linking Dundee and 'the Ferry'. The effect of a rail link was to remove the perceived space between home and resort. In *The Sussex Coast*, published in 1912 as part of the *County Coast* series of guidebooks, Brighton

had no rivals for the same reason that London had none: 'There is but one Metropolis,' pronounced the author, 'and it has but one suburb by the sea.' The opening of the Brighton line had triggered a human tsunami: trippers started arriving from the capital at a rate of 5,000 a day, and on one sunny week in May 1850 the total number of passengers alighting at the resort was recorded to be an astounding 73,000.

Railways brought the coast to the edge of every city, whose better-off inhabitants piled into the carriages. The number of passenger journeys in Britain by railway rose from 28 million in 1844 to an incredible 289 million by 1870; a tenfold increase in just 26 years. For a species that had always travelled on its own feet, or by horse or boat, the appearance of a single contrivance that could shift hundreds of people 60 miles in a couple of hours was scarcely believable. Travelling by railway was so much simpler, quicker, cheaper and more comfortable than trundling between coaching inns in a horse-drawn carriage or taking to the sea. Less spent on travel meant more time and money for the coast, so holidaymakers were able to take longer, more extravagant holidays. In a phrase that might have come from the annals of subtropical exploration, J. K. Walton suggests that middle-class adventurers also began 'to colonize hitherto inaccessible tracts of coastline'. (The doctors and publishers of Islington were not of course hacking their way through mangroves in search of palm-fringed strands; they were taking the new line to Southampton, then exploring the Isle of Wight.)

The railways became an engine of social mobility. Cheap travel made it possible for the penny-counting middle classes and lower 'middling' ranks of shop assistants and young white-collar workers to dip their toes in previously exclusive waters. Variable-price ticketing according to comfort meant that the railway train itself could be used as a fast track to the 'higher classes'; with the right clothes and a bit of spare cash, a humble clerk could elevate himself from a third-class to a second-class traveller. The railway was one of the great levellers of mid-Victorian Britain and it modified the kind of person arriving at resorts; the proportion of passengers buying third-class tickets rose from one-third in 1844 to two-thirds by 1870. Working-class Britons were mobilizing in more ways than one.

The railways helped to accentuate the difference between resorts. At one extreme, there was a breed of tourist who searched for resorts beyond the reach of mass transit. 'When it is stated that Bude is thirty miles from the nearest railway station,' noted one guidebook, 'the heart of the fashion-hating, German-band-dreading sojourner may be at rest. His feminine belongings need not aggravate him by extra luggage, containing promenade dresses or fascinating hats ...' Lyme Regis, which also had no railway station, became a haven for 'quiet families who prefer the beauties of nature to noisy amusements and dress parades'. And then there were the in-betweens: out-of-the way places that were connected but hadn't succumbed to a Margate-makeover. On the Solway coast at Silloth, a little resort that was developed for Carlisle's factory workers after the railway arrived in 1856, the local newspaper summed up the mellow routine thus: 'We eat, we drink, we bathe, we walk, we sleep; and then we eat and drink and bathe and walk and sleep again. Only for variety's sake sometimes we bathe before we walk, and sometimes we walk before we bathe.'

The rate of growth in the top resorts was beyond anything ever seen on the coast. Mass transit and rising living standards fed the growth of existing resorts and encouraged the discovery of new ones. Brighton's population leapt from 46,000 in 1841 to 65,000 in 1851, while houses built over the same decade increased to 2,806 compared to just 437 during the decade before the railway arrived. By 1851, Brighton, the largest resort in England, had seen its population increase by 793 per cent since 1801. Next door, Hove had increased in population by 3,963 per cent over the same period. Housing the population boom altered coastal vistas beyond recognition. The tripling of Ryde's population from under 2,000 to over 7,000 in the 40 years following the construction of the pier converted a village into a town. Between the census of 1801 and 1851, 11 seaside 'watering places' more than quadrupled their population. When Walton totted up the total number of major resorts that existed by 1851, he identified 71 in England and Wales. That's one resort for every 112 miles of coastline.

Resorts bloomed like exotic corals around the coast, in states of constant regrowth. By the mid-19th century, the allure of sea air, salt water and coffee

taken with crinoline-fiction was being layered with less-demanding forms of leisure. The multitudes arriving by train were keener on beach and pier than on circulating libraries and assembly rooms. Piers became the expression of a resort's status. Bigger resorts began building second piers, and in the 1860s at least 21 were completed and others started. Bournemouth built a short wooden jetty in 1856, right beside the mouth of the Bourne stream, and then replaced it five years later with a much longer pier that opened with a 21-gun salute on a September day in 1861. So many piers were being added to the coast that a commentator in the 1890s quipped that maps would need to be redrawn to represent England as 'a huge creature of the porcupine type, with gigantic piers instead of quills'. By 1900, Britain's coast had been modified by no fewer than 80 piers. The promenading and dancing continued, and the bands played on, but piers were now encrusted with booths and theatres, and had become a stage for wilder kinds of entertainment.

At low tide, beaches became sprawling fairgrounds with donkey rides, Punch and Judy shows, and booths selling buckets and spades. The process of other-worldliness that had began with the Royal Pavilion at Brighton rippled along every seafront. 'You're not in Britain,' whispered the architects and gardeners, 'You're in Paris, St Tropez ... Canton.' In Blackpool, two Lancashire architects drew a spidery spire of cast iron and steel after the mayor, John Bickerstaffe, returned from the Exposition Universelle of 1889 in Paris with tales of an extraordinary new tower that had been raised above the blue waters of the Seine. Palms were planted at Torquay. Yarmouth excavated its 'Venetian Waterways'. And on the Isle of Wight, Queen Victoria built an Italianate palace with views over the Solent.

Britain's temperamental climate was treated as an architectural gift; a commission from the heavens to create extravagant all-weather structures. The vast, glazed Winter Gardens in Blackpool contained a concert room, promenades, conservatories 'and other accessories calculated to convert the estate into a pleasant lounge, especially desirous during inclement days'. Esplanades sprouted weather shelters with pagoda roofs and terraces grew elegant pillars and roofs that turned them into cast-iron grottoes. It is one of the wonders of the seaside that so many of these structures have survived. And in a way, we're

still building them. Imaginative shoreline buildings like the Tate at St Ives, the National Marine Aquarium at Plymouth and the Turner Contemporary art gallery by Margate's harbour jetty have inherited the wet-weather role of the Winter Gardens; they're a great place for families when the beach is too blowy, and they take you somewhere new.

Ingenious methods of transportation added to the sense of being 'moved' to another place. The Victorian aversion to walking, and the challenge of overcoming the geography of resorts, led to new kinds of coastal vehicles. Narrowgauge railways were built along promenades, and funiculars up cliffs. Some of these contraptions were more successful than others. Magnus Volk, the Brighton-born son of a German clockmaker, produced a work of genius in the electric railway he built along Brighton's seafront in 1883. He was less successful with his underwater track that carried a double-decker passenger vehicle raised above the sea on 24-foot high legs. 'Daddy-long-legs', as it was fondly christened by locals, proved temperamental and the Brighton and Rottingdean Seashore Railway was closed after only four years. But Volk's seafront line is still running, and is the oldest operating electric railway in the world. Mechanical conveyances could also be used to bring a 'tourist sight' within reach of a resort. In Antrim, the first line in the world to be powered by hydroelectricity was built from the pretty resort of Portrush out to the Giant's Causeway. Opening in September 1883, it was finally closed in 1949. Riding these contraptions was an end in itself; they were fun.

Towards the close of the 19th century, seaside resorts began to mutate yet again. They'd been healthy, and then amusing; now they became exciting. Competitive sport was added to the seaside ritual. The tennis court and golf course were used as social stages, and took some of the tedium out of the seaside holiday. Cowes, Torquay, Lowestoft and Brightlingsea began to specialize in yachting, and at some resorts visitors were invited to join the local cricket teams. On the coast of Yorkshire, Victorian shooting parties took to the water in chartered boats from Bridlington and Scarborough, and blasted at the seabirds that flocked around Yorkshire's chalk cliffs. As a leisure activity, it had little in common with the tweedy tradition of grouse-shooting, for the slaughtered birds simply fell into the sea. Not all the locals were amused. In

September 1869, a correspondent complained to *The Times* that the excursion trains that now ran 'to all parts of the coast' were bringing with them 'a host of Cockneys, who amuse themselves with Brummagem guns – some of which I am happy to say, burst – go prowling all Sunday round the coast blessed by their visit, firing at and generally wounding the gulls, puffins, divers, &c, which, unused to be molested during the week, allow the 'sportsmen' to come within a few yards of them'.

Piers found a new role. By the early 20th century, performers had discovered that a horizontal structure projecting into the sea was an ideal platform for experimenting with pursuits way beyond the genteel practice of social promenading. With the invention of the diamond-framed 'Safety Bicycle' in the 1880s, the road suddenly opened for enterprising nutcases to perform public stunts, among them 'bicycle diving'. At Brighton's West Pier, crowds cheered as balding 'Professor Redditch' pedalled his machine (it had no brakes, as he had no intention of slowing down) off the edge of the pier. Tragically, another bicycle diver called 'Professor Cyril' fractured his skull and died after his bicycle 'had a side-slip'. A little later, in around 1920, Mr H.W.G. Belbin of Battersea achieved a modest level of pier-head notoriety with his amphibious 'Land and Water Cycle', a roadster bicycle with 'catamaran' floats. Belbin, who had pedalled straight out of a Monty Python sketch, demonstrated his machine's versatility by cycling off the end of Southend Pier before an 'interested crowd'. On other occasions, he pedalled across the Bristol Channel from Knightstone to Weston Pier 'in a rough and blusterous sea', which makes his amphibious feat all the more remarkable. Belbin gave exhibitions on life-saving, and prided himself on being unable to swim, which proved, he claimed, how much confidence he had in his amphibious bike.

Seaside thrills were spatially packaged with the development of funfairs that compressed multiple excitements into a single site. The biggest thrill of all was the 'roller coaster', a white-knuckle ride where you found out what it felt like to be on a runaway train in the Alps. Passengers sat in small 'cars' whose wheels ran on a timber track. The first switchback coaster in the UK was laid in 1885 at Skegness, ten years after the resort was connected by rail to the Midlands. Others followed: by 1900, wooden rollercoasters had been laid at various resorts

up and down Britain, including Aberdeen, Douglas, Yarmouth, Scarborough, Blackpool, Southend-on-Sea, Cleethorpes, Barry Island, Bridlington and Folkestone. Surviving wooden 'coasters' now have a cult following, and there are groups who travel the world for a few minutes on the boards. I was lucky enough to get a ride in the early days of filming *Coast*. We were in Southport. On what had once been a deserted sandy foreshore, 2,500 feet of track had been built in 1937 to a design by Charles Paige of the Pennsylvania Roller Coaster Company. Each of the three-carriage trains could take 18 passengers on rides lasting 1 minute 45 seconds. Top speed was a gut-lifting, shrieking 42 mph. (There was a rumour that the operators would wind up the speed if there was a carriage full of pretty girls; the carriages would become airborne on the humps.) 'Cyclone' was one of eight surviving wooden roller coasters in the UK, and I was moderately excited at the prospect of taking a ride, not least because the director had asked me to provide a commentary to a minicam that had been attached to the train with clamps and several kilometres of gaffer tape. So we trundled into the sky. I say 'trundled' because the carriage wheels were bumping over planks of Nicaraguan pitch pine, which provided a pretty good simulation of sledging down a concrete staircase. I remembered my words, but the camera failed to pass the vibration-test. The view over Southport was great, though. The thing is, in 1937, when Cyclone opened, you could still overtake lorries on a bicycle, and a family saloon like the Austin Cambridge had a horsepower of about thirty. Today, the most pathetic BMW 3-series saloon produces 116 horsepower and 'Stealth' at Thorpe Park takes kids from 0 to 80mph in under two seconds. But Cyclone was quite a thrill back when its boards were new.

Seaside resorts have always had a special relationship with the railway. In their heyday, resorts were united by their common link with major cities and industrial towns. From the 1840s, those links had taken the form of engineered, steel threads that connected the heart of conurbations with the beach. At one end of the line lay toil and grime, and at the other fun and sun. The lines themselves carried a meaning. Unambiguous, they told you exactly where you were going, and when. They were symbols of order and destiny. When you got to the resort, you found miniaturized lines, laid as narrow-gauge pleasure rides on esplanades and at funfairs, or as comedic roller-coaster routes that took you

back to your starting point. These play-lines gave holidaymakers a once-a-year chance to dominate the technology that had turned home and city into an irksome production line. The filthy, shrieking loco hauling coal up the Lickey Incline was reinvented at the seaside as a small, polished toy that took you nowhere; the endless lines of 20-ton mineral wagons that rattled the windows of every railside terrace in Darlington were transformed beside the beach into brightly painted carriages pulled by a silent electric loco.

But the 60-year reign of the railed conveyance began to be usurped in the early 20th century by the appearance of mechanical passenger vehicles that could run on roads. By fitting the new internal combustion engine to the old, horse-drawn charabanc, transport operators were able to break free of the rail network. By the 1920s, charabancs had evolved into coaches with roofs. Works groups chartered their own coaches so that they could travel together to the coast. The road trip itself became part of the fun, as drivers called at wayside pubs and viewpoints. Towns with no direct rail links to resorts were able to join the summer exodus to the sea, and cities were able to experiment with resorts in other regions. The balance of popularity shifted from the south-east resorts like Margate and Brighton, to the less familiar – and physically exotic – bays of the south-west.

The golden gulf was Torbay, whose unique geography had been spotted during the early decades of the resort era. Seen from a satellite, Torbay is deeply sculpted from the coast of Devon, like a 5-mile capital 'C'. Unusually on a south-facing coast, Torbay faces east, so that it has all the benefits of Devon's warm climate, while being sheltered from the prevailing, westerly winds. Three towns line the shores of the bay: Torquay on the northern promontory, Paignton in the middle and Brixham on the southern promontory. In the single-most brilliant example of coast branding in the UK, Torbay has become the 'English Riviera'. These days, it's the most popular holiday destination in the UK, accounting for 19 per cent of the domestic total.

While writing this book I found myself filming one morning at a bus stop in Paignton. It was cold, blustery and raining. Unusually, I was wearing a linen jacket, and I'd been allowed to open my umbrella (a practice normally forbidden by sound recordists, who say that the impact of raindrops on the taut fabric

sounds like a firefight). The camera was lurking behind a tossing palm, and I was getting a bit fidgety when a gigantic custard-coloured coach grumbled out of the murk. Bounding down the steps came a sunny Lancastrian called Dave Haddock. He knew what I was going to ask (it was the third take):

'It's an AEC "Duplex Dominant", he laughed. 'Made in Blackpool, in 1976.' Dave is one of those rare individuals who lights up the greyest day. You step through the doors of his coach into a different world. Inside, most of the seats have been removed and replaced by a floor-to-ceiling museum honouring Yelloway Motor Services, a Rochdale company that emerged in 1932 from the economic wreckage of the Depression. The traditional resort for Rochdale had been Blackpool, but that had all changed with the first charabancs. One of the black-and-white prints in Dave's museum shows Arthur Greenoff leaning against the tombstone radiator of his charabanc in 1913, shortly after it made its first run to Torquay. Behind Arthur, the vehicle is crammed with women in puffed white blouses and men in ties and flat caps. The charabanc has wooden, spoked wheels and looks so top-heavy that it seems as though the slightest bend in a road would send it toppling. Many did topple. At the end of each excursion, the passenger body of the charabanc would be removed and the vehicle would revert to a lorry. One of Dave's photos shows a charabanc fitted out with pews from a church.

Britain does museums better than any country in the world, but Dave's Duplex Dominant is up there with the best. He's got maps and timetables, a (live) cockatiel, drivers' badges, posters, an incontinent dog wearing a baby's nappy and rows of cast-metal Yelloway models in cream and orange livery (the colours, it occurred to me, of Devon cream and Torbay's Permian sand). Dave picked up one of the models, a 'half-cab' from the 1940s:

'When I was a young lad, I came on this type of coach … it took 15 hours to get to Torquay from Rochdale.' Dave's mother told him that his first words on arrival at Torquay had been: 'Are we at the other side of the world?'

I asked if we could go for a spin, and we cruised Torbay for an hour while Dave reminisced and the camera crew tried to catch what they could (it was a bit like filming out at sea). The giant steering wheel looked like a tabletop in Dave's hands, as he pointed out Torbay landmarks:

'It was just the most beautiful place you could wish to come to as a child. And the thing that surprised me most, Nick, was that we played out all day long, and when I looked at my hand at the end of the day, it wasn't dirty, and yet if I'd played out for an hour at home, in the industrial north-west, my hands would be black.'

Dave's parents used to come to Torquay for a week every year, and when Dave married he took his bride on their honeymoon by coach:

'The driver gave us the front seat and the passengers clubbed together and bought a bottle of champagne.'

'Were you given the back seat for the journey home?'

Peals of laughter. I was reluctant to leave Dave and his Duplex Dominant. Coach trips must have been a lot of fun in those days.

For 30 or so years, from the 1920s until the 1950s, the internal combustion engine gave millions of holidaymakers the best of both worlds: mobility with tranquillity. You could choose from a score of resorts and spend a week or two freed from infernal machines. From the 1920s, better-off households with £170 to spare could splash on a Morris four-seat tourer that would take the family direct from their home to the seaside of their choice. No timetables; no over-crowding; the route of your choice. And when you reached the resort, you could take day trips to wherever you liked. The numbers tell the story. In 1901, there were just 32,000 cars on British roads. By 1919, it was 109,000 and by 1930 one million. By 1939 the number had doubled to two million. And so it went on. Now there are 30 million. It's been a controversial device. We have become, according to the RAC, 'car reliant'. Like the washing machine, the train, the Pill and the plane, it has liberated and democratized. It's also exported to the seaside many of the stresses that resorts sought to avoid. Public gardens and esplanades that were laid out for their colour, perspective and space, have become bordered with metal boxes that grunt and fart acrid effluvium. Historic buildings have been torn down to widen roads and build carparks. The automotive mael-stroms of Brighton's Old Steine, and the bumper-to-bumper, snarling stench of Grand Junction Road, have driven visitors over the seafront railings, so the crowds now jostle along a narrow shelf on the edge of the beach, where the traffic noise is muted and the cars lost to sight. The cost of car-reliance has

been immeasurable. Let's give the final word on cars to the doyen of seaside historians, J. K. Walton:

'Everywhere … the car was a damaging and disruptive influence, intruding into landscapes, clogging up central streets and promenades, colonising vacant land, encouraging demolitions, siphoning demand away from established accommodation areas where parking was difficult, and bringing inner-city risks and fumes to holiday areas.'

The number of people taking holidays of four days or more in Britain peaked at 40.5 million in 1974, the year that Abba won the Eurovision Song Contest in the seaside resort of Brighton. What happened? Well, two things. The purity that had created and sustained the seaside resort for 200 years was defiled by the motor car, and the hypermobile travelling classes began to be intoxicated by a replacement coast, a coast that promised clearer waters, more heat and a release from choking roads and the drudge of office, factory floor and kitchen. It was a rerun of the 1750s, only this time fleets of Boeing 727s aeroported summer migrants to the Mediterranean. But that was forty years ago. Today, we're coming home.

Once again, this is the age of the coast. We've become masters of recreational invention. Each year, over 300 million trips are taken to the edge of these islands. And for a bewildering range of reasons. Today, we speak less of 'going to the seaside' than of 'heading for the coast', a place that offers an intoxicatingly diverse spectrum of activities way beyond the offerings of a Victorian seaside resort. Far more people walk the South West Coast Path every year than promenade on our threatened piers. The seaside resort, for so long the focal point for a particular stretch of coast, has been subsumed by something far bigger. The original notion of the all-encompassing 'sea coast' has returned.

Last year, I spent a day on the beach at Mellon Udrigle in Scotland, attempting to measure the British coastline, with rulers. Instructing me was Dr Tony Mulholland, a mathematician from Strathclyde University. With three rulers of differing lengths, we measured the same section of coast. Taking turns, one of us would lay the ruler repeatedly around every crevice and spike of the rocks

framing the beach, while the other would attempt to keep track of the numbers in a notebook. The result, for anyone familiar with fractal dimensions, was predictable. The shorter the ruler, the longer the coast became. It's because, explained Tony, the shorter ruler finds its way into more cracks and crevices, so the distance becomes greater; 'The length of the British coastline,' Tony announced when we finished, 'is infinite.' And that is precisely how we view it today as a recreational amenity. Our coastline is no longer a necklace of inter-mittent resorts, but a continuum of infinite possibilities.

With the exception of the odd firing range and industrial facility, there is not a kilometre of our coasts that cannot be adopted for health or pleasure. Climbing cliffs and reclining in deck chairs are extreme pursuits that bracket a cornucopia of coastal activities, and embrace every conceivable landscape and marine precinct. A Saturday spent walking the maritime heritage trail through the 'rows' and quays of Great Yarmouth can be followed by a few loops of the big wheel, a blast on the dodgems and then a Sunday seal-safari by motorboat to Blakeney Point. A 20-mile radius around Caernarfon in North Wales provides a bewildering range of opportunities which include stupendous castles, sea kayaking, horse riding, rock climbing, stunning beaches, the archi-tectural gem of Portmeirion, the Snowdonia National Park, the new geo-park on Anglesey, and Llandudno, a traditional Victorian seaside resort. Historic resorts like Weymouth offer wreck-diving trips and sea-fishing charters. Other resorts have specialized in surfing, sailing and bird-watching cruises. Most resorts find themselves on a long-distance coast path and many have opened yacht marinas. Not for the first time, Brighton has found itself out in front, with the largest marina in Britain and Ireland (it's hideous). The modern coast is dotted with links courses, museums, hideaway hotels, nature reserves, sailing schools, equestrian centres, writing retreats, paragliding sites, restaurants, artists' colonies … the list is as endless as the coast is long.

These are exciting times. It's as if we've suddenly woken up and remem-bered that we are islanders; that none of us live more than a couple of hours from salt water. A return to our shores is being measured in rising visitor figures, media time and websites pulsing with coastal breaks. Binge flying can get boring, and it's no longer smart or original. Coast walking is the new flying.

Hike the Seven Sisters, or the South West Coast Path, or the Antrim cliffs, and you'll see what I mean. A lot of boots have been bought since the gents of the Sunday Tramps club reached for the Neatsfoot oil in the 1870s. Only a century earlier, you had to be a very eccentric or impoverished Briton or Irishman to take a long walk voluntarily. Horses were there for a reason. In 1782, when the German tourist Carl Moritz came to England on a hiking tour, he was treated as a curiosity: 'A traveller on foot in this country,' observed the German, 'seems to be considered as a sort of wild man, or an out-of-the-way-being, who is stared at, pitied, suspected, and shunned by every body that meets him.'

These days, waymarked paths follow hundreds of miles of our coastline. Clockwise, they are the South West Coast Path (630 miles), the Pembrokeshire Coast Path (186 miles), the Fife Coast Path (93 miles), the Northumberland Coast Path (64 miles), the North Yorkshire Coast Path (54 miles) and the North Norfolk Coast Path (45 miles). In Northern Ireland, the Causeway Coast Path (15 miles) treks over the vertiginous headlands between Bushfoot Strand and Ballintoy. These designated routes are just a fraction of the total coastline available to walkers. Some of the most enjoyable coastal walks I've had have been along 'ordinary' bits of shore. An audit by Natural England in 2009 revealed that a 'satisfactorily legally secure path' ran along 66 per cent of the English coastline, while the Marine and Coastal Access Bill promises to open up the remaining 34 per cent of the English coast to public access. The Welsh Assembly Government is creating a continuous 850-mile shoreline path around the coast of Wales.

There are also several coast-to-coast routes. While not actually following coasts, they tell a coastal narrative, beginning and ending at seashores, and conveying the hiker over the intervening watershed. The English coast-to-coast was originally devised by veteran hiker Alfred Wainwright, who chose suitably emblematic termini, one 'spectacular' and the other 'quaint', and then laid a ruler between the two and looked for the public rights of way that ran closest to this personalized meridian. Between St Bees Head on the edge of the Irish Sea, and the smugglers' cottages of Robin Hood's Bay, on the North Sea, he was gratified to see that the line ran through three national parks, and was unsullied throughout by 'industrial blemish'. Wainwright's 190-mile Coast to Coast walk was born of intuition, but owes its unique character to the alchemists of

the English landscape: geology and land use. From the sandstones of St Bees to the Millstone Grits of the Pennine spine and Yorkshire's limestones, this is a hike scattered with topographic delights. And history, too, for this idiosyncratic transect creates a timeline between stone circles, drove roads and abandoned moorland smelt mills. It's the kind of walk that can alter your perceptions of Britain. In 2004, the Coast to Coast was voted the second-best walk in the world. A second coast-to-coast, the Hadrian's Wall Path, shadows the Roman wall for 84 miles, between Bowness-on-Solway in the west and Wallsend in the east. Not to be outdone, Scotland also has two coast-to-coasts. The 73-mile Great Glen Way follows the geological fault line between Fort William and Inverness, and in doing so links the Atlantic with the North Sea, while the much tougher Southern Upland Way takes a roller-coaster, 212-mile course over the hills (some of them fairly large) from Portpatrick near Stranraer to Cock-burnspath, between Berwick and Edinburgh. And there's more than a lifetime's worth of shorter, coastal ambles. The National Trust alone is compiling a web-based series of 1,000 walks, many of them coastal. They're free, and currently being downloaded at a rate of one every two minutes.

One of the most visionary projects to have blessed these isles in recent decades is the National Cycle Network, started in 1977 by a Bristol-based group called Sustrans. Their first route followed the 17-mile trackbed of the disused railway line between Bristol and Bath. The National Cycle Network now covers 12,000 miles in the UK, and is attracting nearly 400 million walking and cycling trips a year. Much of the network uses inland routes, but there are many coastal sections, notably along the Pentland Firth, the eastern coast of Britain from Fife in Scotland to Bridlington in Humberside, the Norfolk coast, the Channel coast of Kent and Sussex, a loop of the Isle of Wight, slices of the Dorset and North Devon coasts, the coasts of Pembrokeshire and North Wales, a Lancashire resort ride from Southport to Fleetwood, bits of the Cumbrian and Kintyre coast, and in Northern Ireland, the ride around Antrim's bays and headlands. In Cornwall, the rail line that used to run from Padstow to Bodmin has become one of the best bike rides in Britain, with its seaward section following along the shore of the Camel Estuary. If you like biking by the sea, there are hundreds (and hundreds) of miles of options.

The defining characteristic of modern coasting is the expansion of aquatic pursuits beyond bathing. While we were shooting Series 5 of *Coast*, I was invited to spend a day training with an all-women team that was about to compete in the annual Three Peaks Race. The competitors run up and down Snowdon, sail to Cumbria, run up and down Scafell Pike and then sail to Scotland, where they run up and down Ben Nevis, to finish the race by the sea at Fort William. To take part, each team must sail, row, run and climb mountains. Helen Acton and her crew took me out into Cardigan Bay in winds gusting to Force 8. The boat, a 38-foot Sigma, felt like a cork in a hurricane. It's the only time I've thrown up while trying to interview someone for a TV programme. Twenty-four hours later, the girls started running; five days and 38 minutes after that, they jogged to the shore at Fort William, in 13th place (25 yachts finished and seven fell out). It's a fascinating (and rather fun) example of the way the coast is no longer viewed as wholly terrestrial or aquatic; it offers the best of both.

After a one-century lay-off, sails can be spotted scooting along the horizon or rattling up masts in rejuvenated harbours. And these are not just Bermuda-rigged, glass-fibre funboats fitted out with hot showers and fridges, but expertly restored sailing barges and pilot cutters, slicing through story-rich seas under straining spritsails. Sailing is back with a bonus; nowadays it's open to pre-teens who can be schooled in the basics for less than the price of a games console. Take a pair of binoculars to the Solent, or to the Olympic reaches of Portland Harbour, or to the Clyde or to Plymouth Sound, and you'll find flotillas of racing boats scudding to and fro like free-minded pixels on the ultimate screensaver. Sea-kayaking schools train young and old alike in how to take to inshore waters in a cockleshell boat.

And what became of the architectural corals that taught inlanders how to love the coast? The resort boom left it lined with seaside towns. Resorts were the bridgeheads that allowed the nations of the archipelago to explore their own shores; the portals through which they could peer at a strange and wonderful outside world. Fitted out with standardized architecture intended to make visitors mix, and with a multiplicity of exciting activities and sights, they were social melting pots and safe arenas in which to experiment with the great outdoors. Their origins are as specialized as ports, and their architecture as

distinct. I don't see them as relics but as hubs of regeneration. Seaside resorts have always been the kernels of reinvention. Brighton, Llandudno, Scarborough still have the capacity to transport us to another place. It's still fun to walk a pier and eat in the open air. They are well served with hotels and guest houses, and their beaches are invariably unchanged. As character-rich accommodation centres, they are ideally placed to respond to a resuscitated demand for coastal holidays. But they are much more than pretty dormitories. The frenetic booms that created their exotic personalities may have been conducted without a nod to the landscapes being lost, but now we have them they should be celebrated for their charms. Given the satisfaction planners have always derived from demolition, it's amazing that so many resorts are still decorated with architectural gems. From 1814 through till 1957, 101 piers were built around the shores of Britain. Today, 55 of them are still standing (although ten of these are in danger of collapse or demolition). But our 55 survivors are more than the number that stand in the entire USA, and there are no piers in the Mediterranean.

Working on *Coast* films has rekindled my deep affection for historic resorts. They're *fun*. This April we spent a family day at Brighton. The seafront resembled a gigantic beach party, with live music and scores of day trippers like us enjoying a drink or a meal at boardwalk tables. I saw the Royal Pavilion for the first time, and was stunned. Many resorts still have steam trains, boat trips and pier shows, making it possible to create your own, Victorian day-at-the-seaside. From the resort of Sheringham on the coast of north Norfolk, you can take a 10-mile round trip in coaches hauled by steam locomotives and vintage diesels on the 'Poppy Line', which has been reconnected to the national network. In Devon, the Dartmouth Steam and River Boat Company offers round trips that link a steam train ride with a boat cruise on the Dart. Sightseeing trips by boat leave Whitby, Weymouth and Paignton, just as they did one century ago.

Sea-bathing still tops the popularity polls, but the coast's founding leisure pursuit has expanded into a range of related activities like surfing, scuba diving, snorkelling, wind surfing, kite surfing and 'coasteering' – a high-adrenaline, hybrid combination of swimming and scrambling along the rocks of the intertidal zone. Swimming at remote beaches and secret coastal nooks has become a badged activity known as 'wild swimming', with its own guidebooks (and

health and safety warnings). Winter swimming has keen adherents – although I can't understand why – and the number of people moved to throw themselves into the sea on New Year's Day increases each year. The organizers of a 1 January fund-raising swim in Bexhill ruled 'no wet suits, no dry suits, no wimps'. That's me, number three.

8.
Sacred Shores:
Safeguarding the Future

We'd been filming all day on a small, uninhabited island off the west coast of Scotland. As dusk began to smudge the crystalline light, the director reluctantly announced that we'd have to 'wrap' if we were to get back to the mainland before nightfall. Ten hours of tension wafted into the gloaming as the banter flowed and the gear was packed for the hike back to the boat. The camera was shouldered, along with the sound-mixer, boom and mikes, and backpacks and bags of varying enormity, until a little column stretched across the rocks and calf-high heather. I found myself alone on the little hill. It was the highest point on the island, and as I watched my friends stumble and wallow along the ridge towards the bay on the far side of the island where the boatman would be waiting, a powerful stillness tiptoed into the evening. It had been a wonderful day, with a great team. The sun had shone and we'd shot some good sequences. And then there was the eagle. Or rather the three eagles. White-tailed eagles; sea eagles. An adult and two youngsters, who'd appeared from nowhere, wheeling over our heads and then slipping behind a cliff. In Gaelic, the sea eagle is *Iolaire suile na grein*, the eagle with the sunlit eye, and in parts of Scotland it's still known as the *Erne*, from the Anglo-Saxon word meaning 'soarer'. We'd been so busy filming that I hadn't had time to think about the eagles. But they'd been there. Real eagles, right above our heads. Now nothing moved and I was alone. The voices had faded, and so had the wind. Under the round ember of the sun the sea was the colour of polished copper and the slopes of the mainland were shading into rich mauves. Everything looked as it did 5,000 years ago when

men and women in boats of skin must have known the island for its fish, and perhaps its eagles too.

There are many places like this in our archipelago. They're sacred places; places apart. We all know at least a few. They're the places whose purity makes it possible to feel time as well as space. On a crowded island, they're better preserved at the coast. To the Greeks who listened to the stories of Homer, the seashore was the best-defined edge of the settled world; the place where those of the land communicated with the deep. The sea was a source of food, yet dangerous to human life. In myth and ritual, it offered a fresh beginning; a rebirth of hope.

Anyone who has taken a holiday on a Greek beach will know that it bears one striking dissimilarity to, say, a beach in Lancashire. There is far more sand on a Lancashire beach. In the Med, the relatively small tides mean that the 'seashore' is a fairly narrow line; in Britain and Ireland, the large tidal range can create beaches so vast that you can barely see the sea from the high-tide mark. So our 'seashore' is more of a zone than a line. And it can be a fairly tempestuous zone. Nevertheless, our shores, like those of the Greeks, have for thousands of years been the setting for rituals and sacred places.

A few weekends ago, we went for a family walk across the salt marshes at Burnham Overy Staithe on the north coast of Norfolk. From the car-parking area on the foreshore by the old quay, we took the regravelled, wheelchair-friendly, dyke path to the mysterious windings of the boardwalk as it wormed through the dunes then rose to a sandy crest and the sudden view of flat sands and ocean. The sea was half a mile away, a quiet rim beyond a rippled plain, glazed with lagoons. We walked and talked, felt the sun and sea air. It was a Sunday and the beach was dotted with people indulging in the same Sunday ritual. Just along the coast from here, in spring 1998, a local man called John Lorimer noticed a strange circle of timber posts on the beach near the village of Holme next the Sea. Lorimer told the Castle Museum in Norwich what he had seen.

One of the two leading archaeologists on the rescue-excavation that followed was Maisie Taylor, a specialist in ancient wood. Maisie can make deep history breathe (I once took a fenland punt voyage with her and within a few minutes of slipping into the narrow, marsh waterway, I was expecting to see

Neolithic spear-fishermen peering through the reeds). The paper Maisie subsequently wrote with Mark Brennand on what turned out to be an early Bronze Age timber circle is one of the most thrilling analyses of sacred places I've read. They know for certain that the circle was erected in the spring or summer of 2049 BC. Dendrochronology, and analysis of axe marks in the timber of the 55 posts, suggest that they were cut from 15 to 20 oak trees using 51 bronze axes wielded by a well-organized group that totalled perhaps 200 people. The posts had been driven into the salt marsh in a slightly irregular circle whose maximum diameter was 7 metres. Most of the posts stood flush with their neighbours. It was, in effect, a circular wall of oak, with the posts arranged so that the tree bark remained on the outside of the wall. In one place, a forked post allowed just enough width for a person to squeeze through the wall. In the centre of the circle, the 2½–ton stump of an oak tree had been buried upside down, with its roots splayed to the sky. When 'Seahenge' was erected, it stood on the salt marsh close to the point of the highest spring tides, and was probably surrounded by various channels winding their way towards the distant sea. On the landward side, there was slightly higher ground with woods of oak and lime. It was, Taylor and Brennand pointed out, 'a liminal space between fertile land and the sea'. Seahenge, they concluded, 'may not have ever contained a human body but contained ties to the dead, and the symbolism of trees, woodland fertility, and regeneration'. The inverted tree may have been connected to the belief – held by the Saami in Lapland – that the underworld existed in a state of inversion beneath the beaches and fields.

We'll never know exactly what moved a community to erect an oak ring on the salt marsh that once connected their woods and pastures to Doggerland. We do know that it was constructed as the climate was entering a phase of global warming. Sea levels were rising and habitats were changing. We also know that the tribes of the early Bronze Age were decorating the archipelago with monumental structures that ranged in scale from causewayed enclosures to the great blue-stones of Stonehenge – hauled from the Presceli Hills of Wales some 600 years before the axemen of Seahenge selected the trees for their own, local monument. Stonehenge was constructed and modified over 2,000 years; Seahenge was probably built in a day or so, and once completed it was probably never

re-entered. Its construction was part of the ritual. And its decoding by Maisie Taylor and Mark Brennand is now a part of our own 'origins story'.

Seahenge may have been built from oak because there was no stone in the tribal territory. How many Seahenges have been lost to the tides, or still lie beneath the peat of Doggerland, Cardigan Bay or Mounts Bay? In Orkney, where there is no woodland but plenty of rock, you can still see some of the most spectacular prehistoric monuments in the archipelago. On Mainland, the largest of the islands of Orkney, there are two lochs separated by a narrow isthmus of land. Loch Harray is fed mainly by rivers, and the Loch of Stenness by the sea. At one end of the isthmus – which is broken by a narrow channel of water – is a ring of standing stones, the Ring of Brodgar, surrounded by burial barrows, and at the other end of the isthmus is a ring of stones with a central hearth, known as the Stones of Stenness. Other standing stones complete an alignment between the two stone circles, which are one mile apart. Some archaeologists think that the isthmus may have been a ceremonial way connecting the 'ring of the dead' with the 'ring of the living'. A similar processional route links Stonehenge with the oval earthwork of Durrington Walls on Salisbury Plain, and that too is interrupted by water – the River Avon. In Orkney, the 'death ring', Brodgar, is isolated on the rounded summit of a low hill, with water on both sides. To the south-east, the isthmus is stretched before you, like a tapering green causeway pointing at the distant 'living' stones of Stenness, which seem to be set in a cradle of hills. But if you stand at the other end of the isthmus, you find yourself looking upward to a dark heather mound and a family of mute, silhouetted figures. Last time I was there, filming the site for a *Map Man* programme, on one of those far-northern April days when the cold Atlantic has sealed the sky with a cast-iron lid, we had the stones to ourselves. The empty road formed a dark avenue between the two rings and the ghosts of stone-raisers blew in from the sea in pale squalls. At Stonehenge, besieged by crowds and cars, you can no longer walk into the monument; on Orkney, you can look through the eyes of Neolithic Britons.

In sight of Stenness is the most astonishing passage grave in Britain. Maeshowe was built around 2,700 BC and experts reckon that it required as many as 100,000 man-hours to construct the cyclopean stonework and to raise its enormous mound – a demonstration of power, perhaps, by the social elite of

the time. The entire grave is aligned on the midwinter sunset, so that the end of the day blazes from the horizon straight down the entire length of the entrance passageway to strike the rear wall of the main chamber. Inside, the stones fit so tightly together that the smooth internal surface of the grave amplifies the acoustics. Faint incised scratches on the stones have led archaeologists to believe that the interior of Maeshowe was painted. In this subterranean temple, with its walls of reflected colour and sound, islanders felt the ancestral presence. The mind boggles with speculation at the kind of Neolithic *son et lumière* these walls witnessed. In the 12th century, scumbag Vikings defaced the tomb with the sort of graffiti you see in violated Type 24 pillboxes: a crude, drooling dog beside the words *Ingigerth is the most beautiful of all women.* Less formally, another Scandinavian chipped: *Thorni fucked. Helgi carved.* (Thorni is a woman's name, btw.) Other Dark Age taggers made no effort to convey anything more than their name, scratching *Haermund Hardaxe carved these runes, Ottarfila carved these runes* and simply *Thorir.* In Camden, where I live, the ritual continues, and it costs the council a small fortune to remove the graffiti.

Orkney is the most astonishing prehistoric site in the entire archipelago, and there's far too much to explore in the space I have here. But I'd like to leave you with one more coastal, Orcadian site, at a place called Isbister. On a clifftop facing the rising sun on the island of South Ronaldsay there is a tomb that was built long before the pyramids of Egypt. It was discovered by chance in 1958 when the local farmer, Ronald Simison, came across partially buried flagstones that turned out to be a chambered tomb. It had been built around 3250 BC, but was enlarged and used for at least a thousand years. Inside, were 16,000 assorted bones, which included the body parts and skulls of 342 humans, together with 70 eagles' talons and the remains of at least 14 white eagles. The eagle bones were radiocarbon-dated to between 2450 and 2050 BC, so had been placed in the cairn over 800 years after the original structure had been built. The last of the birds to be interred may have been killed during the lifespan of the adults who'd built Seahenge in Norfolk. Like Maeshowe and the standing stones at Stenness, it's possible to make your own journey back through time by crawling along the 3-metre entrance tunnel to the internal chambers of the cairn (there's a trolley for non-crawlers). The Tomb of the

Eagles visitor centre has various facilities that weren't available in the Bronze Age, among them flush lavatories and Orkney ice cream.

Off the west coast of Scotland, the Outer Hebrides are also scattered with prehistoric sites. On the Isle of Lewis, there is a complex of 54 standing stones arranged in the form of a Celtic cross – again raised at around the same time as Seahenge, but used for over 1,000 years. They stand on a peninsula which juts west into the sheltered waters of Loch Roag, the four arms of the cross rising to a central circle of stones. The Calanais circle occupies a hill crown, with the sea wrapped around. The stones are Lewisian gneiss, the oldest rock to be found in Britain, and there's compelling evidence that they are aligned with mathematical precision on lunar phases. Perhaps the era during which the tall stones were hauled upright to form a ring – 2900 to 2600 BC – tells us something about their meaning. Agriculture had been practised in the area for over 500 years, and there must have been a considerable population available to execute such a massive civil-engineering project. The community here would have been familiar with the good life. Back then, Loch Roag offered excellent fishing and shelter for boats, and the shores were lined with birch, pine and scrub for firewood and home-building. But it seems that their world was changing for the worse. Sea levels were rising. In fact they were rising so much that the shoreline of 3000 BC is now several metres under water. It seems that the woodland crashed, too. Pollen analysis and radiocarbon-dating suggest that the birch woods declined substantially at around the time the initial ring of Calanais was raised. Today's high-tide mark has crept above field walls that were assiduously piled around cultivation strips during the second millennium BC. Other rings and 'stone settings' were raised in the Western Isles at around the same time as Calanais, and there are hints in their design, locations and associated finds that the Neolithic communities farming the Western Isles used the sea to develop cultural links with similar communities in Scotland and Ireland. Call at Calanais today, and you'll find that it's still a cultural hub, with an excellent visitor centre that welcomes 40,000 Anthropocene callers every year.

We will never know the true meaning of the rings of Holme, Calanais, Brodgar and Stenness, or why sea eagles were taken into the cliff-tomb of Isbister. But it would seem that the oak and the eagle and the sea were a part

of the rituals of the fisher-farmers who settled in these parts of the archipelago. Nature played its part in linking communities to their past and future. Each of these coastal sites has carried through time their sense of being 'on the edge'; of being in limbo between land and sea; between the known and unknown; the past and the future. In that respect, they cannot age, for they mean similar things to each generation who crosses their threshold. A ring by the sea is quite unlike a ring on a plain. Inland, the eye can map every quadrant of the landscape and find a pattern in its form. The same is not true of the sea. When you stand on the cliff at Isbister, looking east into the island-free emptiness of the ocean, you will find no solidity. And were you to risk your neck and scramble down the cliff like Isbister's Neolithic children (whose deformed ankles have suggested that they spent too much time rock climbing for birds' eggs), you would find, if you plunged your hand into the sea, that it parts at the touch. It cannot be held, or sold. The sea has always been a window onto a world of the beholder's choosing.

The coastal circles and tombs of the deep past share a locative bond with every sacred place that has been subsequently added to the coast. They were intended for ritual, and yet have come to mean much more. They shared a common connectivity as waystations on the primary thoroughfares of the sea. There's an island off Anglesey that acts as a marker for the southern gateway to the Menai Strait. It's small and rocky, and sits just a few metres offshore, and it's called Llanddwyn. One of the loveliest beaches in Wales runs for over three unbroken miles from the island to the southern tip of Anglesey at Abermenai Point. I've been here on blue days, grey days and gale-swept days. Half the beach is backed by an undulating sand-sea over a mile deep, and the other half by sighing pine forest. It's immense; secret. The views of Snowdonia's mountains are a bonus. The island is enchanted, and its ruined chapel remembers St Dwynwen, the Welsh patron saint of lovers. The chapel dates from the 16th century, but legend relates that it replaces St Dwynwen's fifth-century original. For over a thousand years, the chapel was one of the most important seamarks on the Welsh coast. Later generations built a small lighthouse on the island, and a row of cottages for the pilots who'd help ships to enter the strait. The same pilots manned a lifeboat, too. Llanddwyn reached out to every passing mariner.

The Celtic seaways of the Irish Sea are lined with Llanddwyns. Most date from those unsettled centuries after the departure of the Romans, when England was being terrorized by pagans from the dark side of the North Sea. In the upland fastness of Wales, Brythonic culture flowered, and so did Christianity. Capes and islands were colonized by early Christians who brought the traditions of desert monasticism to remote spots like Bardsey and Caldey Island. Uninhabited islands and trackless promontories were the temperate equivalent of Sinai and the desert of Zin, where survival depended upon mutual help and a trust in God. Out here, isolated from the clamour of 'civilization', revelation blew in with the sea air and the voice of God rang more clearly.

Both Bardsey and Caldey have retained their sanctity. Reconnecting with the past is one of the constants in sacred sites, and these two islands, one off the north of Wales and the other off the south, repay the cost of a day trip by giving every visitor the chance to walk back in time. They are still remote. Bardsey, or Ynys Enlii, the Isle of the Currents, is separated from the mainland by a tide race that can churn through Bardsey Sound at 6 knots – enough to overcome a boat powered by oars or sails. Bardsey can also get cut off by the weather, and if you want to book the passage you'll have to adopt the patience of a pilgrim and be prepared for the answering machine message informing you that day trips are off until conditions improve. Persevere. Bardsey's inaccessibility gave it sacred status. A Welsh *clas*, a mother church, was founded there 1,500 years ago, and the Vatican's promise of special indulgences to all who braved Bardsey Sound turned this 2-mile scrap of island into one of the busiest pilgrimage sites in Britain, with a correspondingly magnificent oral history telling of 20,000 saints (probably pilgrims who went there to die) and Merlin, asleep in a glass castle. Down south, Caldey is about the same size, but easier to reach – by day trips from the resort of Tenby.

We know a lot more about the rituals and meanings of Christianity than we do about the kinds of ceremonies that might have occurred among the ancient rings of the outer isles. Paganism in Britain had had an unbroken history of at least 10,000 years by the time Roman traders began whispering in Britain's seaports about a secretive new 'Jesus' cult that required exclusive allegiance from its followers. The unwritten doctrines which caused oak stumps to be upturned

on the Norfolk coast and the widespread raising of circles and avenues in stone and timber faded from the inherited record. Christianity brought with it a building programme that swamped the ancient cults and left the archipelago richly scattered with religious houses. To this day, Britain has 47,000 churches. Many occupy sites whose meaning has evolved far beyond the needs of ritual worship; sites that can fill the most secular heart with unbounded joy.

These days, Anglesey is the last stop on the A5, but in the 12th century, Gerald of Wales knew it as *Mon mam Cymru*, Mona, the Mother of Wales. One of the most compelling moments during his circumnavigation of Wales in 1188 was the open-air sermon he attended at a natural amphitheatre formed by a rim of rocks beside the Menai Strait. Anglesey sat at the turning point on the coastal shipping route and, according to Gerald, was so fertile that it could feed the whole of Wales with corn when crops failed in other regions. One thousand years earlier, Tacitus knew Anglesey as an island of Druids; 'a source of strength to rebels … heavily populated and a sanctuary for fugitives'. The 'otherness' of the island endures to this day. Anglesey's seashore churches are coastal spectacles. Llandysilio, on its tiny island in the Menai Strait, is one of the best places to view the twin bridges over the strait: Robert Stephenson's Britannia Bridge and Thomas Telford's suspension bridge. Filming the first series of *Coast*, we were given permission to enter one of the gigantic stone towers supporting the Britannia Bridge. The exterior of the towers was built using hard carboniferous limestone and some of the stones are up to 20 feet long and weigh 14 tons. Inside, our torches picked out flying arches and soaring piers of red, Runcorn sandstone tapering into the gloom like the sooty pillars of a medieval cathedral.

There's another island church off the west coast of Anglesey. You have to walk at low tide along a causeway to reach Llangwyfan, which is marooned on a grass-topped disc of stone, surrounded at high water by lapping waves. More grandly, at the south-eastern tip of Anglesey, the church of St Seirol slumbers in splendid isolation near the tip of the peninsula marking the northern entrance to the Menai Strait. A monastery occupied this site in the seventh or eighth century and Penmon retains a powerful sense of seclusion. The stone well, the pilgrims' cell, the monastic range and dovecote, the little church with its Romanesque arches, take you tumbling back through time. Penmon quarries

were the source of the fossil-studded limestone used to build Stephenson's stone towers for his bridge over the Menai Strait. Half a mile down the lane, there's a lighthouse on the promontory tip, and just across a narrow strait, the islet of three names: Puffin Island, Priestholm or Ynys Seiriol. Gerald, who loved a good story, reported that the 'hermits' who lived off the island's meagre soils and shoreline avoided conflict through their belief that quarrelling would cause the island's population of small mice to consume their food and drink. On a warm day, it's a wonderful place to forget the clock. Ynys Seiriol, the island of saints, has been a seamark since at least the Bronze Age. Skin boats loaded with ingots of copper must have passed this way having taken their cargo at Great Orme – the prominent headland on the mainland that you can see on a fine day from the shores of Anglesey. Since then, hundreds of thousands of vessels have sailed past Ynys Seiriol into the gullet of Menai, the shortest route between Liverpool Bay and Cardigan Bay. To avoid the treacherous Lavan Sands, boats had to hug the Anglesey shore, and Ynys Seiriol was the signpost.

The monks and hermits who were drawn to these remote coastal outposts had a history of helping seafarers. In the 14th century, a hermit called John Puttock, who lived on the bishop's marsh outside Lynn, erected a tall cross to help mariners find their way through the channels of the Wash. The tower of a church glimpsed through the terrifying spume of a Force Eight is not merely a seamark, a last chance to snatch the bearing that might keep a vessel from striking the lurking reef or sandbank; it is a beacon of hope. Where inland churches have a human catchment roughly equivalent to their parish boundary, coastal churches have a 'sacred radius' limited only by the weather and by the curvature of the earth. In Kent the twin towers of Reculver church at the mouth of the Thames were a beacon for a landward congregation and for generations of mariners who sought their silhouette from pitching decks as they struggled to avoid Margate Sand.

There are many sacred radii, and the most far-reaching can be found on, or beside, notorious promontories. On the hill climbing to Filey Brigg on the coast of North Yorkshire, the Norman tower of St Oswald was a beacon for ships on the Tyne–Thames run, and for seafarers aiming for a beach-landing on the sands of Filey Bay. St Oswald's long view extended to one of its Victorian vicars, who

walked from Filey to Venice, and to Rome. And just south of Hartland Point, one of the most lethal capes on the North Devon coast, many a shipman has prayed for the tip of Hartland church, whose 130-foot tower of granite is the second tallest in the county. The church is dedicated to a man from over the sea, the Welsh missionary Nectan, murdered here in the sixth century. St Nectan's is also an interior masterpiece, with an exquisite rood screen that was carved a century before Drake, Raleigh and Hawkins sponsored a parliamentary bill to build a quay at the end of the road beyond the church. The quay became a minor port, shipping coal and granite and produce from North Devon's farms, but has long since been swept away. When I filmed there a few years ago, we had to play hide-and-seek with armadas of breakers that were exploding over the stub of the quay. The church is a haven of tranquillity; a shelter from the storm. It's a place of wonder, with a Norman font, Tudor benches, a Gothic tomb and a 15th-century screen carved with berries, grapes and flowers. There is a humbler Christian seamark on a Dorset cape known to centuries of sailors making the coastal passage between the ports of Poole and Weymouth. It sits atop the 300-foot cliffs of St Aldhelm's Head, just a stone's throw from one of the wartime radar sites that used to track incoming Dorniers. For those who live by the compass, the tiny, square chapel carries particular resonance, for each of its four corners are oriented on cardinal points. It's a ground plan aligned on the magnetic pole rather than the Land of the Holy, so – uniquely in England – it has no east wall. Every time I've been here, the warm thermals have been trembling with hysterical skylarks and I've wanted to bottle St Aldhelm's ecstatic airs.

St Aldhelm's is an extreme location that induces a form of vertigo, whether literal or cosmic. Knowing that old stones have witnessed a long history of worship and ritual underpins the sanctity of any religious site, but so does its physical aura. If you take a short detour from the Pembrokeshire Coast Path near St Govan's Head, you'll find a tiny chapel wedged in the cliff as if it's been lodged there by an early Christian tsunami. When the seas are high, the underworld rumbles with the reverberations of ocean rollers drumming on boulders. At the other end of the scale, there are seashore churches like St Just in Roseland, surrounded by its own casual arboretum coloured with bursts of camellia and magnolia, their butterfly petals tilting in sunlight above the blue

fjord of Falmouth's estuary. When the travel writer H.V. Morton puttered by in the 1920s aboard his Bullnose Morris, he felt that he'd 'blundered into a Garden of Eden that cannot be described in pen or paint'. St Govan's and St Just both make you gasp, one with surprise, and the other with pleasure.

Morton was on his way to Land's End. For all the circle-raising and church-building around our shores, the lure of the neo-pagan promontory and ness is as strong as ever. The latitudinal and longitudinal extremities of the archipel-ago have been pilgrimage sites for centuries, but Land's End is the most popu-lar. Today, over 400,000 people every year take the A30 to a themed terminus serviced by souvenir shops and an extrasensory cinema showing *The Curse of Skull Rock*. 'This is just my idea of the Styx!', exclaimed Morton when he parked his Bullnose at the most westerly point on mainland England. An opaque gale was careering in from the Atlantic and the headland was shivering with the double boom of the Longships' foghorn. Land's End is unique among promon-tories. When the seas settled after the Ice Age, the irregular outline of main-land Britain was characterized in the south-west by a 200-mile tapering peninsula that terminated at a storm-wracked cape facing the setting sun. That cape was the turning point for vessels coasting the southern shores of Britain, and it was known to the earliest sea traders from the continent as one of the seamarks pointing to the land of tin. Penwith, the final 'toe' of land beyond Penzance, was labelled 'Belerion' by Diodorus Siculus and 'Bolerium' by Ptolemy – both names likely to have been derived from the Celtic deity Belenos, the sun god whose curative powers were remembered by Mayday bonfires lit to bring on the warmth of summer. Belerion was the earliest place in Britain to appear in documentary record, and the earliest natural feature on the coast to become a tourist 'sight'; John Leland rode to Land's End in the 1530s or 1540s, describing it as 'a promontory almost entirely surrounded by the sea', with the ruins of what he took to be a castle, whose 'fine squared masonry' had become 'an impregnable refuge for foxes'. Later that century, Camden devoted hundreds of words to 'the utmost part of the Iland toward the West,' repeating the story in the *Anglo Saxon Chronicle* that the 'in-breaking of the sea' between Land's End and the Isles of Scilly had drowned a land known as Lyonesse. Richard Carew, writing in 1602, used Land's End to symbolize the end of the

literary journey he'd undertaken in his *Survey of Cornwall*. By the time Celia Fiennes set off on her 'Great Journey' of 1698, Land's End was an established waymark on the trail being blazed by Britain's proto-tourists; the ease with which she found the road to this seemingly remote spot, and the agreeable bottled beer she came across in Sennen (the last village you pass through before Land's End), suggest that many others had been there before her. Fiennes scrambled along the rocks as far as she dared, but her contemporary Daniel Defoe claims to have gone further by immersing his foot in the sea off Land's End. Defoe is the first to describe the ritual dipping of limbs at Britain's extremities, and although he wasn't always on the correct promontory he writes that he wetted his foot at the most westerly, southerly, easterly and northerly points of mainland Britain. Long before I read Defoe's *Tour*, I too 'dipped' whenever I visited Britain's extremities, and also when I started and finished the 'Three Peaks' by bicycle; it was – and still is – common practice.

John o' Groats was one of the extremities Defoe got wrong, mistakenly thinking that it is the most northerly point of Britain. Although it's twinned with Land's End, John o' Groats isn't an extremity of any kind, but draws its crowds because it's at the end of the A99. Two miles east of John o' Groats, Duncansby Head is the most north-easterly point of mainland Scotland, and the carpark there opens the door to a wonderful cliff walk to the famous Stacks of Duncansby. The most northerly point of mainland Scotland is Dunnet Head; it's disfigured by wartime ruins but the viewpoint by the Ordnance Survey triangulation pillar puts the Orkneys in the palm of your hand – on a clear day. Cape Wrath, the most north-westerly point of mainland Scotland is the trickiest British extremity to reach, with an aura unique to places beyond the reach of the common motor vehicle. The most westerly and easterly points in mainland Britain are known to 'side-to-siders' as a pair of aesthetic extremes: Ardnamurchan Point (or more exactly, the rocky outcrop of Corrachadh Mor) is a sublime spot at the end of a single-track road that opens to a view of the Western Isles; more prosaically, the Ness at Lowestoft is a paved walkway just off Gas Works Road. They'll tell you in Lowestoft that the Ness is famous for having the most easterly rubbish tip, gasometer and sewage works in Britain. Ignore them and enjoy the view. There's a piece of 'informational art' on Ness

Point. It's called 'Euroscope', and it shows the distance in miles to various parts of the British Isles and Europe. (Dunnet Head, should you be thinking of pedalling there, is 465 miles away – as the crow flies; the Lizard is 352 miles.)

Imagination has always been the means of parting the curtains on topography. The flowering of art, music and literature around our shores would not have happened if the coast hadn't been a reservation of the soul; a place where tranquillity and inspiration are brought in with the tide. That creativity, practised on the edge, was a form of endorsement and it's given certain places an additional aura. At Dungeness and Laugharne, the quaint shoreline cabins of Derek Jarman and Dylan Thomas are in locations as filmic and poetic as their creative tenants. These places achieve a modern sanctity that sets them apart from their workaday, inland neighbours. 'Snape is just heaven', wrote the composer Benjamin Britten to a friend after he moved into an old mill on the salt marshes of Suffolk, without realizing that his dream of creating a coastal concert hall would turn the fading fishing village of Aldeburgh into an international shrine for music pilgrims. When Antony Gormley populated the sandy beach at Crosby with 100 life-size, cast-iron figures gazing out at the ocean, he created a 2-mile sanctuary between the tidelines, within which normal beach activity was suspended. With Liverpool just around the corner, 'Another Place' was a reference to emigration and 'the human need', as Gormley puts it, 'to imagine another life in another place and the founding of a better life on better principles'. But as he also says, 'in today's scientific, rational and globalized world we know there is no better place.' Crosby's our reminder that we have one planet, one ocean; one archipelago.

Art has always been adept at conferring sanctity; of contributing to the *meaning* of a place. The coastal 'schools' of art that have flourished at various times have bestowed a cultural branding on their host communities. St Ives, Walberswick and Staithes have been protected by the generations of artists who have painted and sculpted along their shores. Walberswick on the Suffolk coast has been revered by artists since the 1880s when the likes of Keene and Steer arrived with their easels. Staithes is protected from ruination by the colony of Impressionists who gathered there in the 19th century. In the case of St Ives, the painters who followed Turner to its luminous double aspect shore led to the

construction of the Tate St Ives on its western beach. St Ives has been blessed by the patrons of light and colour. Now Margate, too, has a spectacular seafront gallery in the new 'Turner Contemporary', a building that celebrates the artist's fascination with light. Margate has enjoyed many ages; as a port, a ferry terminal, a smugglers' haven and as a seaside resort. And like all towns, it has suffered its share of troughs. Art will revitalise this pioneering Kentish community and give its historic waterfront a bold new role as a magnet for contemplation.

Writers have had the same effect. The Cobb at Lyme Regis was metaphorically strengthened once John Fowles used it in the opening scene of *The French Lieutenant's Woman*. The ghost of John Fowles has become another reason for keeping the historic pier in good repair. A book, a lyric, a painting can invest a place with an aura that acts like a form of designation; a Site of Conferred Beatitude perhaps. Brighton was never quite the same for me after Graham Green and *Quadrophenia*. I can't walk over Waterloo Bridge in the sunset without thinking of the Kinks. And the Tyne became more than a port once Lindisfarne put out their second album. Dr Feelgood rewrote the history of Canvey Island and Fingal's Cave on Staffa is protected by musicologists and vulcanologists alike. These coasts have their own, mute guardians. Who would dare spoil Wordsworth's Duddon Estuary? Or mess with Yeats' Rosses Point?

When he was alive, John Fowles was asked by Greenpeace to contribute a short piece for a book called *Coastline: Britain's Threatened Heritage*. He wrote unhappily of basking sharks and dolphins that no longer rode the swell of Lyme Bay, and of the raven's croak that he hadn't heard for a decade. And he finished by turning on 'man's true profession', an ancient one on those West Country shores: 'He is a wrecker,' wrote Fowles, 'and what he wrecks now is not just ships. It is all that he once most treasured in the world.'

The wrecking goes a lot further than decimated fish stocks, marine pollution and inappropriate coastal development. The scientific consensus (and science is all about probabilities rather than certainties) is that the planet is warming, or in the words of the Intergovernmental Panel on Climate Change, 'more than 89% of >29,000 sets of observational data from 75 studies are consistent with a warming trend'. A warming planet affects sea levels and ecosystems. And it affects us.

Between 1961 and 2003, mean global sea-level rise was around 1.8 millimetres per year, but for the last ten years of that period the mean jumped to 3.1 millimetres per year. Adjusted for land movement, the relative sea-level rise for England in the 20th century was about 1 millimetre a year. However, there are several factors that may increase the possibility of coastal erosion and flooding. Sea temperatures have warmed by 0.7 degrees Celsius over the last three decades, which will increase the rate of sea-level rise through thermal expansion. In the longer term, the melting of polar ice caps and glaciers will also raise sea levels. Currently, the UK Climate Impacts Programme (UKCIP) is predicting that, under a medium-emission scenario, sea levels at London will rise by 21–68 centimetres by 2095. At 7–54cm, the figures for Edinburgh are less because of the difference in vertical land movement. Under their extreme-case scenario, sea levels would rise by 2 metres by the end of the century. Since 1999, there's also been an increased frequency of severe storms compared to the period 1930–99 – though they are still less common than in the 1920s. Severe storms increase the effect of surges and catastrophic floods; during the storm surge of 1953, the sea level rose by 2–2.5 metres all the way from the Humber to the Thames.

Over half a million people are directly employed in maritime activities such as shipping, tourism and fisheries, and 95 per cent of our international trade passes through seaports. The total turnover of the marine sector is around £70 billion. Along the UK coast alone, more than £150 billion of assets are estimated to be at risk from flooding by the sea, with over £75 billion at risk in London.

Sea-level rise is just one result of global warming. On our own, temperate islands, we will be less affected than many other parts of the world, at least initially. UKCIP suggests that, in the south-east of England, under a medium-emissions scenario, the central estimate of increase in summer mean temperature is 1.6 degrees Celsius by the 2020s. By the 2050s, the figure is 2.7 degrees and by the 2080s, 3.9 degrees. These are 'central estimates' so the actual figures might be lower or higher. The effects of a warming planet on the marine and terrestrial ecosystems to which we belong will depend upon the degree of warming.

*

We'd arranged to meet Mary Hughes at high tide by the concrete jetty on the road beyond Carraigahowley Castle. The headlights of the crew van swept alternately across rock and water. The crew had been filming inside the castle the day before, and as we passed the sea creek where its tower cut a dark rectangle in the blue night, they told me about Grace O'Malley, the pirate queen of Carraigahowley, whose war galleys ranged the west coast of 16th-century Ireland. At the quay, Mary helped us hump the kit onto *Shamrock I*, and then she took her fishing boat out through the maze of channels separating the sleeping islands of Clew Bay. As the night sky began to brighten above Mayo's distant uplands, we landed on one of the islands and Mary talked about her childhood as an islander, growing up without electricity, taking a boat to school and once a year making the annual pilgrimage to the 765-metre summit of Croagh Patrick, Ireland's 'Holy Mountain', which rises from the bay's southern shore. 'It was heaven on earth living on the island,' Mary told me, 'it was very peaceful … great tranquillity.' Others came later to Clew Bay, seeking peace, among them John Lennon. That afternoon, geologist Dr Paul Dunlop from the University of Ulster explained to me how the wave motion of a gigantic ice sheet had left smoothed heaps of gravel and rock that had become surrounded by water when sea levels rose, to create 300 small, domed islands. We filmed until dusk and the next morning, after the crew had headed off to another location, I climbed Croagh Patrick in pouring rain. On the stony crest, I huddled in the lee of the chapel hoping for a gap in the buffeting cloud, wondering what kind of weather St Patrick had when he fasted on the summit for 40 days and nights. A bunch of fifth-years from a Jesuit school in Galway emerged from the gale and flopped down on the concrete steps of the chapel. Their teacher explained that they were raising money to send the sixth-years to Africa, where they'd work on aid projects. Most of the teenagers had climbed 'the Reek' several times already, and they told me how amazing the view would have been in better conditions. It was on the way back down, where the trail turned over the ridge and dropped through the floor of the cloud, that I had had my 'Clew Bay moment'. Thackeray, coming from the other direction in 1845, described his first sight of Clew Bay as 'the most beautiful view [he] ever saw in the world'. Up there, at 1,500 feet on Croagh Patrick,

I felt as if I was gazing down on an imaginary land where coast and islands, peaks, farms and cosy seaport had been arranged just to please the eye. But it was the glaciers, the pirates and diligent islanders that gave it the narrative. It was a very complete moment.

Clew Bay is an SAC; not an abbreviation of 'sacred', but the acronym for Special Area of Conservation, the designation which identifies and protects Ireland's prime wildlife conservation areas. In Clew Bay, that means an extraordinary diversity of living things which include the polychaete worm, Euclymene (it likes Clew's muddy sands), sponges, sea squirts and a wide variety of wintering waterfowl, from the great northern diver and curlew to the bar-tailed godwit and common tern. SACs developed out of the EU Habitats Directive, itself the cornerstone of European nature conservation policy. They're sites 'of European importance'. Clew Bay qualifies because it's a large, shallow bay on an Atlantic coast, with uncommon characteristics like salt meadows, perennial vegetation on stony banks and shifting dunes. Environmentally, it's hallowed ground.

The creation of secular sanctuaries can be traced back to the industrial and agrarian cataclysms of the 19th century. William Cobbett's anger at the seaside resort of Margate, frothing ridiculously at the expense of Thanet's celebrated cornfields, was an early reaction to countless encroachments on the countryside; an onslaught perpetrated, as Cobbett saw it, by the 'jolterheads' of the 'Great Wen' who were intent on destroying the shires through parliamentary enclosures and the industrial machine. Cobbett was not alone. As ancient woods and dales were felled and levelled, and birds and beasts banished, the coast became the beneficiary of a new environmental awareness, which was less of a 'movement' than a series of disparate interest groups that sprang into existence in different places over many decades – although in some cases the main movers were the same people. This was never a singular movement, but a motley battle group driven by charismatic individuals, local societies and national organizations with Establishment patronage. Some were motivated by nostalgia for the pre-industrial age, others by a concern to balance economic growth with the countryside ideal; some wanted to save historic buildings, or animals, or birds; others wanted to promote healthy outdoor activities.

It began with natural history, that branch of observation and record that sent the quill of Gerald of Wales racing over the parchment in 1188 as he described the life cycle of beavers and the means by which salmon leap up waterfalls. You can spot natural history in the pages of William Camden during the 16th century, and in Carew's 17th-century *Survey of Cornwall,* where he describes his county's fabulous biodiversity, from otters and oysters to sea trout and hawks. Carew was an attentive beachcomber, and seems to have come across 'sea beans', the fruits from tropical vines and trees that are still carried across the Atlantic on ocean currents; he describes them as 'certain nuts, somewhat resembling a sheep's kidney, save that they are flatter; the outside consisteth of a hard dark coloured rind, the inner part of a kernel void of any taste, but not so of virtue, especially for women travailling in child-birth.' Later that century came the publication of Francis Willoughby's pioneering ornithological work of 1676, the first great 'bird book', and the inspiration for Thomas Pennant to pursue field expeditions to Wales and Scotland during the 1770s. It was the letters Pennant received from his friend Gilbert White that helped to turn *The Natural History of Selborne* into the fourth-most published book in the English language. As the Industrial Revolution began smearing the landscape with soot, White's epistles from the deep nature of Hampshire woke a generation to a disappearing world. William Gilpin, a contemporary of White and Pennant, taught that same generation how to appreciate a landscape; how to look at it as if it were a picture (he called it ' picturesque beauty'). I worked on a film about Gilpin once (and Pennant too), and it affected the way I viewed the coast. Picturesque beauty at its most pure is relatively rare; all it takes is a crisp bag or a car, and it's gone. Gilpin didn't take much to modern humans: 'His spade and his plough, his hedge and his furrow, make shocking encroachments on the simplicity and elegance of landscape.' Fortunately, he never saw Brighton Marina. Painters and poets were part of this movement, Wordsworth writing of Nature's 'violated rights' and anticipating the creation of national parks when he described his beloved Lake District as 'a sort of national property, in which every man has a right and interest who has an eye to perceive and a heart to enjoy'. It was a prescient consideration of shared beauty, written a decade or so before railways began to make that beauty accessible to the urban masses.

Public sensitivity to desecration grew in fits and starts. Since the early 19th century, towns and villages in counties like Lancashire and Yorkshire had been forming their own local botanical societies and field clubs to promote the study and enjoyment of natural history and archaeology. Back in the Middle Ages, nature had revealed to Gerald of Wales the wonders of Creation; to Victorian naturalists too, the study of nature was a form of devotion to 'Nature's God'. Darwin's theory of evolution only added to the momentum, convincing many that Man was just one among many species, and that the living world existed in a state of delicate equilibrium that was highly sensitive to human meddling.

At the same time, the joys of country walking, promoted by all good Romantics since the late 18th century, began to attract a broader slice of society. Attitudes to work and leisure were shifting, with the breakthrough occurring in the 1870s when half-day working on Saturdays, and bank holidays, were formalized. Workers who'd had to walk for miles just to see a patch of countryside, suddenly had more leisure time. It was the railway, the iron rails of the Industrial Revolution, that converted the countryside from an amenity reserved for the affluent into the people's playground. In the vanguard were ramblers, often travelling as clubs, who also lobbied for better access to the countryside.

The creation of protected 'reserves' grew from a concern to preserve uncultivated countryside from development so that the rapidly expanding populations of industrial towns and cities could enjoy green space. Perceptions had to change if open, undeveloped land – categorized as 'waste' by the law of commons – was to be saved from the developer. In 1865, at legal chambers off Fleet Street, a small group convened. They included the gifted Liberal lawyer George John Shaw-Lefevre, the philosopher, civil servant and champion of womens' rights John Stuart Mill, solicitor Sir Robert Hunter and the pioneering social reformer Octavia Hill, who had recently leased three slum properties in Marylebone, with money provided by John Ruskin. The meeting led to the creation of the country's first national conservation body, 'The Commons, Open Spaces and Footpaths Preservation Society', which sought to protect commons from urban development, agricultural enclosure and hunting reserves. Several years later, it was to the society's honorary solicitor, Sir Robert Hunter, that Octavia Hill turned when she was seeking help to set

up 'The National Trust for Places of Historic Interest and Natural Beauty' – a new body intended to 'promote the preservation of places that are of value to the nation'.

The first meeting of the National Trust, on Thursday 16 November 1893, was enthusiastically reported by *The Times*. Here, stated the paper, was a 'highly commendable' scheme that would provide those who cared about beauty with the means of withholding countryside from developers. 'As things are at present,' continued the paper, 'we often hear a chorus of complaints and protestations because some favourite spot is about to be made hideous in obedience to the commercial instinct … A trust of this kind now projected would do something to redress this inequality.' At a meeting in Grosvenor House the following July, Canon Rawnsley was cheered by the assembled dukes, earls, lords and worthy academics when he compared the trust to 'a great National Gallery of natural pictures'.

The National Trust opened its campaign by taking a stand against the greatest threat to the purity of the coast. The first property they acquired was a 4-acre site on the hillslope above the growing resort of Barmouth – a beauty spot that Wordsworth had commended for having both mountain and sea views. 'Barmouth,' he'd announced, 'can always hold its own against any rival.' The Trust's historic viewpoint was known locally as Dinas Oleu, the 'fortress of light', and it had been donated by one of Octavia Hill's friends, Mrs Fanny Talbot – an admirer of John Ruskin and not, it appears, a fan of resort vernacular: 'I have no objection to grassy paths or stone seats in proper places,' wrote Mrs Talbot, 'but I wish to avoid the abomination of asphalt paths and the cast-iron seats of serpent design.' If you ever get the chance, do climb the hill and decide for yourself whether Dinas Oleu would have been more enjoyable if it had been engineered by developers into a suburban park.

The well-mannered environmentalism of Mrs Fanny Talbot set the tone of the age. The leading figures of the emerging countryside movement were not the kinds of individual who'd tuck up their petticoats and barricade themselves in homemade tunnels to prevent wanton resort expansion. The nerve centres were the clubs and chambers of the capital, and the drawing rooms of country houses. Saving scraps of land from developers didn't merit a missed meal, let

alone arrest. Nevertheless, these well-connected, well-to-dos were the only people who were prepared to counter the destruction of the natural world.

Had the havoc being caused to fish stocks by steam drifters been more apparent, marine conservation would have been at the top of the philanthropic hit list. But the sea hides its woes far too well, and it was the much more evident annihilation of birdlife that filled the letters pages of *The Times*. From coast to coast, birds were falling out of the sky, reaching a bloody low-point in the 1860s. A correspondent from Lincoln's Inn claimed to have seen in the course of a single journey '13 separate shooting parties along one side of the Great Eastern Railway, between Stratford and Tottenham stations alone'. Shooting matches were being staged (innkeepers stood accused, and London's bat-fowlers) at which punters bet on the number of birds that could be blasted from the sky when they were released from traps. The paper printed an anonymous, eye-witness account of 'bird murder' in Eastbourne, where '12 dozen sparrows and three dozen linnets' were released in front of the guns. On the estuarine waters of east Norfolk, fowlers in flat-bottomed punts specialized in downing migratory birds, prompting an ornithologist to conclude that 'more rare birds have been killed on Breydon than in any other part of the United Kingdom'. At other spots on the Norfolk coast, gamekeepers were shooting peregrine falcons: in February 1862, 'a fine old female' was shot near Cromer and in April an adult male at Weybourne. In January 1863, a 12-pound female was shot at Horsey while it was carrying off a waterhen. Birds had been airborne vermin too long for their own good; earlier in the century, it was common practice for parish wardens to pay fixed rates for killing birds: sparrows at 2 pence a dozen, crows at 1 penny each, magpies at a halfpenny.

The coast, yet again, seems to have been a magnet for fringe pursuits. Fish stocks were already in trouble, though invisibly. But bird hunting was staining the cliffs. Fishermen at places like Flamborough Head and the Isle of Wight earned good money from shooters who took to the water armed with shotguns and rifles. But not everyone saw it as a sustainable 'sport'. A zoologist writing from Magdalen College, Cambridge complained in *The Times* of 'barbarous and disgusting slaughter … a war of extermination on sea-fowl'. On the 18 miles of coast between Bridlington and Scarborough around 120,000 birds were being killed every year, most of them shot. On one April day in 1865, a

single party of five shooters downed 600 guillemot and razorbills; one shooter claiming he'd bagged 4,000 gulls in a single season. The shooting occurred during the breeding season, and any species would do: seamews, willocks, gulls, auks, oyster catchers.

But the birds of Flamborough had a local champion in the Reverend Francis Orpen Morris, who publicized the carnage through the letters pages of *The Times* and *Selborne Magazine*, then helped to found, in Bridlington in 1867, Britain's first bird protection society: The Association for the Protection of Sea-Birds. Morris had plenty of supporters. A correspondent from Westminster who'd 'been in many parts of the world,' wrote to say that he'd 'met with none who are so given to the wanton destruction of harmless life as your thoughtless Englishman'. 'The culprits ranged from gamekeepers to gun-toting excursionists (gull-blasting at Flamborough Head was blamed by Morris on 'cockney shooters', and by others on day trippers from the Sheffield region) to London's plumage market – which according to one source in *The Times* was receiving 'a thousand wings or more per month' from men who climbed the cliffs of Filey and Flamborough. The solution – according to Mr A. Clayfield Ireland of Grislington – was for 'the ladies in the first place to alter their taste in dress'. He was referring to the fashion for plumage, none of which was being provided with the consent of Britain's wild birds. Or their foreign cousins; in a five-month period between 1884 and 1885, the London market sold the plumage of nearly 775,000 birds from Brazil, the Indies and other overseas sources. Among the Victorian women who sided with the seabirds was Lady Mount-Temple, who founded the Plumage League with the Reverend Morris.

The motivation for setting up all these societies was explained by George Musgrave, the founder of the Selborne Society. Writing in the *Irish Naturalists Journal* in 1893, he condemned the destruction of nature by the world's most 'advanced' society as 'a rather bitter satire on our civilization … With the facilities now afforded for locomotion, thousands of excursionists, in the place of half a dozen quiet visitors, are hurled periodically upon a limited tract of country remarkable for its beauty or associations, and instead of doing their utmost, as intelligent beings, to preserve the objects, such as trees, flowers, ferns, birds, or architectural remains, enhancing the beauty, or giving additional interest to

the spot, they destroy them.' The evil, he concluded, 'is a novel one, hence the necessity for seeking to overcome it by a novel method.' It would be easy to dismiss the multifarious societies as Victorian frivolities. Acts of Parliament were passed to protect wild birds, but London ladies continued to adorn themselves with exotic plumes – which provoked in 1889 the foundation of yet another society: The Society for the Protection of Birds.

Environmental protection required 'no take zones': sanctuaries where wildlife could exist without being subject to periodic slaughter. In its own way, Dinas Oleu was a no-take zone, in that its ownership by the National Trust prevented it being taken by developers. The future of coastal environmentalism in Britain was dependent on expanding the Dinas Oleu model; on rolling out no-take zones around the entire coast.

By the early 20th century, resorts had been booming for more than a hundred years and the coast had become a major development zone: by 1911, eight UK resorts had populations over 50,000, another 39 numbered over 10,000 and virtually every beachside community with transport links had seen growth of some sort. It was clear to anyone poring over a map that there were relatively few extensive tracts of untouched coastline remaining. Cornwall and Cumbria were still free, and north Devon, west Wales, and the east coast of England north of Whitley Bay. The flats of the Wash and north Norfolk had passed unnoticed. In those hectic decades as the car became king of the road, nobody could be sure when, or if, the development would ever stop. There were some, like H.G. Wells, who were bemused (he described the colony of bungalows that had erupted on Shoreham's seafront as 'a queer village of careless sensuality'), and there were those who regarded Shoreham's 'Bungalow Town' as an abhorrence that had to be stopped. It wasn't until 1912 that the National Trust acquired its second coastal property, the sand and shingle spit of Blakeney Point on the coast of Norfolk. And it wasn't until 1930 that the Royal Society for the Protection of Birds purchased its first reserve, an 18-acre meadow on Romney Marsh. By then, the countryside and the coast were facing unprecedented pressures: through the 1920s and 1930s, an average of 300,000 houses were being built every year, consuming 60,000 acres of rural land annually. Cars were breeding like rabbits, filling the countryside with petrol stations and pollution.

As the suburbs, cars and factory smoke spread, a far-sighted town-planner, Sir Patrick Abercrombie, called for the countryside to be protected by a national joint committee. The result was the creation in 1926 of The Council for the Preservation of Rural England. Two years later, one of CPRE's founders, Clough Williams-Ellis, went to press with his anti-sprawl polemic *England and the Octopus*, in which he pointed the finger at south coast resorts: 'Having already had the larger part of the South Downs filched from us, together with the margins of the New Forest and most of the accessible seaboard ... our proposed door-locking comes none to soon.' Balance sheets, Williams-Ellis pointed out, take no account of the 'sacredness of natural beauty'.

The CPRE's immediate targets were ribbon development and badly designed buildings, and then in 1929, they turned to the coast. On behalf of the CPRE, Abercrombie and Dr Vaughan Cornish, a geographer who had made a particular study of waves, sand dunes and sea beaches, submitted evidence to the Government Committee on National Parks, stressing 'the immediate and urgent need for preserving in perpetuity the natural character of some portions of the coast.' Cornish went on to argue that the peculiar pressures then being exerted on the coast by housing development and 'the private motor' meant that the priority should be for coastal national parks. Cornish suggested that the two to be considered first should be Cornwall and Pembroke. It took another 20 years for national parks to appear. Pembrokeshire was the fifth, in 1952, and to this day it is the only truly coastal park in Britain.

The CPRE went on to become the most effective protector of the countryside, helping to establish Areas of Outstanding Natural Beauty and green belts, and campaigning on a vast range of issues from hedgerow destruction to light pollution. Its success in changing the planning laws of Britain has been described by historian Tristram Hunt as 'an incredible legislative monument'. Imagine an England without planning permission, national parks and green belts; the 'planless sprawl' that Clough Williams-Ellis had railed against in 1928 would have spread its tentacles from Brighton to the Solway.

One of the CPRE's recent initiatives was an exercise in mapping tranquillity. I know, it sounds odd. I mean, how do you map peace and calm? It's a sensation, rather than a place, yes? The CPRE divided England into 500 metre squares, and

gave each square a score based on 44 positive and negative 'tranquillity factors' such as the presence of light pollution, airports, towns, woodland, the sea and birds. The result is fascinating. The longest continuous zones of coastal tranquillity in England are in Northumberland, Humberside, the Wash and north Norfolk, north Cornwall and north Devon. It's astonishing how few places remain on the English coast for a hermit in search of a sanctuary.

A century of campaigning by multifarious societies, groups and individuals has led to a pattern of designated protectorates around the coasts of Britain and Ireland. But prepare yourself for a complicated jigsaw …. The British coast is touched at various points by six national parks and 16 Areas of Outstanding Natural Beauty. The National Trust for Scotland now cares for more than 250 miles of coastline. It may not sound much, but almost one-quarter of Scotland's seabirds breed on NTS properties. Down south, 710 miles of English, Welsh and Northern Irish coasts are cared for by the National Trust; that's nearly 10 per cent of the entire coast. Programmes like the Trust's Neptune Coastline Campaign have drawn public attention to the coast as a unique element of the landscape, and led to the protection of more coastline: the first Neptune purchase, in 1965, was Whiteford Burrows on the Gower Peninsula, followed a year later by Worms Head and Rhossili Beach. The handful of Victorian philanthropists who launched the National Trust back in the 1890s has swollen to a membership of 3.5 million. The RSPB now has over 200 reserves, 62 of which are coastal and a membership of one million members (yes, that's really one million; more than twice the combined membership of the UK's three main political parties). Some 33 per cent (657 miles) of the English shoreline is defined as 'Heritage Coast', or 'coastline of greatest scenic quality', a designation that overlaps with AONBs and national parks, and also with National Trust land (the Trust reckons that 40 per cent of Heritage Coasts are in their ownership or under their protection).

UNESCO, the world body charged with promoting international collaboration through education, science and culture, has also taken a stake in our coasts. They have three types of designated area. The box-office designation is the World Heritage Site: a world-class site of cultural or natural importance. There are about 900 of these in all, and Italy has the most, in case you were

wondering. The list includes the Potala Palace and Jokhang Temple in Tibet, the Great Barrier Reef, the pyramids of Egypt and the Serengeti in East Africa. Our own coastal designations include the sacred isles of the far north – Neolithic Orkney – the Dorset and Devon Jurassic Coast, the Causeway Coast of Northern Ireland and the island of Skellig Michael, off the coast of Kerry. Liverpool qualifies too, as 'the supreme example of a commercial port at a time of Britain's greatest global influence'.

The second UNESCO designation is the Biosphere Reserve, which is rather like a huge, living laboratory where the biodiversity and sustainable use of ecosystems can be observed and tested. Coastal examples in this category are the sand-dune system at Braunton Burrows on the coast of North Devon, the salt marshes and tidal creeks of the north Norfolk coast and the exquisite Dyfi valley and estuary in Wales. Scotland has another three coastal Biosphere Reserves, at Cairnsmore of Fleet, Taynish and Loch Druidbeg.

The third UNESCO designation, the Geopark, is intended to protect 'geological heritage', promote geology to the public and use geology and other aspects of the natural and cultural heritage to promote sustainable economic development, normally through tourism. There's just the one coastal Geopark in England: the English Riviera (in south Devon). Ireland has the Copper Coast Geopark in Waterford, Wales has one for Anglesey and Scotland has three: Shetland, the North West Highlands and Lochaber.

And the designations go on: there are 224 National Nature Reserves in England, 51 in Scotland (Staffa's there, and St Kilda, Rum and Rona) and 69 in Wales (including the Harlech salt marshes) – though the UK has just three Marine Nature Reserves: Lundy Island, Skomer Island and Strangford Lough. England has 1,400 Local Nature Reserves. And then there are Marine Protected Areas, Sites of Special Scientific Interest and Ramsar Sites – wetlands of international importance that arose from an agreement signed in 1971, at Ramsar in Iran. Many of the wetlands that have been described earlier in the book, such as the Wash, the Thames Estuary, the Thanet coast, the Solent, Poole harbour and so on, are Ramsar sites.

I'm not going to go on producing more pieces of the designation jigsaw because I've gone far enough to illustrate the mind-scrambling complexity of

the overlapping protectorates. The designations range from the international to the local, and they are administered by a bewildering variety of bodies, from UNESCO to government agencies, to local councils and charities. Each is backed by a specialist constituency. Geologists, ornithologists, zoologists, lovers of historic houses, ramblers, all 'belong' (whether they've paid a sub or not) to umbrella bodies that have ring-fenced parcels of coastline for protection. There is no overall method, no super-brain, behind all the designations, which is why they have worked so successfully. Any developer mounting an assault on the coast of Norfolk or Devon or Skye has to face interlocking barricades of defence. The Canadian geographer Michael Bunce, analysing the protective structures of Britain and America in his book *The Countryside Ideal*, concluded that the British countryside movement was (and still is) 'unrivalled' in the world: 'In no other country,' he writes, 'is there such an institutionalized and persistent campaign for the protection of the countryside.' You only have to look at the coastlines of Ireland or Greece to see how eagerly developers attack ill-defended beauty.

The nature reserve and National Park have joined the stone circle and churchyard as redoubts of tranquillity; refuges for the wildlife and humans jostling this crowded archipelago. This modern spectrum of sacred, 'untouchable' landscapes exists because generations of volunteers, benefactors, NGOs, charities, local and central governments believed they were worth preserving for the future. Their efforts have prevented concrete, brick and tar obliterating swathes of our shoreline. However, the coast is a place of two parts; virtually all the protection has occurred to the landward, visible side of the tide-line, where the effects of human exploitation are most evident. To seaward, it's been a very different story.

Marine ecosystems are largely invisible, and the havoc wreaked over the last couple of centuries has been appalling. But there are signs of change. The Marine and Coastal Access Act of 2009 seeks – at last – to protect our marine habitats. Stand on any beach or clifftop, turn to the sea's horizon, and you will be gazing across the most important – and least visible – habitat on earth. Half of the UK's biodiversity currently lives in our coastal waters, but rising sea temperatures, acidification, bottom trawling, overfishing, sewage,

garbage and a host of ugly threats are exacting a fearful toll. In UK waters, 22 species of wildlife are facing the threat of global extinction. The Marine Conservation Society regards the new Act as 'a milestone' which it hopes will lead to the creation of 73 marine conservation zones intended to protect a range of species from cold-water corals to sea horses and basking sharks. The new Marine Management Organization, set up to implement the Marine and Coastal Access Act 2009, now becomes one of the most important bodies in the UK, charged with critical responsibilities ranging from the management of UK fish stocks to the creation of the new marine conservation zones and the implementation of a new marine planning system intended to balance the social, economic and environmental imperatives of the sea.

While I was writing this book, I took a few days off on Lundy Island, the 3-mile reef of volcanic rock at the mouth of the Bristol Channel. Lundy has become a model sanctuary. It's been owned by the National Trust since 1969, but is managed by the Landmark Trust, a charity that rents the island's holiday cottages and camping ground to visitors. It's car-free and care-free. And it is the UK's first Marine Conservation Zone.

Like so many islands, Lundy has a history of being different. One of the island's earlier owners, William de Marisco, had his bowels burned by Henry III for using the island as a redoubt for 'the King's enemies'. At the death of Elizabeth I, a Robert Bassett plotted to use Lundy as a Catholic power base for a lunge at the English crown, and when William Hudson Heaven bought it in 1834, he declared it a 'free island'; predictably, Lundy was known for a while as 'the Kingdom of Heaven'. Islands release the monarch in every man. Martin Coles Harman's ownership from the 1920s saw the introduction of Lundy's own stamps and coinage, the Half Puffin and One Puffin. To this day, Lundy issues its own stamps and looks (and sounds and feels) utterly unlike the mainland. The island's only pub is the Marisco Tavern, named after its disembowelled martyr.

The island is laced with footpaths, and it's easy to take a wrong turn. This, I discovered, is the point. 'There's no signage at all,' Nicola Saunders told me one evening in the tavern. Saunders is one of two wildlife wardens on the island: 'Lundy is all about self-exploration. Signs take away the aesthetics of the place.'

Visitors are asked to collect a free map from the shop. Compasses can be rented by the day. The wildlife on Lundy is diverse. The sika deer were one of Harman's brainwaves. He also imported Soay sheep, and 42 New Forest ponies that he crossed with horses to produce the stubby Lundy ponies grazing the plateau today. The swans and wallabies didn't do so well. Neither did the nine-hole golf course. Nowadays, Lundy is an eco-testbed. Its waters are the first to be protected in the UK and the no-take zone staked out in 2003 has produced a sevenfold increase in 'landable' lobsters. 'A lot of people are looking to Lundy,' Saunders told me.

It takes a while to adjust to Lundy. For a tiny island, it's deceptively spacious. There are no TVs in the cottages, and I had no mobile signal. Everything moves at a cognitive pace. There's time to look and chat. History becomes audible. Every hundred metres there seems to be another reason to stop or detour. One evening, walking back to our cottage from the Marisco Tavern without torches, one of the children yelped in the dark. Way off to the right was the black rectangle of William de Marisco's 13th-century castle, and in the other direction a solitary dot of light at the tavern. But above us, Heaven's heavens were absolutely stuffed with stars. In the south of England, I've never seen so many at once.

And that is Lundy's message to the rest of our wonderful archipelago. That the brilliance and diversity of the natural world will flourish again if we care how we consume it. These islands are our 'sacred places', our habitat. They're the only islands we have and we're obliged to conserve them for future generations. And the frontline of island conservation is the coast.

Further Reading

This book was inspired by a lifetime spent travelling our coast, yet most of it was written in a small, Web-connected room packed to the ceiling with several thousand books, booklets, maps, leaflets, notebooks, photographs and discs. While writing, I kept a record of the sources I was using, but I didn't want to congest the stories with footnotes. For those of you who'd like to read further, here are a few of the major works.

There are many books about British and Irish geology, but the most readable is Richard Fortey's *The Hidden Landscape: A Journey into the Geological Past*. The processes of erosion and deposition that created the magnificent landforms of the coast are explained in Eric Bird's *Coastal Geomorphology: An Introduction*. Several historians and archaeologists have written superb books on the early human colonization of Ireland and Britain. Among the best are *Maritime Ireland: An Archaeology of Coastal Communities*, by Aidan O'Sullivan and Colin Breen, together with all the books by Steven Mithen and Francis Pryor. Chris Stringer's *Homo Britannicus* and *The Tribes of Britain* by David Miles are also invaluable. To learn more about the landscapes beneath the North Sea, read *Europe's Lost World: The Rediscovery of Doggerland*, by Vince Gaffney, Simon Fitch and David Smith. Barry Cunliffe's book *The Extraordinary Voyage of Pytheas the Greek* describes the first recorded circumnavigation of Britain, with plentiful insights into early trade. The eight-part series *England's Landscape*, published by English Heritage, is an outstanding addition to any library and includes many references to the development of coasts for trade, defence and leisure.

The plight of the seas is extremely well covered in a number of recent, outstanding books. I recommend *The Unnatural History of the Sea* by Callum

Roberts, *The End of the Line* by Charles Clover, *Sea Change by* Richard Girling, *Our Threatened Oceans* by Stefan Rahmstorf and Katherine Richards, and *The Last of the Hunter Gatherers* by Michael Wigan. The best general work on the history of sea fishing is *England's Sea Fisheries*, edited by David J. Starkey, Chris Reid and Neil Ashcroft.

The evolution of ports, trade and navies is covered by Ian Friel in an excellent book published by the British Museum: *Maritime History of Britain and Ireland, c.400–2001*. And although it describes only three tiny ports in Norfolk, the forensic investigation by Jonathan Hooton in *The Glaven Ports* exposes the challenges facing trading havens before the age of dredging. Norman Longmate's bracing volumes *Defending the Island* and *Island Fortress* span 2,000 years of coastal defence. Again, I'd like to recommend a slimmer, local work for its wider interest; Richard Scarth's *Echoes from the Sky* tells the story of the sound mirrors that preceded radar.

The criminal fringe, wreckers and smugglers, are colourfully recalled by Bella Bathurst in her book *The Wreckers* and by Richard Platt in *Smuggling in the British Isles*. From where I'm sitting now I can see at least a dozen more books on smuggling that have been published over the last century. They're all fascinating. The definitive history of smuggling is still *Contraband Cargoes: Seven Centuries of Smuggling*, written by Neville Williams.

One of the many out-of-print treasures I came across while researching this book is *Seamarks, Their History and Development*, by John Naish, which explores the history of land-based navigational aids. There are many books on lighthouses, but the most browsable is *The Lighthouses of Trinity House*, by Richard Woodman and Jane Wilson. The best history of the RNLI is *Riders of the Storm: The Story of the Royal National Lifeboat Institution*, by Ian Cameron. Equally dependable is William Webb's *Coastguard! An Official History of HM Coastguard*.

Seaside resorts have been the beneficiaries of a disproportionate amount of scholarly scrutiny, with the happy result that there are some excellent works available. From the French historian of human sensibilities, Alain Corbin, we have *The Lure of the Sea: The Discovery of the Seaside in the Western World, 1750–1840*, translated by Jocelyn Phelps, while the inestimable John Walton has

produced two standard references: *The English Seaside Resort: A Social History 1750–1914* and *The British Seaside: Holidays and Resorts in the Twentieth Century. Beside the Seaside: A Social History of the Popular Seaside Holiday* by James Walvin is an older work, but still useful. Two recent books, both artfully illustrated, remind us of the architectural value invested in resorts: *England's Seaside Resorts* by Allan Brodie and Gary Winter is another outstanding English Heritage production, while Fred Gray's *Designing the Seaside: Architecture, Society and Nature* measures our resorts against those of foreign shores.

The coast as a 'sacred place' is investigated in some of the archaeological works I've already mentioned, but I must add Richard Bradley's thought-provoking book, *An Archaeology of Natural Places.* For more recent coastal sanctuaries, you need look no further than *England's Thousand Best Churches* and *Wales: Churches, Houses, Castles*, both by Simon Jenkins.

Thanks to the enthusiasm of publishers small and large, and the long tendrils of the Web, a variety of travel narratives and topographies that touch or circumnavigate the coast are available. So you can still find in print or on screen, the travels of Gerald of Wales, John Leland, Martin Martin, Richard Carew, Celia Fiennes, Daniel Defoe, Thomas Pennant, Samuel Johnson and James Boswell, William Cobbett, John Byng, William Daniell and H.V. Morton. William Camden's 16th-century *Britannia* is online and available on CD, too.

It's often the case that local historians produce works equivalent in value to those emerging from major universities. Local archives, local knowledge and interviews with locals invariably lead to magnified pictures of the past, and over the years I've accumulated far too many of these local gems to list. Volumes on Lundy, Great Yarmouth, Amlwch, Brighton, the Orwell, Ailsa Craig and Aberdovey are a few, random examples.

Websites worth exploring include:
BBC Coast: www.bbc.co.uk/coast/archive
Intergovernmental Panel on Climate Change: www.ipcc.ch
UK Climate Impacts Programme: www.ukcip.org.uk
UK Climate Projections: ukclimateprojections.defra.gov.uk

Marine Management Organization: www.marinemanagement.org.uk

Centre for Environment, Fisheries & Aquaculture Science: www.cefas.co.uk

Natural England: www.naturalengland.org.uk

Joint Nature Conservation Committee: www.jncc.gov.uk

Ordnance Survey: www.ordnancesurvey.co.uk

National Parks: www.nationalparks.gov.uk

National Parks & Wildlife Service (Ireland): www.npws.ie

British Geological Society www.bgs.ac.uk

Royal Geographical Society: www.rgs.org

Office for National Statistics: www.statistics.gov.uk

National Trust: www.nationaltrust.org.uk

National Trust for Scotland: www.nts.org.uk

An Taisce (National Trust for Ireland): www.antaisce.org

English Heritage: www.english-heritage.org.uk

CADW: www.cadw.wales.gov.uk

Marine Conservation Society: www.mcsuk.org

Campaign to Protect Rural England: www.cpre.org.uk

The Royal Society for the Protection of Birds: www.rspb.org.uk

Friends of the Earth: www.foe.co.uk

The Ramblers: www.ramblers.org.uk

British History Online: www.british-history.ac.uk

The Statistical Accounts of Scotland 1791–1845: stat-acc-scot.edina.ac.uk

Undiscovered Scotland: www.undiscoveredscotland.co.uk

A Vision of Britain Through Time: www.visionofbritain.org.uk

Picture Credits

Index